Dressed
a Pain

KIMBERLY WAHL

Dressed
as in a
Painting

WOMEN AND BRITISH
AESTHETICISM IN AN
AGE OF REFORM

University of New Hampshire Press
Durham, New Hampshire

University of New Hampshire Press
An imprint of University Press of New England
www.upne.com
© 2013 University of New Hampshire
All rights reserved
Manufactured in the United States of America
Designed by Sara Rutan
Typeset in Adobe Jenson Pro 10.5 / 13.75

University Press of New England is a
member of the Green Press Initiative. The paper used in
this book meets their minimum requirement for recycled paper.

For permission to reproduce any of the material in this book,
contact Permissions, University Press of New England,
One Court Street, Suite 250, Lebanon NH 03766;
or visit www.upne.com

Library of Congress Cataloging-in-Publication Data

Wahl, Kimberly. Dressed as in a painting : women and
British aestheticism in an age of reform / Kimberly Wahl.
pages cm. — (Becoming modern / Reading dress)
ISBN 978-1-61168-425-4 (cloth : alk. paper) —
ISBN 978-1-61168-438-4 (pbk. : alk. paper) —
ISBN 978-1-61168-415-5 (ebook)
1. Women's clothing —
Great Britain — History — 19th century.
2. Fashion — Great Britain — History — 19th century.
3. Fashion design — Great Britain — Hitory — 19th century.
4. Aesthetic movement (Art) — Great Britain — History.
5. Great Britain — History — 19th century. 6. Great Britain —
Social life and customs — 19th century. I. Title.
GT737.W335 2013
391'.2 — dc23 2013001533

5 4 3 2 1

An exhaustive effort has been made to locate the rights holders of
figures 1.5 and 3.8, and to clear reprint permission. If the required
acknowledgments have been omitted, or any rights overlooked,
it is unintentional and understanding is requested.

BECOMING MODERN:
NEW NINETEENTH-CENTURY STUDIES

Series Editors

Sarah Way Sherman
Department of English
University of New Hampshire

Rohan McWilliam
Anglia Ruskin University
Cambridge, England

Janet Aikins Yount
Department of English
University of New Hampshire

Janet Polasky
Department of History
University of New Hampshire

This book series maps the complexity of historical change and assesses the formation of ideas, movements, and institutions crucial to our own time by publishing books that examine the emergence of modernity in North America and Europe. Set primarily but not exclusively in the nineteenth century, the series shifts attention from modernity's twentieth-century forms to its earlier moments of uncertain and often disputed construction. Seeking books of interest to scholars on both sides of the Atlantic, it thereby encourages the expansion of nineteenth-century studies and the exploration of more global patterns of development.

For a complete list of books available in this series, see www.upne.com.

Sarah Way Sherman, *Sacramental Shopping: Louisa May Alcott, Edith Wharton, and the Spirit of Modern Consumerism*

Kimberly Wahl, *Dressed as in a Painting: Women and British Aestheticism in an Age of Reform*

Hildegard Hoeller, *From Gift to Commodity: Capitalism and Sacrifice in Nineteenth-Century American Fiction*

Beth L. Lueck, Brigitte Bailey, and Lucinda L. Damon-Bach, editors, *Transatlantic Women: Nineteenth-Century American Women Writers and Great Britain*

Michael Millner, *Fever Reading: Affect and Reading Badly in the Early American Public Sphere*

Nancy Siegel, editor, *The Cultured Canvas: New Perspectives on American Landscape Painting*

Ilya Parkins and Elizabeth M. Sheehan, editors, *Cultures of Femininity in Modern Fashion*

READING DRESS SERIES

Series Editors

Katherine Joslin
Department of English
Western Michigan University

Daneen Wardrop
Department of English
Western Michigan University

This series engages questions about clothing, textiles, design, and production in relation to history, culture, and literature in its many forms. Set primarily in the long nineteenth century, it examines the emergence of modernity by exploring the interweaving of material culture with social history and literary texts in ways that resonate with readers and scholars at the turn into the twenty-first century. The editors seek books that offer fresh ways of relating fashion to discourse and of understanding dress in the context of social, cultural, and political history. Such topics might include, for example, analyzing American, British, and/or European notions of style or tracing the influence of developing modes of production. As with the Becoming Modern series generally, the editors especially welcome books with transatlantic focus or that appeal to a transatlantic audience.

Reading Dress is a subseries of Becoming Modern: New Nineteenth–Century Studies, published by the University Press of New Hampshire.

Kimberly Wahl, *Dressed as in a Painting: Women and British Aestheticism in an Age of Reform*

Ilya Parkins and Elizabeth M. Sheehan, editors, *Cultures of Femininity in Modern Fashion*

Katherine Joslin, *Edith Wharton and the Making of Fashion* ·

Daneen Wardrop, *Emily Dickinson and the Labor of Clothing*

CONTENTS

ACKNOWLEDGMENTS

Many individuals contributed to the success of this book. First and foremost I wish to thank those who were directly involved with its production. Christine Sprengler inspired me during the crucial first phases of developing the book proposal, reading material and offering invaluable advice and feedback. Alison Syme gave generously of her time and reviewed the completed manuscript in meticulous detail. Her insights, knowledge, and mentorship have provided a model for me to follow. Janna Eggebeen cheerfully rallied me through the tedious process of attaining image permissions. Richard Pult at University Press of New England gave cogent advice and timely prodding, exercising patience and humor while still directing a fledgling author through the confusing terrain of manuscript preparation and submission. In its final stages, Glenn Novak and Ann Brash guided me through the production process with kindness and encouragement.

The Faculty of Communication and Design at Ryerson University extended financial support in the form of a publication grant. I would like to thank Charles Davis and Isabel Pederson for their interest in my work and their continued support and enthusiastic endorsement of my efforts to develop an active research agenda despite heavy teaching and service commitments. I would also like to thank my colleagues and friends in the School of Fashion. The sheer variety and diversity of their professional and academic backgrounds have provided a fertile backdrop for the development of my interdisciplinary approach and have vastly expanded my understanding of the field of fashion. In addition, their good humor, encouragement, support, and shared frustrations have brought me to where I am today.

The majority of the primary sources for this book were gathered during my doctoral studies at Queen's University in Kingston, Ontario, and I wish to thank several individuals despite the lapse in time. My research in Britain was initially funded by Alfred and Isobel Bader, in the form of a Bader Fellowship, and I would like to extend my sincere thanks for this early investment in my work. During my time abroad, many individuals contributed greatly to the quality and direction of my research. I would like to thank Margaret F. MacDonald, from the Centre for Whistler Studies; Sophia Wilson, from the Cheltenham Art Gallery and Museum; and Jenny Lister, from the Museum of London. In addition, the staff at the British Library and at the National Art Library in the Victoria and Albert Museum

deserve a debt of gratitude as well. Early mentors Vojtěch Jirat-Wasiutyński and Janice Helland were welcome sources of academic knowledge and support, and it is with regret that I am unable to share my joy in publishing this work with my then supervisor Vojtěch, because of his untimely passing.

Last but not least, I wish to acknowledge friends and family. Special thanks go to my parents Jill Lowery, Ivan Wahl, and Sharon Wahl for their continued support and enthusiastic endorsement of my chosen vocation. I have been lucky to have many brilliant scholarly friends who have blazed a trail before me; I have benefited from their experience and knowledge, but more important, we have shared in the absurdity of trying to pursue an academic career in a growing climate of anti-intellectualism driven by market-based values. Finally, a particular debt of gratitude is owed to my husband, Carlos, who tolerated much so that I might prosper. His quiet support and strength have been with me always, through some very dark days, and now, coming into the light I am glad he is at my side to help me reap the fruits of our labor.

Origins and Issues

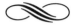

During the 1870s and 1880s, an unconventional form of clothing known as Aesthetic dress crossed over from artistic circles to mainstream fashion culture in Victorian Britain. Romantic and whimsical, it was characterized by its looseness and lack of structure, natural waist, disavowal of the corset, and artistic referencing of sartorial features from earlier periods. Allusions to historical precedents were primarily to classical or medieval models but also to the art and culture of the eighteenth century. Distinctive details in women's dress included puffed or gathered sleeves, looped or trained skirts, and panels of fabric that extended from the back of gowns, high up between the shoulders or just below the neck. Traditional folk techniques of embroidering and gathering, such as wool crewelwork or smocking, were also employed. Colors were natural and soft, and off-tones and sophisticated tints were highly favored. Although the origins of Aesthetic dress may be found in the art and culture of the Pre-Raphaelites, the style was taken up by different artistic circles during the 1860s and '70s, before gaining widespread notoriety in the 1880s. By then, journalistic writing, fashion illustration, commercial projects, and various forms of artistic production reinforced the growing popularity of Aesthetic dress in urban centers such as London.

Closely allied with the concurrent Aesthetic movement, Aesthetic dress served as a visual and sartorial cipher, emblematic of competing discourses surrounding the role and function of femininity in Aesthetic culture. Such discourses ranged from the authority of art in establishing an Aesthetic lifestyle, to medical, social, and political debates centering on issues of health, naturalism, and morality. Like art and other forms of cultural production, Aesthetic dressing was a highly symbolic form of representation in the nineteenth century, with the potential to signify a range of cultural values, from the expression of individual identity to larger shifts in social ideology in relation to the body and clothing. Just as the avant-garde rejected academic institutional values in the art world, so Aesthetic dress, at least in its earliest formations, rejected the dominant aims and practices of mainstream fashion, drawing instead on the authority of art and the clothing

reform movement to help define its oppositional role. Eventually, however, its adoption by mainstream fashion culture signaled a shift in its signification, and many of the original values and aims of the first Aesthetic dressers were appropriated, adulterated, or reframed by competing interests and social groups.

Against the backdrop of sweeping changes in gender relations, as well as the emergence of the "New Woman," late nineteenth-century dress reform was indicative of more than a simple challenge to the constraining aspects of Victorian fashion. Beyond its importance as a precursor to dramatic shifts in fashion culture in the twentieth century, Aesthetic dress represents an intriguing convergence of cultural tensions at the time it was worn. Seemingly isolated to the realm of high art, Aestheticism's connection to social and political reform may seem remote, but closer analysis reveals a reflective and critical process inviting social transformation and progress — an impulse shared by more radical reformers in philanthropic circles. Traditionally viewed as distant from the realities of daily life, particularly among the urban poor, Aestheticism has often been studied in isolation or as a pure artistic movement devoid of political intent. Recent scholarship has challenged this view, with an aim to understand the important interplay between visual and artistic reform and social and political change.[1] Consequently, although I focus on the spirit of reform within the context of artistic culture, I do so with the tacit knowledge that it is a partial view; shifts in artistic culture must be seen as closely allied with the push for reform in other arenas of Victorian culture.

Focusing specifically on the importance of artistic reform in the context of visual culture, this book examines the dominant themes that informed the scope and meaning of Aesthetic dress in artistic and fashionable settings from the 1860s through to the 1890s. My central goal is a close analysis of key discourses in the dissemination and reception of Aesthetic dress by different and occasionally combative audiences. In addition, I outline the degree to which Aesthetic dressing was an empowering practice for women in Aesthetic culture by investigating its potential across categorical boundaries to address, subvert, or otherwise challenge facets of mainstream Victorian culture that were limiting or oppressive for women.

ORIGINS

Although Aesthetic dress was most prominent in the Victorian popular culture of the 1880s, its influence spanned a significantly longer time frame, from its roots in the 1850s well into the twentieth century. Early Pre-Raphaelite forms of dress exemplified many of the stylistic features and design ideals that would later characterize Aesthetic dress after the 1870s. In the art literature and popular press

of the day, Pre-Raphaelite garments were noted for their looseness, comfort, simplicity, and attention to drapery, which attempted to follow or mimic the natural curves of the female body. Both Elizabeth Siddall and Jane Morris, prominent in Pre-Raphaelite circles, wore early versions of Aesthetic dress, which, during the 1860s and '70s, were thus labeled "Pre-Raphaelite dress."[2] In sketches of Siddall executed by Dante Gabriel Rossetti in the mid 1850s and in photographs of Morris well into the 1860s (see chapter 1, figures 1.1 and 1.2), a natural waist, coupled with loose drapery, voluminous sleeves, and simplicity of cut and pattern marked the core stylistic traits of this type of clothing.[3] These garments were intended to enhance comfort and mobility, particularly because many of the women in Pre-Raphaelite circles were artists in their own right and engaged in a wide array of artistic practices (including painting, embroidery, and at times modeling) that would have required their clothing to be flexible. Neither crinolines nor corsets would have been worn, and the sleeves would have been set high on the shoulder or quite loosely so that movement would not be restricted.

Following these early examples, throughout the 1860s and '70s artistic dressing rose in popularity among cultural elites. These included artists, patrons, and art audiences who gathered at establishments such as the Grosvenor Gallery and participated in the social circles and events in the west part of London around the area of South Kensington. Aesthetic styles tended to blend historical details from earlier British modes of dress with orientalizing features drawn from the arts and cultures of the Far East. In addition, in keeping with what was perceived to be the natural construction of artistic forms of clothing, soft, neutral, organic, and off-tone colors tended to be used as well. The growing interest in dress and the artful and creative reconstruction of history through clothing had a reciprocal relationship with the work of artists like James McNeill Whistler, John Everett Millais, Dante Gabriel Rossetti, Louise Jopling, Evelyn de Morgan, Thomas Armstrong, Walter Crane, Henry Holiday, and Marie Spartali Stillman.

A painting by Thomas Armstrong titled *The Hay Field* (figure I.1), first exhibited at the Royal Academy in 1869, is typical of the way in which Aesthetic dress both influenced, and was reflected in, works of art during this period. Set in a peaceful and timeless space of pastoral repose, three figures linger in the moonlight, dressed in simple straight gowns with loosely gathered skirts and natural waists. As Stella Mary Newton has pointed out, despite the title of the painting and the fact that two of the figures are holding rakes, these are not rural peasants engaged in agricultural labor. Rather, they represent early examples of artful and refined Aesthetic dress. The soft colors (perhaps produced with natural dyes) and thin draped fabrics would not have been easily found at a local store of the period, but

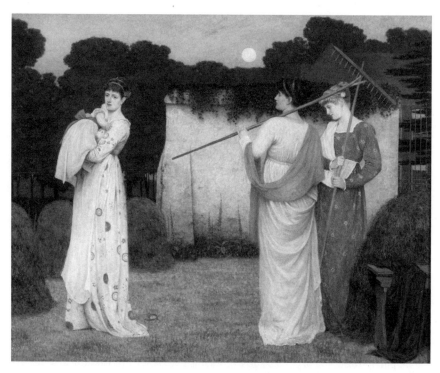

FIGURE I.I Thomas Armstrong, *The Hay Field*, 1869.
Oil on canvas. Victoria and Albert Museum.

indicate an artistic lineage. One gown features a pattern most likely hand-printed from a woodblock, and the figure on the viewer's left wears a garment heavily embroidered with what appears to be crewelwork: an artistic method of working loosely twisted naturally dyed wool through thin, often unbleached fabric.[4] Though critics of the time may not have recognized the significance of the painting, the rising popularity of Aesthetic dress throughout the 1870s and '80s substantiate its importance.

Yet far from being a passive style adopted by followers of art, Aesthetic dress was worn by women artists and patrons, as well as members of art audiences who actively engaged in the growing and participatory world of the Aesthetic movement. An 1871 self-portrait of Marie Spartali Stillman wearing Aesthetic dress illustrates its importance in the definition of an artistic self (figure I.2). Female artists in Pre-Raphaelite circles, as well as in the later Aesthetic movement, strategically mobilized clothing as a signifier of artistic sensibility and authority. While some female artists utilized accepted mainstream fashions to indicate a level of professionalism and respectability, other artists tested the boundaries of

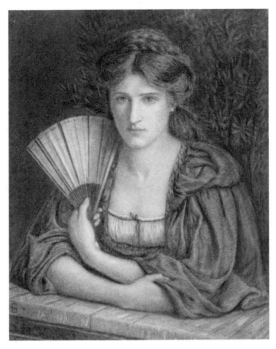

FIGURE I.2 Marie Spartali Stillman, *Self-Portrait*,
1871. Charcoal and white chalk on paper, 63.5 x 51.4 cm.
Delaware Art Museum. Bridgeman Art Library.

public expectation and taste by exploring Aesthetic dress principles not only in their work, but through an embodied exploration of sartorial preferences and styles. Marie Spartali Stillman attained notable stature in the art and fashion literature of the period through her attempt to authenticate Aesthetic dress principles in daily life.

Aesthetic dress was often based on historical precedents, but it was also significant as a current style, illustrating the modernity and chic awareness of its wearers. Its presence in the literature and texts "of the moment," and its growing visibility in artistic circles, attest to its modernity. Nevertheless, Aesthetic dress was also viewed by the cognoscenti as a timeless and stable prototype that criticized the changeability of mainstream fashion. Its paradoxical temporality made it able to inspire many contemporary portraits and genre pieces set in the modern period while simultaneously being heavily influenced by a growing interest in genre and literary paintings set in a distant or indeterminate past. Medievalism, classicism, and orientalism emerged as the three predominant facets of Aesthetic dress in terms of its stylistic roots. Design reformers interested in Aestheticism began

1. TYPES OF ARTISTIC DRESS

FIGURE I.3 Walter Crane,
"Types of Artistic Dress," *Aglaia*
3 (Autumn 1894): 6. National
Art Library, Victoria and
Albert Museum.

to draw on the discourses of art in order to promote the suitability of Aesthetic dress for a growing artistic culture interested in beautifying all aspects of daily living. In the short-lived journal *Aglaia*, the official publication of the Healthy and Artistic Dress Union, types of Aesthetic dress were illustrated and discussed for the edification of its readership. Two models proposed by Walter Crane illustrated similar but distinct styles of artistic dress based on medieval and classical models (figure I.3). Both were loose, featuring the graceful draping of fabric, and were meant to be worn without a corset or bustle/crinoline, each using stylistic details to emphasize either a medieval or a classical appearance. With its emphasis on flowing drapery, and a high-waisted gathering of fabric just under the bust, the dress on the viewer's left recalls classical ideals, as well as their revival in styles made popular during the neoclassicism of the early 1800s. On the right, a blend of late-medieval and early Renaissance signifiers are evident through the linearity and straightness of the gown, combined with the squared-off panel of fabric at the top of the bodice. This panel resembles the thin linen fabrics, often gathered or smocked, that would have served as visible undergarments for the heavier, more elaborate over-gowns of the Renaissance. Yet what is crucial in this invocation of

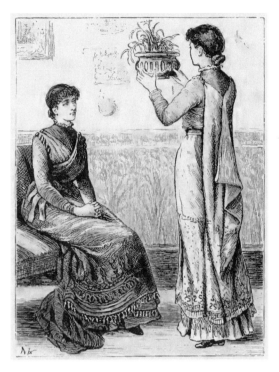

FIGURE 1.4 "Greek Dress,"
Magazine of Art, 1882, p. 336.
University of Toronto Library.

FIGURE 1.5 "Artistic Dress,"
Magazine of Art, 1882, p. 337.
University of Toronto Library.

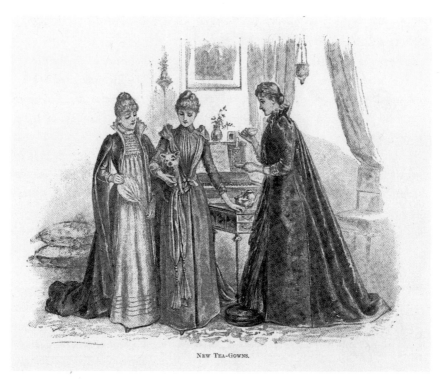

NEW TEA-GOWNS.

FIGURE 1.6 (ABOVE) Three tea gowns,
Woman's World, 1890, p. 76. Courtesy
of Toronto Public Library.

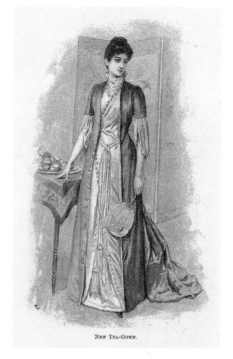

NEW TEA-GOWN.

FIGURE 1.7 (RIGHT) Liberty tea gown,
Woman's World, 1890, p. 26. Courtesy
of Toronto Public Library.

earlier styles is the obvious allegiance to the natural form of the body, and its consequences for modern life.

The impact of Aesthetic dress on the wider fashion culture of the late nineteenth century was profound and yet has been historically underestimated or even overlooked. Aspects of Aesthetic dress were taken up by dress reformers and more politicized groups and individuals who used the authorizing discourses of art to justify social reform in the realm of fashion. The Rational Dress Society, as well as dress reformers such as Margaret Oliphant and Eliza Haweis, often referred to the art world and artistic dress in their publications in order to promote rational and comfortable forms of clothing. Yet, during the late 1870s and 1880s, Aesthetic dress was also absorbed into mainstream fashion culture, and a growing strain of consumerism began to influence the trajectory and cultural meaning of these styles. Appearing in popular art journals such as the *Artist and Journal of Home Culture* and the *Magazine of Art*, as well as fashion journals such as the *Queen*, *Lady's Pictorial*, and *Woman's World*, Aesthetic dress was adopted by and adapted to fit diverse contexts and audiences. During the 1880s there was a pronounced rise in the number of articles and literary columns documenting the growing interest in artistic forms of dress. In 1882, the *Magazine of Art* published the article "Fitness and Fashion." In it, various types of Aesthetic dress were featured, among them examples of "Greek Dress" (figure I.4) and "Artistic Dress" (figure I.5). While these styles were suggested for outerwear, the type of mainstream clothing most significantly influenced by the growing interest in Aesthetic dress was the tea gown. The tea gown was notable as a fashionable, elaborate, yet also comfortable garment that might be worn by women at home between trips outside for shopping or visiting and the more formal setting of dinner. It was primarily valued for its ability to accommodate a wide range of styles; selected examples from the 1890 volume of *Woman's World* illustrate this diversity (figures I.6 and I.7). From orientalizing influences to historical precedents, the wide range of styles available in the form of the tea gown led to a burst in its popularity in the 1880s and 1890s. The similarity between popular models for tea gowns and the types of artistic dresses worn by artistic elites in earlier Aesthetic settings such as the Grosvenor is significant, as it signals the tea gown as an outlet for women's creativity in the home among a wider audience.

DISCURSIVE FORMATIONS

My goal is to map out the territory of Aesthetic dressing in various contexts, with special attention to its pictorial significance in the visual culture of the period. One

of my central assumptions is that the representation and discursive positioning of Aesthetic dress in the fashion and art literature of the late nineteenth century are ultimately as important as the material facts of Aesthetic dressing itself. In this book I try to balance theory with a careful study of the visual, textual, and material culture of the period.[5] In the course of my research I examined extant examples of Aesthetic dress located in the collections of the Victoria and Albert Museum, as well as the Museum of London, in order to gain a sense of what these articles of clothing actually looked like and to understand their basic construction. I discovered that a chasm exists between the material culture evidence of artistic or alternative forms of dress and the representation of Aesthetic dress as an ideal form or as a visual expression of cultural critique. This very discrepancy suggests the importance of Aesthetic dress as a signifying practice within the visual culture of the Aesthetic movement — its rhetorical potential, in many cases, outlived and outlasted its cultural impact as a viable mode of dress reform in practice. Thus the perceived nature and historical construction of Aesthetic dressing as a sartorial and behavioral category are foregrounded in my analysis of Aesthetic dress and its importance for women involved or interested in the Aesthetic movement in Britain.

Methodologically, my approach to this topic is based on a cultural studies model — interdisciplinary in scope, and, as I have just indicated, interested in the social meanings and representations of Aesthetic dress in addition to the material facts of its history. In order to address the complex interrelation of art and fashion, I draw loosely from several theoretical traditions. My emphasis on the importance of discursive practices in the formation of knowledge and subjectivity is based on the theories of Michel Foucault. Equally important is my interest in the analysis of social groupings and the mechanisms by which class and gender are constructed in artistic settings. For this reason, I also follow a social-historical model based on the writings of Pierre Bourdieu.[6] Critically, however, I rely on recent feminist interventions into the theories of both Foucault and Bourdieu, insights that have brought theoretical complexity to the often-overlooked nuances of gender lacking in the analyses of both these theorists. I also draw on new theories in fashion scholarship, a growing and rigorous field of inquiry. Joanne Entwistle, Elizabeth Wilson, Valerie Steele, Lou Taylor, Christopher Breward, and Diana Crane have investigated the interconnectedness between clothing as a form of social practice and its central role in the visual and literary products of culture. Fashion, however, remains a relatively untapped resource within the social history of art. Indeed, as both practice and representation, alternative forms of dress are emerging as a privileged site for the careful study of visual culture. My hope is that this merg-

ing of cultural theory with new directions in the historical study of fashion will provide novel insights into the contested relationship between the female aesthete and her own body.

An analysis of the social function of clothing offers insight into several facets of Aestheticism that would otherwise remain unexamined. Tensions existed between elite and popular constructions of Aestheticism, and these reveal themselves most clearly in how Aesthetic principles were applied in everyday settings, in which sartorial habits played a large role. At various points in its development, and depending on the practitioner(s), Aesthetic dress became emblematic of an art-for-art's-sake stance, distancing itself from mainstream fashion culture and society in general.[7] However, the integral relationship between clothing culture and societal practices grounded Aesthetic dress firmly in the realm of daily experience and thus challenged its potential to embody a set of purified Aesthetic values apart from life. At other moments, even as it continued to criticize aspects of mainstream fashion, Aesthetic dressing was positioned more democratically, representing an attempt to merge art and life for the benefit of all. Foregrounding the importance of fashion in the Aesthetic movement provides new insight into the roles and experiences of artistically inclined women, allowing me to address the many conflicts they faced as both producers and consumers of Aesthetic culture.

CONSUMING AESTHETICISM

Examining the role played by Aesthetic dress in artistic circles, as well as its reception and dissemination among a wider audience through commercial fashion and art journals, provides a glimpse into the myriad ways that gender and consumer culture played a crucial role in the Aesthetic movement in Victorian Britain. In an effort to understand the reception of Aesthetic dress, I looked at a vast array of printed literature and found overwhelming evidence of the rising popularity of Aesthetic culture more generally in the visual culture of the 1880s. For this reason, the study of Aesthetic dress requires a careful balancing of thematic considerations across social and artistic boundaries, with attention to its changing significance in specific contexts. The existence of Aesthetic dress as a facet of artistic culture is necessarily related to developments in consumer culture, where its presence was widely known and accepted by the end of the 1880s, to the extent that special stores and services catered to an "artistic" clientele. The creation of Liberty's artistic dress department is an example of this. In the commercial and popular realm of fashion journalism, Aesthetic lifestyles and accessories were produced, illustrated, discussed, and explored in a variety of contexts and through a range of media. More

importantly, commercial products catering to Aesthetic taste were avidly discussed with regard to artistic discourses and origins, arguably to increase their perceived distinctiveness and desirability. Examples of art production of the period are thus significant for their integral role in the dissemination and reception of Aesthetic dress ideals as part of a vibrant Aesthetic culture.

The commercial applications of Aestheticism contributed to a growing potential for mobility and self-expression on the part of Victorian women newly entering the public sphere after an enforced period of domestic seclusion. With the rise of a market-based economy and the establishment of women's importance in consumer culture, the emergence of commercial and leisure spaces aimed at satisfying the growing artistic tastes of a largely female clientele was inevitable. Significantly, this provided women with greater opportunities to circulate in the public sphere in spaces that were considered both safe and respectable. In these newly defined spaces of taste and freedom, women could explore some of the more empowering aspects of clothing in the process of self-fashioning. Joanne Entwistle has pointed out that fashion can be used "to give oneself impressive 'individual' identity" while at the same time indicating one's communal status "since it enhances uniformity." This duality, and the dual role of private self and public persona, are themes "which have dominated debates about fashion and dress."[8] As the existence of separate and distinct spheres for men and women began to break down in the 1870s and 1880s, Aesthetic dress may have played a crucial role in the process of signifying both individual and group identity for many artistic women. The Aesthetic notion of the revelation of individuality through dress points to a romantic concern with the self and authenticity. Utilized in a self-exploratory way to search for a romantic ideal within oneself, Aesthetic dress attempted to reveal the true self while also functioning as an emblem of commonality — a sign that one was part of a larger group of individuals involved in Aestheticism. The elaboration of Aesthetic standards of taste must therefore take this dualism into account.

In the course of my research, I was surprised to learn how broad the definition of Aesthetic dress was in the literature, and that it was often misrecognized, or not identified at all. Rather, it was variously constructed in the fashion and art literature throughout the course of its development — often in direct contradistinction to the original intent of its designers and wearers. This instability in terms of the place of Aesthetic dress in the various discourses of the art and fashion world of the late nineteenth century solidified my interest in the representative and discursive potential of Aesthetic dress and its ability to point to relevant shifts in cultural values. More important, this flexibility indicates that Aesthetic dressing was used by certain groups and individuals to point to a specific set of artistic and cultural

values, and was crucial in the formation of individual and group identity. It is clear to me that the presentation, representation, commercialization, and, most important, the reception of Aesthetic dress were used by a variety of female subject positions for a variety of purposes and ends. Often, the term "taste" was deployed in the literature of fashion, art, and dress reform to signal an advanced degree of social erudition and artistic sensibility, and was frequently mentioned in descriptions and editorial pieces dealing with the topic of Aesthetic dress, particularly in the popular press. With the plethora of images and descriptions of Aesthetic objects, products, and lifestyles available, the question remains: What did the image of the Aesthetic dresser connote for those who sought to identify with its precepts?

Bourdieu's concept of cultural capital is helpful in providing a partial answer. In his theories outlining the mechanisms of social distinction, cultural capital refers to the acquisition of social power and prestige based on valued forms of cultural currency usually associated with advanced levels of education or specialized artistic, intellectual, or social skills.[9] For many, Aesthetic dress became an indicator of this particular brand of cultural currency, and was largely determined and judged by the prevailing tastes of artistic elites. Yet the term "taste" itself was inherently contradictory because of its variously constructed meanings. Like the fluctuating standards of the fashion world itself, the notion of taste was inextricably linked with the visual preferences and interests of the period. Mobilized by both social reformers and conservatives, artists and critics, the terms of "good taste" were fought over on both sides, with competing authorizing discourses used to garner support for various positions in the debate. Thus, although I often use the term "taste" descriptively to evoke hierarchical value systems in nineteenth-century artistic culture, I do so with the full awareness that the term was highly contested, and that its social meanings were therefore fluid. The theories of Bourdieu are useful in an analysis of how taste functioned in Victorian culture to both promote certain modes of art and design while excluding others — a process that was central in the artistic groupings that together formed the Aesthetic movement, and which necessarily had an impact on the development of Aesthetic dress.

For Bourdieu, taste is defined as an attribute or strategy of the habitus, a set of social assumptions and practices that bind groups and classes together. Learned through various mechanisms of social experience and practice, taste is acquired and passed on within groups in order to exclude others and consolidate the values of the group as a whole. The role of the individual in this process is fluid, since habitus is both a function of social exchange and embodied and practiced by the individual. Taste is thus flexible, but tends to affirm the value system of the group or class to which the individual belongs. Aestheticism was subject

to the habitus of various groups, both those on the inside who reaffirmed and reproduced Aesthetic notions of taste, and those external to Aestheticism who may have perceived an Aesthetic sensibility as "tasteless" according to their own practice of habitus.[10] Both inclusive and exclusive, Aestheticism as a rarefied form of living was reserved for those who understood it best and could most successfully decode its abstruse system of signs and symbols. As a result, any discussion of Aestheticism and taste must always be qualified by the understanding that the use of the term "taste" in Victorian culture was always overdetermined, frequently contradictory and even arbitrary, and usually necessitates a consideration of the context in which the term appears.

A plethora of articles detailing the improvement of taste in the dress literature of the period can be viewed as part of a wider push toward artistic and cultural reform in the art world. The rising interest in artistic and reformed models of architecture and interior decorating made manifest the Aesthetic credo in the form of interior and exterior domestic space, a trend that has been characterized by many design historians as indicative of the growing influence that women had in the field of interior decoration. The opening of the Grosvenor Gallery in 1878 provided a locus for the articulation and dissemination of Aesthetic ideals in a carefully contrived space that clearly emulated domestic settings in a way that other galleries at the time did not. In such a setting, decorative art objects became central to the experience and reception of Aesthetic art. At the Grosvenor, the richness of the domestic items in an exhibition setting — luxurious chairs, exotic rugs, plants, and sumptuous fabrics on the walls and windows, along with decorative panels on the upper walls and ceilings — referred to the domestic spaces of wealthy and/or artistic Aesthetic patrons, as well as of the artists themselves. In essence, exhibition spaces such as the Grosvenor could be viewed as extensions of the refined and self-aware spaces artfully crafted and commissioned by those who either created or bought Aesthetic art. Aesthetic dress both enriched and helped create these Aesthetic spaces.

More broadly, however, the trend toward improving taste in relation to Victorian lifestyles and spaces can be linked with the rise of liberal individualism and the newly acquired wealth mobilized by an emerging and influential middle class whose wealth was based more on industry and commerce than on land ownership or inheritance. The conflation of male and female roles of collector and interior designer within the Aesthetic movement happened at a time when the increasing wealth of the middle classes resulted in increased leisure time for middle-class women interested in the arts, allowing them more time to "decipher the complex cultural codes of the Aesthetic movement."[11] This is not to say that Aestheticism

was a phenomenon limited to the middle classes. Many of its supporters came from the upper classes and nobility, including Princess Louise and her circle of aristocratic friends who attended or exhibited art at the Grosvenor Gallery, and the eclectic and wealthy artistic circle known as "The Souls," who decorated their houses in the Aesthetic style and made the rounds of the studios of those artists most closely allied with the movement.[12]

Many design reformers within Aestheticism aimed at taking artistic concerns out of the arena of class into an alternative hierarchy of refinement based on artistic knowledge and excellence. Arts and Crafts practitioners who strove to democratize and disseminate artistic ideals throughout society disavowed class distinctions, while the hermetic circles surrounding the Grosvenor and its patrons were composed of aristocrats and artistic individuals from all classes who aspired to a bohemian ideal. Those interested in Aestheticism circumvented the normal routes and patterns of aristocratic patronage by drawing the wealthy and powerful into their artistic and cultural milieu.[13] By blurring the lines between a level of refined taste based on class awareness, education, or social opportunity, and the notion of advanced taste as a product of an inherent or instinctive artistic sensibility, the Aesthetic movement presented an alternative set of criteria by which cultural capital was acquired and maintained. This extended to the practice of Aesthetic dressing. Privileging alternative standards of beauty, decorum, and artistic ability, artistic forms of dress challenged Victorian norms of fashionable dress based on wealth or class alone.

AN ANTIMODERN IMPULSE

Aesthetic dress can be viewed as a product of, and response to, modern culture. More importantly, it was a visual and visceral expression of antimodernism, revealed through the dualisms inherent in high versus low culture forms of Aestheticism as well as between historical and contemporary strands within artistic models of dressing. For T. J. Jackson Lears, antimodernism was a critical engagement with the alienating aspects of modern culture through a valorization of past or rural cultures and a perceived set of positive associations and social values. This notion can be fruitfully applied to Aesthetic dress, since the interest in medieval art and culture illustrated by the Pre-Raphaelites, and the blending of medieval, Eastern, and classical influences in Aestheticism, point to this desire to engage with the cultural material of the past. Interest in the visual objects, imagery, and perceived lifestyles of these cultures signals a flight from the present, from the material and commercial concerns of modern living. Aesthetic dress, dominated as it was by

historical references and stylistic features, is symptomatic of this romantic with-drawal from the conditions of modernity.

Acknowledging this recoil from modern culture is only part of the larger picture, however. Crucially, Lears notes that antimodernism was "not simply escapism; it was ambivalent, often coexisting with enthusiasm for material progress." More important, Lears asserts that, far from being the last nostalgic "flutterings" of a "dying Elite," antimodernism was a "complex blend of accommodation and protest which tells us a great deal about the beginnings of present-day values and attitudes."[14] Paramount to antimodernist approaches to art is the belief that authentic forms of experience — and in Aestheticism, one resulting from an encounter with the beautiful — would aid in the recuperative transformation of one's psyche. In addition, a central feature of antimodern texts is the use of premodern symbols in order to address the conditions of modernity. Thus, the passionate alliance between historical clothing details and an emphasis on social reform marks Aesthetic dress as profoundly antimodern.

Lears's characterization of antimodernism is also relevant to a consideration of popular forms of Aesthetic dress resulting from the commercialization of Aesthetic modes and styles. The growing culture of consumption in the nineteenth century is referenced by Lears, who notes that by "exalting 'authentic' experience as an end in itself, antimodern impulses reinforced the shift from a Protestant ethos of salvation through self-denial to a therapeutic ideal of self-fulfillment in this world through exuberant health and intense experience."[15] The development of consumer culture as a route to self-fulfillment and the pursuit of novel experience and pleasures partially explain the rapid spread of Aestheticism as well as the impact of the market on the mass material consumption of Aesthetic lifestyles, goods, and services during the final decades of the nineteenth century.

In more select circles, Aesthetic dress can be seen as a strategic attempt to deal with the changing values of the modern world. In its very engagement and critique of mainstream fashion, and its growing popularity in fashion elites and elsewhere, Aesthetic dress represented a novel form of alternative fashion very much located and disseminated in the modern marketplace of consumer goods. A profusion of luxury fabrics, objects, furniture, and art, purchased and collected to adorn oneself and one's surroundings, both responded to and cemented the wide appeal of the Aesthetic movement and a corresponding interest in Aesthetic dress. Therefore, the impulse toward antimodernism that informed some strains of Aesthetic dressing expresses a complex relationship between consumer culture and Aestheticism, where, on the one hand, aspects of Aestheticism adhere to a romantic separation of self from culture, and, on the other, a contemporary interest in current devel-

opments in the market of consumer and artistic goods speaks to the relationship between artistic dressing and the experience of modernity.

Similarly, while the experience of modernity has invoked responsive changes within dress reform circles, so too have clothing practices impacted modern culture.[16] Ilya Parkins and Elizabeth M. Sheehan have foregrounded the importance of work in the area of consumer culture in providing a full account of the myriad ways the framing of femininity helped shaped concepts of the modern. More significantly, such work has been crucial in "countering the many accounts of modernity that present women as anterior to or excluded from it." Yet Parkins and Sheehan also point out that "fashion has received little attention as a gendered phenomenon that not only reflected but also influenced how modernity and femininity were conceived and experienced."[17] In its complex balancing of modern and antimodern themes, Aesthetic dress expresses key tensions in gender relations arising from women's growing involvement in the consumer cultures of Aestheticism.

AESTHETIC DRESS AND FEMININITY

Aside from its recuperative function in negotiating alternative sartorial modes within modern fashion, Aesthetic dressing also signified and shaped emerging images of the female aesthete. More crucially, the perceived divide between high and low cultural forms of Aesthetic art production and consumption was linked with the agency of women within Aestheticism. Juxtaposing these areas is a productive way of examining the meaning and function of Aesthetic dress and the degree to which it was either empowering or limiting for women in the Aesthetic movement. Throughout the fashion and art literature of this time, rhetorical distinction was drawn between true forms of Aesthetic production and derivative forms of decorative application. Regenia Gagnier and Kathy Alexis Psomiades have explored the high and low culture divide that continues to inform the critical writing on Aestheticism. In their studies on women and the construction of femininity within Aestheticism, both interrogate this split by pointing out its ideological function in the service of gender construction and containment. The explanatory model of high art Aesthetic production by male artists and low art application of Aestheticism in the realm of the decorative arts by craftspeople, and domestic consumerism by women, is fraught with internal contradictions, even as it is reified and supported in contemporary examples of literature on design reform.

Gagnier, in tracing the development of Aesthetic philosophies in art and their relationship to economic forces and theories of consumption, has outlined a trend in the historical framing of Aestheticism that locates the commodification of

art outside the borders of artistic purity by foisting it onto the realm of popular forms of Aestheticism associated with the feminine realm of consumer culture.[18] Psomiades has demonstrated how femininity itself became a trope within Aestheticism — a useful signifier for the double nature of art as both apart from the praxis of daily life and also commodified within the marketplace. Her basic argument relies on the analysis of the nature of femininity as constructed in the nineteenth century. She asserts that femininity functions as a binary where undesirable aspects of the female psyche, constructed or otherwise, are repressed in favor of a more useful and less threatening set of feminine associations. The logic of repression that allows femininity to function as a sign within Aestheticism also allows its development as a useful symbol for other contradictory structures — namely the contradictions within Aestheticism itself. On one level Aestheticism is regarded as an autonomous art form removed from daily life, and on another, it is necessarily commodified and disseminated in the proliferation of goods and services associated with an Aesthetic lifestyle.[19]

Many feminist analyses of Aestheticism have argued that women's role in Aestheticism has not been sufficiently explored or researched. For both Psomiades and Gagnier, the intentional distinction between productive forms of Aestheticism and the consumption of Aesthetic culture obscures the important contribution that women made to Aesthetic culture in the closing years of the nineteenth century. This problematic relationship is best articulated by mapping the absorption of alternative modes of dressing into mainstream fashion, and examining the interrelation between popular and elite forms of Aesthetic dress. Consequently, I do not subscribe to a model that views high culture forms and images of Aesthetic dressing as passively emulated by a populace informed through the texts of popular culture. Rather, I would argue that Aesthetic dress was utilized, deployed, and ultimately re-created in the two spheres with varying results and intentions. Aesthetic dressing existed across a broad spectrum of artistic practices and enterprises. A simple division between those forms donned by the artistic "insiders" of Aestheticism and more popular forms emerging in consumer culture is antithetical to a rigorous analysis of women's art production within Aestheticism and its significance for a wider audience of artistic culture. In fact, I suggest in several places throughout this book that Aesthetic dressing provided an opportunity for women to consolidate and reconcile opposing formations of femininity by allowing them to occupy simultaneously a position as subject of Aesthetic sensibility and object of Aesthetic contemplation. Further, Aesthetic dressing, in its active and performative function, can, in some cases, be viewed as questioning, subverting, and even redressing the terms of female subjectivity within Aestheticism.

Since clothing is one of the most visible forms of cultural consumption and display, it plays a significant role in the formation and construction of identity. Further, as fashion alludes to gender and social status, it is capable of subverting symbolic boundaries or questioning existing social norms.[20] For Entwistle, the construction of gender is inherently linked with the symbolic aspects of the clothed or covered body, so that certain forms of sartorial display stand in for the very thing they are expected to evoke — thus a gown or certain form of dressing connotes femininity, and subsequently that particular style is linked with a particular gender and is, in effect, naturalized.[21] Anything that questions or subverts this relationship makes a powerful statement, although its ultimate meaning is heavily inflected by the way in which it is received, as well as by the embodied experience of various modes of dressing in practice. This aspect of clothing culture makes it especially useful for understanding how individuals or groups position themselves ideologically with respect to the visual culture that surrounds them.

As an embodied form of Aesthetic practice, Aesthetic dress requires a close analysis of the body as a central site of discursive activity and conflict. Along with its adherents among female artists, viewers, and patrons of the arts, Aesthetic dress was taken up by individuals in dress reform circles and women interested in creative dressing in mainstream consumer culture. Subsequently, Aesthetic dress became an identifiable category in mainstream fashion journalism as well as in more politicized forms of clothing literature. Positive views of Aesthetic dressing allied its scope and intention with the highest ideals of artistic and social reform, but more negative views of Aesthetic dressing were often promoted as well. Depending on the textual sources and social groupings, it was often presented as either a humorous and laughable form of fashionable frippery, or conversely as a cipher for underlying moral and corporeal corruption. As a form of social practice, Aesthetic dress was subject to many of the competing discourses of beauty, health, and morality that characterize various dress reform movements during the second half of the nineteenth century. Early in its development, consensus of the importance of health and beauty in dress resulted in the cooperation of Aesthetic dressers and dress reformers intent on social change. Later, as Aestheticism became progressively associated with decadence, artistic excess, and moral and physical forms of corruption, the more politicized dress reform circles began to disassociate themselves from Aesthetic dressing as a viable form of social criticism and practice. These developments point to the importance of the body as a central site for discursive formations.

The material study of dress has sometimes neglected to adequately address the embodied experience of its wearers. In addition, the patterns of social and psy-

chological consumption that lie at the heart of fashion as a dynamic and evolving social practice have been difficult to chart. Aesthetic dress provides an excellent case study for the ways in which issues of embodiment have been both central, but largely ignored, in past analyses of women and Aestheticism. Entwistle has pointed out that traditional analyses of fashion have tended to sidestep or evade questions of the body or, conversely, to deal with them in a reductive or mechanistic way. She argues that although the work of Foucault is useful for thinking about the ways that power is invested in and through bodies, his theories only account for the processes that act on the body, not how the self interprets or translates this in practice. Instead, she proposes an alternative theory of embodiment drawn primarily from a feminist reading of the work of Foucault, Merleau-Ponty, and Bourdieu. In the work of Merleau-Ponty, the body is located in time and space, and thus the interaction between the self and the surrounding environment happens through the body. As the "envelope" of the self, it is more than simply an instrument of perception: the body shapes our experience of the world and partially determines how others perceive us. A phenomenological approach thus holds the key to working through problems inherent in Foucault's work. Entwistle also uses the theories of Bourdieu to propose a theory of dress as a situated bodily practice that helps shape and define a person's experience of the world.[22] The key to understanding the motivations of Aesthetic dressers thus lies not in the visual systems of signification that surround them, but in the understanding of how those sartorial codes affected them physically, in the clothes that encased their bodies, and in the spaces through which they moved.

A common problem in the work of Foucault, Merleau-Ponty, and Bourdieu is that none of them adequately takes into account the question of gender as the primary means of distinction in discourses of the body, and thus, the use of their work must be supplemented by feminist theory. Accounting for the lived, embodied experience of the wearer of Aesthetic dress requires asking particular questions about the meaning and function of Aesthetic dress on both a social level as well as a personal one. In her work on fashion and modernity, Elizabeth Wilson has argued that, like other forms of aesthetic production, fashion can be understood as having an ideological function, where social contradiction and conflict can be resolved on a formal and imaginary level. Fashion, she points out, can be ultimately empowering for the wearer, since it allows for an emphasis on beauty and the body in an ascetic and moralistic Judeo-Christian culture that has tended to belie or repress the sensuality of the body, particularly as expressed by women, for women.[23] Taking as my starting point the development of Aesthetic dress as a set of stylistic markers (as scholars such as Stella Mary Newton have

done), and using the complex and emerging theories of the body in relation to fashion, I demonstrate that Aesthetic dress must be seen as a situated bodily practice that ultimately interacts with and inflects the phenomenological experience and expression of identity both for individual women and within artistic groups and coteries. Thus, the ideological ramifications of fashion as part of a contested visual culture points to the importance of clothing in the negotiation of social convention and relational power structures.

Because of the immediacy and flexible nature of dress as a form of artistic consumption and display, Aesthetic dress presented a rare opportunity for women involved in the Aesthetic movement to assert their preferred standards of artistic taste and thereby actively participate in the discourses of design and art reform that were central to the Aesthetic project. Since its imagery is so central to the pictorial conventions of Aestheticism itself, Aesthetic dressing can be distinguished from other modes of fashion that are primarily self-referential and do not point to outside symbolic systems in a programmatic way. In addition, although artistic dress was also employed by men, its significance for women was of an entirely different order. The ubiquitous formation and cultivation of feminine imagery in the Aesthetic movement and the repetitive nature of representations of women in Aesthetic art are indicative of a central paradox of the Aesthetic movement — namely, that woman as a category and a social reality inhabited the position of both subject and object within the discourses of Aesthetic art practice. A feminist reading of Foucault's theories regarding the centrality of the body in discourses of social control and institutional power signals the importance of gender in the differential experience of such discourses in practice. Entwistle points out that questions of the body with regard to fashion are always complicated by questions of gender, since women have traditionally been associated with the body in Western culture, and thus, their embodied experience and relation to discourses of power are much more reliant on social discourses on the body than male subjectivity.[24]

OUTLINE

In the chapters that follow, I address key themes and their attendant discourses by examining particular contexts or moments in the production, representation, and cultural reception of Aesthetic dress. In chapter 1, I investigate the categorical limits of Aesthetic dress, addressing its coherence and stability as a clearly defined concept in the art literature of the Aesthetic movement. Central to this chapter are the multivalent responses to modernity that characterize the cultural meaning of Aesthetic dress in its earliest incarnation: Pre-Raphaelitism. Chapter

1 also charts the perceived importance of the art world in authorizing artistic and sartorial reform.

Chapter 2 discusses the impact of fashion and Aesthetic dress on the work of James McNeill Whistler, whose artistic approach is central to any consideration of Aestheticism in Victorian culture. Whistler's depiction of Aesthetic dress is significant because it diverges from Pre-Raphaelite imagery in several important ways. The artist's desire to capture the ephemeral nature of fashion reveals an ideal of dress as a form of visual pleasure rather than as an expression of social betterment.

In chapter 3, I examine the artistic circles surrounding the Grosvenor Gallery during the 1870s and 1880s, and the role of Aesthetic dress in the cultivation and maintenance of a rarefied space devoted to the aesthetic contemplation and consumption of art. Worn by many female artists, patrons, and visitors, and represented in many of the works exhibited, Aesthetic dress presented a form of Aesthetic practice in the space of the gallery that positioned its wearers as both subjects of artistic agency and objects of Aesthetic contemplation, and thus mirrored the role of femininity itself in this setting — a relationship that would not have been lost on many of the women who attended or exhibited work at the Grosvenor.

Chapters 4 and 5 address the important repercussions of consumer culture and public discourse on the practice of Aesthetic dress. The popular print culture of the 1880s and '90s attests to the widening circle of influence and visual impact that Aesthetic dress had for a variety of audiences. This dissemination and the eventual absorption of Aesthetic dress into mainstream fashion culture is analyzed, particularly with regard to the use of the tea gown as an artistic outlet for women in consumer culture. Chapter 4 focuses on the reception of Aesthetic dress in journal literature and fashion illustration. In selected publications and in early examples, Aesthetic dress is presented as a creative and expressive mode of sartorial power and autonomy for women. Its flexibility, comfort, and symbolic artistry are highlighted as distinct from many precepts of mainstream modalities. Over time this rhetoric is belied by the visual and material evidence, which suggests that artistic dressing was not always oppositional, or based on reform examples. Representations of Aesthetic dress in the literature are contrasted with extant examples of Aesthetic dress that suggest that "artistic dressing" in practice was a highly contested realm where the individual adaptation of "artistic" principles diverged wildly and often merged with the dictates of fashionable dressing itself.

Chapter 5 examines theories of embodiment and artistic subjectivity with regard to women who wore Aesthetic dress. I explore the female body as a locus of intense critical debate, a site for the discursive formation and negotiation of socially acceptable and unacceptable modes of feminine behavior in Victorian culture. I analyze

the various ways that discourses on health, nature, femininity, and morality serve to position the Aesthetic body as corrupt, deviant, and artificial — a perception that was antithetical to its positive framing in the original literature and activities of early dress reformers. This reversal in meaning ultimately speaks to the ways in which the trajectory of Aesthetic dress was fatally linked to the decline of the Aesthetic movement itself. Yet in establishing Aesthetic dress as a powerful mode of discourse, I argue that its potential to help define and strengthen practices of intellectual play and embodied agency for women points to its life and significance beyond the confines of a single art movement.

Dressed as in
a Painting

CHAPTER I

Dress Reform and the Authority of Art in Victorian Aesthetic Culture

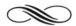

What exactly is Aesthetic dress? Although I ultimately argue that this question is not easily answered, this chapter explores Aesthetic dress as a definable category in the fashion and art literature of the Aesthetic movement. Inherent in its design, production, and presentation were three main principles: an implicit critique of mainstream fashion, an acknowledgment of clothing as a powerful signifier of both individual and collective identity, and a complex negotiation of modernity in terms of historical precedents. The association of Aesthetic dress with Pre-Raphaelitism (as its origin and an ongoing influence) suggested wearers' advanced taste and artistic knowledge. It also exemplified the ambiguous "temporality" of Aesthetic dress, which was both "modern" in nineteenth-century terms (a current, and novel, fashion),[1] and antimodern in its preference for historical dress styles. The Pre-Raphaelites looked to the medieval era in particular, but later Aesthetic dressers drew on a wider and more eclectic range of historical periods and cultures for inspiration, often referencing the past explicitly in the service of future social and artistic reform rather than in a wholesale rejection of modernity.

Many of the cultural values informing Pre-Raphaelite dress were also shared by dress and domestic design reformers throughout the latter part of the nineteenth century. During the first decades of its development, the wider cultural move-ment toward dress reform was as invested in the discourses of art and beauty as it was later in its more overtly political agenda. Toward the end of the 1880s and 1890s, political and health-based concerns over dress would increasingly inform the direction of the movement, but it is crucial to note that in the nascent period of its formation, it was equally based in the world of the visual arts, owing to the overwhelming emphasis on naturalism in the arts at that moment. An avid

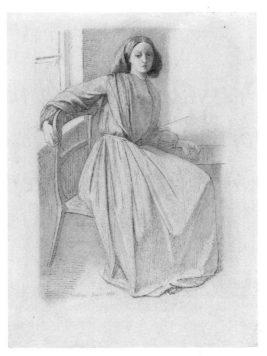

FIGURE I.I Dante Gabriel Rossetti, *Portrait of
Elizabeth Siddal, Seated at a Window*, 1854.
© Fitzwilliam Museum, Cambridge.

and widespread interest in historical models of art and culture was informed
by discourses of naturalism, as well as a belief in the inherent authority of art
in determining all matters of taste. Artistic modes of dress, and, by extension,
artful living, encompassed emerging standards of Aesthetic taste while criticiz-
ing a dominant fashion culture increasingly viewed by reformers as debased and
demoralizing. Across a broad range of media and cultural practices, proponents
of Aestheticism shared a belief in the supreme value and autonomy of art (which
existed for no other purpose than to embody artistic principles; James McNeill
Whistler was perhaps the most famous advocate of this view, particularly in the
arena of painting). However, within the decorative arts, practitioners did not
specifically conform to an art-for-art's-sake stance, instead carrying over beliefs
rooted in an Arts and Crafts sensibility that privileged the usefulness of objects
in relation to their aesthetic value. This is especially true of Aesthetic dress, be-
cause many of its greatest advocates also promoted forms of political and social
reform.

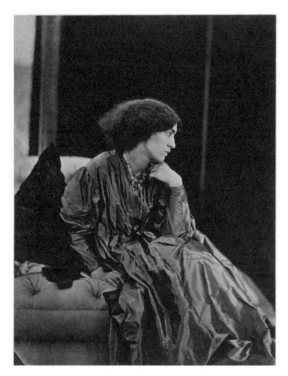

FIGURE 1.2 John Robert Parsons, *Photograph of Jane Morris*, 1865. © Birmingham Museums.

Aesthetic dress must be seen as a nexus of artistic, political, historical, and philosophical discourses and practices. This chapter will thus explore a range of issues necessary to understanding the category of Aesthetic dress, beginning with its Pre-Raphaelite roots and moving on to consider the question of "taste" in dress reform, the idea of naturalism and the female body, the linking of historical reference with authenticity, and the association of women with reform.

PRE-RAPHAELITE DRESS

Most nineteenth-century fashion historians agree that the origins of Aesthetic dress lay in the innovative yet historicized approach to merging art and life outlined and practiced by the Pre-Raphaelites.[2] Many of the women involved in the movement, whether they painted, sat as models, wrote poetry, or engaged in various forms of needlework, weaving, or textile and tapestry production, wore a form of dress that was both artistic and comfortable, the designs for which they often

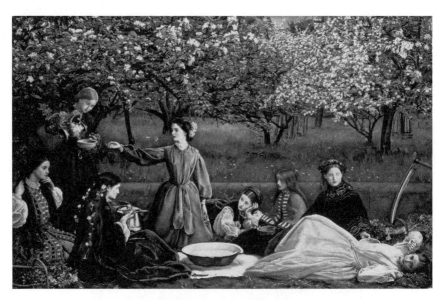

FIGURE 1.3 John Everett Millais, *Spring (Apple Blossoms)*, 1859. Oil
on canvas, 113 x 176.3 cm. Lady Lever Art Gallery, National
Museums Liverpool. Bridgeman Art Library.

devised themselves. They dispensed with the crinoline and designed the bodices of
their gowns to be worn without tightly laced stays.[3] In a sketch of Elizabeth Siddall
by Rossetti (figure 1.1), executed during the mid 1850s, the bodice of her dress is
noticeably loose, and the wide upper sleeves placed high on the shoulder for ease of
movement. This is a design that may have been worn by Christina Rossetti as early
as 1846.[4] The construction of these gowns went against fashionable conventions
of the same period where tight sleeves set low on the shoulder, affixed to equally
restrictive bodices, effectively inhibited the free motion of the arms. Similarly, in
a series of 1865 photographs of Jane Morris, one of her gowns suggests a growing
fullness in the back along with a rising waistline, which was occasionally worn loose
and unbelted (figure 1.2).[5] These two aspects together point to future fashionable
styles based on the Watteau toilette of the eighteenth century — a popular design
that would later be used for tea gowns in the 1880s and 1890s.

 Pre-Raphaelite genre paintings, particularly in the later phases of the movement,
often featured portraits of women, alone or in groups, posed in attire based on his-
torical styles. Picturesque and unspecific as to exact setting or time, these paintings,
in conjunction with portraits of notable figures within Pre-Raphaelite circles, had
a significant impact on the development of models of Aesthetic dress. They also
illustrate artistic responses to such styles. John Everett Millais's painting *Apple Blos-*

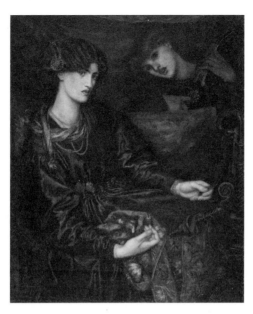

FIGURE I.4 Dante Gabriel Rossetti, *Mariana*, 1868–70. Oil on canvas,
109 x 90 cm. Aberdeen Art Gallery and Museums Collection.

soms (figure 1.3), completed in 1859, features a romanticized and unspecific setting
combined with an attention to naturalistic detail. The sitters exhibit physical ease
and a relaxed pastoralism, despite the intended symbolism of this painting draw-
ing attention to the transience of life.[6] The central figure, extending her right arm
outward, wears a gown that closely resembles the dress worn by Elizabeth Siddall
in sketches by Rossetti. Elsewhere in the painting, figures are lounging, reclining,
and bending over; these women are clearly not wearing crinolines, which would
have been an absolute requisite for public outings by fashionable women in the
late 1850s. In Dante Gabriel Rossetti's *Mariana* of 1870 (figure 1.4) the sitter, Jane
Morris, is pictured in a jewel-tone blue silk dress, romantic and loosely arrayed,
with the sleeves set high and full for ease of movement. The garment worn for the
portrait was likely designed by Jane Morris herself, in consultation with Rossetti.[7]

Later styles based on early Pre-Raphaelite models were commented on fre-
quently in the fashion and dress reform literature of the 1870s and '80s. Eliza
Haweis, a well-known writer on dress and domestic design, described the interest
in Pre-Raphaelite dress as growing "first among art circles who have discovered,
then among aesthetic circles who appreciate the laws which govern beauty."[8] Ha-
weis saw artistic forms of dress as a much-needed corrective to the extravagances
of mainstream fashion. Objecting to fashions that were cumbersome, lumpy, or

needlessly ornamental, she promoted a type of beauty based on an individual's best features and the suitability of attendant garments. Ultimately, Haweis concluded that artistic forms of dress were flattering for the greatest number of people. The use of the term Pre-Raphaelite to describe or delineate forms or styles of Aesthetic dress was in many ways misleading, given the artistic choices and Aesthetic variations in style available. However, its employment as a synonym remains one of the best ways of tracing the presence of Aesthetic dress in the fashion literature at that time.

As late as 1894, Walter Crane, an artist and illustrator who was deeply interested in dress reform, argued that the Pre-Raphaelites were immensely important for all forms of artistic improvement in Victorian culture, in both the fine and applied arts. He posited that Pre-Raphaelite and later Aesthetic approaches to culture were of an organic, instinctive variety rather than an extension of academic teaching and, significantly, singled out women's dress as a primary beneficiary of Pre-Raphaelite aesthetics:

> I think there can be no doubt . . . of the influence in our time of what is commonly known as the pre-Raphaelistic school and its later representatives in this direction, from the influence of Rossetti (which lately, indeed, seems to have revived and renewed itself in various ways) and the influence of William Morris and Edward Burne-Jones. But it is an influence which never owed anything to academic teaching. Under the new impulse, the new inspiration of the mid-century from the purer and simpler lines, forms, and colours of early mediaeval art, the dress of women in our own time may be said to have been quite transformed.[9]

The "simple," "pure" quality of the Pre-Raphaelite approach to aesthetic production is implicitly associated in Crane's rhetoric with an honesty and naturalness that was historically undervalued. In fact, there was a general understanding in the journal literature of the 1870s and 1880s that the art of the Pre-Raphaelites was underappreciated at the time it was first produced. In reference to the emotionally intense subject matter of the Pre-Raphaelites, a writer for the *Artist* remarked that "everybody said such fancies were absurd, and evidence was adduced from Raphael to Sir Joshua to prove the assertion. We now saw these works advance in the estimation of all thoughtful people, while the fashionable pictures of the same period had become of little or no interest." The same article argued that the work of the Pre-Raphaelites, far from being fanciful, was in fact a noble and profound study of humanity and nature.[10]

Recognizing that the Aestheticism of the 1870s and '80s drew on earlier forms of Pre-Raphaelite art is central to the understanding of Aesthetic dressers and

their belief in the authentic nature of artful dressing. Yet the nature of this influence would change over time. In later portraits of Aesthetically clad women by Burne-Jones and Rossetti, an inscrutable and emotionally charged atmosphere emerges, indicative of a more symbolist approach to the depiction of the human form. Rossetti's later use of symbolism was instrumental in advancing a much more sensual image of women within Aestheticism.[11] Crucially, however, in all stages of its development, the modes of feminine beauty explored in Pre-Raphaelite art challenged conventional Victorian standards of femininity and sartorial decorum. More importantly, these values extended and expanded the boundaries of artistic expression, even while laying the groundwork for new hierarchies of distinction and taste.

DESIGN REFORM AND THE RHETORIC OF "TASTE"

The reference to early Pre-Raphaelite art and culture in the discourses of dress and design reform points to the use of art as an authorizing tool in the push for sartorial change. The strategic use of taste as an indicator of an advanced artistic sensibility was an integral part of this process. Like all forms of cultural display that were particular to elite or niche groups, the discourses of Aesthetic dress relied on the notion of "advanced taste." Yet taste was a highly contested term in the nineteenth century. Employed in various ways by groups and individuals, the concept of taste became a useful rhetorical device, strategically applied in order to facilitate exclusionary practices. Its repetitive use within the Aesthetic movement and in much of the design reform literature indicates that it was a potent method of cultural valuation that was socially persuasive as well as meaningful. As Pierre Bourdieu has shown, acknowledging the constructed nature of taste requires looking deeply into the issues and motivators that necessitate its mobilization in the service of specific interests. Just as the obfuscation of the underlying economic structures of the art world were central to its aesthetic survival and autonomy in the late nineteenth century, so the disavowal of the constructed nature of taste was crucial in maintaining its powerful role as a political tool for artistic stability or change, depending on the agenda.

Many design reformers believed that important aspects of taste were inherent, expressed through artistic genius or Aesthetic sensibilities. Lucy Crane, Walter Crane's sister and a writer active in the pedagogical aspects of design reform, argued that an artistic sensibility was intuitive; it might be possessed in greater or lesser degree by a particular individual, but ultimately it could be developed through training and cultivation like any of the other senses: "To cultivate and exercise ju-

diciously the Artistic sense, is to be a person of Taste. To possess it and to cultivate it in an extraordinary degree, is to be an Artist."[12] But what exactly constituted good taste in the realm of artistic dress? George Frederic Watts understood taste to be an ephemeral quality open to debate: "It will be readily agreed that fashion in female dress should be in good taste, but to say dogmatically what constitutes good taste in costume or lay down precise rules to govern it would not be easy." Further, he acknowledged the power of public scrutiny in the formation of one's understanding of taste: "The atmosphere in which we move has much to do with the life we live; no one floats independently on the current that carries all along, and it is impossible to suppose that habits of mind will not be influenced by the impressions surroundings make upon us."[13] Watts's understanding of taste as transient, relative, and context-dependent may seem antithetical to Lucy Crane's, but both believed that it was a quality of mind that might be cultivated.

Taste was also a recurrent and even redundant word used throughout the mainstream fashion world — an arbitrary criterion grafted onto anything being promoted in fashionable circles, particularly if it was the latest trend from Paris. In 1883, Watts lamented the abuse and misappropriation of the word: "The expression 'good taste' has come to be used seriously for much that is in the worst possible taste — alas! for art, and alas! for many things that belong to the beautiful and the noble."[14] For Watts, the only way to move beyond the degradation of good taste by the fashion world was to encourage the best of what existed there, and further, to allow and even laud the fanciful varieties and vagaries of fashion, provided they did not overstep the bounds of reason with regard to good taste. Like many dress reformers in the nineteenth century, he believed that good taste depended on the happy coexistence of comfort and beauty: "in no case can ease and comfort be sacrificed without infringement on good taste."[15] Further, Watts's use of fashion to provide substantive evidence of the need for improvement in the decorative arts was part of a broader movement to realign and merge the values that informed both the fine and applied arts.

Among artists and intellectuals, there was a concentrated effort to raise the status of what were perceived as the "minor arts," particularly those affecting aspects of daily living, such as weaving, tapestry design, metalwork, woodworking, textiles, and dress design. In design reform circles it was felt that these areas should aspire to the fine or high arts status of painting, sculpture, and architecture. For Lucy Crane, success in the decorative arts was an indicator of advancement in the more lofty areas of cultural production. She argued that "dignified" costume in any given period also pointed to beauty and finesse in related arts, such as embroidery. Further, she claimed that the fine arts were dependent on the arts of dressmak-

ing in general: "In times when the general type of the human form is a poorly developed one, and distorted and trammelled by fashion, there can be no great school of sculpture; so without fine and simple and rich dressing and stuffs and embroidery, there will be the less prospect of a great school of painting."[16] Crane's assumption that high artistic values in the fine arts were inherently linked with the adornment and treatment of the human form makes explicit her belief in the cultural importance of dress.

Examples from contemporary journalism also espoused this elevation of the arts of dressmaking and textiles to the level of fine art. The *Artist and Journal of Home Culture* featured a regular column, titled first "Art in the Home" and then, later, the "Ladies Column," where the arts associated with the domestic sphere were reported on and examined. In 1885, a columnist asserted that the word "dress" operated as

> a kind of tocsin in the feminine world; let it be casually heard, and instantly eyes brighten with interest, ears prick up, and the whole woman, whether of the ordinary so-called fashionable, rational, or aesthetic persuasion, is immediately aroused. And yet it is an error to suppose that women care abnormally about their clothing; au contraire, dress has its wearisome side, and becomes terribly monotonous when repeated too often. But fashion is as direct an outcome of the love of beauty as schools of painting and sculpture.[17]

While admitting the seemingly instinctive connection between women and apparel, the writer disputed the notion that this was in any way excessive, narcissistic, or abnormal. At the root of this assertion was the authority of leading intellectuals and artists who promoted the idea that dress and all forms of the decorative arts were a valid way to express advanced artistic ideas. In 1888, Oscar Wilde proclaimed his desire to see dressmaking raised to the level of a fine art: "To construct a costume that will be at once rational and beautiful requires an accurate knowledge of the principles of proportion, a thorough acquaintance with the laws of health, a subtle sense of colour, and a quick appreciation of the proper use of materials, and the proper qualities of pattern design."[18] Wilde's popularity within Aesthetic circles quickly disseminated notions of dress as a legitimate venue for artistic expression.

The view that the authority of art was the final guide regarding true beauty and grace was aptly demonstrated in a lecture given by the dress reformer E. M. King in 1883. An ongoing question within dress reform circles was whether or not the corset was "tasteful" and in keeping with reform principles. In response to an assertion that if the "Venus of Milo or of Medici were to become flesh and blood, these slight stays would no doubt turn them into women with small

waists, upon whom one of Mr. Worth's dresses would not look out of place," King retorted, "That the lovely living Venus should be mutilated to suit Mr. Worth's dresses — No! a thousand times, No! Catch hold of Mr. Worth, and drown him in the Seine quickly, and burn up all his works, and the work of all those who would commit such sacrilege!"[19] The corset controversy was widely debated, not only in the health and medical literature, but throughout the art world as well. Critics of tight-lacing argued that it went against the enlightened view of the female body as a form of living art — the sculptures and paintings cited were seen as providing proof that the artists' collective vision of beauty and femininity was the one that should be followed.[20] In support of this, Lucy Crane denigrated women of fashion who practiced tight-lacing:

> The Venus of Melos and all the goddesses of Olympus are to them as nothing. Instead of a gently undulating line from the shoulder to the hip, they prefer a sudden sharp bend like the narrow part of an hour-glass. In times when figures of the hour-glass contour are admired, there can be no good sculpture; for there is scarcely a natural beauty of figure, or ease of grace and movement, left for the artist to admire, to learn and study from.[21]

Crane drew on the authority of art to draw attention to severe forms of corsetry, typifying the growth of tight-lacing among fashionable women as reaching epidemic proportions. To her, those who practiced tight-lacing were not only incurring risk of personal injury, but were also completely unfamiliar with any sense of artistry or beauty in the female form.

For many proponents of Aesthetic dress, the art of dressmaking was an opportunity to bring bodily comfort and utility into the question of art, forging a more organic connection between art and life. This perspective was shared by many practitioners in the Arts and Crafts movement, as well as early dress reformers who were interested in rational dress. In 1882, the *Magazine of Art* featured an article on "Fitness and Fashion." The ideal that sartorial behavior should be based on the practical requirements of dress, as opposed to merely fashionable or artistic principles, was put forward, and the authorizing discourse of art was used to solidify this link:

> The teaching of such men as Ruskin and William Morris is that the "lesser arts of life" are those which satisfy our bodily wants, and that they should be studied to make common things beautiful, and our daily life a pleasure and a joy. . . . That their teaching is of great and permanent value is a fact that cannot be too vigorously presented. It enables us to make beauty and health and comfort the common material

of life; and we shall do well to extend it, not only to the homes we inhabit, but to the clothes we wear.[22]

The emphasis on bodily comfort and the notion of living a full and "joyful" existence through an artistic lifestyle were indicative of the ways that Aestheticism contributed to the early aims of dress reform.

Despite a perceived consensus regarding the need for the tasteful improvement of all facets of Victorian culture, narratives addressing the authority of art and its rightful place at the forefront of dress reform were far from unified. For Margaret Oliphant, an active dress reformer, the wave of improved artistic taste spreading across the nation was only partially felt in the fashion world. She promoted the idea that only through a thoughtful and rational approach to the question could a viable solution be proposed. The middle ground, one of considered reason and carefully tasteful modifications to prevailing styles, was something she favored, rather than the wholesale acceptance of reform styles based on artistic models. In point of fact, her use of the term "art" was often qualified:

> Art, indeed, in a purely pictorial sense is, we think, a dangerous guide in the article of dress, which involves so many practical matters, and so many individual peculiarities. Whatever painters may think, there are many costumes effective in a picture which would not be at all beautiful upon a living woman, and indiscriminate following of the fancies of art would be not much less fatal than the usual indiscriminate following of fashion. No dress can be good which is not useful and adapted to practical necessities, nor can any dress be perfect into which the element of individuality does not enter.[23]

Far from decrying the use of art for the purposes of improving dress, however, Oliphant argued simply that questions of suitability, individuality, and functionality should bear equal weight when reforms to existing styles were considered. Her discomfort with the notion of artistic dress had more to do with the idea that artistic principles or fads might be followed blindly to the detriment of the wearer. Implying that the "cultivated" sections of the public were too eager to accept the authority of the artist, she concluded that "we make our houses uncomfortable and our rooms dark at his bidding, and we are very apt to make our young women into a series of costumed models for his pictures — which is delightful no doubt for him, but not so good for the rest of the world."[24]

This attitude was to form the root of that branch of dress reform that was more concerned with utility and health than beauty and art. Oliphant's text, through its inclusion in the "Art at Home" series, was positioned as an arbiter of taste as much as a call to rationalism. Also revealing are her summation and commen-

tary on the attitudes toward dress reform up to the mid-1870s.[25] Asserting that fashion was created for commercial motives rather than as a response to cultural needs for beauty and fitness in dress, she wrote that fashion "is supposed now to be at the mercy of a milliner, or a society of milliners in Paris, and of one special man-milliner in particular who invents and modifies at his pleasure, and whose laws the whole feminine portion of the public is supposed to obey servilely. This opinion is too widespread and too universal not to have some truth in it."[26] Ultimately, Oliphant argued that individual choice and the exercise of common sense should guide women in their selection of attire; and while admitting that art can certainly offer suggestions for improved approaches to raiment, she seemed to hold it under some suspicion.

This ambivalence was not shared by Eliza Haweis, who, while wary of mainstream fashion and its excesses, believed wholeheartedly in the authority of art as the best source for sound principles on dress construction and ornamentation. She acknowledged the misuse of art in the fashion world to support bad design, asserting that there were very few examples of "true" artistic dresses in the world of high fashion. If dress "intends to reach, as it evidently aspires to do, the platform of a picture, or a poem, or a fine building," she argued, "the art it adopts must be either good or bad art. I believe the melancholy truth to be that we can hardly find a modern dress which is not throughout in the worst taste and opposed to the principles of all good art."[27] She was careful to note, however, that depending on how knowledgeable and aesthetically sensitive or selective the wearer was, she might be able to discern the good examples amid a sea of bad ones. Haweis cited a tendency toward over-trimming and an insatiable craving for novelty as the main culprits of erroneous principles in fashionable dressing. Both Haweis and Oliphant asserted that the use of historical models for artistic dress design was of interest only where it appealed to reason and beauty. Thus, the "tasteful" simplification and refinement of dress based on the natural forms of the female body was an approach shared by artistic and rational dress reformers alike.

THE PRINCIPLES OF ARTISTIC DRESSING

Eliza Haweis presented two general rules for artistic dressing: first, that "it shall not contradict or falsify the natural lines of the body," and second, that "the attire shall express to a reasonable extent the character of the wearer."[28] These two principles recur throughout the dress reform literature in the decades following the publication of her text, and in hindsight were exemplified by Pre-Raphaelite dress as well,

both real and as imagined in their art. Further, these central tenets also informed Aesthetic dress principles wherein naturalism and expressive individuality would come together to signal the ultimate refinement in sartorial taste. The Rational Dress Society, particularly in the formative years of its development, promoted these ideals as well. According to its announcement in the *Artist and Journal of Home Culture* for 1881, "The objects of the society shall be to promote the adoption, according to individual taste and convenience, of a style of dress based upon considerations of health, comfort and beauty, and to deprecate constant changes of fashion which cannot be recommended on any of these grounds."[29] With Lady Harberton as president, Eliza Haweis as treasurer, and E. M. King as secretary, it was generally agreed that the society would make an impression in fashionable circles, raising standards of taste, comfort, and artistic excellence in dress.

In 1883, the larger Rational Dress Association held an exhibition at Prince's Hall, in Piccadilly. The accompanying catalog proclaimed, "Clothing should follow, and Drapery not contradict, the natural lines of the body." Further, the perfect mode of dress was expected to allow "freedom of movement," prevent undue "pressure over any part of the body," weigh no more than was "necessary for warmth," combine "grace and beauty" with "comfort and convenience," and finally, not depart too "conspicuously from the ordinary dress of the time."[30] Similarly, on the title page of every issue of the *Rational Dress Society's Gazette*, from 1888 to 1889, the following statement was presented:

> The Rational Dress Society protests against the introduction of any fashion in dress that either deforms the figure, impedes the movements of the body, or in any way tends to injure the health. . . . It protests against the wearing of tightly-fitting corsets, of high-heeled or narrow-toed boots and shoes; of heavily-weighted skirts, as rendering healthy exercise almost impossible; and of all tie-down cloaks or other garments impeding the movements of the arms. It protests against crinolines or crinolettes of any kind as ugly and deforming. . . . The maximum weight of underclothing (without shoes), approved of by the Rational Dress Society, does not exceed seven pounds.[31]

Throughout the 1880s, the Rational Dress Society, while admitting the "potent charm" of novelty in fashion, ultimately condemned "a taste which allows fashion to vibrate between extremes which are neither restrained on the one hand by regard for the natural proportions of the human form, nor on the other by reverence for the natural needs and functions of the body." However, despite this assertion, the society maintained that beauty in dress was essential to any plan of reform or any movement toward sartorial change, and further stated that differences of

"colour, of texture, and of material, are a source of pleasure to the eye, and if these are discarded by women as they have already been discarded by men, much that is picturesque in modern life will disappear."[32]

It was the Healthy and Artistic Dress Union, formed in 1890, that most successfully synthesized various strands in the dress reform and design reform movements. Using artistic discourses to combat fashion-driven change, the society brought together artists, designers, and socialites in order to promote an artful approach to dressing that would be both healthy and beautiful. In July 1893, it published the first number of *Aglaia: The Journal of the Healthy and Artistic Dress Union*, and though the journal was only to last through to the following year, the articles and illustrations published across three issues are a rich source of information regarding the theories and sentiments behind Aesthetic dress.[33] Members of the union included Louise Jopling, Hamo Thornycroft, his wife, and the Wattses, all of whom were active in artistic circles. The artist Henry Holiday was president of the union as well as a tireless advocate of artistic and social reforms in both dress and culture. In his *Reminiscences*, he recalled having

> long held the view that the art of a country is in a poor way if it does not make the externals of its daily life beautiful. The art which is limited to pictures and sculpture affects only a few rich people, and it is impossible for the plastic arts to maintain a high level when those who exercise them live in daily contemplation of nothing but what is common or ugly in their surroundings. They can only know beauty second-hand, not as the Greeks, the Florentines, or the Venetians knew it, who lived in the midst of it. This was not a new idea, but it was strongly reinforced when I studied the possibilities of a future for the human community, in which something better than greed and profit-making would be the basis of our social-industrial life. This led to a keen desire to do something to promote an improvement in dress, a very important part of the "externals" of our lives.[34]

Holiday's sense of social conscience and interest in artistic communal life link him to the political views of William Morris and others active in the Arts and Crafts movement. However, the idealizing focus on the Greeks and Florentines is very much part of a wider revival of classicism within Aestheticism. *Aglaia* is a rare document that details the existence of a collection of individuals who tried to synthesize some of the related strands of meaning and artistic ideology linking rational dress reform approaches with the historicism and artistic discourses extending from Pre-Raphaelite and Aesthetic cultural milieus.

For the members of the Healthy and Artistic Dress Union, the importance of beauty was implicit in the name of the journal *Aglaia*, which recalled the presence

of "Adornment" as one of the three Graces of antiquity. The introduction to the first issue offered an explanation of the importance of the name:

> Grace — almost the fairest word in the English language — fitly expresses the dominating idea of the movement which this Journal represents: hence the name "Aglaia." ... Of the three Graces who presided over the Beauty of life, Thalia represented the healthy bloom of youth, — Euphrosyne, "heart-easing mirth," and Aglaia, adornment. In appealing to the Grace with whom we are more immediately concerned we need not separate her from her sisters. Dress is needed for play as well as for work, and above all should it be healthy, so that we seek the aid of all the Graces.[35]

The explicit goal of the journal was to promote the idea that the cultivation of beauty and taste in one's appearance was as important as the improvement of design standards in other aspects of the decorative arts. A contributor to the journal admitted that house decoration had made "striking progress within the last 30 years," but that the arts of personal adornment had not undergone the same transformation. As in other attempts at dress reform in the preceding decades, members of the union argued that in order for dress reform to be lasting it had to be gradual and use common sense as its guiding principle, building on what was positive about contemporary fashion and dispensing slowly with aspects that were ugly, ill-adapted, or unsuitable to the human frame. Using an analogy drawn from the natural world, in which the "spontaneous growth" wished for in the arts of dress was characterized as a root plant that must be watered, *Aglaia* asserted: "We may tend and nurture the plant, we may water and prune it, but this is all we can do. To attempt to provide Society with a complete set of new and reformed fashions would be about as wise as to tie a lot of blooms on the branches of a weakly plant, and the results would be about as lasting."[36] Above all, artistic principles were to inform this movement, and the authorizing discourses of art would have the last word.

Holding meetings, giving talks, hosting lectures and discussions, and exhibiting reformed designs, the union promoted the adoption of Aesthetic dress through both education and persuasion.[37] It even arranged a collection of texts to serve as an informal library for members of the union who wished to further their knowledge in the art of dress as well as related topics. Subjects ranged from rational texts such as the *Manual of Personal and Domestic Hygiene* by A. T. Schofield and *Health Culture* by Dr. Jaeger to texts that looked at dress reform from a more artistic standpoint, such as Eliza Haweis's *The Art of Beauty*; Ward, Lock and Co.'s *Dress, Health, and Beauty*; and *Form and Colour*, illustrated by Liberty and Co. Perhaps most significantly, general texts on selected art historical topics were included, for

example Jane Harrison's *Studies in Greek Art*.[38] The activities, publications, events, library resources, and social gatherings and performances organized by those connected with the Healthy and Artistic Dress Union provide clear examples of the exploration and dissemination of Aesthetic standards of taste and the implementation of this taste in practice.

NATURALISM AND THE FEMALE BODY

In both its performative and representative aspects, Aesthetic dress was a powerful signifier of Aesthetic ideals and principles, attempting to elevate everyday life to the status of art. However, there was an inherent tension between standards of Aesthetic taste in theory and the reception and negotiation of these ideals in practice. This was true whether such principles derived from early Pre-Raphaelite models or exemplified later, more popular models based on commercial forms of Aestheticism during the 1880s and 1890s. Within Aestheticism, there was a conflation of a rarefied level of taste and artistic vision on the part of the artist (usually male) and iconic images of women. The female body served as a site for Aesthetic contemplation, embodying a brand of femininity that was depicted as unchanging, passive, beautiful, mysterious, but above all, natural. This focus on nature as an inherent and positive aspect of female beauty, as well as the concept of "noble humanity," links Pre-Raphaelite dress with other concurrent forms of dress reform in Victorian culture. The activities and publications of the vast majority of dress reformers, artistic, rational, or otherwise, almost always refer back to the notion of the human body as inherently beautiful in its natural state.

One way to approach an understanding of the reception and negotiation of Aesthetic dress on an ideological level is through an exploration of the imagery associated with Aestheticized notions of feminine beauty and an analysis of the underlying assumptions inherent in such discourses. The concept of naturalism binding various strands of dress reform together rests on the rather simple assumption that the body in its natural state is a healthy body. Forms of clothing that encourage mobility and comfort are positioned as "healthy," and conversely, designs that inhibit the normal functioning of the body are presented as inherently unhealthy. An overt concern with health and the repeated references in the dress reform literature to the discourses of medicine illustrate an overriding concern with physical well-being and the desire to align the "natural" body with signifiers of health.

Perhaps because of the visual attributes of clothing, the majority of dress reform texts conflate scientific discourses with artistic principles in order to formulate

codes for social and artistic change. In 1883 the *Artist and Journal of Home Culture* featured a report on an exhibition of "hygienic" and "artistic" dress and household decoration put on by the National Health Society in Knightsbridge.[39] The following year, for the International Health Exhibition, E. W. Godwin published a short handbook titled *Dress and Its Relation to Health and Climate*, in which he advocated the necessity of medical and aesthetic cooperation:

> No doubt art and science might be on a more distinctly sympathetic footing than they have been, they might take more delight in one another's work. The scientifically-minded is too apt to look on art with a sort of pitying smile, as if it were something to play with; while the artistically-minded, though perhaps more sensitive and sympathetic, is still too often disposed to view his ideal as the ideal, and refuse to profit by the offices science might and, I venture to say, would gladly render him. Science and art must walk hand in hand if life is to be worth living. Beauty without health is incomplete. Health can never be perfect for you so long as your eye is troubled with ugliness.[40]

That the discourses of health and science were used repeatedly by artists in order to validate proposed methods of reform for clothing highlights the centrality and materiality of the body in Victorian culture.

The linking of art, health, and beauty during the early part of the Aesthetic movement owed much to the dress reform literature, which emphasized the healthful benefits of rational dress and its emphasis on comfort and freedom. At least in the early stages of dress reform, health and beauty were seen as synonymous, and thus, early examples of Aesthetic dress were also considered hygienic and rational by many critics of fashion. Yet in order to promote rational styles, it was necessary to emphasize the attractiveness and visual appeal of such clothing. In 1888 the *Rational Dress Society's Gazette* noted that there wasn't "much hope of influencing fashion from the purely medical side. The world must be convinced not only that modern costume is unhealthy, but that it is ugly, and public taste must condemn what is distorted from an artistic standpoint, before we can hope for any permanent improvement in the vagaries of fashion."[41] As a consequence, although rational and hygienic approaches to dress reform were mainly fueled by medical concerns over the health and well-being of Victorian women, a large proportion of the literature drew on the discourses of art and beauty in order to promote changes in fashionable dress. A general consensus among dress reformers was that without health and comfort, there could be no beauty. The approach to naturalism associated with this ideal of beauty was contingent upon an assumed inviolable and coherent image of femininity, where a unified female body, unmodified by fashion culture, could be expressive of beauty and health through the exercise of free motion.

Early forms of Aesthetic dress, particularly Pre-Raphaelite dress in its earliest stages, drew on these discourses in the designing of gowns, which were intended to allow a full range of motion and exemplify a simplicity of purpose. The possibility of an alternative Aesthetic body, one that was "constructed" as much as the fashionable body, was largely disavowed, since naturalism was the discourse used to establish an innate and direct link between the body and narratives of mobility, beauty, health, and art. Yet beneath this seemingly organic and holistic view of the body ran a deep current of conflict and overdetermination with regard to Victorian notions of the natural in juxtaposition with the feminine. Nineteenth-century scientific discourse positioned women as closer to nature than men; biologically determined by their reproductive role, women were connected to the body and the natural world in a way that was emphasized repeatedly in the literature of nineteenth-century science and medicine. Nature was diametrically opposed to culture. Victorian scientific discourse is rich in metaphors of control and domination over nature, which is frequently presented as something unknowable, wild, unmediated, and ultimately dangerous.[42] The romantic strain of vanguard art found in the Pre-Raphaelites and in later decadent and symbolist authors and artists celebrated this unruly side of nature. Thus the wearer of Aesthetic dress represents a hybrid of these opposing formations of the natural body. On the one hand, the female form is depicted as inherently beautiful and natural, a concept that relies on classical ideals of grace, balance, proportion, and line. On the other, notions of the female body rely on an intensity and ferocity derived from an image of nature in the raw, unmediated by culture. In general, the overt concern with health seems to win out in the early stages of artistic dress reform, but the specter of the unruly, uncontrolled, and wild female body is always present by its pronounced absence in the literature, which insistently conforms to a simplistic belief in a unified and pristine natural body.

The construction of this artistic and healthy body was premised on several assumptions. The ability of the body to move and breathe was seen as synonymous with good health. The need for physical culture and the importance of exercise not only for children and men, but also for adult women, were becoming increasingly recognized during the nineteenth century. In the rational approach to the human body, the mechanisms of eating, sleeping, breathing, growing, reproducing, and even aging were equated with both mechanical and natural structures — analogies that were echoed in the art world by the use of architecture as an appropriate metaphor for analyzing and ordering the human body. Seen as a structure that might enclose the inner sanctum of the human soul, dress was viewed as subject to the same design principles as any work of art. E. W. Godwin argued that, as

"Architecture is the art and science of building, so Dress is the art and science of clothing. To construct and decorate a covering for the human body that shall be beautiful and healthy is as important as to build a shelter for it when so covered that shall be also both beautiful and healthy."[43]

All wearers of Aesthetic dress held the concept of beauty and utility as inextricably linked, since clothing was a logical extension of the body's needs. At the beginning of the 1870s, following the rejection of the crinoline and before the adoption of the bustle, there was a brief period when the basic shape of fashionable dress was most closely allied with the principles of Aesthetic dress. A silhouette based loosely on the Watteau toilette emerged at that time: gowns with a relatively straight skirt were accompanied by a flowing fullness in the back. Stella Mary Newton has argued that this style must have caught the imagination of many women, not only artists and intellectuals, for in its reliance on the use of draping and the body language of the wearer to animate its form, it allowed women a level of freedom and comfort combined with beauty that had rarely been seen in several centuries of fashionable dress. Further, she asserts that many women who would later wear Aesthetic dress may have come out of this context and simply refused to adapt to the new fashionable styles based on the bustle in the middle and late 1870s.[44] The sense of ease of movement associated with these gowns was their key feature for Newton; and indeed, the ability to sit down without a stiff interlocking network of structural supports to the skirt must have been very liberating.[45]

The Victorian preoccupation with structure and utility in dress and other arts was no doubt indebted to the widespread interest in the natural sciences. The various definitions and uses of the term "natural" to describe what were viewed as obvious physical, spiritual, or moral truths came to have a crucial impact on the activities and belief systems of dress reformers. In a discussion of color, a writer for the *Magazine of Art* noted,

> In this climate Nature teaches us to use colours in rich but subdued tones, especially when they are presented in any mass. Grass is not really emerald-green; look carefully at the brightest green field, and you will see that it is toned with a delicate bloom of grey, purple, or reddish. The reds and yellows of sunset are nowhere without hints and suggestions of purple. The brilliancy of flowers we can scarcely emulate; and if we could, the mass of bright colour would be too large. The right use of very bright colours is to adorn our dress as flowers adorn the landscape.[46]

In this example, the artistic use of color was seen as closer to nature, more "true," and required the enhanced acuity and perceptive abilities of an Aesthetic sensibility. The selective appreciation, absorption, and artful application of nature in Aes-

theticism for the purposes of locating and consuming beauty conflated naturalism with an idealistic, almost pantheistic vision of the natural world, rather than with a mimetic reproduction of the material world. Thus, the interpretative function of art in rendering nature itself beautiful was central to Aestheticist notions of the natural world. Watts, writing for the *Transactions of the Guild & School of Handicraft*, argued that the grayness of the English climate demanded the use of color by craftsmen to animate and bring pleasure to the minds and homes of the public. Crediting the work of Ruskin as a source of this appreciation, he wrote: "Our designers have left to them the inexhaustible book of nature, the only basis of all true decoration, ever open for reference; to their generation Mr. Ruskin has spoken with the language of inspired insight on the beauty of leaf, and flower, and stem; and he has shown that nearly every kind of loveliness and interest in line and arrangement is to be found in them."[47]

Many dress and design reformers lamented the use of nature to validate current color trends in mainstream fashion. Lucy Crane complained, "The defenders of bright aniline dyes say, that since there is brilliant colour in Nature, in flowers, in the sunset, in birds, in tropical foliage, that it is quite natural and right to prefer them (the aniline dyes), and to use them in dress and in household decoration." Attempting to reclaim the natural world for the Aesthetic realm (and its preference for subtle, complicated off-tones), Crane argued that the presence of jarring or bright colors in nature was by necessity fleeting and transitory:

> The hues of the rainbow melt into thin air as we gaze, they have no time to dazzle us; the brilliant tropical flower fades in a day; the most glowing assemblage of autumn tints burns itself out and turns to dull ashen brown. Suppose, then, we were able to procure stuffs to match some of the hues of the flowers, the rainbow, the sunset, in brilliancy, suppose we hung our rooms with them, they would be always appealing to the colour sense so strongly that they would be as fatiguing as a perpetual succession of loud screams to the ear — and, their first freshness worn off, they would soon look shabby, and with a worse sort of shabbiness than hues of less pretension.[48]

Conflating interior decoration with the art of dress, Crane asserted that while one might admire nature's more brilliant displays of color, one should never try to imitate them. "The infinite powers of Nature supply the place of the faded flower every day with a fresh one, and the sunlight is ever fresh and new, while our dresses and carpets and curtains must last a certain time, as they do not grow spontaneously to the hand."[49] Thus, naturalism and its related discourses were as contested as narratives of taste in the nineteenth century. Both were used, along with the authority of the art world and science, to establish and maintain a set of

criteria by which preferred cultural objects and practices might gain recognition and symbolic capital.

Within Pre-Raphaelite art itself, a shifting and unstable approach to naturalism can be observed. In the founding years of the movement, the artists espoused a rhetoric of "truth to nature." The tendency to reproduce nature in its variety of forms, including those that were irregular, odd, or less than ideal, was widely criticized in the art journalism of the period, to the point where some critics felt that the Pre-Raphaelites were deliberately seeking out the ugly or coarse side of culture and humanity. One critic from the *Art Journal* described Millais's 1851 *Mariana* as "an ill-complexioned lady straining herself into an ungraceful attitude." What appears to be a casual gesture, a natural display of human fatigue and its logical alleviation through the act of stretching, was viewed as awkward and inartistic according to early Victorian pictorial and social conventions. Susan Casteras has persuasively argued that early Pre-Raphaelite depictions of the feminine challenged Victorian canons of beauty, which espoused domesticity, symmetry, self-containment, and restraint. Eventually, the intense and sensual portrayal of the feminine body in Pre-Raphaelite painting came to inflect, and in some cases replace, standard approaches for the pictorial representation of women in late-Victorian art.[50] Yet within Pre-Raphaelitism itself, especially during its later phases, conventions shifted in the direction of idealization and the elaboration of natural forms in favor of Aesthetic ideals. Thus, there is an important distinction to be made between forms of naturalism in the early Pre-Raphaelite movement and later manifestations that altered the approaches to the natural world in the direction of symbolism. The implications for Aesthetic dress are significant — what began as a simple, comfortable, and pared down approach to dressing became progressively more erudite, complex, eclectic, and multilayered in terms of its historical referents, mainly because of changing constructions of femininity and naturalism within the Aesthetic movement itself.

HISTORICISM AND AUTHENTICITY

Shifting concepts of naturalism in Pre-Raphaelite and later Aesthetic art relied in part on a mediated and continually evolving form of historicism. Medievalism, classicism, and an interest in the Renaissance and eighteenth century all informed a vast array of period details in the forms and features of Aesthetic dress. Medievalism, however, was the strongest component of Pre-Raphaelite dress and would also inform the majority of stylistic features in later models of Aesthetic dress. Yet rather than a simple revival of historical models, Aestheticism used eclecticism

and innovation to explore utopian reinterpretations of history in order to negoti-ate the demands of the modern world. Drawing on models of dress from valued periods of history and different regions of the world, Aesthetic dress provided a partially modernist reformation and critique of specific attributes of contemporary mainstream fashion through its self-reflexivity, stylistic elaboration, refinement, and abstraction. This new emphasis in design circles is aptly revealed through the abundance of art literature aimed at the transformation and improvement of one's environment through the artful integration of Aestheticism into all facets of daily living.

In terms of the historicizing aspects of Aesthetic dress, early Pre-Raphaelite influences were of primary importance. Yet the uses of historical models of dress within Aestheticism went beyond a conception of art and beauty based on nostalgia and an idealized medieval past. The perceived ability of Aesthetic dress to func-tion as the embodiment of a refined artistic lifestyle led to its prolonged presence in sartorial culture even after the initial period of Pre-Raphaelite art production was past. In addition, the emphasis on the authentic re-creation of past historical models within Pre-Raphaelitism itself also set the standard for later forms of historicism within dress reform. Using all forms of reference available to them, the Pre-Raphaelite painters strove to paint genuinely from nature by either recon-structing gowns based on past documented models, or by using fabrics, drapery, and accessories that would truthfully recall past eras. There is evidence that Ford Madox Brown, Millais, and Rossetti had all consulted Camille Bonnard's famous volume *Costume Historique*, published in Paris in two volumes in 1829 and 1830.[51] In addition, Millais's mother researched and sewed costumes for his paintings.[52] Real garments, fabric samples, props, and accessories were actively acquired by Rossetti, and formed the basis of his costume collection for painting purposes.[53]

In 1879, Eliza Haweis concluded that aside from its being "simple without bareness" and "complex without confusion," the key feature of Pre-Raphaelite dress was its harmonious use of color, which "however varied . . . mark[s] roughly speaking, the period of Edward III's reign, from 1327–1377."[54] Certainly, many of the women painted by those in Pre-Raphaelite circles were aware of how they might be pictured, and the material presence of these portraits represents a conscious effort on the part of sitters to inhabit a semi-imaginary space of advanced artistic taste. Stella Mary Newton has argued that Rossetti was aware of current trends in fashion, even while following his historicist approach to dress in painting. In *Monna Rosa* of 1867 (figure 1.5), Rossetti portrayed Mrs. F. R. Leyland wearing a garment fashioned from a piece of eighteenth-century brocade. Draped full in the back, the fabric was worn in a way that foreshadowed fashionable styles of

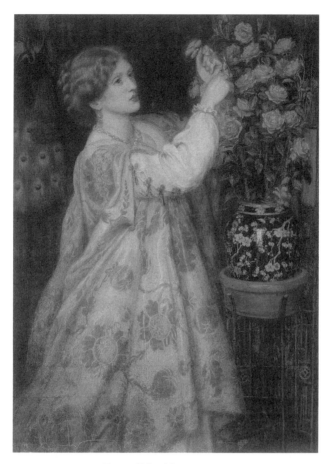

FIGURE 1.5 Dante Gabriel Rossetti, *Monna Rosa*, 1867.
Oil on canvas, 174.2 x 136 cm. Private collection.

the early 1870s, when the crinoline was abandoned and the bustle had not yet appeared.[55] *Monna Rosa* displays a blending of fact and fantasy, sartorial idealism and an awareness of current fashions and contemporary trends. This rendering enabled Rossetti to represent Mrs. Leyland in a way that illustrated his advanced sensibility. More significantly, in the context of Aesthetic dress, it allowed Mrs. Leyland to "enact" a particular kind of artistic persona through her participation in the Pre-Raphaelite pictorial discourse of beauty and refined sartorial taste.

The historicizing aspects of Aesthetic dress can thus be viewed as an ambivalent response to rapid shifts in the fashion world and the experience of modernity as an ever-quickening process of social and technological change. Aestheticism drew on the perceived stability and unchanging grace of the medieval period as a foil

against which the arbitrary aspects of fashion might be highlighted and criticized. Godwin, writing on the clothing of ancient cultures, stated that "Egyptian, and, indeed, all costumes of old civilizations, do not appear to have been affected by that spirit of change which has dominated European dress since the close of the thirteenth century."[56] It is interesting to note that he cites the thirteenth century as the cutoff point between timeless and gradually changing modes of dress in Western culture. Discussing the dress of the nineteenth century, Godwin wrote:

> Of the dresses worn since 1850, of the few distinctive forms such as the crinoline and the princess, of the many varieties, good and bad, which every month brought forth, of the multitude of trimmings appropriate and monstrous, of the new sickly tones of colour of the atrocious aniline dyes, of the masher's collar, the pointed-toed boot, the divided skirt, and the more or less accurate revivals from the wardrobes of the last three centuries, I can but venture on a passing judgment that, taking the evil with the good, the period of 1873–1883 has given us dresses (for both women and men) where beauty and health have had more chance of flourishing than at any other time since 1640.[57]

Aside from a brief period in the seventeenth century, Godwin condemned the majority of styles available from the medieval period onward, including most vociferously the nineteenth century. While he did not advocate for Aesthetic dress as such, the brief period he highlighted as attaining a small measure of distinction, from 1873 to 1883, is also the period when Aesthetic dress was most widespread.

The medievalizing tendencies of Aesthetic dress need to be considered in terms of the Gothic revival. The theories of A. N. W. Pugin, which were central to the Gothic revival, influenced the later Arts and Crafts movement as well as other areas of reform in the decorative arts. In the context of architecture, Pugin declared, "1st, that there should be no features about a building which are not necessary for convenience, construction, or propriety; 2nd, that all ornament should consist of enrichment of the essential construction of the building."[58] Eliza Haweis drew on the discourses of architecture to support her criticism of the needless ornamentation of fashionable clothing:

> In architecture do we not immediately detect and condemn a pillar that, resting on nothing, appears to support a heavy mass of masonry; an arch that is gummed against and not built into a wall, unsupported, and therefore in an impossible position; or a balcony that has neither base nor motive, unsupported and supporting nothing? . . . Whether it occur in a house or in a gown, the principle must be the same.[59]

Referring to the existence of "Imbecile Ornament," she outlined the evils of superfluous trimming devices such as bows that are "stuck about when there is no

possibility of their fastening two parts." In 1882, a writer for the *Magazine of Art* concurred: "Bows are all very well in their place — when they tie, or may be supposed to tie, something; but one does not want a gown to be a mere opportunity for bows."[60] Thus, medievalism in dress reform called for simplicity and distinction based on the cut of the clothes rather than superfluous details of decoration and surface ornamentation. Crucially, these critiques reflect emerging discourses in design reform circles regarding the functional and structural integrity of designed objects as well as a new emphasis on truth to materials and authenticity — all values perceived to originate in the distant past.

The well-known Aesthetic dresser Alice Comyns Carr contributed an article to the *Magazine of Art* titled "The Artistic Aspect of Modern Dress." In describing the medieval form of the "Princess" mode, she highlighted the hanging sleeve's wide opening covering a tighter-fitting sleeve beneath, which allowed for a free range of motion. For her, the medieval silhouette represented the most elegant kind of dress "fitting tightly but easily over the bust and thighs, and then falling in folds to the feet. This make is very similar to the 'Princess' robe of recent times, which one is sorry to find less popular than a few years ago. It is the most graceful of modern dresses, whether made to fasten up the front or at the back."[61] She contrasted this construction with standard approaches in fashionable dress, which she characterized as overly complex and "overloaded with ornament."[62] Further, she noted that despite some improvement in the use of color, the basic structure of fashionable clothing remained ill-fitting and ungraceful, and she argued for a return to medieval models that might respect the natural movement of the body.

Alice Comyns Carr's article is an interesting example of a type of historical utopianism that envisaged future ideal modes of dress based on past models. She points to "obsolete" and "national costumes" as clothing for a particular task or region, which exemplified good form and fitting function, as well as individual charm: "In the simpler modes of bygone ages, and in the national costumes of the present century, are innumerable hints and suggestions which, if we but tried to adopt them intelligently, would save us from most of those madnesses of fashion to which it is our fortune to be subject."[63] This sentiment echoes repeatedly throughout the literature of Aesthetic dress, as well as more broadly among dress reformers. Looking to a distant English past, Margaret Oliphant commented: "A woman's gown in its simplicity, fitting closely, but not too tightly to the body, and with long skirts falling to the feet, the original garment of all Northern women, is in itself one of the most reasonable and beautiful dresses that can be imagined."[64]

Old English costume was often proposed as the most appropriate model for dress reform, given the climate and social strictures of Victorian England. In 1882

FIGURE 1.6 Kate Greenaway, *Afternoon Tea*, 1880. Illustration in *Birthday Book for Children*, 1880. Color wood engraving. Courtesy of the Osborne Collection of Early Children's Books, Toronto Public Library.

FIGURE 1.7 Walter Crane, *My Lady's Chamber*, 1878. Illustration from Clarence Cook, *The House Beautiful*, 1878. Bridgeman Art Library.

the *Magazine of Art* claimed that by "many who make their gowns according to their own idea of beauty, and not according to the regulation fashion of a French or English milliner, an artistic Old English costume will perhaps be preferred to one imitated from the antique."[65] This comment was accompanied by a suggestion for smocking not only in children's clothing, but for women's gowns as well. "Old English" was a vague term that could reference anything in the history of the British Isles, from medieval modes to eighteenth-century models — particularly those taken from rural or picturesque settings. Smocking, a sewing technique where the fabric is gathered in repeated patterns to form a kind of quilted panel beneath which the fabric hangs freely, invoked a rural countryside ideal — and was often associated with the illustrations of Kate Greenaway and Walter Crane (figures 1.6 and 1.7). In the Greenaway illustration, young ladies of an indeterminate age, wearing white gowns with puffed sleeves and simple gathers of fabric, sit contentedly at a tea table in an English garden. The dresses seem immutable and timeless — but most closely resemble fashions of the first two decades of the nineteenth century. In Crane's image, a recognizable Aesthetic interior forms the backdrop for an elegant figure in artistic dress. With richly textured smocking on both sleeves, the dress features an intricately gathered skirt that hangs in classically inspired folds beneath an elongated bodice ornamented with simple ruffles at the neck. The woman bends over gracefully and easily. Both scenes are picturesque and evoke a comfortable domesticity. Such images of playful innocence and the representation of rural traditions and scenes as both romantic and quaint tended to be most popular in journals such as the *Girl's Own Paper*. The sense of timeless tradition and elegant innocence invoked by this rural ideal of "Old England" seemed to blend harmoniously with received notions of Pre-Raphaelite domestic harmony to form a strong medieval strain within Aesthetic dress.[66]

Those who favored the "Old England" ideal over an overly idealizing strain of classicism did so for a variety of reasons. Like all aspects of Aesthetic dress, the terrain was highly contested. Godwin argued that a revival of classical Greek dress was not possible in Europe because of the colder climate.[67] Margaret Oliphant objected to most forms of Greek revivalism in dress because she felt they were ill adapted to the needs of modern life. She was also deeply suspicious of any artistic theory that might be viewed as a form of extremism, affectedness, or Aesthetic foppery. She dismissed unequivocally the notion of the Greek chiton as an appropriate model for dress reform: "It would be vain to attempt to discuss this ingenious notion with any seriousness. The French revolution was nothing to it; in our own opinion it would be more possible to disestablish the Church, abolish the House of Lords, and cut the sacred vesture of the British Constitution

into little pieces, than to translate English garments into Greek."[68] In her primary objections, Oliphant asserted that the fashion for close-fitting dresses was initially a response to climatic demands that became firmly entrenched in European culture as individual national characteristics emerged. She argued that, once established, sartorial conventions were harder to change than many other forms of social organization, whether they dealt with "manners, morals, government, [or] even religion." Ultimately, her argument centered on the notion that sumptuary laws were the only laws that were guaranteed to fail.[69] Thus, for Oliphant, classical dress, regardless of its antiquated charm, was ultimately antithetical to the practices of European custom and convention.

For Valerie Steele, the Victorian objection to classicism is indicative of underlying tensions between values based on Christianity and the temptations of Hellenism.[70] The nineteenth-century understanding of classicism drew on a historical model of cultural birth, ascendancy, and decay, where Hellenism represented a perceived decline of moral, artistic, and spiritual values after they had reached their height during the classical period proper. As indicated through the myriad perspectives on the correct use of the corset, the regulation, confinement, and manipulation of the body by fashion was closely linked with moral views, issues, and debates during the Victorian era.[71] This discourse of classicism played upon these ambivalences toward the covering of the female body, for, in its idealized artistic form, classical dress stood for the lofty values of art and beauty, but when translated into the sartorial behavior of real women in a Victorian context, it signaled a laxity toward physical deportment that would have placed many in a precarious position with regard to morality.

Thus, medieval forms of dress were privileged over other past stylistic modes primarily for their perceived suitability and inherent Englishness (just as Pugin considered English medieval architecture to be an inherently superior style of architecture over the classical). Whether this trend was a result of the unsuitable nature of classical styles for the British climate or their associations with hedonism and loose sexual mores is unclear. In practice, medieval modes seem to have been preferred despite the continued use of classical art and culture in authorizing discourses on naturalism and the body in Aesthetic dress. Located at the nexus of artistic culture, dress reform, and Aestheticism, the writing, illustrations, events, and activities of the Healthy and Artistic Dress Union exemplified a utopian perception of the past and a historicism that precluded any anthropological interest in culture. Instead, the union expressed a curious and imaginative re-creation of previous ages and eras for the purposes of artistic inspiration and production in the present. Both medieval and classical forms were exploited for their potential

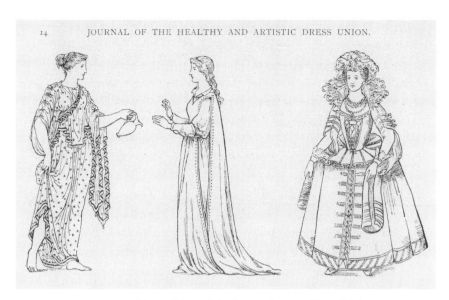

FIGURE 1.8 Henry Holiday, "The Artistic Aspect of Dress," *Aglaia* 1 (July 1893): 14. National Art Library, Victoria and Albert Museum.

in idealizing modes that might accommodate the human form in its natural state. Henry Holiday asserted that "beautiful dress must be founded upon the human figure, and fails in its aim whenever it misrepresents or distorts the figure. This was clearly felt in past ages, notably by the Greeks in the classic period and by the principal European Nations in the best mediaeval period, say from the 12th to the 14th century."[72] In an accompanying illustration, Holiday compared the awkwardness of a dress of the time of James I with a Greek and medieval model (figure 1.8). Turning to engage one another and gesturing gracefully in their flowing garments, the classical and medieval figure are marked by their mobility and physical ease. In contrast, the figure on the right is excluded and separate, her arms stiffly hovering and partially immobilized about her ungainly costume.

Spanning many decades, from the beginnings of dress reform in the 1840s to later design reforms in the 1880s and '90s, the idea that the past held the key to the future of dress reform was in constant circulation. A particularly telling quotation is found in Walter Crane's 1894 contribution to the journal *Aglaia* titled "On the Progress of Taste in Dress, in relation to Art Education":

> Primitive again and picturesque is the dress of the labourer — ploughman, fisherman, navvy, though purely adapted to use and service. Concessions to aestheticism, if any, only come in by way of a coloured neckerchief, the broidery of a smock frock, or the

pattern of a knitted jersey. Yet each and all are constant and favourite subjects of the modern painter. Why? Fundamentally because, I think, their dress is expressive of their occupation and character, as may be said of the dress of all working people. The peasantry in all European countries alone have preserved anywhere national and local picturesqueness and character in their dress, often, too, where it still lingers unspoiled, as in Greece, beautiful embroidery worked by the women themselves. The last relics of historic and traditional costume must be sought, therefore, among the people, and for the picturesqueness we must still seek the labourer.[73]

Walter Crane's text on the picturesque charm of the dress of the laborer illustrates an idealizing brand of socialist thinking, significant for its utopian overtones. The concept of art and utility together as the basis for leading a beautiful life is implicit throughout: "This seems a strange commentary upon all modern painstaking, conscious efforts to attain the national, simple, beautiful, and suitable in dress, to be at once healthy and artistic. There really ought not to be so much difficulty about it. If we lived simple, useful, and beautiful lives, we could not help being picturesque in the highest sense."[74] By the end of the 1880s the assumed relationship between simplicity and beauty was firmly entrenched in design reform circles and, further, had attained a moralizing stance that, though nascent at this stage, was long-lived and continued to impact design principles well into the twentieth century.

At the heart of this historically based idealism was the assumption that cultures of the past — and by association rural cultures whose inhabitants were perceived as leading lives similar to those of the past — had a more direct relationship with themselves and others. This view adhered to the notion of "self" as an uncomplicated and unself-conscious entity, vulnerable to the corrupting forces of civilization. Members of such cultures were perceived as having a more authentic relationship with daily living, so that all the objects they created or came into contact with (including dress) were subject to the needs and requirements of their simple yet dignified lives. This brand of Aesthetic historicism was closely related to the growing theme of antimodernism in the nineteenth century. Many intellectuals viewed modern life with a sense of ambivalence, leading to disquieting questions about the loss of basic and time-honored values as a result of the development of mass-produced goods, increasing mechanization, urban crowding, and, most crucially, a growing level of commercial materialism. In response to this supposed decay of culture, many artists and intellectuals felt the necessary antidote was the self-conscious adherence to lost human values, exemplified not only in the art that might be produced, but in careful attention to the way in which daily life was un-

dertaken and lived. T. J. Jackson Lears has summarized the antimodern impulse as "the recoil from an 'overcivilized' modern existence to more intense forms of physical or spiritual experience supposedly embodied in medieval or Oriental cultures." More importantly, he connects antimodernism to artistic and intellectual leaders in the late nineteenth century who had the power and authority to reshape social values and cultural trends: "In America (as in Europe), antimodern sentiments affected more than a handful of intellectuals; they pervaded the middle and upper classes. Aesthetes and reformers sought to recover the hard but satisfying life of the medieval craftsman."[75]

A desire for social change through artistic reform was proposed as a viable means of moving beyond the materialism of modern culture. In 1890, in a lecture for the Guild and School of Handicraft, Henry Holiday railed against the "vulgar ostentation" of current taste by referring to John Stuart Mill's *Principles of Political Economy* and Edward Bellamy's *Looking Backward*:

> So long as difference of material possessions exists and represents a difference of social power and distinction, so long will ostentation exist, so long will people surround themselves with finery for the sake of display, instead of beauty for the sake of enjoyment. What Mill well designates as the "silly desire for the appearance of a large expenditure," will, under present influences, always cause people to rent houses, to wear clothes, and take what they are pleased to call their pleasures, not because they like any of the things in question, but because it is expected of the class of society to which they belong, or, too often, because it is a mark of a class of society to which they would like to be thought to belong. The whole system, the whole sentiment, is corrupt, and the taste bred of the system and sentiment is worthy of them.[76]

Holding Bellamy's text up as an example to follow, Holiday asserted that simplicity and individuality were at the heart of good taste; by removing the "tyranny of snobbery" and the "silly desire to do what everybody else does, for fear of losing social status," people would be liberated to do as they pleased. In effect, this would allow the freedom to obtain things to suit individual needs and tastes rather than allowing class expectations to shape one's existence. In turn, Holiday argued, this would benefit society at large, for through a tasteful simplicity in one's private life, there would be a simultaneous development in the realm of public life, resulting in great public works.

To further emphasize his point, Holiday drew a parallel between the vulgar taste displayed throughout Victorian society and the monotonous, ill-fitting principles of modern dress: "Let us now look at dress. Here, surely, there will be more freedom. Cannot the individual assert his personality here? . . . Gloom, and the total

absence of individuality are the characteristics of our system."[77] Holiday was not alone in his assertion that modern fashions were antithetical to individuality and social freedom. In her lectures *Art and the Formation of Taste*, Lucy Crane identified the "greatest objection to the despotism of fashion" as "the uniformity it leads to."[78] Joanne Entwistle has pointed out that this focus on individualism within the art world in the nineteenth century marked a renewed interest in romanticism. Here, the individual seeks a form of privacy and "refuge in the imagination" enabling him or her to find a sense of self in and among the "debris of modern life."[79] However, beyond seeking individual gratification, artistic freedom and the idea of social empowerment were closely connected in the minds of many design reformers. Subsequently, for many makers and wearers of Aesthetic dress, taste was more than simply a means of distinguishing their artistic preferences from other members of society; it revealed their cultural knowledge, vision, and utopian hopes for the future.

This view must now be tempered with an awareness of the historical legacy of the Arts and Crafts movement, as well as other socialist artistic enterprises, which in retrospect proved to be anything but egalitarian. It has been the ultimate irony of such design reform that the implementation of many of these artistic principles in practice was possible only through the patronage of the wealthy classes, many of whom were industrialists who had little concern for the social betterment of the working classes.[80] Despite this qualification of the design reform literature that espoused socialist or utopian principles, it is still necessary to consider the motivations behind such forms of cultural critique. Peter Stansky has argued that the communal vision of social reformers interested in bettering society through art is useful for its cultural commentary rather than its lasting effects or efficacy in practice. Further, he points out that one of the shared motivations of design reformers in the Aesthetic movement and the Arts and Crafts movement was a "sense of the relationship of both the higher and lesser arts: that an aesthetic approach suffused all aspects of life."[81] This is of key importance to questions of Aesthetic dress, where the intention was to improve the quality of life for all through the creation and experience of the beautiful. More importantly, an analysis of such principles is ultimately most useful for the cultural critique it entailed.

WOMEN AND REFORM

The complicated terrain women faced in this process of social and artistic reform will be addressed more fully in other chapters, but it is necessary to point out here that assessing the social empowerment of women involved with the Arts and

Crafts movement and Aestheticism is a difficult process. The majority of design associations and craft "brotherhoods" denied women entrance to their clubs and professional activities. Women who trained at art schools often ended up practicing their crafts outside the professional sphere as a pastime or as philanthropy. This gap was often bridged only by women who were related by birth or marriage to male designers and artists.[82] Anthea Callen has argued that the division of labor within the Arts and Crafts movement, with women tending to carry out the designs of men in typically feminine crafts such as textiles, pottery decoration, lace making, and embroidery, had the effect of reinforcing patterns of gender inequality in Victorian culture. Further, she contends, the movement provided little escape from the rigid oppositions imposed on women in the arts and indeed across a wider Victorian sphere, of "lady and work, woman and artist, private and public."[83]

This analysis of history conflicts with the stated social ideals of many design reformers, reported both in the historical literature and in current scholarship, and indicates that the roles of women in such positions were constantly being negotiated and reformed. Lynn Walker has suggested a very different interpretation, arguing that the Arts and Crafts model and its celebration of typically feminine craft practices provided an alternative sphere for women in the arts, one that was relatively empowering for women when compared with the challenges they faced professionally in a wider artistic setting. Further, by the end of the Arts and Crafts movement, there had been a significant increase in the number of women who functioned professionally as designers of their crafts rather than as executors of others' designs, proving that their involvement was significant even during the years they lacked adequate representation.[84]

In conclusion, Aesthetic dress played a critical role in the process of cultivating and displaying an increased level of knowledge and taste for many late nineteenth-century artists and intellectuals, both for individual gratification and for the purposes of self-conscious communication of artistic ideals to others through the very public display of reformed styles of dress based on artistic principles. A certain level of flexibility and ambiguity about what Aesthetic dress was and how it functioned in Victorian culture must be acknowledged, owing to the fact that taste itself was a contested term. What was shared by all wearers of Aesthetic dress was an idealizing brand of historicism that positioned itself in opposition to mainstream fashion in order to both reveal and disavow the degraded aspects of modern culture. Thus, it can be argued that a pronounced antimodernism lay at the foundation of Aesthetic dress and its preference for historically based dress styles, particularly in terms of its Pre-Raphaelite roots and influences. The use of historicism within the discourses of Aesthetic dress represents not so much a

romantic withdrawal from the conditions of modernity as a strategic reframing of history in order to engage with the rapid changes of modern culture in an artistic and productive way. A utopian emphasis in this process allowed Aesthetic dress reformers to mobilize authorizing discourses of naturalism, science, and art in order to solidify a perceived relationship between the nobility and inherent beauty of the human form, in connection with good health, and the need to adorn one's body and environment in the products of artful labor in the service of social and artistic betterment. Aesthetic dress was one practical and pictorial means by which this relationship might not only be facilitated but also celebrated; looking to a distant and romanticized past for an organic understanding of the connection between art and life, and enacting this through sartorial culture, Aesthetic dressers sought to alter their modern landscape by "performing" an altered sense of self.

Aesthetic Dress in the Work of James McNeill Whistler

In the 1860s and 1870s, James McNeill Whistler made several paintings exploring aspects of Aesthetic dress, among them two of his *White Girl* series from the 1860s, as well as *Symphony in Flesh Colour and Pink*. In the growing Aesthetic climate of 1870s London, these works served as a focal point for erudite audiences interested in alternative modes of dress. Whistler's approach to fashion evokes the Baudelairean image of the artist-dandy, a romanticized figure who seeks to represent the transitory, the fugitive, and the ephemeral, but who simultaneously extracts the eternal qualities of beauty from daily life in the service of art. In this chapter, I argue that Whistler's self-fashioning and carefully cultivated artistic persona directly influenced his conception and depiction of Aesthetic dress, which provided a self-consciously modern interpretation of alternative modes of artistic dressing. His fascination with this subject reveals an attempt to capture the innovatory and novel aspects of the Aesthetic movement, as well as presenting a unique moment in his artistic development and individuated aesthetic. More importantly, his vision of Aesthetic dress encouraged a rarefied strand of artistic self-fashioning for female aesthetes and ultimately contributed to a growing awareness of the Aesthetic self as a carefully constructed subject/object.

Whistler's painterly approach exploited the transience of fashion as well as its centrality to a nineteenth-century construction of the feminine. Intriguingly, his brief interest in Aesthetic dress coincided with a pivotal moment in his artistic development. I argue that Aesthetic dress functioned, for him, as a specific site of artistic theorizing, that his depiction and exploration of the Aestheticized female body was a response to a compelling model of art subsuming life. As crucial as

this moment was for Whistler's artistic development, it was also significant for its impact on the sartorial category of the female aesthete and a generation of female artists, viewers, and patrons. There are important distinctions to be made between the branch of Aesthetic dress developing out of Pre-Raphaelite art and merging with dress reform in the 1880s, and the strand of Aestheticism professing an art-for-art's-sake view of fashion's role in art, a view that is central to Whistler's work. Whistler showed little concern for the rational or hygienic aspects of dress reform with its emphasis on social reform and corporeal mobility and comfort. Rather, he was interested in visuality and display. In the final analysis, he seemed fascinated by the ways that Aesthetic dress might be visualized in his art, as opposed to how it might actually function as clothing, a feature that distinguished Pre-Raphaelite dress with its emphasis on the "natural" female form.

Another important distinction between Whistler and other proponents of artistic dress reform was the central and defining role of *japonisme* in his work. Implicit in his overt interest in the arts and cultures of the East is an understanding of Aestheticism that, though laudatory, positions other cultures as exotic, distant, and — crucially, in the service of critiquing Western modes of visuality — foreign. The implications for this orientalizing aspect of Aestheticism are particularly significant when attempting to evaluate aspects of social agency and empowerment for women in Aesthetic circles. By examining how orientalism shaped the representation and practice of wearing certain types of Aesthetic dress, we can better understand the ideological function of fashion, not only as a form of social fantasy and play, but also in terms of how innovative or exploratory sartorial modes engaged with the codes of gender construction in Victorian culture. Ultimately, Aesthetic dress was an important space for the negotiation between the artistic discourses that bounded and/or enabled female subjectivity and imperial projections of an exotic "other" within British Aestheticism.

THE AESTHETIC BODY IN PAINTERLY SETTINGS

Whistler's depictions of Aesthetic dress must be situated in relation to his interest in Aesthetic space and décor. In both he professed a holistic approach to visual spectacle where minimalism and harmonious color arrangements might correct and surpass the mundane, the ugly, and the commonplace. Thus, the integration of a sartorial focus on the body with the depiction of Aesthetic space was the subject of many of Whistler's works. In his *Portrait of Miss May Alexander*, from 1873 (figure 2.1), the exact setting depicted in the painting was also the intended space for its later display. At the Alexanders' home at Aubrey House in Kensington, May

FIGURE 2.1 James McNeill Whistler,
Portrait of Miss May Alexander, 1873. Oil on
canvas, 192.4 x 101.6 cm. Tate Britain, London.

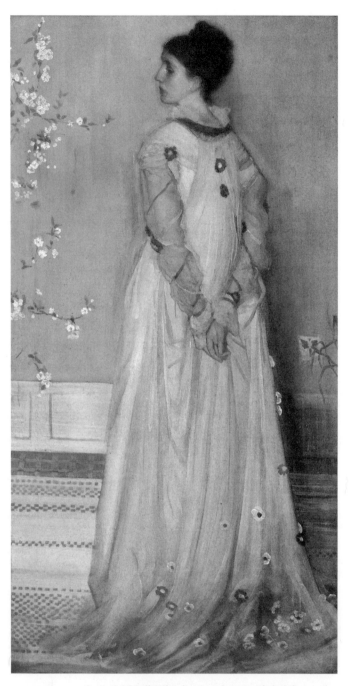

FIGURE 2.2 James McNeill Whistler, *Symphony in Flesh Colour and Pink: Portrait of Mrs. Frances Leyland*, 1871–74. Oil on canvas, 195.9 x 102.2 cm. The Frick Collection, New York.

Alexander was painted against the backdrop of one wall in the drawing room. The portrait was meant to hang in that space and was intended to create the illusion of her presence in the room, pictured as though seen in a mirror, since the portrait would reflect the space itself. An artistic conceit of this kind clearly references the importance of her figure as an integral element of an Aesthetic interior.[1]

Elsewhere, this relationship between sitter and space is less overt, but nonetheless significant in terms of the idealizing principles of Aestheticism. In Whistler's portrait of Frances Leyland, *Symphony in Flesh Colour and Pink* (figure 2.2), the overall appearance of the work, the Aesthetic tea gown, and the color scheme of the room all harmonize with the auburn color of the subject's hair. For Whistler, there was a crucial relationship between the physical environment depicted and the Platonic implications of that same space as an Aestheticized ideal. Although it was started at the Leyland's home at Speke Hall, Whistler transported the painting back to London so that he could work on it in a space he felt was more conducive to the color scheme he had envisioned for Mrs. Leyland; the salmon-colored walls were in fact those of his drawing room at 2 Lindsay Row. Throughout the London social season of 1871, Mrs. Leyland came to pose in Whistler's home in Chelsea.[2] Painted in one of the rooms of his home rather than his studio, this portrait references Whistler's Aesthetic interior as much as it points to the Aestheticized figure of Frances Leyland herself. Significantly, the actual physical and social relationship between sitter and space was less important than the visual resonances between them.

In some cases, Whistler designed the gowns of sitters for commissioned portraits, indicating his desire to place the stamp of his Aesthetic sensibility on all facets of his work, including setting and attire. He painted Frances Leyland, Lady Archibald Campbell, and Cicely Alexander in dresses he designed.[3] In his portrait of May Alexander, Whistler depicted her in riding habit at the request of her father. One study for the completed portrait clearly shows her holding a riding crop. In the final portrait, however, the details of the dress are simplified and, in some instances, obscured so that it represents a more Aestheticized version of the gown.[4] Textures and colors modulate in broad strokes and finely applied layers throughout the gown; these echo, and in places are indecipherable from, the painterly treatment of the back wall, particularly in the area where her figure casts a shadow. More importantly, the generalized shape and flow of the garment indicate the suitability of artistic dress as a malleable and flexible form in keeping with his spatial arrangements and settings. There is ample evidence of Whistler's interest in Aesthetic dress in the 1860s and early 1870s in the many drawings he completed in preparation for larger paintings, as well as in smaller-scale works.

FIGURE 2.3 (LEFT) James McNeill Whistler, sketch in the
Valparaiso Notebook. University of Glasgow Library, Special Collections (MS
Whistler NB9), 28. By permission of University of Glasgow Library, Special Collections.

FIGURE 2.4 (RIGHT) James McNeill Whistler, sketch in the *Valparaiso Notebook*.
University of Glasgow Library, Special Collections (MS Whistler NB9), 26. By
permission of University of Glasgow Library, Special Collections

Also, in a notebook he kept when he was in Valparaiso, there are three small
sketches of gowns that are very close to the Aesthetic dress styles worn at that
time. These may refer to his later designs for Frances Leyland's dress (figure 2.3)
and possibly for May Alexander's as well (figure 2.4). The notebook was mainly
used in 1866, but some of the notes and drawings date from 1865–75, suggesting
the notebook remained in his studio, and he returned to this topic repeatedly.[5]

Whistler was so concerned with the integrity of artistic environments that he
often left spaces devoid of any embellishment in the form of paintings, leaving
the color scheme, arrangement, and furnishings to stand on their own as a well-
balanced spatial composition. Deanna Bendix has pointed out that in some cases
Whistler deliberately left works of art out of artistic interiors because he considered
them extraneous to the overall concept. The blue and green dining room at his Tite
Street address was one example.[6] Perhaps for Whistler, life itself was fair game for

his artistic schemes, where Aesthetically dressed sitters, visitors, mistresses, and patrons who entered his spaces were part of the composition, completing and, in some cases, enhancing it. Elements in a living work of art, they were integral to the space as part of a larger Aesthetic project. Eliza Haweis certainly believed in the possibility of individuals with an advanced aesthetic sensibility. She wrote that such people cultivated these skills by surrounding themselves with beautiful things. More tellingly, she concluded that they were "incredibly sensitive to awkward forms, inappropriate colours, and inharmonious combinations," and that for them, "certain rooms, certain draperies, certain faces, cause not only the mere feeling of disapprobation, but even a kind of physical pain."[7] Whistler's famous Sunday brunches, held in his blue and green dining room, were an example of these Aesthetic principles in practice. The menus (handwritten in French), as well as the food, were all color-coordinated to work with each other and the room. Most crucially, however, guests were expected to match their costumes to this scheme. With the theatricality and staged quality of these events, his breakfasts can be viewed as an early example of performance art.[8]

Whistler himself can be viewed in this context. For Bendix, Whistler was "a symbolic configuration circulating in London, a living, breathing embodiment of haute couture Aestheticism, a designed object himself."[9] Contemporary accounts of Whistler often included notes on his personal appearance and the way this was inflected by his artistic practice. Louisine Elder, who, along with Oscar Wilde, visited Whistler's studio at 13 Tite Street in 1881, described the effect in her memoirs. Upon entering his Aesthetic interior, where the walls were washed in distempered yellow, and the furnishings sparse, she was struck by his appearance, with "piercing black eyes" and dressed all in black "against the yellow light." She was "persuaded that Whistler had made a background for himself." This must have impressed Elder, since she described it as having more visual impact than his Peacock Room, which she had also seen.[10]

HISTORICAL AND EASTERN SOURCES

Whistler's interest in visually harmonious space was complemented by the material cultures of the Aesthetic movement: artistic fabrics, decorative objects, and even illustrations of dress designs. Like many other artists of the Aesthetic movement, Whistler patronized Liberty's in search of fabrics and oriental decorative art objects to use in his creative process. Along with his friend Albert Moore, Whistler loved the texture and appearance of the gauzy and lustrous silks imported from and inspired by countries in the Far East, primarily India, China, and Japan. Moore

argued that nothing of European make draped as beautifully or was as evocative in terms of color. Many of Whistler's figures during the 1880s are swathed in a kind of gauzy display of fabric that was filmy and transparent enough to show off the contours of the bodies beneath. Some of his portraits have a more understated effect but can also be linked with his patronage of shops that carried Asian merchandise. The gown that Maud Franklin wore in Whistler's 1883–84 watercolor *The Yellow Room* may have been made of fabric from Liberty's.[11]

A vast array of studies and drawings reflect Whistler's fascination with the sartorial forms of the East. *The Japanese Dress* (figure 2.5), executed between 1870 and 1878, illustrates a generalized emphasis on the shape and flow of draped clothing, but is distinctly Eastern in its use of color, the pattern and texture of the fabric, and the stance of the model. Margaret MacDonald has pointed out that this portrait is a blend of Eastern and Western traditions: the curving stance of the figure echoes the typical pose of women in Japanese prints; the parasol, while "oriental," is resolutely Whistlerian; and the round pink face and curly hairstyle (close to the head in a classical fillet style) show the model to be of European origin. Additionally, the kimono worn by the figure is pictured open and draped in a classical manner, making the exact nature of her garb ambiguous. Finally, the narrow ribbon surrounding the high-waisted gown worn under the kimono is more like an Empire waistline than the broad obi typically worn in Japan at that time.[12] The work exemplifies the strange modern blending of classicism and orientalism in Aestheticism that had become the hallmark of Whistler's style.

Whistler's use of a tea gown for *Symphony in Flesh Colour and Pink* allowed for a full synthesis of Eastern and Western modes, reflecting a unique and novel approach to the painterly depiction of fashion. However, many of his artful gowns and sartorial arrangements were directly influenced by recognizable historical and Eastern styles. The inclusion of an eighteenth-century Watteau pleat in the back of the gown, and distinct references to the Japanese kimono, illustrate this fact. For many artistically inclined Europeans, the latter evoked the exotic ritual of the Japanese tea ceremony. Aileen Ribeiro has pointed out that the comfort and elegance of the tea gown, as well as its incorporation of historical and exotic influences, encouraged its perception as an "essential luxury." As late as the early twentieth century, tea gowns were still perceived as flowing and elegant garments that relied on "a love of art and beauty."[13]

Preparatory sketches as well as the final painting reveal that Whistler looked to eighteenth-century French fashion for inspiration. Many of the studies for Frances Leyland's portrait are far more detailed than the finished painting, and illustrate a number of stylistic features and traits associated with clothing construction of

FIGURE 2.5 James McNeill Whistler, *Study in Lemon and Turquoise:*
The Japanese Dress, ca. 870–78. Courtesy Davison Art Center,
Wesleyan University, photo by Ralph Phil.

the previous century.[14] Some of the drawings probably date from before the actual
dress was constructed, when Whistler was first conceiving the arrangement of
fabric, and a great deal of detail is lavished on the individual features of the dress
in these early studies (figures 2.6 and 2.7), which suggest the influence of earlier
depictions of fashion by artists such as Jean-Antoine Watteau. However, the study
that most closely resembles the finished portrait in terms of the pose and stance
of the figure is extremely rough and contains very little sartorial detail.[15] By that
point Whistler was likely concentrating on the general pose of Leyland's figure
and the accompanying flow of fabric. This abstracting quality echoes the difference
between early studies of May Alexander's painting, and the simplified appearance
of the gown in the final portrait.

FIGURE 2.6 James McNeill Whistler, *Study of Mrs. Leyland*, 1871–74.
Chalk and pastel on brown paper, 26.5 x 17.4 cm. Freer Gallery
of Art, Smithsonian Institution, Washington, DC.

RHETORICAL MODERNISM
IN THE WORK OF WHISTLER

Whistler was always insistent that any influence or inspiration in his work was
secondary to his novel approach and artistic integrity. In fact it is ironic that later
in his development, Whistler criticized historicism and eclecticism in the settings,
clothing, and general mood of paintings. Specifically, he took to task those artists
who attempted to revive bygone eras by dressing up their figures in the costumes
of the past. In his *Ten O'Clock Lecture* of 1885, he proclaimed,

> Costume is not dress — and the wearers of wardrobes may not be doctors of
> "taste"! — For by what authority shall these be pretty masters! — Look well, and
> nothing have they invented! — nothing put together for comeliness' sake — Haphazard

FIGURE 2.7 James McNeill Whistler, *Study for Symphony in Flesh Colour and Pink: Portrait of Mrs. F. R. Leyland*, 1871–74. Chalk and pastel on brown paper, 26.7 x 17.6 cm. Freer Gallery of Art, Smithsonian Institution, Washington, D.C.

from their shoulders hang the garments of the Hawker — combining in their person, the motley of many manners, with the medley of the mummers' closet — Set up as a warning, and a fingerpost of danger — they point to the disastrous effect of Art upon the Middle Classes — Why this lifting of the brow in deprecation of the present? — this pathos in reference to the past! — If Art be rare today, it was seldom heretofore — It is false this teaching of decay.[16]

In retrospect, we can now see this kind of language as modernist rhetoric, an attempt on the part of Whistler to distinguish his work more and more from other schools of painting in England or elsewhere. His assertions of creative autonomy and artistic originality were intrinsic to his persona as artist-dandy, as was his privileging of an elitist conception of art over the misapplication of art by the undeserving in daily life.

Later in the 1880s, Whistler appeared to lose interest in Aesthetic dress and moved on to a visual exploration of more restrictive and fashionable silhouettes. At the time of his lecture, certain members of the Aesthetic elite found fault with Whistler's words and sensed a note of hypocrisy contained in his condemnation of forms of dress derived from historical models. In the February 1885 issue of the *Pall Mall Gazette*, perhaps in response to this shift, Oscar Wilde stated,

> I hardly think that pretty and delightful people will continue to wear a style of dress, as ugly as it is useless, and as meaningless as it is monstrous, even on the chance of such a master as Mr. Whistler spiritualising them into a symphony, or refining them into a mist, for the arts are made for life, and not life for the arts. . . . Nor do I feel quite sure that Mr. Whistler has been himself always true to the dogma he seems to lay down, that a painter should only paint the dress of his age, and of his actual surroundings. . . . For all costumes are caricatures. The basis of Art is not the Fancy Ball. Where there is loveliness of dress, there is no dressing up.[17]

At the center of this debate was the proper function of artistic forms of dress. For Whistler, Aesthetic dress was a fashionable phase, passing in and out of relevance with the attendant aspects of its relation to the conditions of modern life. Ultimately, it gained longevity only through its inclusion in the world of art. It was more useful as an artistic concept in paintings that explored the sartorial and Aesthetic aspects of the clothed or draped figure at a particular point in his development. Conversely, for Wilde and many other aesthetes, Aesthetic dress was a permanent example of beautiful dress — a mode of dressing that would retain its relevance regardless of social developments and changes in the art world. Art might always be expressed through artful dressing in the minds of Oscar Wilde and many other Aesthetic dressers, whereas for Whistler, life was secondary to the creative process, and Aesthetic dress had limited uses. Once Aesthetic dress neglected to reflect the fugitive and ephemeral nature of fashion, and therefore of life, it ceased to be significant in Whistler's artistic approach.

From the vantage point of Baudelaire's category of the artist-dandy, Whistler's creative vision and painterly technique — his sensibility, in effect — took on the role of the permanent, immutable, and eternal aspect of his art as a representation and exploration of Aestheticism. Aesthetic dress itself was reduced to a symptomatic and fleeting expression of modernity. He adopted it briefly as a muse that must find expression, but moved on from Aesthetic dress to other forms, styles, and values drawn from fashion, even while his artistic process and belief in the ascendancy of art remained constant. For this reason, certain approaches and techniques in presenting the human figure in clothing remained the same in all his work. Most

notable were a concern with balance and harmony of color, and simplification of detail in a process of artistic abstraction, as well as an aesthetic rendering of forms in space. Thus, Whistler's interest in Aesthetic dress, manifested in the elaborate garment he designed for Frances Leyland, can be related to an aspect of "modernity" connoted by the novel form of the tea gown itself. As a form of clothing that progressively came to symbolize women's comfort and leisure in the 1870s and 1880s, it was a hybrid of many competing and complementary influences and stylistic traits, a theme that will be explored more fully in subsequent chapters.

Whistler's self-professed modernity was largely based on his perception of himself as a distinctive, innovative, and original artist. In *Symphony in White No. 2: The Little White Girl* (figure 2.8), the amalgamation of Western and Eastern pictorial devices, combined with the inclusion of Aesthetic decorative art objects, establishes this painting as one of Whistler's most emblematic aesthetic statements. The flattened perspective, as well as the asymmetrical and partial framing of the white girl's figure in the room, points to Japanese prints as sources. The perspective and placement of objects in the painting are complicated by a spray of flowers that runs down the right side of the painting, neither fully in front nor fully behind the skirt of the gown. Both the flowers and the dress seem to be floating in an ill-defined spatial plane. Eastern influence is further established through the inclusion of a piece of blue and white china and the fan loosely held in the woman's hand. The close, almost claustrophobic position of the viewer with respect to the voluminous gown and mantelpiece, combined with the ambiguity of space resulting from various pictorial devices — including the use of a mirror—serves to render this work supremely Aesthetic in its removal from the external world, and invites contemplation rather than direct interpretation. This reading is further supported by an examination of what is depicted in the mirror above the mantel. It shows the model's face against the backdrop of one of Whistler's paintings of the Thames, hanging behind her on the opposite wall. Cut off from the outside world, this work is self-referential, pointing to the hermetic realm of Aestheticism far removed from the logic of daily life.[18]

Despite its historical references and seemingly eclectic interpretation of Eastern and Western sartorial traditions, Whistler's *Symphony in Flesh Colour and Pink* represents the most fully developed relationship between the artist's modernism and his interest in Aesthetic dress.[19] More importantly, the dress in this portrait may have in fact inspired real sartorial change outside artistic circles, becoming a model for later Aesthetic styles in mainstream fashion throughout the following decade and right up until the early to mid-1880s. Bendix has even suggested that Whistler's delicate sensitivity to color, and his unified view of figures in particular

FIGURE 2.8 James McNeill Whistler, *Symphony in White, No. 2: The Little
White Girl*, 1864. Oil on canvas, 76 x 51 cm. Tate Britain, London.

settings, evoke the pose, costume, and coloring of a Watteau painting. This rococo elegance in combination with Eastern elements of Whistler's work anticipates art nouveau figures and interiors of the 1890s.[20] This is particularly evident in *Symphony in Flesh Colour and Pink*. The pastel creaminess of varying shades of pink, in combination with the gauzy quality of the outer layers of the tea gown, evokes the fussiness and intense focus on textiles and costume evident in much of eighteenth-century portrait and genre painting. Grafted onto this seemingly innocent play of texture and color, however, is a programmatic and structuring approach to composition and a carefully considered emphasis on line. The flow of fabric sweeping down from the back of the gown is prescient, anticipating the linear and organic qualities of much later forms of artistic dress and reform dress at the turn of the century — particularly those in the context of art nouveau and the Vienna Secession.

Whistler's interest in Japanese art is fully synthesized with his modernist aesthetic in this portrait. Certainly, Whistler was not alone in his interest in orientalism and in realizing its importance for Aesthetic interiors. Paintings such as John Atkinson Grimshaw's *Dulce Domum* and Edward Poynter's portrait of Lady Elcho show Aesthetically dressed women in Aesthetic interiors, signified in large part by the presence of fans, blue and white china, and peacock feathers. However, there is a distinct difference between these examples and the work of Whistler. No longer connoted by obvious symbols or elements such as the use of blue and white china, the integrated nature of Whistler's orientalism is illustrated through his use of ambiguous spacing and the nuanced pose of the figure itself. The non-perspectival depiction of space, the decorative spray of flowers, and Whistler's butterfly monogram all evoke the appearance of Japanese prints. In addition, the sitter's pose may have been derived from Japanese woodblock prints; Ukiyo-e prints often pictured women from the rear in order to feature the backs of their kimonos as well as their necks.[21] These indicators of Japanese art are far more subtle and ephemeral in Whistler's work than in Grimshaw's and Poynter's, suggesting that he had fully absorbed these sources and influences by this point, and that they were essential to his Aesthetic outlook and method.

Whistler's modernist approach was aided by his interest in contemporary fashion illustration. In one study for the portrait of Frances Leyland, the dress is pictured from both the front and back, drawing on conventional approaches in fashion illustration, which often featured both views of a dress.[22] Beyond the functional value of these drawings in the design process for the final garment, he was clearly interested in its visual impact from a variety of perspectives. The highly detailed nature and sheer number of these studies confirm this reading. Moreover,

his familiarity with fashion journalism is demonstrated by material that came from his estate, including multiple issues of fashion magazines. It is possible that these belonged to Beatrice Whistler, but the fact that they were still in his possession long after her death in 1896 would seem to indicate that the artist had more than a passing interest in them.

Mrs. Leyland's gown is also linked to modern fashion through the realistic setting of Whistler's studio. Though depicted in an abstracted, evocative style, the room in which Frances Leyland posed was a room in Whistler's house, which would have been recognizable to those who knew him, or had visited his home. The floor matting, dado, and decorative border on the wall also refer to contemporary Aesthetic interiors more generally. Thus, critics would not have perceived this gown as an imaginary rendition of dress, as was the case with many Pre-Raphaelite portraits and genre works.[23] Taking into account the modern interior of the room, in combination with the contemporary hairstyle worn by Leyland, this dress would have been viewed as a modern fashionable gown with Aesthetic pretensions. Whistler's portrait of Leyland stands in direct contrast to Rossetti's *Monna Rosa*, painted in 1867 (see figure 1.5), a romanticized portrait of the same woman set in an indefinite and ambiguous space. Rossetti's choice of fabric and interior detail for the portrait indicates a quasi-medieval setting, in which the figure of Frances Leyland could easily be taken for a mythological or literary figure set in the distant past.

AESTHETIC DRESS AND THE
TRANSFORMATIVE POWERS OF FASHION

In light of Whistler's self-consciously modernist stance, I argue that his depiction of Aesthetic dress drew on current modes of Aesthetic display and represented an alternative to the established view of Aesthetic dress as an adapted form of Pre-Raphaelite dress. In contrast with the Pre-Raphaelites' homage to history through their idealization of medieval art and culture, Whistler felt that great art had always existed, even during the nineteenth century, whether or not it was understood, appreciated, or utilized by the general public. In his *Ten O'Clock Lecture*, Whistler criticized the tendency to privilege the Greek, Renaissance, or other historical periods as superior and inherently artistic, asserting instead that, "there never was an artistic period!"[24] Thus, an important distinction should be made between Whistler's interest in Aesthetic dress as a current and novel mode of artistic expression, and notions of Aesthetic dress as a means of gaining access to past eras of beauty, nobility, and naturalism. Exemplified by Pre-Raphaelite art

and dress, naturalism was understood as a set of truthful pictorial approaches for clothing and representing the female form in the resplendent beauty of its natural state. Whistler was indifferent to such discourses of naturalism, and further, despite his own transcendent view of art, was dismissive of other forms of artistic idealism, especially if they presumed to place life at the center of the debate.

Whistler also acknowledged the studied artifice of fashion and its importance as a facet of self-creation and definition. This too, stood in stark contrast with the values of authenticity and historical integrity witnessed in Pre-Raphaelite circles. In the work of artists such as William Morris, Burne-Jones, and Rossetti, an exploration of nature was central to an idealized Aesthetic lifestyle. In this framework, art could enhance and elaborate nature's presence in all things; in other words, art was an expression of the beauty of nature in life. Thus, Aesthetic dress was one way to express the natural beauty of the female body through clothing. This position assumed that there was a natural body that could be located in a natural and authentic mode of clothing. Whistler was far more interested in the transformative powers of art and the ways that life could be used to access a higher artistic plane. In 1880, in a letter to his mother, Whistler proclaimed that the people in Venice, "with their gay gowns and handkerchiefs — and the many tinted buildings for them to lounge against or pose before, seem to exist especially for one's pictures — and to have no other reason for being!"[25] Baudelaire had argued that fashion should be considered as a "symptom of the taste for the ideal which floats on the surface of all the crude, terrestrial and loathsome bric-à-brac that the natural life accumulates in the human brain: as a sublime deformation of Nature, or rather a permanent and repeated attempt at her reformation."[26] Baudelaire's notion of the artist-dandy figure posits an individual who moves away from naturalism toward the artificial, an impulse that was considered inherently modern by the end of the nineteenth century. For such an artist, artifice was the means of perfecting and improving upon nature, and was thus superior and nearly supernatural.

Whistler's desire to exceed, transcend, or otherwise perfect the natural can be seen as positioning his work, and indeed himself, as the very incarnation of Baudelaire's modern artist-dandy, and it is tempting to view his work in this way. Although it can be argued that the Pre-Raphaelite view of art and fashion is far from simplistic, Whistler's interest in fashion illustrates a more sophisticated understanding of the social construction of fashion and its increasingly important role in the visually competitive world of late nineteenth-century Western culture. Nature, for Whistler, was merely the crude material from which the artist selected and reorganized elements to attain artistic perfection. It was the artist's vision, not nature, that was central to an aesthetic appreciation of the beautiful:

That Nature is always right, is an assertion, artistically, as untrue, as it is one whose truth is universally taken for granted — Nature is very rarely right, to such an extent even, that it might almost be said that Nature is usually wrong — that is to say — the condition of things that shall bring about the perfection of harmony worthy a picture, is rare, and not common at all.[27]

For Whistler, Aestheticism required a thoughtful distance from contemporary life; in this he sided with Swinburne, who, in his work on William Blake, asserted that the business of art was "not to do good on other grounds, but to be good on her own."[28] For Whistler, then, nature and all that was involved with the social mechanics of daily living were subservient to the higher purpose of creating art. This does not mean he was unaware of social conditions or the less savory aspects of Victorian culture. Rather, he simply did not share the aims of social improvement and enlightenment through art espoused by design reformers tied to Pre-Raphaelite and Arts and Crafts circles. Thus, for Whistler, the relevance of Aesthetic dress extended from its ability to speak about art, to embody and visually manifest artistic idealism in and of itself, rather than its functional value as an indicator of authentic and timeless forms of beauty or even as an emblem of social and artistic reform.

Beyond his burgeoning "art for art's sake" stance, Whistler exhibited Platonic tendencies in his aesthetic theories, and his work was increasingly esoteric as it attempted to become more truthful, referring to an ideal realm beyond the surface reality of things. I would argue that the refinement of details, generalizing aesthetic, overall attention to color, mood, and harmony all point toward Whistler's belief in the power of art to improve upon the material of life and to create artistic spaces that might supersede life in the name of art. Though he might have resented the comparison, his use of Aesthetic dress to depict this process writ upon the bodies of women is not so far from the strategy used by the Pre-Raphaelites to exemplify their ideals regarding naturalism using the female body as a blank canvas upon which to enact such universal themes. Understanding this process in the work of Whistler can then lead to a parallel between his aesthetic project and the very ways that Aesthetic dress itself as a practice sought to improve the material side of fashion, to reform it in the direction of art and Aestheticism.

WHISTLER AND SELF-FASHIONING

Looking more closely at Whistler's Baudelairean approach to artistic living and his embodiment of Aesthetic principles in his own dress and that of others il-

luminates his work in a telling way. Baudelaire, in "The Painter of Modern Life," wrote that it was the business of the artist to "extract from fashion whatever element it may contain of poetry within history, to distill the eternal from the transitory." Criticizing a growing tendency among artists to depict the costumes of the past, and labeling the impulse as "lazy," Baudelaire asserted that for many an artist it seemed "much easier to decide outright that everything about the garb of an age is absolutely ugly than to devote oneself to the task of distilling from it the mysterious element of beauty that it may contain, however slight or minimal that element may be."[29] Whistler's art production seemed to remedy this situation, echoing Baudelaire's theories regarding the important role of modernity in the art production of great artists. Fashion, for both Whistler and Baudelaire, was central to a process of discovery and recovery within modernity. In its pattern of continual and unceasing change, fashion was the very incarnation of all that was transitory, fleeting, and ephemeral about nineteenth-century culture. Yet, at the same time, the ongoing importance of fashion for establishing status and connoting a sense of self lent it a sense of permanence, pointing to eternal truths about the importance of self-crafting and its pivotal role in the relation between self and culture. Changeable in its forms and stylistic manifestations, but unchanging in its basic function, fashion has always been indicative of self-refinement, transformation, and the display of one's wealth or status for members of various elites — a process that Whistler often explored through his use of portraiture.

Baudelaire's writings provide insight into the ways in which Whistler might have conceived of his own artistic process, as well as the role of self-fashioning, display, and artistic showmanship. Whistler's method of picturing his sitters in their clothing not only conveyed an interest in the modernity of fashion, but also served as a pictorial representation of his own artistic practice, methodology, and technique. His emphasis on artistic originality, the privileged vision and sensibility of the artist, and the production of art as an indicator of genius were indicative of a set of modernist values to which he subscribed. In pursuit of a pure art, daily life might prove useful or inspirational, but ultimately artistic change was driven through an internal logic of its own, far removed from the requirements of social, moral, or institutional standards. Whistler believed in his own ability to look beyond the surface of life to extract the immutable, eternal, and ultimate perfection of an idealized vision of life. His interest in Aestheticism and in Aestheticized modes of living linked this artistic approach with his self-image and might explain his intense interest in self-fashioning as more than simply a form of self-display and social presentation, but as an artistic act in and of itself.

Whistler's often-noted perfectionism is evidence of the intensity with which

he pursued an idealized notion of life through art. His impossibly high standards resulted in his repeatedly scraping down his canvases in order to redo sections of works or works in their entirety and retaining paintings for years on end, withholding them from clients — sometimes modifying them, and sometimes destroying them altogether. Some of this destruction was likely due to his temperamental nature, which in turn had disastrous effects on his relationships with patrons. However, most of it can be attributed to his constant search for aesthetic perfection. A formalist reading of Whistler's work suggests that his evocative use of clothing, the poses that he chose for his sitters, the setting, lighting, and use of color to create mood were all elements in a fairly abstract artistic process — one that rendered all facets of a painting equivalent and subordinate to an emphasis on composition and painterly technique.

However, Whistler's social persona as an artist-dandy drew on current and contemporary developments in his social and artistic milieu. His use of fashion in its novel and up-to-date forms implies this connection with his social surroundings and his familiarity with the cultural symbols associated with particular forms of self-display. Unlike the ongoing relationship with Aesthetic dress shown by those associated with the Pre-Raphaelite tradition, Whistler's interest in Aesthetic dress coincided with the brief period where it first spread through a fairly hermetic social and artistic circle, from the 1860s to the late 1870s. As such, it represents a moment in the history of art and fashion when various influences and styles converged, confirming its status at that time as an approach to dressing that was novel and indicative of modernity. Further, Whistler's interest in the forms associated with Aesthetic dress were inextricably linked with his growing use of Japanese and East Asian motifs and techniques; through a reframing of these influences, he created a rarefied and unfamiliar language with which to depict European interior spaces and figures and, in so doing, removed himself from the sphere of conventional Victorian art practice.

While Whistler's incorporation of Japanese and Chinese decorative art practices helped create an air of exoticism in his work, originality and individualism were at the forefront of his emerging popularity. In retrospect, his contribution can be viewed as developing out of a general design reform movement, but with important contributions from modern art. Bendix has argued that part of Whistler's originality lay in his ability to translate and transmit various international trends in art, using his experiences in France, America, Belgium, and Britain to synthesize his own unique approach and, in the process, turn away from Victorian historicism and eclecticism.[30] This is a further indicator of Whistler's desire to attain a level of notoriety as an artist interested in an advanced modernism. In

fact, the goal of originality was so central for Whistler that, despite his admiration for Albert Moore's work, he expressed the concern that there were too many similarities between their work in certain compositions. In response, both artists asked a friend, William Eden Nesfield, to act as an intermediary and settle what for Whistler was a question of infringement on artistic property. In September of 1870 Nesfield wrote to Whistler to reassure him:

> My dear Whistler, Albert Moore called here today & we went to Chelsea to examine conscientiously the causes which led to your note to him, which I have read — I must must [sic] preamble my opinion by stating that as you & Albert have asked me to be arbitrator in this matter I of course take it for granted that my decision is valuable.... I strongly feel that you have seen & felt Moore's specialité in his female figures, method of clothing them and use of colored muslin also his hard study of Greek work — Then Moore has thoroughly appreciated & felt your mastery of painting in a light key — I have such sincere admiration for you both that this slight awkwardness has considerably worried me ... the treatment is different enough despite the shared subject matter of "shore, sea, sky, & a young woman walking on the foreground.[31]

The fact that Whistler needed assurances that his work was sufficiently distinctive to stand on its own, without too close comparison to the work of others, indicates how crucial originality was to Whistler's sense of self, and to his art production.

Throughout his career, Whistler reveled in the attention he received, both good and bad. He kept press clippings spanning many years, collecting reviews of his work, including even short entries where only his name was mentioned, assembling them into notebooks and sometimes writing notes in the margins.[32] Opinions in the press varied wildly concerning both Whistler's work and the details of his life. Of little dispute, however, was the original and unique nature of his work. H. Heathcote Statham, an architect and critic, wrote in *Macmillan's Magazine*, "While still among the singularities of the exhibition, Mr. Whistler's art is at least no echo of anything else; it expresses his own idiosyncrasy. If we fail to find sufficient motive for painting, on a scale of life size, what may be called phantoms of figures, we at least feel that these are genuine as far as they go."[33]

In some journals, both positive and negative estimations of his work could be found, often forming a dialogue regarding the value and worth of his unconventional approaches. In an 1884 issue of the *Artist and Journal of Home Culture*, a self-titled "Enthusiast" wrote, "Mr. Whistler, unlike history, never repeats himself: he has almost given us the right to look for novelty from him; and this, the most important collection of his works yet brought together, shows him quite at his best. Here all is new."[34] Opposing the views of this critic, in the following month's

issue a sarcastic "Philistine" attacked Whistler's technique of rendering a general impression of a figure rather than a detailed, highly mimetic portrait:

> When you are at the right distance (about three yards out of the gallery) the picture looks well, for the pose is masterly, the drawing fine, and the colour very pleasant; but when you come closer, in order to see the face, you are shocked to find that the young lady is suffering from eczema, or some other skin disease on the left cheek, and has a cataract in the left eye. This discovery, doubtless due to the fact that Mr. Whistler did not think it worth while to finish the picture, robs you of nearly all pleasure in it.[35]

Titling his article "Mr. Whistler and his Artifices," the author cast Whistler in the role of poseur, viewing his work as disingenuous attempts to pull the wool over the eyes of the public. Calling on the authority of Ruskin and attacking the flattery put forth by "Enthusiast," "A Philistine" asks whether "Enthusiast" doubts that Ruskin "has given thought and observation to art matters? Or does he suggest that the author of 'Modern Painters' has no mind? Are all those of us who do not agree with the Enthusiast, mindless, thoughtless things?"[36] The polarizing effect that Whistler's painterly approach had on the critical reception of his work reveals both the avant-garde nature of his production and the instability of artistic tradition and authority during this period.

Whistler's *Ten O'Clock Lecture* heralds the artist as a gifted and superior individual with advanced sensibilities. His lecture remains one of the clearest examples of a modernist reframing of the role of the artist in modern culture, including the gender biases implicit in the language and tone of his address. In Whistler's rhetoric, art is the feminine counterpart to the masculine and active agency of the artist:

> He it is who calls her — he who holds her —
> ... Art seeks the Artist alone — Where he is, there she appears — and remains with him — loving and fruitful — turning never aside in moments of hope deferred — of insult and of ribald misunderstanding — and when he dies, she sadly takes her flight — though loitering yet in the land — from fond association — but refusing to be consoled.[37]

Crucially, Whistler's concept of the true artist was one who was surrounded by amateurs, philistines, and the inartistic hordes. Art was a fleeting mistress who must be wooed by the worthy: "ages had gone by, and few had been her choice! — Countless, indeed, the horde of pretenders!" Unsurprisingly, heated debates in the journal literature not only considered the meaning and value of his work, but more frequently focused on his perceived artistic pretense and elitism. In a review of an exhibition of his works at Dowdeswell's gallery in 1884, a reviewer for the *Artist and Journal of Home Culture* described Whistler as someone who, "with characteristic

desire to emphasise that separation from the vulgar artistic herd, after which he has consistently striven throughout his career, has again designed a special setting for the pearls of great price, that he proposes to cast before most unappreciative swine."[38] Regardless of the positive or negative associations the public had with Whistler's temperament and personality, his highly visible presence in the art and fashion literature of the day, largely due to his carefully constructed artistic persona, cannot be disputed.

FEMALE SITTERS, VIEWERS, AND PATRONS

Joanne Entwistle has suggested that Baudelaire's artist-dandy is the requisite figure of the modern self, one that is "increasingly aware of itself, including its appearance, and able to intervene and act upon it."[39] Fashion is a central component of this process, explaining its enduring presence in the work of Whistler. Yet Whistler's depiction of women in Aesthetic dress, most notably Joanna Hiffernan and Frances Leyland, is much more than a painterly exploration of the forms, colors, and compositional aspects of a particular and artistic strand of an up-to-date fashionability. It is also a visual manifestation of the complex relations between Aesthetic dress, the identity of its wearers/sitters, and Whistler's own identity as an aesthete and dandy. As master artist, he is removed from life, yet in a position to comment on and critique forms of culture that appeal to or repel his eye.

Woman as an aesthetic category was often the chief concern in Whistler's work and, consequently, central in his Aesthetic spaces and lifestyle. Baudelaire had noted the importance of the female figure for artists, asserting that she was "far more than just the female of Man. Rather she is a divinity, a star, which presides at all the conceptions of the brain of man; a glittering conglomeration of all the graces of Nature, condensed into a single being." Fashion and appearance were equally crucial in Baudelaire's assertion of women's importance for modern art:

Everything that adorns woman, everything that serves to show off her beauty, is part of herself; and those artists who have made a particular study of this enigmatic being dote not less on all the details of the *mundus muliebris* than on Woman herself. No doubt Woman is sometimes a light, a glance, an invitation to happiness, sometimes just a word; but above all she is a general harmony, not only in her bearing and the way in which she moves and walks, but also in the muslins, the gauzes, the vast, iridescent clouds of stuff in which she envelops herself, and which are as it were the attributes and the pedestal of her divinity.[40]

The careful attention to the details of dress and the fascination with the means by which his sitters enhanced their personalities through their choice of costume point to the centrality of fashion in Whistler's work as well. Yet beyond the symbolic potential of the female figure for Whistler's work, his lived relationships with women in the artistic and social circles surrounding him should not be overlooked and cannot be separated from the ideological and pictorial dimensions of his work. His work had a marked effect on artistic circles, society in general, and the patrons (as well as sitters and models to some extent) who chose Whistler as their portraitist.

Whistler was particularly attractive to individuals who were located on the periphery of respectable society and who, in many cases, also had an abiding interest in marginal or challenging forms of fashion. Much of Whistler's allure for the socially daring probably lay in his open depiction of his mistresses in his work, neither obscured nor mediated through the use of myth, romance, or narrative. Without apology, he depicted the realities of his social world, albeit in an abstracted and aestheticized fashion. This tendency in his work places him squarely in the tradition of a modern artist such as Manet, who painted *Olympia*, an unabashed portrayal of nineteenth-century prostitution. Whistler's first public full-length portrayal of his then mistress Joanna Hiffernan occurred with *Symphony in White, No. 1: The White Girl* (figure 2.9), which was rejected by the Royal Academy and was subsequently exhibited privately at Berners Street Gallery in June 1862 and the Salon des Refusés in 1863. While Whistler was anxious to discuss and promote the abstract, artistic values of his painting, it was clear he also reveled in the social controversy it was sparking.[41]

Part of the controversy surrounding the exhibition of Whistler's *White Girl* arose because of various critical attempts to explain the subject matter of the painting. In the absence of a clear narrative or any straightforward clues to decode the symbolism in the picture, the critics read the image as best they could, according to Victorian values. The wilting lily, bearskin rug, and flushed yet vacant facial expression of the figure led some critics to believe this work was about the deflowering of a virgin (hence the symbolism of the white gown, which some saw as dirty).[42] Some described his depiction of the girl in the white dress as an illustration based on Wilkie Collins's popular sensation novel, *The Woman in White*, a charge that Whistler vigorously denied. Certainly this work, without a clear moral imperative and lacking any obvious literary associations, left the public and many critics bewildered and casting around for some clear meaning.

In fact, Whistler resisted any and all narrative or literary interpretations of his portrait and, indeed, of his work in general, describing his own subject matter as simply "a girl dressed in white standing in front of a white curtain." For Linda

FIGURE 2.9 James McNeill Whistler, *Symphony in White, No. 1:*
The White Girl, 1862. Oil on canvas, 213 x 108 cm.
National Gallery of Art, Washington, DC.

Merrill, this description offers up an alternative reading, of a painting showing a professional model at work, surrounded by props, having dropped her pose, her vacant expression related to the long ordeal of posing and her weariness at the end of a working day. Many people may have overlooked this possibility of the painting simply depicting a model — unsurprisingly, given the public's expectation of, and comfort with, fictional or narrative scenes.[43] Another consideration is the gown itself, which is a clear example of Aesthetic dress with its high natural waist, puffed sleeves, and lack of structure or bustle to bolster the dress from beneath. Additionally, the color white itself provided a contrast to the brightly colored and harsh aniline dyes used concurrently in fashionable gowns and much reviled by artists and dress reformers alike. However, at the early date of 1862, most members of the public, and even some in artistic circles, would not have recognized the dress for what it was — an example of rarefied artistic raiment in keeping with Whistler's rhetoric of Aestheticism and art for art's sake.

Whistler's next contribution to the series, *Symphony in White No. 2: The Little White Girl*, resolved little of the mystery of his *White Girl* paintings in the minds of the public. The ambiguous role of the sitter in this work is complicated by the appearance of a noticeable gold band on the third finger of her left hand. Since there is no evidence that Whistler married Joanna Hiffernan, it can be assumed that its appearance in the painting had a symbolic function. Perhaps Whistler depicted Hiffernan wearing this ring as a token of his commitment to her; conversely, he might have painted it as a challenge to Victorian moralism. A more abstract view presents itself: it might have pointed toward a perfected realm of aesthetic beauty where all things were true, all things possible. In any case, the exact statement that Whistler was trying to make by including a glistening ring so prominently in the painting remains obscure, as do Hiffernan's own thoughts regarding the controversies surrounding Whistler's depictions of her.[44]

Regardless of the moral dimensions of the work, the social context for Aesthetic dress in the *White Girl* series of paintings becomes clearer in *Symphony in White No. 2*. By this time, Hiffernan was known to Whistler's social and artistic circle; in an 1862 letter to Thomas Armstrong, George du Maurier noted with disapproval that Hiffernan would often appear "got up like a duchess, without crinoline."[45] Based on this comment, Aesthetic dress may have been something she wore frequently outside the studio. However, in the painting, the only label that critics could affix to the dress was that of "morning dress," a loose gown worn at home by middle-class Victorian women early in the day.[46] Thus, the exact function of this dress outside the studio remains unclear. In addition, despite Whistler's later disavowal of his connection to a specifically British school of painting, during the

years that the *White Girl* series was painted, he was in close acquaintance with members of the Pre-Raphaelite circle and shared similar ideas and influences regarding clothing and the role of art in daily life. Choosing to take a separate path later, he shared ideas about costumes and the evocative role they could play in art with members of that circle, in particular Rossetti.[47] Rossetti's portraits of women usually placed them in opulent but oppressive pictorial spaces, providing an alternative to Whistler's more restrained and sparse portrayals; but both positioned Aesthetically dressed women at the center of their work for a time.

It is open to debate how much credence Whistler gave to women's processes of sartorial choice and self-crafting. However, in the use of Aesthetic dress in many of his portraits, there is a pictorial exploration of the process of Aesthetic self-crafting itself, which must have provided a model for female art audiences. Given the conventional power imbalances between male artists and female sitters, as well as the potentially conflicted and often ambiguous power dynamics between male artists and female artists or patrons, an interpretation of the role of Aesthetic dress in the lives of women involved in Whistler's circle is bound to be highly speculative. One possible avenue to explore in order to understand Whistler's relationships with and depictions of women is consideration of the artist's own use of self-crafting and admiration of it in others. The powerful effect of personal presentation, dress, behavior, and decorum on a viewing public or audience fascinated Whistler, and would appear to be a central preoccupation in most of his portraits.

It is significant that Whistler was on good terms with many women — in fact, frequently women in the art world had far more tolerance for his antics than others did, particularly his male patrons and even some of his male colleagues and fellow artists. The literature of the nineteenth century is rife with positive anecdotes regarding Whistler's warm friendships with many women. In her memoirs, Ellen Terry wrote,

> He gave me the most lovely dinner-set of blue and white Nanking that any woman ever possessed, and a set of Venetian glass, too good for a world where glass is broken. He sent my little girl a tiny Japanese kimono when Liberty was hardly a name. Many of his friends were my friends. . . . The most remarkable men I have known were, without a doubt, Whistler and Oscar Wilde. This does not imply that I liked them better or admired them more than the others, but there was something about both of them more instantaneously individual and audacious than it is possible to describe.[48]

Whistler's Sunday breakfasts at his house in Tite Street were renowned in artistic circles for their wit and gaiety. Louise Jopling, an artist and Grosvenor Gallery exhibitor like Whistler, wrote that she was a constant guest at these gatherings.

"One met all the best in Society there — the people with brains, and those who had enough to appreciate them." Jopling asserted that Whistler was an "inimitable host" who "loved to be the Sun round whom . . . lesser lights revolved." Yet Jopling also clearly displayed a high degree of affection for him, stating: "He ignored no one. All came under his influence, and in consequence no one was bored, no one was dull. . . . Whistler had a most beautiful, loyal and kindly heart."[49] In the end, although Whistler's imperious manner and artistic approach put many people off, he was popular with many in artistic and social circles, in particular those whose status was questionable, fluid, or peripheral to mainstream Victorian culture — bohemians, theater people, and female artists. More importantly, the perceived stance of Whistler as a solitary artistic figure, a painter fiercely experimental and singular in his artistic approach and removed from the artistic climate surrounding him, must be tempered by an acknowledgment of his rich social life and many artistic connections. I would argue that his close friendships with the women who sat for him played a significant role in the development and scope of his oeuvre.

Whistler's relationship to his sitters is both intriguing and revealing if one closely examines the social contexts from which the majority of them emerged. Bendix has noted that most respectable patrons were repelled by Whistler's notoriety and that only a daring few came to sit for him after 1880.[50] No doubt some of this had to do with his peripheral and occasionally questionable position in society. Significantly, this would have made him particularly aware of the fluid nature of Victorian economic and social wealth, particularly among the middle classes. Many of his sitters were at transitional points in their lives, exploring the edges of artistic culture, or were the newly wealthy, anxious to attain social prestige through art. Aware that many social circles were closed to them, particularly those associated with the Royal Academy or with more traditional artistic and cultural settings, many of Whistler's sitters were anxious to establish social worth on their own terms and might have even been attracted to his notoriety and emphasis on originality. Branka Nakanishi has argued that Whistler's clients did not mind that Whistler was concerned with fashion and appearance, since they were aware that social prestige, achieved through the visual display of wealth and taste, could be aptly portrayed in fashionable portraiture.[51]

Frances Leyland's position as patron, sitter, and friend places her in a unique position with respect to Whistler's artistic process. As the wife of Whistler's most powerful and significant patron at the time, Leyland was in a position of social importance. She is one of the few sitters who claimed to enjoy the process of posing for him. They became friends through many sittings, and there is clear evidence that they were close. Extant letters exchanged between them record the

affection they felt for each other and the friendly accord they shared with regard to artistic issues. In a letter to Leyland written sometime between 1868 and 1871, Whistler recorded his attempt to acquire some rare, artistic amber beads for her. He apparently sent them to her and enclosed a letter characterizing the beads as "the very best amber to be had at any price — beautiful in color and very pure." Later in the letter, he refers to similar beads worn by one of the Spartali sisters, both well-known for their beauty and artistic sensibility: "It was quite a mistake of mine about the beads of Miss Spartali's being all equal in size — Lucas says they never are — and the effect would be clumsy and wrong on the neck."[52] Both Whistler and Leyland were interested in fashion and artistic dress as a pursuit, which might reflect their respective Aesthetic sensibilities, his as artist, and hers as discerning patron.

An analysis of possible motivations for Whistler's portrayal of her in the gown that he designed reveals the importance of fashion in his work. Evidently, Frances Leyland initially requested that Whistler paint her in black velvet. In an interview with Joseph and Elizabeth Pennell, Whistler's official biographers, she stated that she had tried to persuade Whistler to let her wear a black velvet dress similar to one worn by another patron. Whistler did make several drawings in 1872–73 of Mrs. Leyland wearing a black velvet dress, studies that he may have carried out to satisfy her wish.[53] Yet, when the final portrait was sketched, she was wearing the tea gown he had designed for her. Nakanishi has argued that Whistler shared in a long tradition of portraiture in which details of costume and the elaborate display of wealth superseded concerns for expressing the personality of the sitters. Certainly, the use of a pose from the back, displaying the expanse of the gown and the richness of the material, would support this conclusion.[54]

Other considerations point to a different reading of Whistler's portrait of Mrs. Leyland. Given their close relationship and the affectionate friendship between them, it is probable that Leyland's donning of her aesthetic tea gown was not an example of Whistler asserting his will over hers, but the result of an ongoing dialogue between them. In all likelihood, she came to appreciate his creative view of how she might be portrayed. Furthermore, she herself may have had some hand in deciding certain details of the dress and even the way she might be depicted. The Pennells, in speaking of the portrait, stated that the pose he chose to picture her in was one that was "natural to her, one she took unconsciously when she stood talking."[55] Clearly, if this was the case, the portrait of Frances Leyland, while exploring Whistler's views of Aestheticism, also represents aspects of Frances Leyland's personality. Nakanishi acknowledges that the portrait took into account and even aptly expressed many aspects of Frances Leyland's character. Susan Galassi seems

more divided on the issue. Pointing out the rather somber, "majestic," and "remote" nature of the portrait, she questions why Whistler chose to depict Leyland in this way when she was "by all accounts, lively and accessible."[56] It is possible, of course, that Whistler considered her a rather intimate friend, and perhaps saw her in a different light outside her usual social role as hostess and wife to the powerful Frederick Leyland.

COLONIAL SUBJECTS AND AESTHETIC OBJECTS

Whistler's portrayal of many of his sitters in garments inspired by Eastern or Oriental themes is particularly revealing in an analysis of the role and function of women within Aestheticism — not just in terms of how they were represented, but how, in fact, they chose to represent themselves. Further, the valorization of Eastern cultures through the gendered gaze of women involved with the Aesthetic movement points to a certain ambivalence within the visual culture of British imperialism. Reina Lewis has argued that women's artistic production in the late nineteenth century complicates traditional postcolonial critiques of orientalism. Through an understanding of difference and a "gendered access to the position-alities of imperial discourse," women are in a unique position to view a colonial "other" "less pejoratively and less absolutely than was implied by Said's original formulation."[57] In the realm of fashion, other cultures served not only as a differ-ential foil against which the fast-changing and innovative styles of modern culture might be compared, but simultaneously they provided inspiration, intrigue, and visual relief from the monotony and ubiquity of mainstream modes. Inasmuch as the clothing associated with Eastern cultures might be pejoratively viewed by the imperial project as traditional, antiquated, and even backward, such styles were also looked upon with fascination and a certain level of recognition by artistic women in Victorian Britain.

Whistler's *Purple and Rose: The Lange Leizen of the Six Marks*, painted in 1864, shows Joanna Hiffernan surrounded by Asian decorative art objects (figure 2.10). It displays the blending of Eastern and Western elements typical of many of Whistler's other works, but serves another function as well. The social elements of Whistler's work cannot be overlooked and need to be emphasized. Although he professed to care little for the role of art in life, he was not averse to using life in the service of art. Many of his works feature his models, mistresses, and later, his wife Beatrice, and should be viewed in this light. All of them speak volumes about a view of the female figure in the Aesthetic movement as, first and foremost, an ornamental element in an overall scheme. Pictured among Whistler's collection of

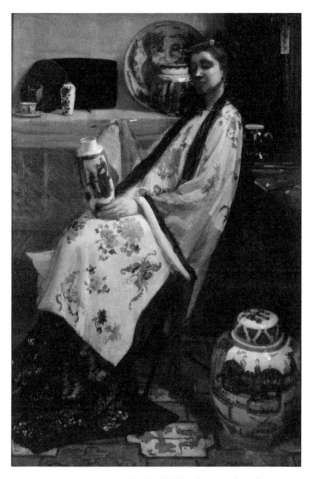

FIGURE 2.10 James McNeill Whistler, *Purple and Rose:*
The Lange Leizen of the Six Marks, 1864. Oil on canvas, 93.3 x 61.3 cm.
Philadelphia Museum of Art, John G. Johnson Collection, 1917.

rare blue and white china, and wearing a luxurious rendition of Eastern clothing, Hiffernan is a collected object as much as anything else on display in this work. However, as valid as this reading of his work may be, it tells only part of the story. The level of comfort shown by her demeanor suggests the possibility that this painting also illustrates Hiffernan's daily involvement in Whistler's collecting and painting practices as more than simply model and muse; his repeated use of her figure and face throughout the 1860s is as much an indication of their intimacy and shared attitudes toward Aestheticism as it is a documentation of an artist's depiction of a lover and live-in model.

Frances Leyland's tea gown was a significant indicator of the complex role of orientalism in Aesthetic dress — particularly in the ways that women interacted with Aesthetic works of art as both sitters and viewers. The sartorial category of the tea gown was deeply influenced by conflicted and at times contradictory themes, and this is evident when one closely examines contemporary forms of fashion communication — fashion plates, journalistic writing and reportage, and portraits of women wearing artistic forms of dress heavily influenced by colonial narratives. Accessing the views, experiences, and subjective responses of the wearers and consumers of Aesthetic dress provides a challenge. While multiple records of the perspectives of artists, writers, and critics exist, few accounts remain (or were likely undertaken) to translate and express the views of Aesthetic dressers themselves. A more complex question has to do with the agency of Frances Leyland as a female sitter within aesthetic culture; as both subject of the painting and agent of its creation, she is in a unique position, and, like many women pictured by male artists in the Aesthetic movement, her role in Aestheticism has been historically marginalized. Yet socially, and ideologically, she played a crucial role in the dissemination of artistic principles.

The notion of self-fashioning was central in the artistic culture of Aestheticism. Given that orientalism was rampant in the visual culture of Victorian Britain, it played a crucial role in terms of the construction of gender and the possibilities, pleasures, and perils of the "female aesthete." Through the lens of orientalism and a postcolonial examination of the exoticism of tea gowns, one discovers that tea gowns in particular, and fashion more generally, complicate and magnify some of the debates surrounding gender, space, and identity in late nineteenth-century Britain. On the one hand, the feminine serves as "other" in a standardization of male norms, preferences, and professions in Victorian Britain. Embodying exotic roles of hostess, mistress, or model, particularly in domestic or privatized spaces associated with the feminine, women engaging in Aesthetic forms of dress reify concurrent notions of the "other" in the nineteenth century. A visual foil for masculinity as well as a foil for the body fashioned on Western standards of decorum, constraint, and modern fashionability, a British woman in "Eastern" or exotic dress symbolizes an overdetermined nexus of colonial and gendered discourses, which serve to position women in restrictive ways, both socially and ideologically.

However, a British woman at this time, particularly one in a privileged position with regard to social class, is definitively not a colonial subject, but is simultaneously an agent of imperialism, both in terms of race and class. It can also be said that women who engaged in the practice of Aesthetic dressing were promoting social change, and were thus empowered in a creative and embodied way; here,

intellectual freedom and play are central, and are enabled through the creative act of Aesthetic dressing. Though differentially constructed within colonial and artistic discourses, both of these positions — imperial agent and artistic subject — are ones of agency, although Aesthetic dress presents a less oppressive outlet for the enactment of social power. Playing with the codes of both fashion and culture, vacillating between masquerade and the sincere attempt to express inner identity, such women, it can be argued, actively negotiated the complex terrain of social roles available to them, and in this very act distanced themselves from some of the more hegemonic aspects of Victorian culture. Ultimately, my argument rests on the assumption that an increased level of choice and intellectual mastery represents empowerment and social agency.

WHISTLER'S INFLUENCE ON
FASHION IN ARTISTIC CIRCLES

The impact of Whistler's work and life on fashion in artistic circles has not been fully articulated, although it has been recently explored by several scholars. For Aileen Ribeiro, art and fashion were progressively linked as cultures of consumption during Whistler's artistic career. She points out that the rise of haute couture and the distribution of more accessible forms of fashion to a wider social audience were connected with an interest in portraiture among female patrons — not only in terms of commissioning portraits but for the importance of going to view them in exhibitions as a pleasurable pastime.[58] Whistler's relevance for Aesthetic dressers lies in the indiscernible relationship between painters of Aesthetic dress and those who wore artistic clothing as a material enactment of an Aestheticized lifestyle. Further, Whistler's emphasis on self-display and his own dandy persona form a second parallel between his aims of crafting himself as the requisite modern artist-dandy and those wearers of Aesthetic dress who used self-crafting as means of creating themselves as artistic subjects. Though objectified, in the attention to detail and self-directed choices in sartorial arrangements along Aesthetic principles, these women were artistic subjects as well. In their view, Whistler's portraits and figure studies might not serve so much as artistic suggestions from which to model their own attire as artistic imagery, which, in the final analysis, merely reflected a process that was already at work and actualized in the act of wearing Aesthetic dress. Progressive women involved in artistic circles would have seen themselves as having direct access to the practices and tenets of the Aesthetic movement. Although the use of portraiture to solidify or visually record this process might have been available only for the well-connected or wealthier members

of Aesthetic circles, it provided all Aesthetic dressers with a visual reminder of the Aesthetic context they themselves helped to construct through the use of Aesthetic dressing.

There can be no doubt of the effect that Whistler had on Aesthetic dress, an influence that spread to a wider fashion audience over the decades following the opening of the Grosvenor. In the January 7, 1888, edition of the *Queen*, under the heading "Dress at the Private View at the Grosvenor Gallery," the fashion writer reported that a "tall lady wore a harmony of browny browns and greens, rich in effect, and somewhat Whistlerian."[59] It is clear from such remarks that, despite Whistler's art-for-art's-sake stance and snobbery with regard to what he felt was a surplus in the art world of amateurs, poseurs, and artistic dilettantes, his work made its way into the daily lives of many producers and consumers of art in the late nineteenth century, having a greater social impact than even he might have surmised. At a time when women were increasingly moving out into the public sphere of professional art production, and indeed the public consumption of art as well, Whistler's work provided a growing female audience with modern images of fashionable women worthy of a level of artistic attention that transcended the conventional notions of Victorian portraiture.

Whistler was also to have a broader impact on the art communities of late Victorian Britain. His innovative interiors and the alternative ways he pictured women of indeterminate background or social standing in sumptuous and contemporary scenes connoting luxury, enjoyment, and fashion challenged many Victorian mores that had been steadily losing their hold over art audiences and a wider art-going public for some time. His work destabilized notions of artistic convention, as well as gender and class boundaries. Andrew Stephenson, in his article "Refashioning Modern Masculinity: Whistler, Aestheticism and National Identity," argues that "the dangers of Whistler's seductive ambience, like that of Aestheticism's radicalism, lay in its failure to distinguish between English 'private' and 'public' spatial protocols and in its promotion of new forms of spectatorship that sanctioned altered modes of viewing in public for a growing number of fashionable female spectators and modern young men."[60] It could be argued that for Whistler, Aestheticism itself became a useful tool. The synthetic blending of Eastern influences, orientalism, and historicism, and his intense desire to express the novel, the original, and the artistically significant, created for Whistler an abstract, aestheticized space of reflection, which referenced the modern world while at the same time allowing him to be removed. These contrasting tendencies in his work positioned him as a Baudelairean artist-dandy with a unique perspective on modernity, particularly within a British setting during the years

between 1860 and 1880, when antimodernist themes were already well-established in Pre-Raphaelite circles.

While Aestheticism privileged individual responses to art and indulged in the pleasures of viewing, so too did Whistler seem to value subjective and contingent responses to the visual. Aesthetic dress was an important facet of this experience — individual, eclectic, and ultimately subjective, it signified a level of sartorial distinction over and above the uniformity of mainstream fashion. Further, as an embodied social practice, Aesthetic dress may have stood for far more than social or artistic distinction, but may in fact have alluded to a shift from what was seen as visually pleasing to a more visceral form of sartorial pleasure. Progressively within Aestheticism, there was an emphasis on the reception and consumption of the beautiful, which expanded the interest in Aestheticism beyond pictorial forms to lived experience and social formations. The role of artistic spaces and the embodiment of artistic principles through clothing would therefore become increasingly central in the emerging discourses of Aesthetic dress.

The Grosvenor Gallery

Context and Climate for Artistic Dressing

During the 1870s and 1880s, the Grosvenor Gallery functioned as more than a central site for the exhibition and sale of Aesthetic works of art: it provided a significant spatial realm for the enactment of Aesthetic ideals through the practice of sartorial display and experimentation. Aesthetic dress played an important role in the cultivation and maintenance of a rarefied space devoted to the Aesthetic contemplation of art. Worn by female artists, patrons, and visitors, and represented in many of the works exhibited, Aesthetic dress was a performative aspect of Aestheticism that coexisted in this space as both the subject and object of Aesthetic contemplation and social practice, and thus mirrored the constructive role of femininity itself in this setting.

Clothing is a form of cultural production that implicates questions of the body; its various expressions and manifestations can be situated spatially, as capable of articulating social values and preferences in specific cultural settings. Pierre Bourdieu has noted that the value of a work of art is dependent on the support and admiration of audiences, critics, and dealers who aid in the creation of that work of art as a culturally consecrated object. The traditional charismatic ideology that locates the value of a work of art in the creative genius of the artist draws attention away from the supporting activities of other cultural producers in the field. What thus remains unacknowledged are the cultural values that authorize validating narratives with respect to works of art, many of which are shaped and disseminated by art audiences, professionals, and patrons.[1]

Since clothing is one of the most visible forms of cultural consumption and display, it plays a significant role in the formation and construction of identity. Christopher Breward and Elizabeth Wilson have both explored the importance of self-fashioning as a mode of cultural consecration in the process of modernity; here, the competing needs of different groups and social classes produced rapid

transformations in visual culture, promoting the use of fashion as a means of social empowerment.[2] Furthermore, many fashion historians, such as Diana Crane and Joanne Entwistle, have argued that since clothing and fashion allude to gender and social status, they are particularly useful for subverting symbolic boundaries or questioning existing social norms.[3] This facet of clothing culture makes it especially useful for understanding the ways in which individuals or groups position themselves ideologically with respect to the visual culture that surrounds them.

Women in Aesthetic circles were inundated by artistic representations of the female body — in private patrons' homes, or in gallery and exhibition spaces — and were thus implicated in a range of literary, mythic, and idyllic themes. As a consequence, the centrality of the female body as a signifying system within Aestheticism created an environment conducive to a heightened awareness of the body as a physical presence in space. Through association or even identification, female aesthetes were aware of themselves as objects of artistic contemplation and display. However, this understanding could not have completely obscured their experience of themselves as embodied subjects. Nor could it have negated the agency they possessed with regard to the importance of the feminine in domestic Aesthetic settings. This seemingly contradictory position was constructively addressed in Aesthetic dressing, as the wearer both enacted herself as a creative work, and presented herself as an image of Aesthetic idealism. In turn, this provided a synthesis of the subject/object split that characterized the position of female viewers in relation to academic art throughout the nineteenth century. However, this assertion is tenable only if one considers the act of Aesthetic dressing as a form of artistic production. Framing Aesthetic dress in this way offers a plausible critique of the ways in which design history and culture have marginalized and trivialized the making and wearing of clothing, and more generally, fashion as a valid art form.

Aesthetic dressing at the Grosvenor Gallery provided an opportunity for women to consolidate and reconcile opposing formations of femininity within Aestheticism by allowing them to simultaneously occupy subject positions as both agents of Aesthetic sensibility and objects of Aesthetic contemplation. Self-reflexive and self-defining, women who wore Aesthetic dress were involved in the activities and events held at the Grosvenor each social season; many of these women were artists or writers in their own right, a fact that has been largely ignored or overlooked in the histories of Aestheticism.[4] Acknowledging the productivity of their artistic lives contradicts a general understanding of female Aesthetic audiences as passive consumers and followers of the art produced by leading male artists such as Edward Burne-Jones, G. F. Watts, John Everett Millais, and Lawrence Alma-Tadema. This assumed relationship between active artists and passive patrons and viewers of art

in the Aesthetic movement can be both challenged and refuted through an analysis of the mediating function of Aesthetic dress in the exhibition spaces and practices of the Grosvenor Gallery. An interdependent relationship existed between the active effort on the part of many Grosvenor attendees to embody Aestheticism through their choice of clothing and personal appearance, and works exhibited at the Grosvenor — in particular, portraits of artistic women wearing Aesthetic dress.

A SPACE FOR THE THOUGHTFUL
CONTEMPLATION OF ART

The rich cultural life of the Grosvenor not only provided a suitable backdrop for the practice of Aesthetic dressing; it likely solidified the important mediating function of Aesthetic dress for women in British Aestheticism. The status of the Grosvenor Gallery as an arena of refined Aesthetic principles was dependent on a system of social and cultural exchange between groups and individuals who together created and supported an environment conducive to the art production of the Aesthetic movement. Aesthetic dress, as an embodied and interactive per-formative strategy, played a crucial role in this process. The connection between the Grosvenor Gallery as an exemplary setting for the Aesthetic movement and the elite social groups that converged there is well documented. Colleen Denney has argued that the kind of artistic consumption that took place at the Grosvenor was perceived by contemporary writers as a form of artistic devotion approach-ing religion. She points to an early 1877 article by the critic Heathcote Statham in which Grosvenor audiences and patrons are typified as a "special cultus of a small group of worshippers" who "offer up a blind admiration, each to their own special high priest."[5] Aesthetic dress should be viewed as an authorizing facet of this artistic culture, affirming the values of the Aesthetic movement and finding expression in the artistic spaces of the Grosvenor Gallery.

As part of a system of cultural consecration, the wearing of Aesthetic dress was expressive of symbolic capital, signifying key artistic associations for a select group of art viewers, patrons, and artists. Thus, the phenomenon of Aesthetic audiences participating in a highly codified arena of cultural exchange, reaffirming and per-petuating artistic values and standards, invites closer examination. Consumption becomes more than an absorptive process where art is exhibited to a particular audience — rather, it reveals itself as a complex reflexive strategy whereby audience members (in this case, many of whom were wearers of Aesthetic dress) actively participated in promoting types of art that both inflected and reflected their self-

perceptions. Geoffrey Squire has argued that at the heart of Aestheticism lay an emphasis on the thoughtful, passive contemplation of art, not only on the part of the viewer but also on the part of the artists themselves. Emphasizing the heterogeneous nature of the various subject positions within Aestheticism, he notes that a large percentage of those who participated were considered amateurs, if they practiced art at all, and were likewise perceived as "consumers of art rather than creators of art."[6] Citing Walter Hamilton's definition of the Aesthetic movement in 1882 as a "union of persons of cultivated taste" whose sole purpose was to "define and decide upon what is to be admired," Squire successfully illustrates the central role of individualism in this process.[7] In line with Oscar Wilde's assertion that the mission of the Aesthetic movement was to lead people to contemplate rather than create art, this turning inward, with its attendant focus on the temperament and emotional experience of the viewer of art, placed value on individual perception over a view of art based on consensus and conformity. More importantly, it throws new light on the experiences and perspectives of those who viewed and contemplated Aesthetic works of art, regardless of their status as artists themselves. For this reason, the simple dichotomy of active "creators" and passive "consumers" of art is inadequate in an explanation of the relationship between Aesthetic paintings and illustrations and Aesthetic dressing as a practice.

A belief in the relevance of art to individual lives was among the more important, and widely shared, aspects of the movement. While those acquainted with the inner workings of the Grosvenor may have perceived themselves as occupying a place at the center, the wider swirls and eddies that moved in and through the Grosvenor exhibitions, and indeed the space of the Grosvenor itself, were also crucial to the maintenance of the Aesthetic world it supported.[8] This more complex view of Aestheticism as both an active and passive process of visual contemplation and cultural production contributes to an understanding of Aesthetic dress as more than a mimetic attempt to copy or emulate the forms of dress represented in Aesthetic paintings. For women who wore Aesthetic forms of clothing, individualism, artistic contemplation, and the opportunity to actively embody artistic principles through dress in an Aesthetic setting, such as the Grosvenor, were all intertwined, illustrating the committed involvement of these women on a number of levels. While observing and reflecting upon the Aesthetic codes and visual cues communicated through the representation of artistic clothing in this setting, these women were actively producing Aesthetic culture even while they were absorbing it.

The symbolic function of Aesthetic dress at the Grosvenor points to several complex issues. Joanne Entwistle has pointed out the performative qualities of fashion and its ability to encode significant aspects of one's identity. However, she

also notes that this process is not without limits. Fashion, particularly in terms of modern culture, expresses a tension between artifice and authenticity, an awareness of the self as constructed while at the same time invoking a belief in oneself as a natural and holistic being. Further, the performance of one's identity through fashion reveals a contradictory impulse to distinguish oneself from others while at the same time claiming shared values with an identifiable group or class of similarly positioned individuals in society.[9] In the case of Aestheticism, women who wore Aesthetic dress wished to appear distinctive and individual, but also desired identification and membership in a broader Aesthetic culture. These tensions, between artifice and authenticity, individuality and community, as well as the often unacknowledged role of women in the art production of the Aesthetic movement, all found expression in the cultural life of the Grosvenor Gallery.

The rise and fall of the Grosvenor Gallery, from its creation in 1877 by Sir Coutts Lindsay to the time when his associates Charles Hallé and Joseph Comyns Carr abandoned it to start the New Gallery in 1888, have been well documented in several key texts by Christopher Newall, Susan Casteras, and Colleen Denney.[10] A survey of the journal literature and critical writing on the gallery following its opening reveals the close association between the high-profile image of the gallery and the popularization of the Aesthetic movement. From articles detailing the interior design and layout of the gallery to society reports detailing the latest gowns spotted at the various private views and who wore them, the Grosvenor appears in contemporary texts as a cornerstone of Aesthetic culture. This evidence of public interest in the literature suggests that in the minds of many nineteenth-century readers, the social structures, aristocratic circles that patronized the gallery, and the physical context and spatial atmosphere of the institution were as important as the works of art located there.

The role of Sir Coutts Lindsay and his wife, Lady Lindsay (née Caroline Blanche Elizabeth FitzRoy), in cultivating this sophisticated image of the Grosvenor was central. In many ways, the Lindsays, their social circle, and their artistic preferences were at the center of the atmosphere and mandate of the gallery. Many perceived the gallery to be the preferred alternative to the more conservative atmosphere of the Royal Academy. One critic noted that the Grosvenor had "many of those elements of interest which are so conspicuous by their absence at the Royal Academy. It is varied; it contains a fair proportion of really excellent work; it is unconventional; and last, and most important of all, it is not too large."[11] Unlike larger institutions with more entrenched traditions and broader collecting mandates, the Grosvenor was a timely and hermetic expression of Aestheticism's rising popularity in artistic circles. The private and closed realm of the patrons and directors of the

gallery, in combination with the careful and considered selection of works of art that appeared there, enhanced its cult status.

The Grosvenor Gallery's carefully crafted Aesthetic spaces were central to the social and artistic networks that were created and cultivated there. Reports on the interior of the Grosvenor and the way in which it was laid out were as numerous as the critical reviews of the works being exhibited. The antique furniture, luxurious oriental rugs, statues, and fresh exotic flowers helped to create a space of opulence that far surpassed anything the Royal Academy or even Burlington House could have offered.[12] Not long after the opening of the Grosvenor, a critic wrote,

> Artists and amateurs have at last obtained through the munificence of Sir Coutts Lindsay a picture-gallery after their own heart. The rooms in Bond-street are furnished with Persian rugs, gilt console tables, rococo chairs, and fine old china just as luxuriously as if they were part of a fashionable west-end mansion. . . . The principle on which the pictures are hung, that of giving each of them plenty of space and grouping those by the same painter together, is one which has met with universal approval.[13]

The carefully considered and sparse hanging of the pictures was closely related to the interior layout, overall setting, and atmosphere of the gallery. Thus, the Aestheticism of the space expressed itself through a vision of how art might best be contemplated — the viewer's experience was therefore central.

The luxurious and decorative interior of the Grosvenor should be seen as part of a larger Aesthetic project, namely, the reification of art and beauty in three-dimensional space. The Grosvenor was more than a place to view art — it strove to be worthy itself of being represented in art. The hedonistic setting was intended to be inclusive, one's movement through the works of art a route through which to enter the world of delight, fantasy, beauty, and heightened Aesthetic emotions depicted in the paintings themselves. Thus the Grosvenor, rather than representing life by showing the art of the period, sought to bring art into life. Beyond being a showcase for the paintings exhibited, the Grosvenor's setting was meant to be an extension of the Aesthetic realms portrayed in the art objects themselves. The idea that art must be examined from a disinterested standpoint, where the setting is immaterial, was observed at the Royal Academy. Critics and patrons were required to ignore the clutter and look into the works of art. Their ability to filter out the extraneous and irrelevant details of daily life was crucial to their functioning as art critics and connoisseurs; it was felt that nothing should interfere with the disinterested contemplation of art, least of all the bodily state or environment of the viewer. Conversely, at the Grosvenor, the setting was to be enjoyed as part of the total experience of artful contemplation.

The Grosvenor set itself apart in several ways, not only through the inclusion of artists exclusive to the gallery, but also in terms of the range of quality and caliber of exhibiting artists. Many critics objected to the inclusion of "amateur" works as well as contributions by the Lindsays and their personal acquaintances.[14] However, despite the fact that some critics perceived the quality of the art shown at the Grosvenor to be uneven and prone to a certain level of nepotism, there was a general consensus about the excellence of other artists who regularly exhibited there. The inclusion of amateur works at the Grosvenor is a complex issue that can be partially explained by the goals of Aestheticism, which above all else outlined a movement for the enjoyment of art, and the expression of that experience. In many cases, the role of "greater" artists in the inspiration of, and emulation by, admiring "amateurs" was encouraged within the movement. All of these facets of the creative process would have been viewed as a valid way to participate in the world of Aestheticism. This was an attitude and orientation that proved more inclusive for members of the Victorian art world who might have been snubbed elsewhere — amateur artists, independent artists following nonacademic styles or methods, and of course, women. Thus, the Grosvenor, despite its rarefied and often exclusive atmosphere, was also a productive and empowering space for many women artists. Despite this, much of this work was categorized and subsequently marginalized through the gendered use of the term "amateur." Given the lack of professional support and rigorous art education available to women for most of the nineteenth century, this critical dismissal of women's art production at the Grosvenor is lamentable, but hardly surprising. This is particularly true given the increased visibility of female artists' patrons, and attendees at the Grosvenor Gallery each season — a development that would have been unsettling or even threatening to conservative factions within the art world.

Critiques of the wider movement toward Aestheticized lifestyles and the accompanying interiors and wardrobes came from both outside and inside artistic circles. Much of this writing exemplified a view of art that was high-minded, serious, and above all derisive of the notion that amateur and professional artists belonged in the same group. In critical writing such as this, a deep discomfort, and a growing ambivalence toward Aestheticism, were in evidence; having little to do with the defense of art itself, it was aimed instead at preserving artistic boundaries between what were perceived as high and low art forms. Aestheticism, in its dramatic appeal to a wider audience and its adoption of alternate forms of artistic expression, including interior design and fashion, proved problematic for traditionalists. This was particularly true in light of the increasing role of women in design reform and the decorative arts in the closing years of the nineteenth century.

While it is true that many of the women artists who exhibited at the Grosvenor tended to do so in a separate room reserved for watercolors, the fact that they were included at all is worth noting. A progressive and distinguishing factor of the Grosvenor was its egalitarian approach to the display and promotion of women's art production. Lady Lindsay, aside from exhibiting works of her own, actively promoted other women artists and ensured inclusion of their works at the Grosvenor. Colleen Denney and Paula Gillett have shown that the Grosvenor became a prestigious and highly visible location for women artists wishing to exhibit. On average, the Grosvenor included a far higher proportion of women artists in its shows than most other major exhibiting societies and venues in London at the time.[15] These artists included Louisa Stuart, Lady Waterford, and Princess Louise, as well as better-known professional artists such as Louise Jopling. Two notable artists associated with Aesthetic dress were Marie Spartali Stillman and Evelyn Pickering De Morgan, both of whom exhibited regularly at the Grosvenor and, in the case of De Morgan, going against convention, exhibiting oils. Both were also associated with the Pre-Raphaelite circle of painters, providing another link in both theory and practice between female artists associated with Pre-Raphaelite circles and later proponents of artistic dress in Aesthetic circles.

The social status of many of the artists, viewers, and patrons of the Grosvenor added to its air of exclusivity. Even before its opening, the Lindsays had connections with well-known "Aesthetic" families associated with artists who would later exhibit at the Grosvenor. Among these, Mr. and Mrs. Thoby Prinsep of Little Holland House, along with the Sartoris circle, were important figures in the London social seasons throughout the 1870s. Individuals connected with the Pre-Raphaelites regularly congregated at the Prinseps', and George Frederic Watts lived with them until 1875.[16] In fact, it was among these artistic circles that, in 1865, Lindsay met his future wife, Blanche, who was the daughter of Hannah Mayer Rothschild FitzRoy and Henry FitzRoy. Multitalented — she played the violin and painted — she was popular with the artistic crowd following her debut into London society. Her role in organizing and publicizing Grosvenor social functions should not be underestimated, and through her family and friends, she provided important links with royal and aristocratic patrons, which helped raise the profile of the gallery.[17]

ARTFUL DRESS FOR ARTFUL SPACES

Another crucial aspect of the Aesthetic space at the Grosvenor was its reference to refined domestic space. In her memoirs, Louise Jopling remarked that the main

room "looked like one of those one sees in Italian palaces. The walls were hung with old red damask, and the ceiling was a blue firmament, powdered over with stars, copied from the studio in Sir Coutts's own house at No. 5 Cromwell place, now the residence of that distinguished artist, Sir John Lavery."[18] The reflection in the Grosvenor of the Lindsays' own domestic interior signals the very personal influence of the organizers on the gallery. For them, it was an artistic home away from home, a comfortable space that was ultimately an extension of their Aesthetic personalities.

In the art literature of the 1870s and '80s, a great interest in the domestic spaces of artists led to several publications, books and articles, describing these spaces for the public's enjoyment and reverie. In a special issue of the *Magazine of Art* in 1882, an article featured the many Aesthetic qualities of Alma-Tadema's domestic interior, citing the harmony created despite a certain eclectic approach to collecting pieces and elements from disparate historical and geographical sources:

> Old times and new, the East and the West, have been made to contribute some line of form, some subtlety of colour to a cluster of rooms which is as brilliant and attractive as a bunch of flowers. Nevertheless these several components are all correct in themselves. What is Roman is pure Roman — not that adaptation after the "Empire" taste which so often does duty for the true thing; and what is Japanese is pure Japanese, and no half-occidentalised corruption.[19]

What is remarkable about this quotation is the explicit emphasis on purism. While the collected elements are allowed to come from distinct sources, to contribute to a unified and comprehensive whole, the individual components must be pure, authentic, and original in their makeup. One of the ambiguous aspects of the Aesthetic movement was its emphasis on a rarefied brand of authentic eclecticism. While criticizing other aspects of Victorian historicism and "sham" interest in other cultures, many Aesthetic individuals reserved the realm of proper cultural and historical appropriation as their sole and deserved right. This is also true of Aesthetic dressers. As previously discussed in earlier chapters, the essence of what made a particular mode beautiful in the past was expected to hold true for its use in the nineteenth century. Aesthetic dressers did not merely view themselves as copying past models of clothing; they viewed their clothing as a genuine expression of the principles underlying the fashions of the past, albeit reinvented to suit nineteenth-century life.

Eliza Haweis, aside from writing on the arts of dress and beauty, wrote at length about artistic domestic space. In her 1882 text *Beautiful Houses: Being a Description of Certain Well-Known Artistic Houses*, she linked originality with the kind of authentic eclecticism mentioned above:

No house, no book, no picture, no piece of music is interesting or instructive which is the servile copy of something else. Only the individual character which makes itself felt in it, is of value. . . . Originality is neither rare nor hard to obtain, fearful as are many people to lay claim to it. Originality is like a house built of bricks taken from many places — it is the new disposal of the old bricks which makes the house an original one.[20]

The search for originality that was based on historicism, rather than new forms, is a paradox that marked many facets of the Aesthetic movement — not just the artwork produced, but the overall approach to life it inspired as well. This sort of originality was ultimately seen to inflect not only the objects associated with artistic individuals, but their very personalities. Elected by the faithful, Aesthetic artists were somehow perceived as having better innate taste than the majority of art practitioners (and, of course, Victorians in general). The critic reviewing Alma-Tadema's house in the *Magazine of Art* thus noted, "The artist lives his whole life under his own roof, and every room bears witness to his presence. Every nook and corner is inhabited, and possesses in consequence that human interest which is wanting in half the fine houses of the day."[21]

Haweis linked dress with all other aspects of the "artistic" way of life. In the preface to her book on historic artists' houses, she asserted that dress and decorations were being studied with renewed "scientific ardour" due to a rebirth of English culture.[22] Like dress and clothing, Haweis asserted, originality was in the reach of all artistically minded people, provided they looked to the inspired work of others:

Seeing the work that has been done by others often rouses the power in us to work in a similar spirit, though not necessarily on the same lines. . . . This I endeavoured to show in my book the Art of Decoration, is the only way to awaken originality, and give courage to have, and to hold, opinions of one's own — no other opinions being any addition to the world's stock-in-trade.[23]

Haweis's assessment of Alma-Tadema's house was that it was "essentially individual, essentially an Alma-Tadema house; in fact, a Tadema picture that one is able to walk through."[24] The presence of artistic women in domestic Aesthetic space is aptly illustrated by the way in which Mrs. Alma-Tadema's image recurred in the home of the Tademas. In the article on their house in the *Magazine of Art* in 1882, the author reported that "a bust or portrait of Mrs. Alma-Tadema may be found in nearly every room," including an "important portrait — exhibited at the Grosvenor Gallery a few seasons ago — from Mr. Alma-Tadema's own brush."[25] The integration of domestic space and artistic excellence points to an emphasis on lifestyle for proponents of the Aesthetic movement. For many, their interest in art was far more than a hobby or passion: it was a way of life. This is the image they

wished to promote, both in their own immediate social circles and in the public display of these artistic values.

The subsequent conflation of Aesthetic dress with the stylistic and visual preferences for Aesthetic interiors is not surprising. In a speech on dress given in 1885, Oscar Wilde emphasized the interdependent principles for both dress and interior design; as one critic summarized the talk,

> Mr. Wilde . . . compared the decoration of the person to that of a room, for he put forward the statement that there was but one universal law which applied to all things; thus: — A deeply marked horizontal band diminished the height of a room, so it did of the figure. Vertical lines gave increased height (not by means of pattern, but by folds) the same effect in a room being produced by the use of pillars. The waistline which has varied so much, Mr. Wilde remarked should be fixed high, as in the dresses of the Empress Josephine period, and short skirts be avoided as excessively ugly.[26]

Although the relationship between principles of interior design and fashion might not have been so rigorously followed by some, the evidence that space was a consideration in the ways that dress might be perceived was certainly there. Henry Holiday, commenting on styles of furniture and interior designs utilized in many of the artistic homes in and around Hampstead, argued that even before the popular Queen Anne revival, modes of dress were in accord with artistic interiors. Referring to the tendency for those in his artistic circle to wear Aesthetic dress, he lauded the pleasing effect of this practice on the perception of the interior: "Some of us, who felt the incongruity of the present-day costume with these surroundings, agreed to give ourselves the pleasure of dressing in the proper costume, not by way of holding 'fancy dress' evenings, but simply to gratify an artistic sense, and very charming the effect was, I can assure you. There was no sense of masquerading about it, simply a fitness between the rooms and their occupants."[27]

This interest in artistic dressing for artistic interiors made its way into the journal literature of the period, where a preoccupation with dressing suitably for any and all art-related events or interiors was evident, particularly from the late 1870s to the mid-1880s. Though not referring specifically to Aesthetic dress, the *Artist and Journal of Home Culture* was clearly interested in the interplay between space and appropriate dressing:

> The true appreciation of art in the home is particularly shown in dressing suitably. . . . Those who know and practise the art of suitable dressing at home will do the same when away from it, and one can almost tell at a glance which of the many visitors one meets are certain or otherwise, by the fitness or unfitness of their attire, to look always suitable to the occasions of life.[28]

The obvious moral overtones to such an outlook are particularly intriguing when one considers the diversity of opinion on Aesthetic dress. For some, it was the ultimate in tasteful dressing. For others more rigorously puritanical in outlook, Aesthetic dress was completely inappropriate given its loose, unstructured, and essentially experimental nature. Valerie Steele has noted that aspects of Aesthetic dress inspired by classical as well as neoclassical styles were widely perceived as scanty, loose-fitting, and indecent. In addition, those wearing classically inspired forms of Aesthetic dress were mocked as dressing up like muses or goddesses.[29] This viewpoint was often displayed by those discussing fashion at the Grosvenor, where artistic gowns were seen as a simple attempt to copy the goddesses, nymphs, and other historical or mythological characters depicted in the paintings. The resemblance between the pictorial imagery of Aesthetically clad women and the sartorial habits of Grosvenor patrons was a source of humor, more than anything else, for these critics.

Yet interest in the appearance and demeanor of Aesthetic dressers was apparent long before it found its focus in the sumptuous halls of the Grosvenor Gallery. Journalism covering the social life of artistic individuals and groups surrounding the west end of London in the 1870s emphasized distinguishing visual features that set the Aesthetic crowd apart from others, before the term "Aesthetic dress" had even entered the terminology of the popular press. In 1876 E. W. Godwin described how the London suburbs were home to

> a small settlement of "artistic" folk, including a few painters, some wood draughtsmen, and one or two architects who, being more or less blessed with wives and families more or less "artistic," have established a little world of fashion among themselves. Ladies and Gentlemen, with a courage and a logic equally to be admired, have subscribed not merely to the architecture but to the costume of the middle of the 18th century.[30]

Godwin's description of the adaptation of eighteenth-century dress refers to the strand of Aesthetic dress that promoted knee breeches for men and the Watteau toilette for women. Remarkable for the all-pervasive nature of the influence of the Queen Anne style on all aspects of daily living, it was nonetheless restricted, at first, to a small group of art followers and intellectuals.

The Grosvenor played a vital role in bringing to public attention these kinds of artistic currents, for it was following the gallery's opening in 1877 that reports of Aesthetic dress began to find their way into mainstream fashion journals. Furthermore, the media coverage of what was currently being worn at the Grosvenor openings was as revealing as the critical reviews of the works exhibited there. By the closing years of the Grosvenor, well-known personalities who attended the

gallery's private views were consistently mentioned in the fashion and art literature. In 1887, in the *Artist and Journal of Home Culture*, a critic noted that "Mrs. Stillman came into the Grosvenor very late, looking charming in her usual style of quiet and elegant dressing — a style which will not be contorted and altered by the fashion of the hour, and yet which is so soft and graceful that it is never conspicuous.... It was round Mrs. Stillman that the aesthetes ... were for the most part gathered."[31] The effort to identify the type of dress these celebrities in the art world were wearing, and to whom their raiment most appealed, illustrates a growing public perception that linked certain styles of clothing with corresponding types of art.

The society journal the *Queen* regularly reported on the presence of Aesthetic dressers at the Grosvenor private views, often conflating the role of fashion in the artistic pedigree of certain high-profile artists, celebrities, and gallery attendees — and sometimes ignoring the art entirely in favor of the fashion, as one 1881 reviewer does:

> If it be frankly admitted by those who go to private views, that they go to see the people rather than the pictures, it must be allowed that the sight is a notable one at the Grosvenor Gallery. Perhaps nowhere could we see better expressed than we do in those crimson-draped rooms, some of the characteristics of the day's fashion and eccentricities in dress and manners, or carry away, after having scanned the crowd, a more vivid impression of the artistic and intellectual activity of the present. The world of London congregates there.... No wonder that the pictures on the walls occupy but the background of our thoughts.[32]

REFLECTIVE DRESSING: THEORY AND PRACTICE

If often unacknowledged, there was a direct link between the types of fashions promoted by Aesthetic dressers and the works of art exhibited at the Grosvenor. For over a decade, the Grosvenor Gallery provided a context in which Aesthetic dressers might feel at home and display their creations. It also provided inspiration and models for such individuals. Of the works shown at the Grosvenor, a large number of images based on mythological, literary, or genre scenes featured female figures wearing garments resembling Aesthetic dress. Almost from the very beginning of its existence, the Grosvenor Gallery was seen as a distinctive place to show refined, sophisticated art, and the sartorial performances of many of the individuals who circulated in that environment reflected this awareness of the importance of the gallery in Aesthetic circles. The paintings shown at the Grosvenor were frequently viewed as inaccessible to the average gallery attendee outside

of Aesthetic circles, an image that helped propagate a hermetic and desirable air of intellectual refinement. The iconography of symbols and the textual allusions were often rooted firmly in Pre-Raphaelite literary references and visual markers drawn from early Italian painting, known only to a small circle of readers and artistic followers. In 1877, a critic commented on the kind of erudite, historicizing art increasingly shown at the Grosvenor:

> The result of the exhibition has been to reveal to the public at large what was already known to a small circle of critics and collectors, that England possesses a school of imaginative painters of the highest type, and totally distinct in its aims from the main body of contributors to the Royal Academy. . . . It is certainly most improbable that this eclectic manner of painting will obtain any wide approval. It is only a limited number of admirers of art who can love or appreciate the productions of the earlier Italian masters.[33]

Edward Burne-Jones rapidly became one of the most sought-after contributors to the Grosvenor Gallery, but outside Aesthetic circles, his work was sometimes characterized as a soulless version of the early Italian masters. The overriding sentimentalism and focus on morality evident in much of the painting elsewhere in the Victorian art world partially explains this response. Burne-Jones's work was often perceived as difficult to interpret and abstruse in its construction, confirming the common perception that only those deeply invested in Aesthetic works, with an intimate knowledge of their inner working, could decode and appreciate the importance of his work in terms of the precepts of Aestheticism. The popular criticisms leveled against Burne-Jones were also applicable to other pieces shown at the Grosvenor, and highlight the inscrutability of such works for many critics who regularly covered more conventional forms of Victorian art, primarily displayed in larger, well-attended mainstream exhibitions like the Royal Academy.

In 1876 a critic described the work of Burne-Jones as belonging to "a novel school of Art and thought." Yet although the writer acknowledged that the work drew from the "Venetian school," he or she also asserted that "there is what is at once a more purely classical, that is to say Greek, reference, in those pictures, and an inspiration which is thoroughly modern."[34] This illustrates the contemporary understanding of Burne-Jones's work as a blend of past inspiration and modern innovation — an idealizing tendency shared by many proponents of the Aesthetic movement. And, as established in my earlier exploration of the antimodern roots of Aesthetic culture, this adaptive impulse was one of recuperative nostalgia, related more to coping strategies associated with the modern world than to a simple fictional or fanciful retreat into the past. Aestheticism invoked the search for

beauty in the lives of those living in the present, an aspect that is often overlooked in modernist narratives that position Aestheticism as antiquated or backward looking. The approach of many wearers of Aesthetic dress echoed this complex relationship with modernity, adopting elements of past models, be they Greek, medieval, or Pre-Raphaelite in conception, that might be usefully applied to the needs of modern living.

Burne-Jones's *Laus Veneris*, exhibited at the Grosvenor in 1878, is an example of a work that clearly references a narrative set in the distant past, but which had connotations for modern viewers in terms of providing models for Aesthetic dress (figure 3.1). In contemporary reviews, particular attention was paid to the use of color to enhance the close relationship between the figures themselves and the figures and their setting. In an 1876 review of this painting, a critic for the *Athenaeum* described the dress of the figure of the Queen in terms of color and setting: "Her robe is of pure vermilion, having a golden tinge within, its lustre being subdued to a perfect harmony with the shadows of the half-lighted chamber, and thus dimmed garments and ornaments of her companions."[35] The author's focus on the drapery and colors of the garments worn by the women in this painting illustrates the interest in clothing, in general, as a valid topic for art criticism. The main figure of the Queen, in a relaxed, almost languid position, wears a red gown that has a loose bodice and long flowing sleeves. Similarly, the figure in the blue dress depicted with her back to the viewer wears a variation of this medieval gown, with a panel of extra cloth extending from between the shoulder blades of the back of her dress. Both of these features — the loose natural bodice and the extra, voluminous drapery at the back of the gown — were popular stylistic details of many of the Aesthetic gowns worn at the time this painting was exhibited.

In another work by Burne-Jones, *The Mill*, exhibited in 1882 at the Grosvenor, the depiction of Aesthetic dress in an idealized fictional setting was taken one step closer to the daily life of Grosvenor audiences by the use of sitters in the production of the work who regularly wore Aesthetic dress in their day-to-day lives (figure 3.2). The scene, which shows a nostalgic yet nonspecific event of three girls dancing in the summer evening air, featured the likenesses of Aglaia Coronia (the daughter of the Aesthetic art patron Constantine Ionides) for the figure on the far left; Marie Spartali Stillman, the painter, in the middle; and Maria Zambaco, the mistress of Burne-Jones, in the figure on the right. The blue gown worn by the figure in the middle, modeled after Stillman, featured the loose unstructured bodice and generous sleeves utilized in early models of Pre-Raphaelite dress. In fact, all three figures merge aspects of medieval and early Renaissance dress — in their verticality, naturally placed waist, and in the dress on the viewer's left, an overdress revealing

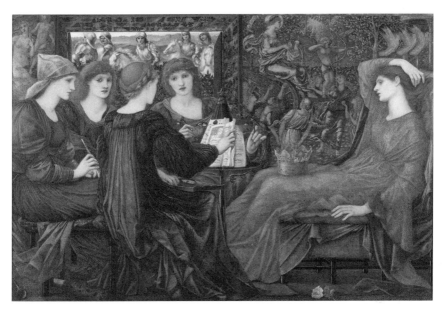

FIGURE 3.1 Edward Burne-Jones, *Laus Veneris*,
1873–78. Oil on canvas, 106.7 x 180.3 cm. Laing Art Gallery,
Newcastle-upon-Tyne. Bridgeman Art Library.

the full sleeves of a blouse worn beneath. Yet these garments also recall classical dress ideals in their emphasis on columnar drapery and simplified form. The use of recognizable models in fictional works such as this, who were well-known among Aesthetic circles, confirms the importance of these paintings in the minds of Aesthetic dressers at the Grosvenor. In the case of Marie Spartali Stillman, the circulation of her own image, represented by other artists, by her own hand, or in person through her sartorial styling, ensured a blurring of boundaries between the presentation of the self in Aesthetic dress, and representations of Aesthetic dress displayed through the works exhibited at the Grosvenor.

Many works exhibited at the Grosvenor featured no specific religious, mytho-logical, or literary reference, but were instead genre scenes with a particular interest in Aesthetic dress. Another example is John Everett Millais's *Shelling Peas*, exhibited at the Grosvenor in 1889 (figure 3.3). In this whimsical portrait, given to Frederick Lord Leighton by Millais as a gift, an unknown sitter is pictured wearing a fluffy gown, with a gauzy (and perhaps lace?) ruff at the neck, with a bowl of peas in her lap, busy with her domestic task. With its natural waist, pale color, loose sleeves, and timeless appearance, the gown is an example of Aesthetic dress. The frequent exhibition of these scenes and portraits of women in Aestheticized garments at

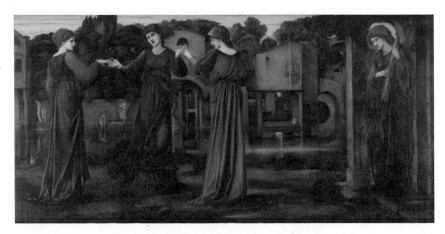

FIGURE 3.2 Edward Burne-Jones, *The Mill*, 1882.
Oil on canvas, 90.8 x 197.5 cm. Victoria and Albert Museum.

the Grosvenor indicates the high level of interest in clothing and the role of art in documenting this fascination. Many artists were aware of the influence of art on contemporary fashion — some of those interested in this relationship utilized art talks and published articles to comment on the intersection of artistic lifestyles and the types of work that inspired it. Walter Crane, in an article for *Aglaia*, asserted that "we have living artists, many of whom have survived the usual art school or academic training, and who through their works have certainly influenced contemporary taste in dress, at least as far as the costume of woman is concerned."[36]

Several artists placed even greater emphasis on clothing and textiles as a central facet of culture. Interested in the Aesthetic impact of art on clothing, they turned to past models for inspiration, arguing that artistic clothing, in turn, influenced the great art produced in "artistically advanced" civilizations of the past, with Greek culture being the most often cited. Henry Holiday argued that the artists who "lived when dress was beautiful show the influence of this healthy nourishment in their work. Look at the Greek statuary, look at the Venetian and Florentine pictures. We see at a glance that they were daily feasting on beautiful images, and they had only to express the poetic thoughts which arose in their minds clothed in the imagery suggested by their daily experiences."[37]

The wider classical revival in Victorian artistic culture was a determining factor in the work of Frederick Lord Leighton, Lawrence Alma-Tadema, Albert Moore, and others who exhibited at the Grosvenor and drew on a classicizing repertoire of images and influences. Alma-Tadema's work *Who Is It?* exhibited in 1884, featured three young women, dressed artistically, lounging about and conversing in a

FIGURE 3.3 John Everett Millais, *Shelling Peas*, 1889. Oil on canvas.
© Leighton House Museum. The painting was given to Leighton
by Milais and is currently displayed in Leighton House
Museum, which is open to the public.

FIGURE 3.4 Lawrence Alma-Tadema, *Who Is It?* 1884. Oil
on canvas, 26.1 x 21.4 cm. Victor Hammer Galleries,
New York. Bridgeman Art Library.

classical yet exotic setting (figure 3.4). Elaborately pleated and draped, the gowns
are held in place by ties across the back and under the bust, in what appears to
be a picturesque interpretation of the Hellenistic period of classical dress. More
austere, Albert Moore's series of iconic female images, titled after flowers or gems,
illustrates that the interest in classical dress was integral to the message of truth to
beauty these works sought to convey. In 1881 at the Grosvenor, Moore exhibited
Blossoms (figure 3.5) and *Forget Me Nots* (figure 3.6). Though the figures are fully
covered in these examples, the loose drapery is suggestive of the nudity that lay
beneath, the uncorseted and uncontained body artfully arranged and sinuously
displayed. These tensions, between the nude and covered body, and the distance
and proximity to flesh suggested by the classicizing drapery, speak to the paradox
of Aesthetic beauty ideals, which though alluring, are always placed at a distance.

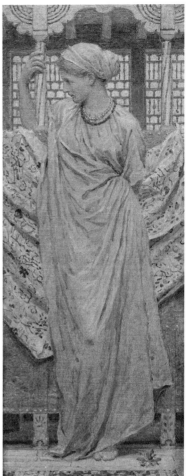

FIGURE 3.6 (ABOVE)
Albert Moore, *Forget-Me-Nots*, 1881.
Oil on canvas, 37.7 x 14.9 cm. The Maas
Gallery, London. Bridgeman Art Library.

FIGURE 3.5 (LEFT) Albert Moore,
Blossoms, 1881. Oil on canvas, 147.3 x
46.4 cm. Tate Britain, London.

The use of color, to harmonize with, and augment the setting, is further evidence of the intentional synthesis between Aesthetic figure and ground. In both these works, great attention to detail in the drapery assures its complementary framing of the pose and bearing of the body it covers, proving that the interest in the forms and features of Greek dress were crucial for the final composition. That these paintings might be used as inspiration or even, in some cases, as models for actual gowns, was commonly understood among the artistic elite that patronized the Grosvenor Gallery.

The vast majority of these works used representations of women in various forms of Aesthetic dress in a symbolic way. The circulation of iconic images of generalized female beauty in Aestheticism points to an intricate system of signs signifying artistic erudition and culture at the highest level. The literature examining the representation of women in nineteenth-century art is extensive, but the work of Deborah Cherry, Elizabeth Cowie, and Griselda Pollock on the Pre-Raphaelite image of beauty as a sign — a stand-in for artistic culture with a complex and associated body of literary and cultural associations, which in actuality define the artistic disposition and value systems of an artistic culture based on male experience and evolution — is relevant here. Such mechanisms function primarily through the rendering of woman as a signifier of difference — yet, in the setting of the Grosvenor Gallery, such signs were mediated by the performative aspect of Aesthetic dress and its ability to help artistic women reclaim such images for their own self-definition.[38]

More problematic still was the connection between women, space, and the commercialization of Aesthetic culture — a theme I return to in more depth in subsequent chapters. Kathy Alexis Psomiades has argued that women who appeared to resemble the female Aesthetic figure in art were seen as emblematic of the "dangers of feminine consumer desire" or as a sign of the difficulties "posed by the commodification of aestheticism."[39] The female Aesthetic dresser was, as such, a contested figure — the site of her own subjectivity and the embodiment of her own tastes, even as she was equally viewed as a cipher of artistic taste, or even of market forces within the material cultures of Aestheticism. According to Psomiades, it was the popular forms of Aestheticism wherein the female aesthete was constructed as a "desiring subject."[40] More importantly, in the very construction of a female Aesthetic figure who responds to her own artistic needs and desires, the Aesthetic dresser can be viewed as a subversive and potentially empowering figure for women in artistic circles. Thus, the theory of Aesthetic culture and the practice of Aesthetic dressing collided in the spaces of the Grosvenor Gallery to create new subject positions for female consumers of art.

Those creative individuals who wore Aesthetic dress were mutually admiring women (and a few men) of great artistic ability and interest. Fashion was, for them, a valid way they might participate in the world of Aestheticism, particularly when circumstances prevented them from being commercially successful painters themselves, as was often the case with many women in the arts at that time. Given the constraints they faced, Aesthetic dressing can be viewed as a productive avenue for artistic women. In addition, those women painters who were successful enough to win commissions and show their work brought a level of professionalism and achievement to the Grosvenor to which amateur women artists could aspire.

Louise Jopling was one such example, having the stature of a professional painter who exhibited at both the Grosvenor and at the Royal Academy. Always supportive of other women in the arts, in 1887 Jopling started her own art school to train and professionalize women artists. In a well-known portrait of her, painted by John Everett Millais and hung in the 1879 exhibition at the Grosvenor Gallery, she wears a dark fashionable gown featuring artistically embroidered flowers (figure 3.7). Her gown, though distinctive, does not follow the tenets of Aesthetic dress, but displays a more conventional fashionable silhouette. Its dark color, contrasting sleeves, and corseted waist are all features common to fashionable dress in the period.[41] However, there are some artful contrivances to the garment — the overdress appears to derive from an adapted princess line often used in tea gowns of this period, partially open to reveal what appears to be a cuirass bodice beneath. The suggestion of the tea gown style is further emphasized by the vertical row of ruffles adorning her neck. The flowers and floral embroidery are artistically done, in a restrained manner, the texture creating the illusion of fullness in the sleeve. In her memoirs she wrote of this dress and how she chose it for her portrait: "I had at that time a dress that was universally admired. It was black with coloured flowers embroidered on it. It was made in Paris. I remember so well dressing for my first sitting."[42] Colleen Denney has argued that this dress was a signature item of clothing for Jopling, in the same way that Lillie Langtry was famous for her "little black dress."[43] Deborah Cherry has noted that Jopling made important connections, both at the Grosvenor and the Royal Academy, and that from the late 1870s she began giving exhibition previews in her studio, which was designed by the much sought-after architect and designer William Burges.[44] Both Cherry and Denney discuss Jopling's deliberate cultivation of a professional female artist's identity and assert that her awareness of herself as a spectacle of artistic refinement played an important role in this process. Her distinctive yet fashionable

FIGURE 3.7 John Everett Millais, *Louise Jopling*, 1879.
Oil on canvas, 125.1 x 76.2 cm. National Portrait Gallery, London.

clothing, which combined Aesthetic and conventional sartorial details, allowed her to impress, and cultivate relationships with, the widest range of possible patrons, art audiences, and social connections. Perhaps most significantly, her later efforts to open an art school for women, as well as to bring equal rights to women in the Society of Portrait Painters, attest to her commitment to promoting women in the arts.[45]

Like Louise Jopling, Lady Lindsay provides another example of a woman involved in the often-hostile terrain of the Victorian art world, who utilized an artistic persona to promote herself (and other women) in the arts. Both aristocratic and artistic, Lady Lindsay attained a level of visibility and power at the Grosvenor that was complemented and solidified by her refined Aesthetic appearance. Her contribution to the gallery was considerable, both financially and socially; her graciousness and ability to host social events successfully were often noted. She held great influence over patrons and artists, and set an example for other women artists exhibiting at the Grosvenor — all of which was integral to its success. The activities of Lady Lindsay were frequently reported on, particularly in the social pages of fashion and art journals. A critic for the *Queen* noticed her absence from the gallery at an event in January 1881: "In this slight sketch of last Friday's gathering in the Grosvenor Gallery, we must not omit to notice the gap made by the absence of Lady Lindsay (of Balcarres). Her bright and welcoming presence was missed from a scene that must always be intimately associated with her. We trust at the réunion next spring she may be there to grace it once more."[46]

Lady Lindsay's appearance at Grosvenor events was always commented on by the *Queen*, and after the closing of the gallery, she was still remembered for her Aesthetic vision and self-presentation. Her friend George Russell wrote that she was "a true 'aesthete' before the word 'aestheticism' became fashionable, and was one of the first women in London to … drape herself after artistic models in form and colour, and to make her rooms unconventionally beautiful."[47] Lady Lindsay was unconventional in appearance and risked social censure by asserting her own distinctive tastes. Her aristocratic aunt, Charlotte de Rothschild, described her particular aesthetic: "She wears neither cuffs, nor collars, nor crinoline, but Mediaeval Italian sweeping skirts and innumerable chains, lockets, rings, bracelets, embroidered girdles and all the paraphernalia of Pre-Raphaelite pictures."[48] Cherry has pointed out that her personal style was such that she could bring together disparate groups, both the upper classes and artistic groups.[49] Most authors, including Denney and Cherry, agree that among Aesthetic dressers, it was women's personal style and flouting of convention that influenced the interior design and decoration of artistic venues such as the Grosvenor. This facet of women's involve-

FIGURE 3.8 G. F. Watts, *Portrait of Lady Lindsay Playing
the Violin*, 1876–77. Oil on canvas, 109.9 x 85.1 cm. Private collection.

ment in design reform continues to be underestimated in modernist histories of
nineteenth-century art.

Paula Gillett has suggested that the portrait of Lady Lindsay by G. F. Watts
(figure 3.8), exhibited at the Grosvenor in the opening exhibition of 1877, illustrates
the distinctive personal style that Lady Lindsay exemplified.[50] Wearing a sage-green
Aesthetic dress and playing the violin — which was not a typically feminine musical
instrument to be pictured with at that time — she was portrayed as both aestheti-

cally pleasing to look at and aesthetically productive. The conventions normally used to depict amateur female artists (for example, a representation of the sitter working at a traditionally feminine artistic task such as sketching a landscape) were rarely followed at the Grosvenor.[51] The portrait of Lady Lindsay is one such example of this new imagining of the female artist. Her portrait, combined with the fact that she herself exhibited numerous times at the Grosvenor, points to her position as both a consumer and producer of Aesthetic art. Thus, for female artists like Lady Lindsay, who were also Aesthetic dressers and were represented in various portraits during the history of the Grosvenor, the polarization of passive art consumption and active art production is a dichotomous model that is not useful in an account of women's roles and experiences within Aesthetic culture.

As fashion was a socially sanctioned and even expected outlet for women's self-expression, Aesthetic dress was a logical outcropping of women's interest in artistic culture and design reform during the Victorian period. Various erudite and influential women served as examples of how women could carve out an artistic persona for themselves outside of normative cultural boundaries. Perhaps the best example is the life and work of Marie Spartali Stillman, who was an active artist in Pre-Raphaelite circles. She both depicted Aesthetic themes in her painting and wore Aesthetic dress as part of her artistic persona and production. Stillman was one of the more flamboyant and independent female artists who exhibited at the Grosvenor Gallery. Sought after by many artists to sit for portraits and genre pieces, she was also prolific with her own art production, and purposefully cultivated an Aestheticized image of herself. Her version of Aesthetic dress tended to adapt or reinvent styles of clothing as depicted in art; for the most part she utilized Renaissance portraits and Pre-Raphaelite imagery to inform her choices of attire. More than this, she repeated her own image in many of her works. Her image is inextricably linked with her own art, and thus her role as a viewer and producer of art is synthetic and corporeal.[52] Her physical awareness of herself while wearing Aesthetic dress was closely related to the often-produced images of her in Aesthetic raiment. This reveals an often unacknowledged tension between representations of women in the visual culture of the Aesthetic movement and the embodied subjectivity of female artists, patrons, and viewers in those same artistic circles.[53]

Works such as *Love's Messenger* (figure 3.9), exhibited in 1885, are evidence of this tension. Pictured in a scene that appears to be a Pre-Raphaelite interpretation of Renaissance culture, she is wearing a gown that incorporates dress-reform tendencies toward a full yet relaxed fit, with late medieval and early Renaissance details — most notably the hat and neckline of the gown. The dress is noticeably loose in comparison to the tightly fitted bodices of fashionable dress in the 1880s.

FIGURE 3.9 Marie Spartali Stillman, *Love's Messenger*, 1885.
Watercolor, tempera, and gold paint on paper, 82.9 x 67.4 cm.
Delaware Art Museum. Bridgeman Art Library.

In addition, the ornately detailed and gathered sleeves are composed of two layers, the under-sleeve cuffs falling open with small silver buttons visible. This layering of the sleeves is reminiscent of late medieval dress. The squared-off neckline, and close-fitting cap with the hair partially braided and a long veil intertwining through and secured low at the back of the neck, appear to be a fanciful compilation of late medieval, Renaissance, and early nineteenth-century styles. The clothing in the

portrait is a fabrication — but the overall effect is one that communicates an air of history even while it seems timeless and difficult to place. It is as though the figure in the painting is beyond the reach of history and the specificities of fashionable dress, existing in an idealized realm of pure art, where the function and meaning of dress become primarily symbolic. However, this visual process stood in stark contrast with the realities of dressing artistically, which would have necessarily been constrained by more practical matters.

In *Love's Messenger* as well as her self-portrait of 1871 (see figure I.2), her image is inextricably linked with her own art, and thus she is able to synthesize her role as both a viewer and producer of art. Such a nuanced understanding of self-presentation reveals an aspect of Aesthetic dressing that is considered, calculated, and most of all, corporeal. Further, as her attire was based on Renaissance and medieval models, she had little in common with nineteenth-century fashion and more in common with Lady Lindsay, since both of them eschewed conventional fashion.[54] Her relationship to artists such as Jopling, however, is more ambiguous. Both were professional artists, selling their work, but their approach to self-representation differed in a critical way. Jopling chose to follow convention more closely in order to access a broader range of exhibition venues and potential patrons, while Stillman clearly had a more select following. The differing way that these two artists used clothing and fashioned their own personas in carefully cultivated ways illustrates the fact that they were aware of the performative potential of alternative forms of dress, particularly as an embodied form of Aesthetic practice on both a spatial and metaphorical level in such settings as the Grosvenor Gallery.

While this sartorial self-styling was a crucial component in the definition and cultivation of the Grosvenor as a rarefied Aesthetic environment, there were differing perspectives on what constituted true Aesthetic space. The diversity of definitions and practices of Aestheticism reveals an underlying fragmentation at the root of the Aesthetic movement, present from its very inception and resulting in its inherently heterogeneous nature. It should be remembered that the terms of Aestheticism were always contested and as a result constantly renegotiated. Add to this the emphasis within Aestheticism on the importance of the subjective reception and experience of beauty, and divided opinions were the logical consequence. Eventually, such divisions led to the dissolution of the movement as a focused and somewhat directed evolution in design and art reform. For a short time, however, the Grosvenor Gallery worked as a unifying force in a broader cultural movement toward the appreciation of beauty in art and design. Although there were standards and trends (Pre-Raphaelite types of beauty, for example), a notion of beauty based on sentiment or experience is partially contradictory and has the ability to threaten

or challenge a definition of beauty based on the principles of utility (and, implicitly, reason). This contradiction was addressed and, perhaps, partially resolved in the minds of many Aesthetic dressers, for whom utility, comfort, sentiment, and beauty were synonymous and equally valued. Consequently, such values inflected the types of basic models that would be chosen for Aesthetic dress.

Most crucially, the Grosvenor presented a unique exhibition space for women artists, whether they were aristocratic, bohemian, professional, or amateur. This is not to say that these distinctions did not have any bearing on social relations at the Grosvenor. Rather, it points to the polymorphic nature of the Aesthetic movement in general. What is of central importance is the way in which these disparate factions and their representatives could coexist in an artistic space that was more flexible in terms of prescribed social roles, particularly for women. In spaces like the Royal Academy and elsewhere, in those institutions that refused women membership, the role of women artists was circumscribed by fairly rigid categories of social decorum. The category of "amateur" was deeply gendered and served as an exclusionary tactic, rather than as a valid means by which art might be judged and criticized in the press. Conversely, at the Grosvenor, the worst that could be said of a female amateur was that she was a follower rather than a leader of Aesthetic art production. In fact, the "amateur" interest in art and the desire to improve one's artistic sensibility was likely to be valued quite highly, and therefore the label of amateur, particularly when attached to women, was not necessarily seen as denigrating, or as indicating a lack of involvement or dedication to the Aesthetic cause. While still facing a variety of societal constraints and limitations across a broader artistic context, the Aesthetic movement, with its close ties to the Arts and Crafts movement, and the realm of the decorative and applied arts, was often an empowering and enabling context for aspiring female artists. Aestheticism, with its emphasis on a contemplative and rarefied artistic sensibility, was similarly inclusive of a wide range of artistic behaviors and proclivities historically gendered "feminine." Therefore, the wearing and enjoyment of Aesthetic dress testify to the active and productive nature of many female artists and viewers at the Grosvenor, regardless of the societal roles and expectations imposed on them.

However, the incidence of artistic dressing in the spaces of the Grosvenor was a practice that eventually faded from public view in the late 1880s. Critiques of the wider movement toward Aestheticized lifestyles and the accompanying interiors and wardrobes came from both outside and inside artistic circles. For many, it was one thing to be artistic, and an entirely different thing to aspire to be artistic or to affect artistic manners in order to be perceived as somehow superior in artistic talent or intellect. Journals such as the *Artist* seemed to repre-

sent both perspectives, promoting the superiority of Aesthetic dress while at the same time critiquing those who took the fad too far or misapplied its principles. In a review of a speech given at Trinity College in 1880 by J. C. Dollman, the blame for the wider fad of Aestheticism is ultimately laid at the door of the artists themselves:

> If some affected creatures had never appeared clad in velvet coats, eccentric hats — and occasionally indulged in a length of hair belonging rather to the middle ages than the nineteenth century, the public would never have evolved the ideal of itself. There is no doubt that there is much less of such absurdity found in the profession than there used to be, and an excellent thing too. This affectation of genius is a very different matter from the real thing.[55]

This brand of critical writing points to a deeper discomfort with Aestheticism, and has little to do with the defense of art itself and more to do with preserving the artistic boundaries surrounding a privileged subset of artistic practices. Aestheticism, in its dramatic appeal to a wider audience and its adoption of forms of artistic expression, including interior design and fashion, was problematic for some. This is particularly true when one factors in the increasing role of women in design reform and the decorative arts in the nineteenth century.

Toward the end of 1887, a dispute broke out at the Grosvenor based on the dissatisfaction of most of the artists and two of the organizers, C. E. Hallé and J. Comyns Carr, with the way that Lindsay was running the gallery. The criticism and ultimate abandonment of the Grosvenor by many of its more prestigious exhibitors, such as Burne-Jones, centered on the perception that the Grosvenor was becoming too commercial, degraded by lowbrow events and commercializing policies that had a negative impact on the high-art image of the gallery. In a letter to Hallé, dated October 1887, Burne-Jones wrote,

> I am troubled and anxious more than I can say by the way in which it seems to me the Gallery has been gradually slipping from its first position, and from the point to which it was so laboriously worked up, to that of a room which can be hired for evening parties. The Gallery has had some struggles for existence, and has had to stand the test of incessant comparison with the Royal Academy, and many used to comfort themselves by thinking it had more directness of aim than the older body had been able to preserve on its enormous scale of exhibition — any way, the place got a character of its own, and its name has been respected, and I do seriously feel that all this is being imperiled by the innovations of this last season, and that steadily and surely the Gallery is losing caste — club rooms, concert rooms, and the rest, were not in the plan, and must and will degrade it.[56]

Not long after letters such as this were exchanged, Hallé and Carr resigned from the Grosvenor, set up the New Gallery, and took many of the better-known Aesthetic artists with them.

Reactions to these debates and the popularization and even commercialization of the Aesthetic movement were more complex where Aesthetic dress was concerned. Years before the tensions at the Grosvenor reached their highest point, Louise Jopling, in her memoirs, commented on the relationship of the fashion world to the rarefied world at the Grosvenor. Discussing the work of Burne-Jones, Jopling recalled that after 1881, "Fashion, always ready to adopt anything new, set all the town wild to copy the dress and attitudes of his wonderful nymphs. As Schwenck Gilbert wrote in his amusing play Patience, 'Greenery, yallery, Grosvenor Gallery' costumes were the mode."[57] Ironically, the popularization of Aesthetic dress through the highly successful production of Patience seemed to provoke a reactive withdrawal by Aesthetic dressers who no longer wished to be associated with the wider strands of popular Aestheticism. In 1882, soon after the production of Patience had reached its full impact, the Artist and Journal of Home Culture reported that there was a "scarcity of dresses usually classified as 'high art' and 'aesthetic' at the Academy and the Grosvenor private views this winter."[58] As more and more fashion consumers and readers of fashion literature were becoming interested in the expressive potential of Aesthetic dress, and given the way in which it was being lampooned by many in the press, it is not surprising that those most closely associated with the rarefied world of high art would distance themselves from public scrutiny.

However, despite this apparent withdrawal on the part of some artistically garbed women, the impetus toward dress reform and a heightened artistic sensibility was still very much in evidence in the work of serious design reformers, long after the Grosvenor Gallery had closed its doors. Lucy Crane summed up the Aesthetic stance that many would continue to take after the movement had lost its initial hold on public attention:

> Those of us who have learned in house-decoration and dress find how much more becoming and agreeable, delicate and soft colouring is than glaring metallic dyes; how much more delightful and serviceable are softly-falling and clinging silks and stuffs, than stiff and rustling ones; and how much better and more elegant are simplicity and delicacy in form than massiveness and cumbrousness; those, I say, who have learned all this are never likely to return to mauve and magenta, to crinolines, to yards of gilt cornices and acres of costly looking-glass.[59]

For women who sought to integrate artistic standards, experiences, and developments into their daily lives, Aesthetic dress continued to be a factor in the way in which they expressed themselves artistically in an active and productive way. For over a decade the Grosvenor provided an ideal context for artistic clothing, where the sartorial expression of an artistically advanced taste in dress could be explored in the ultimate Aesthetic environment.

Popular Culture and the Fashioning of Aestheticism

Throughout the 1880s, a fascination with Aesthetic dress grew alongside the wider proliferation of Aesthetic culture across a broad range of audiences. The critical attention focused on the self-fashioning of Grosvenor Gallery patrons illustrates this growing interest in Aestheticism as more than just an art movement to be followed visually. Rather, it indicates a public increasingly responsive to the notion that commercial forms of culture could provide a viable form of artistic expression and communication. This chapter is about the popularization of Aesthetic dress and some of the complexities and critical debates that evolved out of its absorption by mainstream consumer culture. The significant role of consumer culture in cultivating and perhaps even creating this interest in artistic modes of dressing is also explored. The practice of artistic dressing reveals itself as a fluid entity in the fashion literature, highly contested and emblematic of a range of competing cultural interests. Its material expressions are varied and ill-defined, where hybrid garments displaying both "Aesthetic" and "fashionable" features demonstrate the discursive uncertainty of both these terms. Ultimately, popular iterations of Aesthetic dress point to the visual power of dress to disseminate complex and often contradictory cultural meanings in the public realm.

AESTHETIC DRESS IN THE POPULAR PRESS

Evidence of the growing popularity of Aesthetic dress abounds in the journal literature of the 1880s. Occasionally, visual and written accounts are conjoined, as in the *Queen* in 1881 (figure 4.1): "Notwithstanding the amusement the aesthetic style of dress has created, it is affected by many, and for these we offer two illustrations

intended for evening wear."[1] Often ambivalent or humorous, these descriptions nonetheless point to the multifaceted nature and flexibility of artistic dressing. A range of references in Victorian art and culture are usually cited — an eclectic mix drawn from the orientalism, historicism, and neoclassicism of the period. Particularly during the early 1880s, it is hard to pick up an issue of any of the leading fashion journals without coming across at least one mention of Aesthetic dress. Further, the language used reveals an important reliance on fantasy and eclecticism in the framing of Aesthetic dress:

> Artistic dresses are on the increase. In the Row during the week many are seen, as, for example, a short dress of brocaded China silk of a grass green shade, the bodice pointed back and front. . . . Old-gold finds many patrons among artistic dressers. With a short skirt of satin de Lyon and a long pointed piece coming from the back of the waist, a cream bodice and tunic of soft woollen material was worn, the sleeves puffed and tied between the puffings with bands of old-gold. . . . An Indian red soft silk was made with a very wide Watteau plait at the back and a full banded bodice with tight sleeves. . . . In the evening artistic dressing takes the form of a Watteau plait. A low square-bodiced dress of a tussore silk with one of these, worn at a dinner party last week, had the front gathered, but cut in one with the skirt, and not drawn in at all to the figure — a veritable smock.[2]

Visually evocative, though vague with regard to exact reference, the terminology used is significant. The origin of fabrics, both Asian and Indian, evokes the sumptuous exotic world of orientalism (an arena shared with the fine arts). "Old-gold," "satin de Lyon," slashed or banded sleeves, and Watteau plaits extending from the back of the shoulders all point to stylistic features used in the clothing of previous centuries. Finally, the use of the term "smock" to describe one of the gowns recalls a pastoral and timeless kind of garment — symptomatic of a nostalgic yearning for other spaces, distant eras, or bohemian locales.

The existence of Aesthetic dress as an identifiable category in the fashion literature extended to the world of commerce and advertising as well. A large half-page advertisement for a London dressmaker, Mme Bengough of Notting Hill, illustrates different types of outfits available for purchase, including the "Kate Greenaway," "the aesthetic," and the "Girton" blouse. Such advertisements demonstrate that by the early part of the 1880s, Aesthetic dress as a fashionable trope was widely understood.[3] Similarly, in July and December 1888, the *Lady's Pictorial* advertised a new fabric, "'My Queen' Vel-Vel," borrowing artistic terminology to illustrate the advantages of the textile, its ability to drape softly and naturally being among its chief attractions. In the first ad (figure 4.2), a woman is depicted in

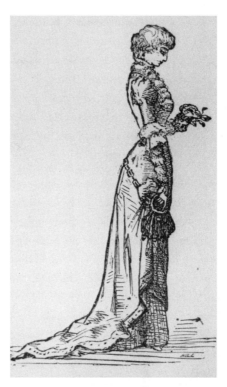

a romantic and simple garment with a slight bustle, puffed sleeves, and flowing skirt, twisting slightly to look behind her, indicating the comfort and flexibility of the garment.[4] In the second (figure 4.3), a Kate Greenaway–type figure, innocent and whimsical, is wearing an Empire-waisted garment with a long easy skirt flowing to the ground unhampered by a bustle or crinoline.[5] In December of the same year, the *Lady's Pictorial* featured an article with a full-page advertisement illustrated by Pilotell under the heading of "Artistic Home Dress" (figure 4.4). The author described the fashions as "becoming," as long as they were "carried out in obedience to the latest dictates of French fashion, in that exquisite English fabric known as 'My Queen Vel-Vel.'" Later in the article, the connection to Artistic dressing becomes clear when the author writes: "For the artistic tea-gowns now so generally worn, nothing is more beautiful or more appropriate than My Queen Vel-Vel, and in the new selection of 'Art Shades,' recently submitted to our notice, ladies will find a complete rainbow of the most dainty and delicate colours which it is possible to imagine."[6]

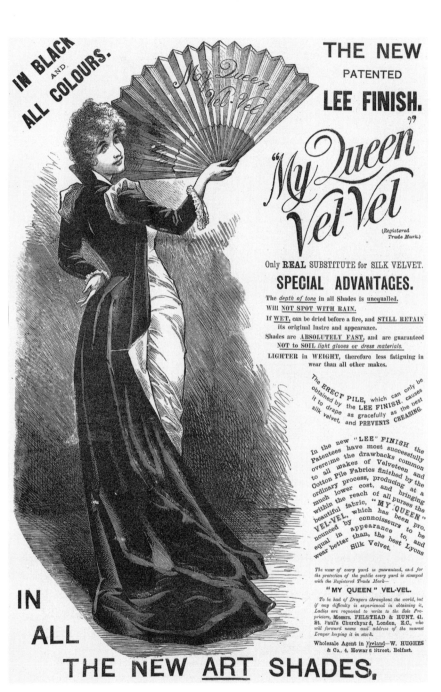

FIGURE 4.2 "'My Queen' Vel-Vel" advertisement, *Lady's Pictorial* 16 (July 21, 1888): 80 (insert). Courtesy of Toronto Public Library.

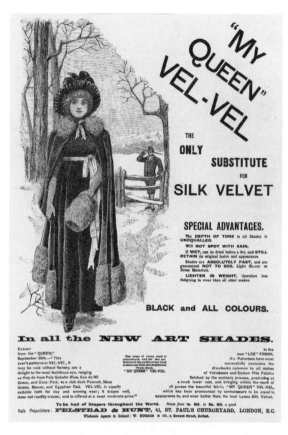

FIGURE 4.3 "'My Queen' Vel-Vel" Advertisement,
Lady's Pictorial 16 (December 1, 1888): 628 (insert).
Courtesy of Toronto Public Library.

Such advertisements indicate a growing demand in mainstream Victorian cul-
ture for information about Aesthetic dress, both in terms of what it was and
where one could find appropriate textiles, as well as gowns ready made. Despite
the relatively conservative flavor of the *Queen*, frequent reports suggest the grow-
ing interest in artistic forms of dress among the normally reserved social elites in
London. In 1881, a writer for the *Queen* noted that the

aesthetic taste of the day is on the increase. When it was first developed, we were
constantly applied to for addresses where gowns made in aesthetic style could be
had. Now leading London firms are seriously studying the subject. Messrs Lewis and
Allenby, of Regent-street, for example, have on view several aesthetic dresses fashioned

FIGURE 4.4 Pilotell, "Artistic Home Dress,"
Lady's Pictorial 16 (December 15, 1888): 701.
Courtesy of Toronto Public Library.

with great skill. To meet the tastes and requirements of many of their customers, the aesthetic style is indeed quite a feature in their preparations for the season, and some of their designs deserve special mention.[7]

Descriptions of some of the gowns offered by this firm followed this assertion of rising Aesthetic tastes. Among them was a dress of a greenish yellow hue, based on thirteenth-century models with slashed sleeves and a long straight skirt, as well as a garment based on the style of the time of Louis XV, utilizing "old gold cashmere, slashed at the sides nearly to the waist," with an "underskirt of striped silk." Most significantly, the writer emphasizes the role art played in the historicism inherent in these models: "These are but a few of the many artistic gowns prepared, and

from them we gather that old pictures have been consulted intelligently, and that great attention has been paid to colour."

Many women who would not necessarily have worn Aesthetic dress in public were quite willing to don an outfit based on earlier models to wear to a "fancy dress" ball. *Cassell's Family Magazine* noted the growing historicism evident at such balls: "Nearly every style of dress has been resuscitated; the Louis XIII time, severe and rich, gives modistes many suggestions, as well as the paintings of Vandyck and Rubens, and the materials used are of surpassing richness: brocaded silks and velvets, and Turkish cashmere, amethyst-violet being the particular colour of the season."[8] Such balls were a staple part of the season for London's fashionable elite, providing a chance for respectable society to indulge in its interest in history while still obeying the fashion dictates of Victorian culture.

What distinguishes Aesthetic dress from the rampant historicism of the popular fancy dress of the period is its allegiance to the notion of advanced artistic taste and the willingness of its wearers to risk social censure by wearing it in spaces normally reserved for "proper" or conventional dress. The appearance of Aesthetic dress at modern, as opposed to costume, balls must have caused some consternation. Certainly the journal literature demonstrates a concern with clearly demarcating the lines between fashionable modes and what would have been considered "artistic" or "eccentric" forms of dress. In 1880, a fashion writer expressed a certain dismay at the growing sartorial freedom to be found at these formal occasions. "In a word, there are but very few fashions of any period that are not being ... revived at the present moment. Modern balls look like fancy balls, and that is the reason that 'coloured' balls have been introduced, and that real fancy balls state the style of costume to be adopted. Thus one lady gives a 'Louis XIV Court Ball,' whilst another gives a 'Harvest Home' ball."[9] Such attempts to clearly define the clothing dictums of events demonstrate the growing popularity of Aesthetic dress outside specific artistic settings or venues.

The fashion literature also offered practical advice for those enterprising enough to construct their own artistic gowns. The *Queen* regularly provided readers with space for questions and comments. In an 1880 issue under the heading of "Artistic Dress," in response to a query from a reader calling herself "Sunflower," a writer for the *Queen* suggested that one might find "coloured Indian silks charming for an artistic evening dress; they are to be had both at Liberty's and at the School of Art-Needlework. A pale blue one would be very graceful made en sacque, or in the quaint mingling of Watteau and mediaeval fashions we have lately affected in dress-making."[10] These kinds of question-and-answer columns in the fashion literature tended to focus only on the visual impact of Aesthetic dressing. Selected features

and physical attributes are disseminated without any information regarding the origins or meanings of Aesthetic dress, or reference to its initial adoption by the social and bohemian circles surrounding South Kensington, Holland Park, and the Grosvenor Gallery. In essence, as presented in much of the fashion literature of the 1880s, Aesthetic dress was often reduced to a purely visual style, a quaint alternative to fashionable modes, but still within the range of normative dressing.

Society reports from the art world also played a crucial role in popularizing Aesthetic dress. Unconnected to the inner workings of the art world themselves, readers gleaned insight into the sartorial habits of the artistic elite through articles featured in both the fashion and art literature. Often these accounts were circulated and repeated among the fashion journals themselves, thereby spreading information regarding key figures and their attire to a wider and wider audience. This kind of repetition and reiteration also underscores the perceived importance of dress itself as both social marker and vessel for artistic expression. In May 1882, the *Artist and Journal of Home Culture* reported that at "the soirée of the Kensington artists in connection with their late combined show, Mrs. Emily Pfeiffer" — a painter and writer who contributed to many publications of the time, including the *Contemporary Review* and *Women and Work* — "appeared in the Greek dress which she has designed and written about. . . . The clinging, almost seamless underdress, was of gold hued satin, over which was draped a white peplum of Indian fabric, cunningly embroidered in gold."[11] Along with specific accounts on notable individuals, general reportage of the growing popularity of Aesthetic dress at social events, parties, and openings can easily be found. Describing fashions seen on the opening night of the 1881 production of *The Belle's Stratagem*, a writer for the *Queen* noted, "The aesthetics still adhere to the puffed sleeves, the square-cut short-waisted bodices, made with a multitude of small plaits. A mélange of the Watteau and the Greek appears a favourite arrangement with those sectarians."[12]

Reports on private views at artistic establishments such as the Grosvenor Gallery and the Royal Academy were another source of sought-after fashion information. Closed to the general public, such gatherings had a high social cachet, one that fashion journalists were eager to exploit. Bringing to light the rarefied and artistic ambience at the winter 1880 private view at Burlington House, the *Queen* reported to its readers,

The gathering assembled . . . to inspect the works of the old masters was a résumé of London, artistic, intellectual, fashionable. It cannot be said that the pictures can be seen and appreciated on those days of privileged admission as they may be on the ordinary days. They are only part of the show. The eye wanders from them to the living pictures

around. We look at the beauties of the long ago in their gala dresses, and turn to watch the countenances of the living women wearing the fashions of to-day. . . . Aesthetic dressing had its votaries; it went through its usual variations of the untidily picturesque and the over-conscious get-up.[13]

In accounts such as these, fashionable dress and Aesthetic dress are presented as related or even interchangeable in a heavily artistic environment.

Celebrated figures in the public eye had a special influence among artistic audiences. Ellen Terry, through her work on the stage, her experimental and open approach to dress, and her association with people like E. W. Godwin and Alice Comyns Carr, contributed to the elite image of Aesthetic dress in the minds of many fashion-conscious consumers. The importance of dress in maintaining an artistic persona was well understood by Terry; in her memoirs, she frequently referred to the gowns designed for her by various artists, friends, and seamstresses. She highlighted those that had an artistic cachet, such as the dresses designed for her by Alma-Tadema for *Cymbeline* and by Burne-Jones for *King Arthur*.[14] In 1864, wearing a Renaissance-inspired gown designed by Holman Hunt, she married George Frederic Watts. In the same year she wore this gown for Watts's painting of her titled *Choosing*, as well as for an artistic portrait by the photographer Julia Margaret Cameron. In the following year, more than six months after her separation from Watts, she again wore her wedding dress for a photographic portrait — this time by Charles Dodgson (Lewis Carroll).[15] Through the print culture of the day, Terry's performance of herself as an artistic individual went beyond theatrical and private artistic settings, out into the public realm. The connection between Terry and an idealized bohemian sensibility was consolidated and firmly entrenched in the minds of the public when she appeared in Aesthetic dress at artistic events and private views.

Terry's personal and professional lives were inextricably linked — her stage costumes and personal garments merging in the minds of many of her fans and followers. For Valerie Cumming, "unlike many exquisite confections whose owners are anonymous, theatre costume can be conjured into life by reading the criticisms and commentaries of those who observed, designed, and wore it."[16] Such was the visual power of high-profile individuals such as Terry that their very names were frequently used as points of reference in the fashion literature, evoking a whole set of associations more successfully than any visual image or lengthy verbal description could. In the July 24, 1880, issue of the *Queen*, a visual image of an Aesthetic bridal gown is defined through references to a dress worn by Terry onstage. The fashion reporter described the cream-colored dress as being "bordered with plait-

ings and lace," the full skirt "caught up on one side, like the dress worn by Ellen Terry in [the role of] Portia."[17]

For some socially conscious fashion reformers, the spread of Aesthetic styles into a wider public was the desired goal. In accordance with reformers in all branches of the decorative arts, many fashion journalists believed that the democratization of Aesthetic ideals in dress would benefit society in general and the lifestyles of women in particular. In 1882, the *Magazine of Art*'s stated goal was "the popularisation of Art, and the gratification of the growing interest of all classes in whatever is beautiful and refined."[18] Often, this found expression in the popular press of home improvement, where columns, articles, texts, and guides to decorating included such rhetoric about the need for a wider appreciation of the arts in all sectors of society. Journals such as the *Artist and Journal of Home Culture* regularly featured a column titled "Art in the Home," largely devoted to the "minor developments of Art and Taste, such as Dress, Furnishing, Art Needlework, Tapestry, Artistic Stationery, Jewellery, Articles of Domestic Ornament, Fancy Goods, Design in Wall Papers, Painting on Textile Fabrics, &c." Further, this column was mainly "intended to be, in a measure, the Ladies' Column of the paper."[19] Although categorical distinctions of this kind clearly reinforced and further inscribed gender boundaries, these features were intended to provide insight, direction, inspiration, and, occasionally, criticism, to a growing demographic of female consumers interested in Aestheticism.

PUBLIC CULTURES OF
CRITIQUE AND CONTAINMENT

As the pursuit of artistic dressing became common in fashionable circles, debates arose regarding the true nature of Aesthetic dress. Competition over the ownership of and authority over such modes led to proclamations of insight and superior knowledge on the part of certain individuals. Many writers and readers of popular fashion journals felt they had special insight into, and intimate knowledge of, Aesthetic dress in its original or intended form. The *Queen*, for example, pronounced that

> the apparel variously termed "Pre-Raphaelite," "Artistic," "High Art," or more generally "Aesthetic," has become a recognised factor in the dress of English women. So much attention has been called to it during the last three or four years, that many people fancy the "craze," as they term it, has only sprung up within the last decade or so; but many among us can remember that we always numbered among our friends women whose

art-sense and knowledge of the beautiful prevented their blindly resigning themselves to the tyrannous dictates of "La Mode."[20]

The author makes a distinction between those newly aware of Aesthetic dress and those who originally wore the style years before it came into public view. By privileging a select group of women who had worn an earlier style and followed the values and practices behind dress reform, this author's assertion articulates the contested nature of Aesthetic dress in the print culture of the 1880s.

Early proponents of Aesthetic dress feared that through its adoption by mainstream fashion consumers, it might become adulterated in some way. Through letters and articles, many expressed a desire to protect the authenticity or purity of Aesthetic dress as they understood it. This included, but was not limited to, expressions of exclusion where they differentiated between true wearers of Aesthetic dress and those who were mere imitators. Others offered directions on the proper use of materials, stylistic traits, and combinations of colors in order to achieve a true Aesthetic appearance in their dress. In 1881, a commentator for the *Queen* wrote,

> One of the charges often brought against the pre-Raphaelite style of dress as adopted by many ladies of the present day, is that an absolute sincerity as to material is not practised, and there is some reason in the complaint [that] . . . if a dress be simply made, relying for its effect on harmony of colour and grace of folds, the stuff is of far more consequence than it is in elaborately devised costumes. Velveteens, cotton-backed satins of the cheaper kind, and stuffs of that nature, are seldom satisfactory when made in the fashion called "aesthetic." The material of a dress need not necessarily be costly, but it must be real; let the wool be wool, the silk silk, the linen linen. The difference between a pure and a mixed material may not be very visible in the rolled-up piece of goods, but when it comes to the draping it tells directly.[21]

For many women influenced by Aestheticism, a graceful and artistic gown was more than a collection of stylistic traits or historical references. Artistry could also be found in truth to materials, and in the functional aspects of garments — how they moved with the body, and how they should be composed, constructed, and draped to artistic effect.

Yet the legitimacy of Aestheticism as a viable influence on dress reform was constantly under debate in the public realm. The use of humor and satire to poke fun at Aesthetic lifestyles and fashions highlights some of the more outlandish perceptions held by the general public in response to the Aesthetic craze. Soon after the premiere of Gilbert and Sullivan's *Patience* in 1881, mention of the Aesthetic opera began to proliferate in the fashion literature. A writer for the *Queen*

reported on a private view held at the Grosvenor Gallery, musing, "The Aesthetics mustered in force on their great field day ... the new aesthetic opera had provided them with fresh hints of strange get-ups."[22] Such comments illustrate the possibility that theatrical performances such as *Patience* provided both the general public and those involved directly in the art circles of the Grosvenor Gallery with models of Aesthetic dress that might be followed. Further evidence of this is given in a later issue of the *Queen* in August of that same year, when a writer reported that the "Aesthetic dresses worn by the love-sick maidens in 'Patience' are all of one cut ... loose flowing skirts, and a half high classic bodice with a ribbon belt round the waist, tied in a looped bow in front ... long drooping sleeves are fastened with three buttons on the outside of the shoulder, and spring from the fullness of the dress at the back."[23]

Even before *Patience* immortalized Aesthetic dress for the stage, *Punch* magazine had published cartoons and satirical illustrations detailing the overly theatrical lifestyles of the terminally "Aesthetic." Carried out by George du Maurier, these drawings were another rich source of visual information for the general public. Given the wide circulation of *Punch*, these satirical cartoons were extremely successful at popularizing Aesthetic dress even while divesting it of its aura of exclusivity as a sartorial pursuit.[24] In fact, the boundary between Aestheticism as a serious movement and Aestheticism as a humorous category of artistic melodrama, open to derision by the popular media and serious art critics alike, was blurred by individuals such as du Maurier. Ironically, du Maurier himself was part of, or had access to, the very social circles he satirized in *Punch*. Louise Jopling, in her memoirs, remembered du Maurier's presence at many social and artistic functions. Recalling one such incident where he attended a musical afternoon she was hosting and refused to sing, Jopling wrote: "In answer to my request, he said: 'No; unless you want every one to leave the room. Ha! That is a good idea for Punch!' And sure enough in the following week's Punch appeared a faithful picture of my Studio and its guests, including an exact likeness of himself, looking most lugubrious, whilst I, the hostess, am saying: 'Oh, do sing for me!'"[25]

Such parody and play brings to light the fact that many of the wearers of Aesthetic dress must have had a sense of humor and some measure of self-awareness regarding how they were perceived by others and the media. Alice Comyns Carr, in her memoirs, makes the suggestion that she herself may have been one of the models for du Maurier's ultra-aesthetic character, Mrs. Cimabue Brown. She notes that although the role was commonly thought to belong to the wife of the director of the Grosvenor Gallery (Lady Lindsay), she herself had "long been accustomed to supporting a certain amount of ridicule in the matter of clothes,

because in the days when bustles and skin-tight dresses were the fashion, and a twenty-inch waist the aim of every self-respecting woman, my frocks followed the simple, straight line as waistless as those of to-day."[26] The criticism and public scrutiny suffered by individuals such as Alice Comyns Carr are confirmed by the mocking and derogatory comments that frequently appeared in the journal literature of the time. In the *Magazine of Art* in 1882, the author of an article titled "Colour in Dress" remarked, "There seems to be a prevailing impression that if womenkind dress themselves in olive-greens and *teints dégradés*, their garments will immediately become pleasing to the lover of the beautiful."[27] It is telling that even as Alice Comyns Carr acknowledged the derisive humor others enjoyed at her expense, she still vied for a role as the exemplary Aesthetic woman.

Derisive or negative stereotypes of the aesthete may have in fact more firmly entrenched the cultural forms and visual signs that connoted a sartorial subculture based on the tenets of Aestheticism. In the *Lady's Pictorial*, a cartoon featured a series of iconic art types in attendance at a local art education function, among them an "inevitable aesthete" and a "high art" maiden.[28] Other disgruntled accounts of the growing popularity of Aesthetic dress at home and abroad cite *Punch* magazine directly as one of the mouthpieces responsible for the spread and dissemination of artistic dressing, regardless of its satirical intent:

> The fashion perversely called "Aestheticism" is said . . . to have crossed the Channel, and to have penetrated as far as Paris. There, as here (and as in New York), the women have begun to indulge in that chromatic misery — the "green and yellow melancholy" — which is supposed to distinguish the Aesthetic habit of attire. It remains to be seen if the craze will spread. It is not too much to say that everything depends on the caricaturists. . . . But for the violent attentions of Messrs. Gilbert and Du Maurier and Burnand, it would probably have vanished from among ourselves.[29]

Counterbalancing this negative press was the support shown by many popular individuals and celebrities from well-known artistic backgrounds and their highly visible presence in the print culture of the late Victorian era. Oscar Wilde's pronounced views on fashion and self-presentation formed not only a point of reference for those who wished to make fun of Aesthetic dress, but also drew attention the integral role of Aesthetic dress in leading an "authentic" bohemian lifestyle. Wilde was overflowing with judgments about artistic neophytes. Using a strange blend of humor and playful irreverence, he dismissed individuals lacking in Aesthetic sensibility. Taking his derision further, he encouraged those he deemed suitably artistic to disregard or banish these undesirables from the

FIGURE 4.5 Pilotell, "Gothic Gowns," *Lady's Pictorial*
16 (December 1, 1888): 613. Courtesy of Toronto Public Library.

pristine Aesthetic environments they were blighting. During a lecture in 1884, he stated that portraits, including photographs of one's relations, should fit into the overall Aesthetic scheme of any tasteful interior. A reviewer summarized his words: "Concerning the modern photographs of relations the audience were advised to exhibit them if they were 'Decorative Relations,' otherwise to sacrifice their friendship to their artistic beliefs and turn their faces to the wall."[30] In addition to his public lectures and highly visible presence at many artistic functions, Wilde edited *Woman's World*, which, despite its relatively short run (1888–1890), presented readers with an alternative fashion press that subtly challenged the

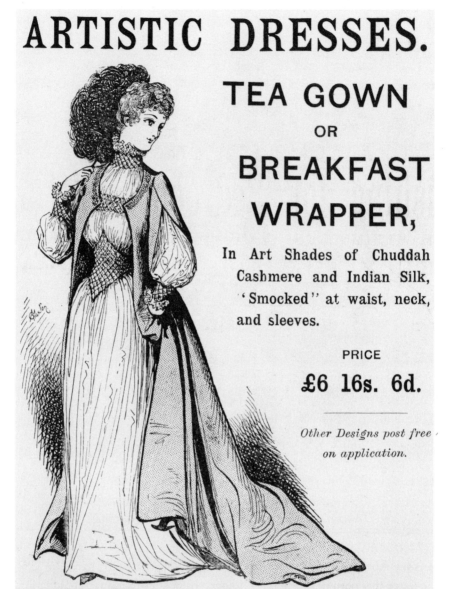

ARTISTIC DRESSES.

TEA GOWN

OR

BREAKFAST WRAPPER,

In Art Shades of Chuddah Cashmere and Indian Silk, "Smocked" at waist, neck, and sleeves.

PRICE

£6 16s. 6d.

Other Designs post free on application.

DEBENHAM & FREEBODY,

Wigmore Street & WelbeckStreet, W.

FIGURE 4.6 Debenham & Freebody Advertisement,
"Artistic Tea Gown or Breakfast Wrapper," *Lady's Pictorial* 15
(April 28, 1888): 470 (insert). Courtesy of Toronto Public Library.

tenets and representational practices of more mainstream fashion journals such as the *Queen* and *Lady's Pictorial*.[31]

HEGEMONIC FORCES

The concern expressed by writers who wished to keep Aesthetic dress separate from conventional fashion charts the discernable appropriation and nullification of alternative forms of dress by mainstream fashion edicts and practices. A telling example is given in an illustration of "gothic" gowns found in the December 1, 1888, edition of the *Lady's Pictorial* by Pilotell (figure 4.5). In this example, as well as the one given earlier in figure 4.4, Pilotell presented all gowns as "Aesthetic" or artistic, yet rendered them with a fashionable silhouette. In figure 4.5, despite the supposed Gothic or medieval flavor of the gowns in question, all indicate tightly cinched waists and voluminous bustles in the rear — attributes of contemporary styles that were highly restrictive.[32] These dresses, therefore, are not Aesthetic in their construction; they neither represent the Gothic era nor follow medieval structures in dressmaking. Rather, these gowns signal a nineteenth-century translation of medievalism, updated and modified to reflect mainstream standards of beauty and decorum. The same can be said of the "artistic" models presented in figure 4.4, which resemble fashionable interpretations of Aesthetic dress that do little to challenge conventional clothing practices of the time.

As Aesthetic dress was gradually adopted, manufactured, and represented by fashionable journals, illustrators, dressmakers, and commercial firms, it began to lose the original spirit of its construction — both physical and symbolic — as an alternative to fashionable dress. Progressively, it began to exhibit more and more closely the main features of mainstream fashions, calling itself "artistic" when in truth it was only the smallest puff of a sleeve, or the barest hint of smocking that signaled the influence, however slight, of earlier models of Aesthetic dress. Another example of this can be found in an advertisement illustrating an "Artistic Tea Gown or Breakfast Wrapper" (figure 4.6). Across the narrow expanse of an impossibly small and clearly corseted waist, smocking is used. This is a dressmaking technique normally associated with the loose gathering of fabric in Aesthetic dressing used instead of structured undergarments and/or tailoring; therefore, its purpose was both utilitarian and decorative. In contrast, in this advertisement, smocking functions as a symbolic stand-in for everything "artistic." Ironically, it contradicts the inherent functional attributes of smocking as it was originally used in Aesthetic dress. Instead, it indicates and decorates the tightly laced fashionable waist, which would clearly restrain the body in an uncomfortable way.[33]

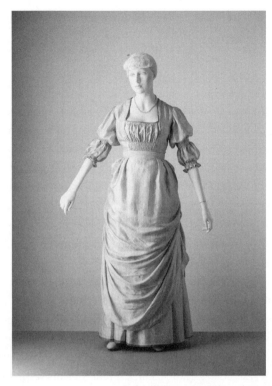

FIGURE 4.7 Aesthetic Dress, English, 1880s. Blue and white
striped Liberty washing silk (design attributed to Hamo
Thornycroft). Victoria and Albert Museum.

Many of the surviving gowns classified as Aesthetic or artistic in various museum-based clothing collections in Britain and elsewhere are hybrids of this kind. These dresses collapse the categorical distinction between fashionable and Aesthetic dressing and were the focus of the debate, discussed above, that existed in the fashion literature of 1870s and 1880s. The dates given for the majority of these gowns are in the late 1880s and early 1890s, a time when Aesthetic dress would have been a well-understood category in the fashion literature. In some of the garments an eclectic mix of stylistic traits, often competing with each other, are in evidence. A dress designed and sewn by Hamo Thornycroft and his wife, who were members of the Healthy and Artistic Dress Union, is among the textile holdings of the Victoria and Albert Museum (figure 4.7). In this gown, the high natural waist, puffed sleeves, and use of smocking on the bodice and the sleeves indicate that this dress is appropriately Aesthetic. In addition, the blue and white washing silk used in the gown probably came from Liberty's. However, there is

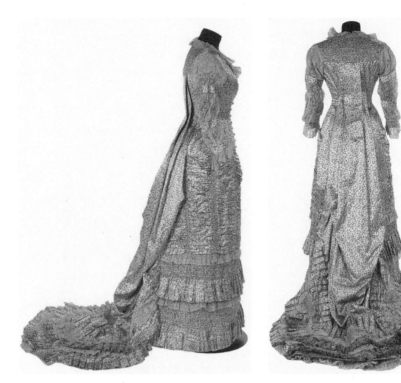

FIGURE 4.8 (LEFT) Tea gown, Chipperfield and Butler of
Brighton, 1880s. Floral printed satin with Watteau pleat. © Museum of London.

FIGURE 4.9 (RIGHT) Back view of tea gown. © Museum of London.

one feature that ties it firmly to the fashionable dress of the 1880s when it was
made: a bustle is suggested through the elaborate use of gathers, folds, tapes, and
bunching of the fabric in the upper part of the back of the skirt.[34]

While the Thornycroft dress is mostly Aesthetic with some fashionable fea-
tures, in other extant gowns, fashionable dress has taken over and appropriated
Aestheticized elements in the service of a predominantly modish silhouette. In
many of these gowns, though individual features point to historicism or Aesthetic
dressmaking techniques (the use of smocking or choice of fabric), the overall
outline and construction of the gown are drawn from conventional mainstream
fashion. This is the case in a tea gown held by the Museum of London, dated to
the 1880s (figures 4.8–4.10). The overall construction of the gown is based on the
fashionable princess shape, cut close to the body and very tight-fitting around the
waist. However, the quality and print of the fabric (sprig print silk, popular in the
eighteenth century), the addition of a Watteau panel across the back, and the use of

smocking all point toward Aesthetic dress.[35] It is the way in which these features are added that deviates from Aesthetic norms. The use of smocking is arbitrary and decorative. It extends across the back of the shoulders in a broad flat panel and circles the bottom of the skirt in repetitive rows, a playful inversion of the Aesthetic trait of smocked gathers on the upper part of garments, on the bodice or sleeves (see figures 4.9 and 4.10). In addition, the use of alternating bands of fabric and lace on the arms pays homage to Aesthetic dress through a fanciful collection of details rather than as an overall arrangement or a coherent structure; the bands of fabric do not gather looser lace or fabric as

they might in an Aesthetic gown, but seem to be mere visual indicators of differences in texture, echoing the fascination in mainstream fashion with decorative trimming. In such Artistic-fashionable hybrids, Aestheticism is a whimsical pastiche of ideas and details rather than a set of underlying and unified artistic principles.

The hybridized and highly contested terrain between fashionable and alternative forms of dress articulates the profound and lasting effect that Aesthetic dress was to have on mainstream fashion culture. The work of Stella Mary Newton has established the significant impact that dress reform and Aesthetic dressing had on the trajectory of mainstream fashion and the development of haute couture. She has pointed to a moment at the beginning of the 1880s when wearers of high fashion wore neither crinolettes nor bustles. This was followed by the sheath dress, which, when constructed without constricting the body, provided a model of dressing that resembled Aesthetic dress. Perhaps it is for this reason that mainstream fashion became so receptive to alternative forms of dress at this time. It is hard to say which way the influence went; it is enough to conclude that for a brief period, fashionable and artistic dressing were quite similar. Newton writes, "The woman of fashion who wore her sheath dress and held herself in the fashionable 'S' shape was of course usually unconscious that she was, like those with artistic taste, contributing to the prevailing mediaevalism or that while related to a fourteenth-century French Virgin she also looked like a lady in a Japanese print. These were characteristics she would have regarded as the province of the aesthetes."[36] This brief convergence between fashionable and alternative forms of dress not only left its stamp on Victorian notions of beauty and decorum, but it further fueled the debate when fashionable dress again diverged from Aesthetic principles, reviving the bustle in an even more extreme and awkward manner toward the middle of the 1880s.

Beyond the basic shape and cut of clothing, the influence of the Aesthetic movement on mainstream fashion occurred at the level of language and quickly altered descriptive fashion writing. Here, it influenced changing trends in describing and qualifying color, fabric, shape, and construction in the fashion reportage of popular culture. For Valerie Steele, the tendency toward more nuanced descriptions of the use of color led to a growing fascination with harmonious color combinations, particularly in the use of one tint in several shades. Decades earlier, in the 1860s, this was a feature of Aesthetic dress at a time when mainstream fashion favored aniline dyes and the jarring contrast of bright colors — for example, a magenta dress with lemon yellow lace trimming. Other examples include the growing use of descriptive terms such as Whistlerian "symphonies" of color, as well as the attention

paid to "art silks."[37] Despite the controversy surrounding dress reform debates, the conflation of Aesthetic dress and mainstream fashion happened gradually and, in many cases, went unnoticed by the vast majority of fashion-conscious readers and writers in the journal literature of the 1880s. The convergence of Aesthetic and mainstream fashion terminology and taste, and the adoption of artistic styles by individuals outside artistic circles, together represent a key moment in the history of consumer culture.

THE COMMERCIALIZATION OF AESTHETIC CULTURE

Public perception usually applauded the efforts of design reformers, but opinions were divided on the issue of consumer culture and whether it was a help or a hindrance in improving taste and bringing culture to the general public. For those who felt that the popular movement in art-related products and the spread of Aestheticism in home furnishings was a positive occurrence, the possibilities provided by the growing market for such merchandise were unlimited. In 1881 an author for the *Artist and Journal of Home Culture* reported,

> Everybody's aim just now is to be "artistic"; art in building, art in decorating, art in furnishing, art in working, art in dressing, is the talk of all. Beautiful designs and productions for carrying true art into the most minute details of home life are to be found all round and in all the largest and best of London warehouse: it is really the buyers' fault if anything ugly and unartistic is purchased, for the eye revels in both the designs, colours, and form of every article needed to make a house perfect.[38]

For these writers, the commercial availability of Aesthetically inspired decorative objects for the body and the home was a sign of social progress. It could be viewed as building on reforms originally proposed by the artistic elites and groups directly involved with Pre-Raphaelitism and the Arts and Crafts movement. Most importantly, the sentiment that those with a moderate income might attain taste and art through commerce was further evidence of a growing belief that popular culture could facilitate the spread of artistic values and practices through all levels of society.

However, there were also many who publicly criticized the growing popularity of Aesthetic dress, viewing it as a corrupt and commercialized movement against art and culture rather than as evidence of its democratic spread. William Powell Frith's depiction of Aesthetic visitors in his *Private View at the Royal Academy* from

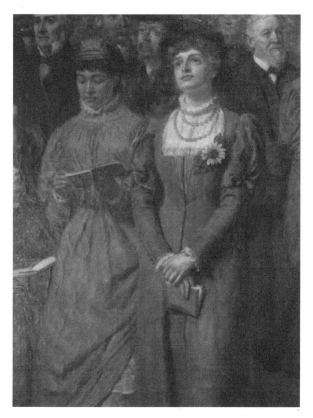

FIGURE 4.11 William Powell Frith, *Private View at
the Royal Academy* (detail), 1881. Oil on canvas, 102.9 x 195.6 cm.
Pope Family Trust, photographed with permission while on
temporary loan to Leighton House Museum.

1881 illustrates the growing visibility of this style at semi-public artistic functions
(detail figure 4.11). Royal Academy private views were larger and more popular
than those at the Grosvenor. The appearance of these gowns in otherwise fairly
conservative artistic settings illustrates the ever-wider dispersal of Aesthetic dress.
In his autobiography 1887, Frith reflected on his 1881 painting:

> Seven years ago certain ladies delighted to display themselves at public gatherings in
> what are called aesthetic dresses; in some cases the costumes were pretty enough, in
> others they seemed to rival each other in ugliness of form and oddity of colour. There
> were — and still are, I believe — preachers of aestheticism in dress; but I think, and
> hope, that the preaching is much less effective than it used to be. The contrast between

the really beautiful costumes of some of the lady habituées of our private view, and the eccentric garments of others, together with the opportunity offered for portraits of eminent persons, suggested a subject for a picture, and I hastened to avail myself of it.[39]

Two figures emerge from the crowd, one in golden yellow, the other in sage green. Smocked necklines, ruffed collars, puffed sleeves, and a relaxed fit identify both gowns as artistically inspired. In the case of the figure on the right, a sunflower and a chunky beaded necklace are further evidence of her Aesthetic persuasion. Derisively Frith wrote, "I wished to hit the folly of listening to the self-elected critics in matters of taste, whether in dress or art." Given the fact that those who exhibited at the Royal Academy were also those who chose the next generation of Royal Academicians, the irony of this statement is not lost on present-day readers. In describing the individuals he chose to depict in this painting, Frith made it clear that well-known public figures were present, as well as the more visible group of aesthetes: "On the left of the composition is a family of pure aesthetes absorbed in affected study of the pictures. . . . The rest of the composition is made up of celebrities of all kinds, statesmen, poets, judges, philosophers, musicians, painters, actors, and others."[40] For Stella Mary Newton, there was little division socially between those who wore Aesthetic dress and those who did not in the early 1880s. Further, she has suggested that there was a great deal of it present in the higher social echelons.[41] Certainly the social circles around Holland Park from the 1850s to the 1880s brought artists together with wealthy patrons and resulted in a great deal of Aesthetic portraiture.[42] However, for artists such as Frith, the aesthetes were little more than high-profile individuals who wished to make an impact. They were noteworthy for their appearance at public gatherings, but not really worthy of critical attention or studied reflection. His trivializing of Aesthetic personalities was shared by many in the art world.

Without doubt, notable artistic personalities and the truly wealthy raised levels of awareness of Aesthetic lifestyles and pastimes. At the same time, however, existence of a much larger market for Aesthetic dress perturbed many of the artistic elite who were anxious to preserve and rarefy the realm of the fine arts for themselves. Bourdieu has argued that specific dispositions or preferences, acquired through education, mark the habitus of a given social class or grouping.[43] Thus, social distinction is based on the proprietary claim certain groups have over key indicators of taste. As an embodied aspect of the habitus of artistic elites, Aesthetic dress was therefore subject to the same processes of social differentiation as other cultural expressions of taste and class. Thus, while using a rhetoric of

social advancement in all the arts and the need for a wider appreciation of art in society, the terms of that advancement and its applications were fought over and contested by the very elites that proposed them. In 1894, Walter Crane looked back at the roots of Aesthetic dressing:

> Beginning in the households of the artists themselves, the type of dress to which I allude, by imitation (which is the sincerest form of flattery — or insult as some will have it) it soon became spread abroad until in the seventies and early eighties we saw the fashionable world and the stage aping, with more or less grotesque vulgarity, what it was fain to think were the fashions of the inner and most refined artistic cult. Commerce, ever ready to dot the i's and cross the t's of anything that spells increased profits, was not slow to flood the market with what were labelled "art-colours" and "aesthetic" fabrics of all kinds; but whatever vulgarity, absurdity, and insincerity might have been mixed up by its enemies with what was known as the aesthetic movement, it undoubtedly did indicate a general desire for greater beauty in ordinary life.[44]

While acknowledging the overall beneficial outcome of the spread of Aesthetic ideas among the general public, he maintained a pronounced level of criticism and suspicion of the commercial aspects of an applied or popular Aesthetic movement. Perhaps not intentionally, some of Crane's writings support the distinction between high art and more popular forms of culture, confirming the stereotype that viewed them as derivative, commercial, and therefore debased. Lucy Crane shared her brother's suspicions when she implied that those who worked in commercial settings were unlikely to have the aptitude or sensibility to appreciate true art:

> We do not ask the book-seller to guide our taste in reading, or the music-seller to form our taste in music; still less do we allow the cook and wine-merchant the uncontrolled management of our tables. Yet the furnishing of a house in many, if not in all, important particulars is commonly left to the upholsterer, or decorator as he prefers to be called; and as he, not working with his own hands, takes no pleasure in the work, but has gain for his first object, so his only idea is to carry out what he supposes to be the prevailing style, so as to produce the most show for the money.[45]

This anti-commercialist stance was shared by many in British artistic circles of the nineteenth century.

In terms of fashion, this relationship was even more pronounced. Dress reform produced heated criticisms of the commercial nature of mainstream fashion — attacks were aimed at the uncomfortable and deforming styles that were promoted

as well as the underlying economic structures that drove continuous change in the color, cut, and textures of fashionable dress. What makes these kinds of critiques so interesting is that they are frequently found in mainstream fashion journals, where the effort to preserve the authenticity of Aesthetic dress was addressed to the very audience that threatened to compromise its existence as an exclusive aspect of Aesthetic artistic culture. In this light, such critiques can be seen as cautionary, outlining the proper realm of artistic dressing, and instructing those who were unenlightened on the basic principles of good taste. A critic from the *Queen* complained,

> More than half the so-called "artistic" dresses are unsatisfactory. . . . The reasons for aesthetic — misused word — raiment often failing in its assumed aim are many, but among them may be noted lack of a clear idea, or presence of an idea badly or clumsily carried out; unfitness to the purpose or occasion for which the dress is worn; and over-strength, or general dinginess of hue. The mistakes of construction that even advanced aesthetes make in this matter of attire are, to use one of their pet words, quite pathetic.[46]

Here, the proper application of Aesthetic principles is contrasted with the pursuit of Aestheticism as a fashionable and ultimately meaningless pastime. Many blamed the materialism and ignorance of the commercial fashion world, and further implied that artistic dressing as the embodiment of high-art principles was impossible or, at the very least, ill-advised. The fact that this writer's views were published in a mainstream journal like the *Queen*, with a widely fashionable and somewhat conservative audience, demonstrates her wish to make an impact on that very demographic.

FEMALE AUDIENCES

Without doubt, consumerism was central in the reception and dissemination of Aesthetic culture for women. Interlaced with the growing involvement of women in the arts, the commercial aspects of Aesthetic dress as a possible source of empowerment, pleasure, and productivity for women remain largely unexamined. So, too, is the overlooked role of women as viewers of Aesthetic culture. Art and industry did not remain in discrete realms, but were interconnected in complex ways through the processes of design reform. Anne Anderson has pointed out that despite the scholarly focus on male sexuality and the male gaze in cultural studies of the nineteenth century, images of women in art were viewed just as much by a female audience, one that was increasingly well educated. Further, she asserts that many journal accounts at the time also refer to the ways in which women were

emulating the effects seen in these paintings.[47] The central role of a largely female audience should also be considered with regard to the images of women circulating in advertising, fashion illustration, and other print media. Many of these images drew on the discourse of the Aesthetic movement, presenting examples of tastefully artful attire and fueling the desire for further images of creative or alternative dress. The impact of this exchange on women in consumer culture was both extensive and potentially subversive with regard to Victorian norms.

The importance of female readers of print culture has been fruitfully explored by several scholars of popular culture.[48] My interests lie in those female readers who may not have had direct contact with artistic circles, but who, through various journals, developed an interest in artistic culture that was both genuine and mediated by the commercial world of advertising, promotion, and art sales. Notable fashion journals such as the *Queen* and *Lady's Pictorial* had regular columns devoted to the art world, including regular reports on "Lady Artists" or "Lady Exhibitors" at various artistic functions and exhibitions. This relationship is even more significant when one considers how female artists were framed by dominant media discourses, their art identified with, and in some cases obscured by, their personal appearance. The discussion of Marie Spartali Stillman in the previous chapter attests to the ways in which the female artist could turn this stereotype to her advantage through the construction of an Aesthetic persona. Many female consumers would have had ample opportunity to maintain an awareness of various artistic elites. Regardless of how much this connection was contrived or even selectively biased in the direction of media interests and foci, what is crucial is the reception and construction of an imaginary artistic realm in the minds of readers. Readers might, in turn, be motivated to search for artistic gratification and self-expression by emulating these female role models in a more accessible sphere — the very public arena of consumer culture.

Contemporary with this developing interest in the art world, a growing female audience turned its attention more specifically to the issue of dress reform, which in turn was linked with artistic circles, particularly in the 1870s and early 1880s. In 1882, the *Magazine of Art* published an article titled "Fitness and Fashion," highlighting lectures on dress reform given in Kensington by the National Health Society. The public interest in this subject was pronounced, as was evident in the large turnout to the event. Commenting on the debates over dress reform, a critic concluded that "the female mind is deeply exercised by the question, and very ready for practical hints about reform."[49] The fact that such reports were worthy of mention in a magazine dedicated primarily to the arts illustrates the abiding interest that artistically inclined female audiences had in the subject of clothing

and the adornment of the self, whether it was based on principles of good health or good taste.

For many female readers of magazines that were both artistic and fashionable, Aesthetic dress was an attractive form of attire that criticized the fashion industry from inside its borders, keeping abreast of fashionable events and developments while still respecting the values of the dress reform movement, which emphasized stability over change, utility over excessive ornamentation, and individuality over homogeneity. In the 1880s a writer for *Cassell's Family Magazine* asserted, "Each month I notice how completely dress is becoming an artistic study. People do not indulge, perhaps, in as many gowns as they used to do; but those they have are very complete, are made to fit and adapt themselves well to the wearer, and show (or ought to show, in order to be a success) that they are the result of a well-grounded knowledge of what is individually becoming."[50] For the audiences of this kind of fashion journalism, dress reform was a serious topic, and the importance of clothing was central.

Female patrons held sway over a widening sphere of influence in dress reform circles. In 1896, Henry Holiday wrote a letter to Miss Osborne, a member of the circle associated with the activities of the Healthy and Artistic Dress Union. Referring to an event in the process of being organized, a production of various clothing tableaux titled "Living Pictures," he wrote, "I have asked the Sec of our Healthy and Artistic Dress Association to send you a few programmes of some 'Living Pictures' we are going to set up in May, illustrating Dress Past, Present, & Future." He then asks her for her social and financial support, suggesting that she promote the event if possible among her society friends and acquaintances. Dropping the name of a common acquaintance and referring to the tableaux in question, he hints: "W. Bedford suggested to me that I should let you know of this undertaking, & mentioned that you 'receive' on Saturday so that the extra day may make a difference. . . . We mean to make them the best of their kind."[51] Of the nine tableaux staged, three were focused specifically on modes deeply influenced by Aesthetic dress reform principles. "Aglaia — the Three Graces" depicted three women in classical dress, bringing to life the exact pose found on the illustrated cover of *Aglaia*, the official publication of the Healthy and Artistic Dress Union. "Pastoral Scene" revealed six women in embroidered costumes holding rakes and three men in smocks carrying scythes. Importantly, this scene was arranged by Walter Crane, an early proponent of picturesque dress reform. Finally, the last "Evening Scene," arranged by Louise Jopling, with dresses supplied by Arthur Lazenby Liberty, featured eight women in Empire-waisted dresses accompanied by seven men wearing velvet suits, knee breeches, and silk stockings.[52] Merg-

ing art, theater, education, and social reform, these staged scenes successfully brought to life the visual impact of dress reform ideals to an eager and attentive audience. Female patrons with social influence were crucial to the success of such ventures.

CONSUMER PLACES AS
TRANSFORMATIVE SPACES

The significance of commercial spaces in terms of women's autonomy and growing sense of cultural power, including the ability to exercise choice, should not be trivialized or dismissed. Although past analyses of Victorian culture have often cited separate spheres as the underlying reason for the political and economic inequality women often faced, more recent scholarship has complicated this picture by emphasizing the interrelatedness of gender-inscribed roles in both public and private spaces. Elizabeth Wilson has pointed out that the private domestic realm, normally associated with the feminine, can be viewed as a male space, since by and large its makeup and functioning were designed to provide for the convenience and comfort of men.[53] Middle-class Victorian women were encouraged to focus on the needs of others and respond to the requirements of domestic settings. The myriad choices they made in day-to-day life can be viewed as somewhat illusory, since these choices were usually based on this agenda of domestic improvement and security. Thus, the home can be viewed as the "workplace" of women, meaning that often, in the pursuit of leisure, they had to go elsewhere. In the 1888 edition of *Woman's World*, an article titled "Women and Club Life" emphasized the importance of club life in providing a level of freedom and autonomy for women. Amy Levy, the author, asserted, "Here is a haven of refuge, where we can write our letters and read the news, undisturbed by the importunities of a family circle, which can never bring itself to regard feminine leisure and feminine solitude as things to be respected."[54]

Conversely, the public realm cannot be seen as specifically male, owing to the fact that increasingly toward the end of the nineteenth century, women were becoming more involved in social and cultural institutions and pastimes, joining clubs, entering colleges, and taking part in the economic mechanisms of modern capitalism through their roles as consumers.[55] More and more, shopping allowed women to move out into public spaces. The development of the department store with its services specifically designed for women — lavatories, cloakrooms, and respectable restaurant spaces that catered to women — meant that women could feel physically as well as ideologically safe in an environment that was public.[56]

Commercial spaces can thus be viewed as partially subversive or liberatory, for they provided an escape from the prescribed roles of mother, daughter, or sister, reified and enforced by the constraints of domestic space. Although the public realm had its own set of regulatory codes for proper feminine behavior, the power of women as consumers was increasingly recognized and catered to. Women could exercise greater and greater choice, under the guise of improving the self and home. According to Erika Diane Rappaport, in the early years of the Victorian era the female shopper was a particularly disruptive figure, since a middle-class family's level of respectability and social position depended on the separation of the women in the household from the "filthy, fraudulent, and dangerous world of the urban marketplace." Increasingly, however, as public spaces catered more and more to respectable female consumers, shopping areas were progressive spaces for women that simultaneously, and sometimes contradictorily, produced and challenged gender roles for women.[57]

Beyond the economic and familial implications of the market for Victorian women lay the importance of popular Aestheticism in the formation of a new leisured breed of female consumer. In her work on fashion and modernity, Wilson has often emphasized the quality of fantasy and transformation that marked the atmosphere of the department store. These new commercial spaces were public and yet also enclosed, clean, safe, and decorated in ways that evoked a sense of private intimacy. Consumer sites were liminal spaces where domestic and public identities lost their hard-edged boundaries.[58] The display and visual array of objects designed for private consumption, such as undergarments, home products, and personal toiletries, further blurred this boundary. For many women, the arcades and shops were spaces where they could visually consume materials, objects, and the latest developments in fashion. They could stroll along, socialize, and enjoy the view of objects, people, and spaces in a variety of comfortable settings, and thus, in a sense, they could appropriate the role of the flâneur.[59] More importantly, the pleasure found in examining, choosing, and purchasing exquisite fabrics and other goods associated with the display of one's personal ideals of beauty would naturally have affected their choices with regard to attire. Commercial spaces were increasingly central for women who shopped for materials or ready-to-wear items associated with Aesthetic dress. Despite the anti-materialism expressed by many of those associated with the Aesthetic movement, consumer culture can be credited, at least in part, with the dissemination of Aesthetic principles across a broader public spectrum.

Retailers capitalized on the growing popularity of Aestheticism by linking consumer choice with artistic sensibility. For those who straddled the worlds of design

reform and commercial profit, the Aesthetic movement provided an opportunity to promote their artistic ideals while exploring and exploiting a growing market for art-decorative objects. Lewis F. Day, in his article "Fashion and Manufacture," asserted that industry should not blindly follow trends in the market: "I am not undervaluing the business side of manufacture, only I contend that the artistic side is of importance too; and the balance between claims artistic and commercial can scarcely be satisfactorily struck until the advocate of artistic interests stands on the same level as the man of business."[60]

Many advocates of consumer culture, like Day, assumed that the importation of artistic principles might benefit industry and the public equally. Some even felt that it might result in social improvement as well, echoing the earlier idealism of the Arts and Crafts movement, whose members were in favor of restructuring the ways artistic objects might be produced and sold. The crucial difference lay in the importance of consumer culture in this later movement for artistic reform. Dorothy Lane, in an article of 1898, endorsed the rising consumerism of fashion, provided that high-quality goods were produced under socially conscious conditions: "When the statement is made, that it is wrong to spend more money than can be helped on dress, it must be admitted in contradiction to this view that money so spent passes through a very great number of hands and has a most beneficial effect on trade, especially if the women who spend it are, as far as it lies in their power, careful to deal only with firms who pay their work people a fair wage."[61] Lane's awareness of the powerful influence that female consumers might wield over the fashion industry indicates the growing power of female choice in the economic structures of capitalism.

What remained highly contested was the use of artistic terminology in commercial spaces. While many in industry felt that art could greatly improve the commercial world of fashion, many felt that the spreading popularity of cheap goods connected with the Aesthetic movement might in the end undermine the truly innovative or artistic art-based manufacturers. Day asserted, "To the producer who does not firmly believe in art I would say, don't pretend to. You will only bring discredit upon the genuine thing, just as vulgar advertisers have sickened us with the word 'Art' as applied to anything and everything."[62] Those who believed in their artistic superiority while still including themselves in the world of industry and commerce feared that the misuse of terminology associated with the Aesthetic movement by less scrupulous retailers might degrade the quality of merchandise available to the artistically discerning shopper.

There was a pronounced desire for alternative clothing expressed by an artistic cross-section of Victorian culture. These were women who were looking for an

alternative to fashionable dress, but who did not have the skills, aptitudes, or resources available to those most closely connected with artistic circles. Early hygienic and rational dress reformers shared many of the same underlying concerns as Aesthetic dressers, as they tried to answer the needs of female consumers interested in alternative forms of dress. A text published by E. Ward and Co., "The Dress Reform Problem: A Chapter for Women," sympathizes with "ladies who, sensible of its advantages, resolve to adopt a reformed style of dress," but who

> are continually hampered by difficulties in having their ideas carried out. In fact, we
> who are in the trade, are probably even more alive than they, to the indifference of the
> trade in general, to any such movement originating outside its pale . . . we think the
> suggestions of a firm of outfitters, who, for the past ten years, have personally worn
> and advocated hygienic clothing, who possess some knowledge of physiology, and who,
> as a matter of business, are continually brought into contact with the experiences of
> many, may be of use.[63]

The call for innovation from a small section of the clothing industry was mirrored and in many way inspired by the activities of groups such as the Rational Dress Society, who in the early years of their exhibiting practices often held up Aesthetic dress as a model of beautiful and hygienic attire. Such garments were cited as examples of what might be achieved from within the clothing industry if more credence were given to women's choices and the growing demands of consumers tiring of the constraining factors of mainstream fashion. In the Rational Dress Association Exhibition Catalogue from 1883, E. M. King stated: "For Dress Reform it is necessary to gain the ear of two parties. If one only is gained, the Reform comes to a standstill. That is to say, we must gain not only those who wear dresses, but those who make them; not only must the demand be created, but the supply produced."[64]

The effort to combine rational values in dressmaking with the social cachet and beauty associated with the Aesthetic movement is evident throughout the journal literature of the 1880s. Even as factions of the dress reform movement became more politicized, there were those who recognized that the best way to bring change to the clothing industry was to educate and alter the values of consumers themselves, particularly those in a position to influence audiences and inspire change. In 1888, a writer for the *Rational Dress Society's Gazette* suggested,

> Further practical help could be given to the movement thus carried out by its more
> wealthy advocates, through the interest with which such action would not fail to inspire
> those pundits of the dressmaking art, who are now, for trade reasons, its enemies.
> Their successful efforts to stamp with some sort of style, and thus popularise rational

ideas, would find place in their show-rooms, and thus bring the matter under the consideration of fashionable customers who have hitherto viewed it with contempt.[65]

Clearly, the Rational Dress Society acknowledged the importance of consumer advocacy in the processes of industry-wide change. Here, the fashion world is seen as a positive force for change, with the potential to aid rather than hinder cultural progress, provided certain high-profile individuals lead the way in supporting and donning the alternative fashions being produced. Through such commercial and social collaboration, the improvement of taste across a wide social spectrum was presented as an attainable goal.

DISCOURSES OF LEISURE:
THE PLEASURES OF CHOOSING

One of the chief attractions of artistic dressing for women lay in its inherent ability to express the personality of the wearer. Criticism of mainstream fashion accused dressmakers and retailers of distorting the female form and simultaneously forcing everyone to abide by the same rigid sartorial structures. Fashion, with its unending and rapid turnover of changing styles, was seen as both homogeneous and needlessly transformative. Threaded through the fashion literature is a growing readership interested in modes of dress that were stable, timelessly beautiful, and expressive of individual aims and tastes. The influence of the art world lay at the heart of the push for change in consumer tastes and preferences. As questions of dress reform began to dominate public discourses on fashion, the struggle between the changeability and novelty of modern fashion was contrasted with the call for utility and stability in dress. A writer for the *Magazine of Art* reasoned,

> Surely we may hope for a costume constructed with due regard to the fitness of things, and to the avocations of the wearer, which shall check the restlessness of fashion and imply a recognition that all which appertains to us, whether in personal attire or domestic surroundings, should be expressive of our individuality, and not of slavish obedience to a code of fashion which disregards the requirements of health and common sense, and imposes on us not only ill-health but ugliness.[66]

Similarly, in a paper given for the National Association for the Advancement of Art in the late 1880s, Lewis F. Day held up past modes of art manufacture as an example of what might be achieved in the nineteenth century: "In whatever art that is of any account you can see the growth. It is the outcome either of antecedent art or of gradual mastery in craftsmanship. With all the variety in old work, you see no evidence of fits and starts and sudden turns of fashion."[67] Later in the

same paper, Day asserted, "Fashion means change. What we want is progress. With fashion forever shifting, improvement is well-nigh hopeless, perfection impossible."[68]

Yet in 1881 in the *Queen*, under the title of "Fashion and Change," a critic, while acknowledging the "capricious and 'fickle'" aspects of fashion, admitted that "the love of change is a law of our nature, and cannot be ignored." While pointing to the allure of novelty, this writer still invested a certain amount of authority in the world of art when she concluded that "while admitting the principle of change, there is no reason why we should not train that natural desire for variety along the lines of good taste. . . . This art-perception is a gift in some people, which, with a little cultivation, enables them at a glance to know what is good from what is meretricious, or merely the imitation of goodness."[69] Comments such as these reveal a growing slippage in the definition and use of artistic terminology in conjunction with fashion. Contested even in the popular media, artful dressing was still seen by many as reserved primarily for those initiated into the rarefied realm of the Aesthetic movement. This increased the desirability of artistic goods and spawned a wide variety of hybrid styles donned by those who positioned themselves along a continuum that ranged from fashionably conservative to unfashionably eclectic in apparel.

Undoubtedly, the publications of Eliza Haweis had a significant impact on the popular understanding of Aesthetic dress by a primarily female readership. Her articles, books, and activities were mentioned frequently in journals during the late 1870s and 1880s. In "The Art of Beauty," she cited artistic taste and an allegiance to individualism as viable antidotes for the slavish following of fashion:

> How difficult it is for a woman to be really well dressed, under the existing prejudice that everybody must be dressed like everybody else! This notion of a requisite livery is paralysing to anything like the development of individual taste, and simply springs from the incapacity of the many to originate, wherefore they are glad to copy others; but this majority have succeeded in suffocating the aesthetic minority, many of whom are now forced to suppress really good taste for fear of being called "affected."[70]

In her writings, she encouraged women to decide for themselves what was most suitable, useful, and beautiful. Her praise for individualism in fashion was largely mediated by her views on art and design reform, where she privileged Aestheticism. In "The Art of Beauty," she argued that "it is the People that must originate, that must discriminate, that must encourage Art. . . . We cannot all hope to develop into Turners, Burne Joneses, Wagners . . . yet the mother of originality is freedom. . . .

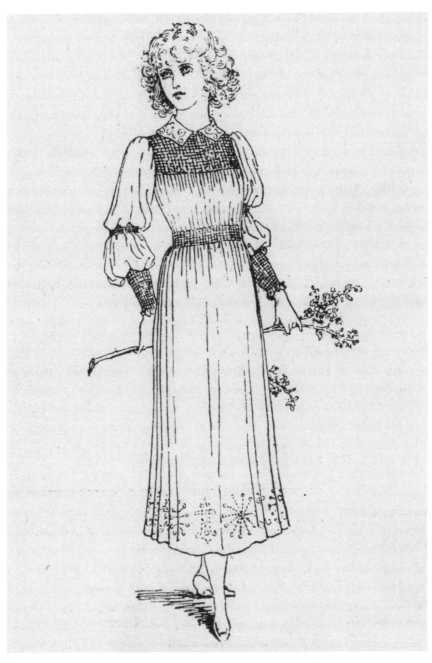

FIGURE 4.12 Illustration of an artistic gown for a
young girl, Messrs. Stephens and Co., *Home Art Work* 7, no. 32
(April 1890): 9. National Art Library, Victoria and Albert Museum.

In dress, in home-adornment, in every department of art — regardless of derision, censure, and 'advice' — WE MUST DO AS WE LIKE."[71] This sentiment was repeated elsewhere in the fashion literature. In the *Magazine of Art*, the writer of the article "Colour in Dress" compared dressing to "composing a picture, and as we are not all artists, we are not all happily attired."[72] By implication, the central message of many critiques of mainstream fashion points to artistic culture as a viable guide for the tasteful and original construction of the sartorial self.

Public demand for increased choice was cited as a major factor behind the spread of popular Aestheticism in industries connected with the decorative arts, including fashion. Shopping as a form of both leisure and artistic expression became a central theme in the journal literature aimed at middle-class women interested in participating in the wider climate of design reform. This interest was reported on and celebrated frequently in the popular journals connected with fashion, the decorative arts, and the domestic art world in general. In the journal *Home Art Work* for April 1890, an article titled "A Fairyland of Fabrics" praised the firm of Messrs. Stephens and its artistic presence on Regent Street:

> Day by day the windows of 326 Regent Street, and the adjoining establishments are arranged in such a manner as to afford a perfect feast of delight to the eye trained to appreciate the lively shades of colour that can now be produced by the blending together of such dainty Eastern fabrics as are offered for sale by the Messrs. Stephens, and a walk through the galleries of their establishment is a pleasure which should be enjoyed by all who wish to attire themselves, or adorn their apartments, with textiles absolutely perfect in colouring and manufacture.[73]

Later in the article, suggestions were given for fabrics to be used in the making of artistic gowns, as well as information about ready-made artistic gowns, mantles, and hats available for purchase. Also emphasized was their ability to supply sketches and designs by an artist in their employ who could cater to the wishes of customers. By way of illustration, one of the sketches available at Messrs. Stephens, for an artistic gown for a young girl, was reproduced for the *Home Art Work* journal (figure 4.12). With its squared-off panel of smocking at the top of the bodice, double-puffed sleeves, and simple straight skirt, the whimsical design of the dress recalls the illustrations of Kate Greenaway. Further, the languid pose, upturned gaze, loose hair, and graceful stance of the figure holding a leafy branch behind her is reminiscent of the body language and pose of the standard Aesthetic maiden in myriad genre paintings of the period.

The frequent descriptions of goods on display in the windows of various clothing and fabric establishments present the items arrayed for visual pleasure as a

series of artistic tableaux where artistic colors, textures, and compositions appeal to the "trained" eye of the artistic consumer. For Valerie Steele, such theatrical displays of goods were designed to appeal to the fantasy life of consumers as well as the belief in the potential of shopping for personal transformation.[74] This was reinforced by the journal literature; even when humor was used to point out the link between Liberty's and the extravagances of the artistically inclined, shopping was presented as central to the experience of artful consuming. In an article titled "Shopping in London" featured in the 1889 volume of *Woman's World*, the author declared authoritatively that

> Liberty's is the chosen resort for the artistic shopper. Note this lady robed in "Liberty silk" of sad-coloured green, with rather more than a suspicion of yellow in ribbons, sash, and hat (suggestive of a badly-made salad), who talks learnedly to her young friend — clothed in russet-brown, with salmon-pink reliefs showing in quaint slashings in unexpected places — of "the value of tone," of negatives and positives, of delicious half-tones, and charming introductions of colour, fingering the while the art-stuffs and fade silks shown her with a certain amount of reverence expressive of the artistic yearnings of her soul.[75]

Liberty's department store was increasingly influential in the rise and spread of Aestheticism in terms of commercial consumption. Such was the artistic importance of Liberty's that the journal *Aglaia* recommended the store's catalogs, as well as related texts like *Form and Colour* (illustrated by Liberty and Co.), as valuable sources of information on Aesthetic dress.[76]

Liberty's cultivated an artistic clientele by advertising in periodicals like the *Artist and Journal of Home Culture*. In the June 1, 1881, edition, an advertisement for Liberty's lists a range of exotic and artistic fabrics in the latest Aesthetic colors: "Persian Pink, Venetian Red, Terra Cotta, Ochre Yellow, Sapphire and Peacock Blue, Sage, Olive, and Willow Green, Soft Brown, Warm Grey, Drab, Old Gold, &c."[77] Color and its use for the expression of mood and emotion in the Aesthetic movement were often highlighted in advertising for Aesthetic materials and goods — the rarefied pleasure in seeking out, experiencing, and purchasing such unique wares was assumed, as was the unquestioned ability of Liberty's to answer every need of artistic living and dressing. Further, this belief was reproduced and reinforced in the fashion reportage of these journals as well. In the article "Colour and Dress" featured in the 1882 volume of the *Magazine of Art*, the author noted the folly of fashionable hues or colors "of the season" that suffer in obedience to the latest "dictates of fashion, without the slightest regard to fitness or propriety." In contrast to this trend, the author of the article praised Liberty's for its timeless

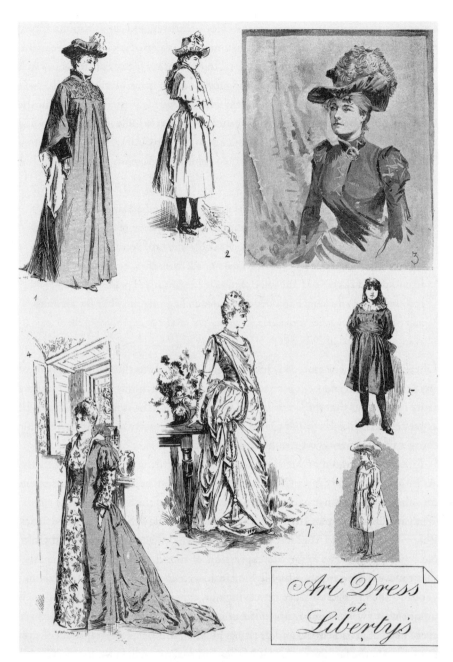

FIGURE 4.13 "Art Dress at Liberty's," *Lady's Pictorial*
16 (October 6, 1888): 351. Courtesy of Toronto Public Library.

and tasteful colors that would never go out of season or be inappropriate for a given setting or event: "Fortunately there are some shops yet — as Brunet's [sic] and Liberty's — where you can buy old-fashioned colours; so that you may still practise in your own garments a refreshing change from the general livery."[78]

Proponents and supporters of artistic dress praised Liberty's for its approach to manufacturing as well as its conscientious use of materials in keeping with the spirit of artistic and healthy dressing. In 1883, the Rational Dress Association provided this testimonial:

> Messrs. Liberty have made it their special study to revive the materials so much in favour with ancient Greece, having at the same time due regard to the requirements of modern times.... In these days of adulteration, it is difficult to detect at first sight of what many textile fabrics are really made. Liberty's Art Fabrics are pure — silk is called silk, and may be depended upon to justify its name.... Liberty's Art Fabrics might almost be said to be without finish, inasmuch as they are totally free from any of the processes so often resorted to in order to impart a genuine appearance to false materials.[79]

Many fashion journalists also noted Liberty's industry practices, which allowed for a high level of artistic quality and innovation. In 1881, a writer for the *Queen* reported on the newest Mysore printed silks available at Liberty's, stating that, "most of the designs printed on them are taken from the original wood blocks in the Indian Museum, of which exact reproductions have been produced. The silks are thin, and the designs and colors characteristic of their Eastern origin." A final seal of approval was given when the fashion critic concluded, "The aesthetic world will delight in them, and for dresses or upholstery, or indeed for any purpose where a soft draping fabric is required, they would be suitable and uncommon."[80] It is crucial to observe that the repetitive notices, advertisements, and journalistic reports favoring Eastern, exotic, or archaic techniques in the production, dyeing, and finishing of fabrics for artistic dress designs solidify and centralize orientalist narratives and the tendency toward medievalism/historicism found in representations of goods available at Liberty's.[81]

Liberty designs were frequently described and even illustrated in the fashion press, where such descriptions were clearly aligned with Aestheticized principles of dress and home decoration. The *Lady's Pictorial* reminds us, in 1888, that "whatever the season of the year may be, one may be sure of finding at Liberty's garments which are so beautiful in colour, and so artistic in design, that they form a perfect feast for the eyes, and linger in the memory long by reason of their graceful beauty.... In the matter of really artistic dress Liberty remains unrivalled."[82]

Accompanying this description was a full-page illustration of several models of Aesthetic dress available at the store (figure 4.13). Among them was featured an "autumn mantle of terra-cotta cashmere, reaching from throat to feet in lovely unbroken lines" (figure 4.13 upper left). The long angel sleeves were described as "lined with silk of the palest salmon pink, toning well with the terra-cotta cashmere, while the collar and the long tight-fitting undersleeves of plush are in a still darker shade of the same colour." The use of various shades of one color was an aspect of Aesthetic taste that Liberty's capitalized on and featured in many of its designs. Also on the same page was an example of a "graceful and original tea-gown of nut-brown Venetian silk" (lower left) as well as an evening gown in "soft white china silk, gracefully arranged with classical Greek draperies, the bodice being outlined with a white silk cord entwined with tiny pearls" (middle). All designs were notably artistic, the tea gown with historical referents, and the white gown based on oriental and classical models in terms of textile choice and finishing, although it echoed a fashionable silhouette in cut and overall appearance. Importantly, a range of styles was featured on the same page — encouraging choice and showing consumers a range of Aestheticized garments.

The tea gown was a sartorial category especially favored by artistic stores such as Liberty's. In these gowns, innovation was possible, since they were primarily intended to be worn in the home, and thus were less subject to the social censure that might be experienced in the public realm. Allowing for more creativity in personal adornment, they represent one of the largest sections of clothing in mainstream fashion influenced by Aesthetic dress design principles. Exploring and indulging their fantasies, women could examine, choose, and purchase finished gowns or the materials to construct such gowns. Commercial spaces like Liberty's encouraged sartorial play and enjoyment. Particularly in the way that these items of clothing were displayed in the public spaces of consumer culture, alternative forms of dress were potentially subversive, destabilizing accepted notions of appropriate and inappropriate dress for women, a theme I address more closely in the next chapter. Steele has argued that Aesthetic dress became more acceptable once it ceased to carry exclusive connotations to particular artistic communities or to the loose and immoral dress of neoclassicism. Further, she asserts that the fad for Aesthetic dress in the 1870s was ultimately "less significant than the more gradual adoption of artistic dress for private occasions in the wearer's home. The tea-gown, for example, played an important role in the development of new styles of dress."[83] Thus, it was the gradual adoption and acceptance of garments like the tea gown into mainstream fashion that changed the popular perception of artistic dress.

The Artful Containment of the Aesthetic Female Body

In the closing years of the nineteenth century, critics and writers began to document a growing instability in dress among the fashionable elite. They recorded new levels of anxiety and concern over what constituted good taste in clothing and, throughout the 1880s, targeted the tea gown as an emblem of questionable taste and propriety. As noted in the 1890 *Woman's World*,

> Life in the nineteenth century becomes more and more complex, and this is demonstrated as much as anything in the matter of dress. Twenty years ago you needed a morning-dress, a visiting-dress, a low-necked dinner-dress, and a ball-gown, the number of each of these garments being decided by individual requirements. Now women dress for dinner in as many ways as the meal is served. Low gowns, half-high gowns, or tea-gowns which are akin to dressing-gowns, or tea-gowns that closely resemble the revised Court bodice inspired by the modes of mediaeval times — all these are popular, and you have to know the habits of your host and hostess when you pack your trunks for a round of visits.[1]

As such, the tea gown came to be seen as an unstable and evolving garment, its creativity, changeability, and flexibility frequently linked to the development of Aesthetic dress. Characterized by their looseness, comfort, and adherence to classical and medieval dress ideals, artistic and creative versions of tea gowns designed for use exclusively in the home shared much with Aesthetic forms of outerwear. Both Aesthetic dress and artistic tea gowns were perceived as a healthy, beautiful, and refined alternative to mainstream fashionable dress of the same period. Yet while these kinds of garments shared roots in earlier forms of artistic dress reform, as well as in garments worn in Pre-Raphaelite circles from the 1850s to the 1870s,

the connection between them was most fully developed in the 1880s in relation to the concurrent Aesthetic movement in the fine and applied arts. During this decade, Aesthetic dress was often used as a model for fashionable tea gowns. Such garments were intended to be worn in the privacy of one's home and were viewed as a respectable form of "undress" worn between social calls, or outside of shopping trips and the formality of dressing for dinner. However, despite continuous support for dress reform by health practitioners and design reformers, Aesthetic dress fell out of favor in the late 1880s and '90s. Ironically, it was increasingly associated with ill health and lax morality because of its association with the perceived decadence and excessiveness of the Aesthetic movement in its later incarnation.

In this chapter, I am primarily interested in how this transformation took place. I will examine some of the key discourses that effected this change, and point to the importance of the tea gown as a crucial site for the instantiation of embodied forms of Aesthetic display and individuation. The pronounced critique of Aesthetic dress by mainstream Victorian culture in response to its widespread popularity in the early 1880s bears investigation, especially in light of the fact that in an era of growing decadence in the fine and applied arts, the body occupied a key position in the writings of cultural theorists and critics, who questioned the adoption of Aesthetic principles in daily life. I will look at how the female body operated as a contested site wherein the ideological function of clothing in relation to art was mapped and fought over within Aestheticism. In the process, I will speak to the importance of the tea gown as both an individual and mass manifestation of sartorial innovation, adaptation, and even resistance to mainstream cultural norms.

To better understand why Victorian culture rejected Aesthetic dress — and looser-fitting tea gowns as an example of this practice — we need to consider several key cultural impulses. The first is the tendency in the literature of the period to generate an opposition between "rational" or "healthy" dressing, and "fashionable" dressing. A pervasive rhetoric of health and beauty tended to focus its critique on the practice of tight-lacing within a smaller subset of popular fashion culture as a deviant and extreme form of corsetry. Elsewhere, the moderation or absence of corsetry was noted within Aesthetic and dress-reform circles. Thus, in the early stages of dress reform among the intellectual elite, the rejection of tight-lacing was shared by bohemian reformers as well as conservative factions of mainstream fashion culture. This uneasy alliance in principle masked deeply contradictory constructions of femininity within Victorian culture.

Second, the ascendancy of the tea gown as a popular yet frequently criticized article of clothing was closely linked with notions of female leisure and Aesthetic dress principles. On the one hand, the corporeal aspects of Aesthetic dress allowed

it to become an important site for Aesthetic principles as an embodied practice. The popularity of the tea gown and its perceived ability to express the authentic identity of the wearer imbued it with symbolic significance for many consumers of Aesthetic culture, not only among artistic groups but more broadly in a variety of cultural settings.

Finally, changing definitions of naturalism in Victorian culture affected the view of art's relation to the self and society in the later stages of the Aesthetic movement. By extension, this complicated the perceived authenticity of Aesthetic dress as an embodied practice. Progressively, as Aestheticism came under fire within the art criticism of the period as an excessive, decadent, and an ultimately corrupt mode of artistic expression, so too was Aesthetic dress interrogated as the expression of an unnatural and deviant body and self. Examined in relation to one another, these histories realign the meaning and importance of the tea gown in mainstream fashion culture, rendering it a useful case study through which to analyze the complex and somewhat ironic conflation of cultural discourses linking notions of ill health and lax morality with the Aestheticized body and, by extension, Aesthetic dress.

THE ISSUE OF TIGHT-LACING

The Victorian corset debate centered on notions of appropriate sartorial etiquette as well as health. An important distinction existed between the wearing of corsets and the practice of tight-lacing, which was considered by the vast majority of critics, writers, and cultural commentators to be outside the realm of desirable or normal female behavior. Recurring instances of critical writing opposing tight-lacing indicate that regardless of whether or not it was being practiced by a visible portion of fashionable dressers, its symbolic potential was far-reaching and significant. Those who disapproved were often divided in their primary motivation for opposition and critique. Most proponents of dress reform based on creative and artistic principles disapproved of tight-lacing on the grounds of both health and beauty. In 1893, Ada Ballin used scientific terminology to outline natural bodily processes and the normal functioning of internal organs to explain the health risks of tight-lacing. Her final argument, however, rested on standards of beauty in order to promote the advantages of healthy codes for dressing: "We want in dress to obtain the maximum of health with the maximum of beauty. If our girls were taught the laws of health and a few of the principles of art as known to the ancient Greeks, they would soon see 'what a deformed thief this fashion is,' and would laugh at the squeezed-in waist."[2]

More conservative objectors also questioned the use of corsets but added moral-

ity to the mix, associating the practice of tight-lacing with the moral and spiritual decline of Victorian women. It was often suggested that women, overly concerned with their waists, were willful and vain to the point of folly. In an 1883 issue of the *Girl's Own Paper*, an article titled "Correct Clothing, and How It Should Be Made" dictated the terms of appropriate sartorial behavior for an audience of young girls: "We know that high principle and good taste are their two best safeguards against the temptation of producing a smaller waist than Nature gave them. Fortunately, Society has also come to our aid, and public opinion comments pretty strongly on those unfortunate girls who have 'made figures' for themselves."[3] This rejection of young women who flouted convention points to a wider intolerance of any behavior that exceeded the accepted boundaries of proper Victorian etiquette.

Like other extreme or unusual forms of sartorial expression, wearing Aesthetic dress challenged socially acceptable norms and practices. Ironically, women who subscribed to tight-lacing and women who rejected the use of corsets or stays of any kind both received the same type of vehement cultural criticism, despite the differing positions and often oppositional logic behind such clothing choices. This highlights the symbolic importance of tight-lacing, not as a form of bodily mutilation, but rather as an example of physical and sartorial display that was considered deviant or unnatural by Victorian standards — an objection that would later be applied to the Aestheticized body, both in artistic representations and in terms of Aesthetic dress.

The clothed body has often been discussed in terms of social control, its multiple facets and expressions constructed through specific cultural discourses and practices. Drawing on the work of Pierre Bourdieu and Maurice Merleau-Ponty, Joanne Entwistle has proposed a theory of sartorial embodiment that accounts for the ways in which people understand and perceive the world through their bodies. She argues that the body is located in a specific time and in particular places — and is thus as historically situated as other aspects of the "self" in the formation of subjectivity.[4] The notion of the disciplined and controlled female body in Victorian culture immediately conjures images of a nineteenth-century fashionable woman, rigidly conformist and physically restricted by the ubiquitous corset. However, the tight-lacing debate in the nineteenth century was extremely complex and cannot be simplified into a formula where the restricted body signals oppression for women and the unrestricted body signifies female empowerment and agency. Valerie Steele and Elizabeth Wilson have both pointed out that the use of extreme forms of corsetry, such as tight-lacing, was often viewed as a symbol of sexual empowerment, expression, and cultural transgression.[5] Despite this potential, in the literature and visual culture of the period, polarized notions of

freedom and constraint were mobilized in a strategic effort to fix fluid and chang-ing gender boundaries and expectations, resulting in the corset becoming highly politicized. References to this debate abound in the dress reform literature, fashion journals, arts-related magazines, and medical texts of the period. The opposing terms of health versus ill health, and naturalism versus artificiality, were binaries on which the discourses of art, beauty, and femininity hinged. They inflected cultural products in both the art world and across the wider Victorian social strata, with the corseted body often forming the focal point in the debate.

Artistic, medical, and moral arguments were often employed together across a variety of literary genres in defense of moderation. Comparing the ideal of the classical nude, naturalized in Victorian culture, with the body of modern women shaped by their dress, Luke Limner wrote, "Take an antique Venus, pure as the day, and pare her down to the fashionable dimensions of a modern corset, and see how the chastity of divine truth would depart, and feelings of disgust and im-modesty usurp their place."[6] Thus, the tight-laced body, imagined unclothed as a nude, was linked with sexual excess and immorality as well as ill health. The fact that the discourses of health, art, and beauty were all conflated and mobilized in the debates for and against the use of the corset became increasingly significant as dress reform and Aesthetic dress began to gain favor in the 1870s.

Paradoxically, though the natural and unrestricted body served as an ideal for many dress reformers and wearers and makers of Aesthetic dress, there was a growing tendency in the 1880s to associate Aesthetic lifestyles and artistic products with deviance and licentiousness. Originally linked with health and mobility, this mode of attire was increasingly viewed as indicative of spiritual and physical illness as well as questionable morals. The Aesthetic body was not one body, but must be understood as signifying a range of representational strategies across a broad spectrum of cultural practices and discourses. Rather than being a homogeneous category of clothing, Aesthetic dress, particularly in its later manifestations, was fragmentary, fought over, and "owned" by various groups and individuals, mobilized for specific and often contradictory reasons. It was a much contested practice, its discursive expressions as complex as other forms of fashionable and/or rational dress reform, and must be understood as such in order to assess its role in gender construction and the agency of women in Victorian culture.

THE TEA GOWN AS SARTORIAL CIPHER

I want to consider the role of the corseted waist in the form of fashionable dress-ing most closely related to Aesthetic dress: the tea gown. It has been argued that

the tea gown and Aesthetic dress both originated from an earlier type of indoor garment, variously understood as a wrapper, dressing gown, or peignoir. Mary W. Blanchard, in her work on Aesthetic dress, suggests that the tea gown of the 1880s was the latest and most close-fitting version of the earlier wrapper, a "one-piece dress, adjustable and loose down the front with many variations." Further, she links the tea gown of the 1880s with Aesthetic dress by claiming that both were derived from the uncorseted version of the wrapper, "often with a puffed shoulder and loose sleeve that made use of elaborate fabrics in aesthetic colors (sage and Venetian green, brick red, blue-green, yellow, and dove gray)."[7] The tea gown was often subject to the influences of artistic innovation and dress reform, since it was worn within the privacy of the home where public scrutiny was at a minimum. Tea gowns were consistently cited in the fashion literature as privileging female comfort and leisure over all other concerns. This expressed goal often coincided with the stated aims of Aesthetic dress, which also emphasized comfort, but ultimately focused on intellectual and artistic refinement and pleasure.

As artistically inspired tea gowns gradually became an acceptable way of dressing for fashionable women, the use of the tea gown expanded — often it would be worn at times other than teatime, particularly for hosting dinners at home. In the 1880 volume of *Cassell's Family Magazine*, a fashion commentator noted that "tea-gowns have come to be the accepted style of dress for home dinner wear, and these are often made up with the Watteau plate."[8] By the 1890s, many fashion writers disagreed with the designation of "tea gown" for attire worn at dinner, since many of these gowns differed little from fashionable dinner wear. One writer asserted: "Many 'tea-gowns,' as they are unfairly called, for they are worn principally at dinner-time, are made of magnificent brocades on a plain or corded satin ground, silk and velvet blending in the floral design."[9] Much of the confusion around the tea gown stemmed from an understanding that properly corseted underclothing was a requisite component of outdoor clothing.

The issue of corsetry and its use or rejection in tea gown design/construction is as complex and multifaceted as the tight-lacing controversy itself. There is evidence that many fashionable tea gowns were as heavily boned and tight fitting as other forms of feminine dress at the time, meaning that they were worn primarily for reasons of etiquette and convention rather than comfort and utility of function. Many of the gowns designed by the house of Worth, for example, represented the blending of mainstream fashion with artistic innovation and were intended to be worn with a corset. However, throughout the fashion literature of the 1880s, the tea gown was consistently praised as a garment that was both elegant and comfortable

precisely because of its potential to be unstructured, with designs that could be worn without a corset, or at the very least would allow for the loosening of one's stays before the formality of evening wear. With its connection to the corsetry debate, the tea gown often came under attack when issues of proper dress and morality were being discussed.

As a site of conflict and resistance, where female comfort and pleasure were both celebrated and contested by a range of cultural commentators, the tea gown represents a crucial area of artistic exchange between reform principles and developments in the mainstream fashion world. Tea gowns, originally worn at home between trips out visiting or shopping, and dinner, were designed to be comfortable. Yet they also presented an opportunity for many women to express themselves and their ideas about aesthetic beauty through dress. Valerie Steele has argued that in mainstream fashion, dresses deemed inappropriate for outerwear were often used as models for indoor tea dresses,[10] highlighting the exploratory potential of the tea gown as a creative mode of attire through which women might convey their personal preferences. In addition, since afternoon tea was normally viewed as a time when upper-class women might indulge in leisure or rest, sometimes attended by an intimate circle of friends or guests, the tea gown was associated with female pleasure and sociability. It is crucial to note, however, that the Victorian identification of domestic space with the feminine signals the overdetermined meaning of the tea gown. There is a tension between perceptions of the Victorian home as, on the one hand, a comfortable and empowering realm for women, and on the other, a limiting geography of physical and ideological control and containment. The tea gown, therefore, with its emphasis on female comfort, placed in a setting that was subject to a range of gendered discourses in regard to domestic space, had the potential to express the complexities and inconsistencies of changing standards of beauty and sartorial decorum within the home.

Dress and design reformers celebrated the tea gown for its comfort and ability to accommodate hygienic underclothing, and thus used it as a model for other forms of rational and Aesthetic dress that might be worn outside the home. In 1883, the Rational Dress Association held an exhibition of hygienic and rational clothing — Grace et Cie of London supplied a garment that was featured in the catalog (figure 5.1). Though somewhat crudely drawn, the illustration reveals a "dinnerdress" that is more reminiscent of fashionable tea gowns of the period — albeit more loosely constructed. Elsewhere, an author for the *Magazine of Art* noted dress reformers' insistence "on the minimum amount of underclothing being worn, so as to diminish weight." Describing a combination of garments worn by a rational dresser, the author went on, "Over this is worn a boneless or very light form of

No. 9.
DINNER DRESS.
(*Exhibited by* GRACE ET CIE.)

FIGURE 5.1 Dinner dress, Grace et Cie, London, 1883.
*The Exhibition of the Rational Dress Association, Catalogue of Exhibits
and List of Exhibitors* (London: Rational Dress Association, 1883),
No. 9. Library of Congress, Washington, DC.

NATURE PROPOSES, BUT THE CORSET DISPOSES.

FIGURE 5.2 Henry Holiday, *Nature Proposes, but the Corset Disposes*. From "The Artistic Aspect of Dress," in *Aglaia* 1 (July 1893): 21–22. National Art Library, Victoria and Albert Museum.

corset. . . . Mrs. Pfeiffer wears a perfectly plain princess dress, made much like a tea-gown — of silk, velvet, cashmere, and so forth."[11]

For advocates of Aesthetic dress such as Henry Holiday, the president of the Healthy and Artistic Dress Union, the offenses of tight-lacing were many, but even the most rational and comfortable corsets were viewed as incompatible with the principles of graceful and beautiful attire. *Aglaia*, the official journal of the union, contained articles, illustrations, and reportage of current events that focused on artistic and Aesthetic forms of dress reform. In a series of drawings accompanying a lengthy article, Holiday demonstrated the inflexibility of the corset and the way in which it hampered both the easy movement of the body and the graceful curvature of the spine (figure 5.2). In describing his illustration he stressed the lack of harmony between the corset and the body in motion: "Though a well made corset may agree with the form of the figure when it is perfectly upright and the hips and shoulders facing exactly in the right direction, the agreement ceases with the least curvature or revolution of the body."[12] For Holiday, the chief attraction of Aesthetic dress was that it allowed the easy and free movement of the female body, thereby enabling the graceful display of its natural forms, not just in a static position, but in motion as well. Thus, the tea gown, one of the

few articles of fashionable Victorian clothing that might appropriately be worn without a corset in the comfort of one's home, exhibited many of the same attributes as Aesthetic dress.

The growing popularity of the tea gown as a creative and comfortable form of attire is well documented in the mainstream fashion literature as well as in artistic circles. In the early 1880s, comfort and convenience seemed to be the chief concerns for tea gown designs. In 1880, a fashion writer criticized the use of the princess dress as a model for tea gowns: "the Princess dress, especially when fastened at the back, is not easy or convenient enough for a tea-toilette, whose chief characteristics should be comfort."[13] This is significant, since the majority of fashionable tea gowns were made in this style. In the 1888 volume of *Woman's World*, a columnist discussed the latest fashion in tea gowns, noting the growing demand for mobility and comfort and concluding that, importantly, such garments "could be worn without stays, as tea-gowns all originally were."[14]

Into the late 1880s and early 1890s, creative sartorial expression surpassed comfort as the central motif in tea gowns, particularly in journals such as *Woman's World*, which, though it had a limited run, was edited by Oscar Wilde and as such suggests the presence of Aestheticism in mainstream fashion culture. Comfort and convenience were still emphasized, but a growing fascination with the decorative potential of these dresses was evident as well. In an 1890 illustration (see figure I.6) previously discussed in the introduction, three tea gowns, very different in cut and construction, reveal individual approaches through the distinctive use of textiles and decorative effects. Their stylistic variability signals a call for novelty and transformation. In the same 1890 volume, a fashion writer discussed the garment's longevity and creative possibilities: "Tea-gowns are still the favourite dress of many elegant women. The loose unconventional robe is not influenced by the last decree in fashion, and the wearer's personality seems to have scope for freer expression in this picturesque garment."[15] Elsewhere, under "Paris Fashions," a critic reports that internationally, tea gowns are "more and more in favour. . . . It is the time to wear a gown of easy fit, lending itself to a certain picturesque individuality."[16] In these descriptions, an artistic awareness of uniqueness and distinction is prized and, moreover, closely linked to ideas of comfort and utility.

Popularized through such journals as *Woman's World*, *Ladies' Pictorial*, *Lady's Pictorial*, and the *Queen*, tea gowns allowed fashion-conscious women to indulge their interest in Aesthetic models of dress reform. In 1898, Dorothy Lane celebrated the tea gown as a category of dress that easily lent itself to personal imagination and artistic taste.[17] This partial acceptance from the mainstream fashion world likely encouraged self-proclaimed Aesthetic dressers, who were well versed in the

worlds of artistic and/or reform dressing, and who would have viewed the tea gown as a chance to illustrate their virtuosity and creativity before carrying their designs out into the public realm.[18] In 1890, the *Artist and Journal of Home Culture* featured a detailed description of a tea gown:

> Of the many beautiful tea-gowns that have come to us this season from the Paris Exhibition ... was [one] made like a "Directoire" coat with a long train and a "Medici" collar in crimson cashmere, having a band of gold Indian embroidery.... The underdress, or front, merely consisted of plain folds of cashmere falling from the neck to the feet and just kept in to the figure by means of two narrow straps of embroidery crossing diagonally from the shoulder to the waist on either side ... The sleeves were of cashmere, full to the elbow and slashed with gold.[19]

The historical references, use of luxurious fabrics, harmonies of color and texture, and "exotic" techniques for the embroidered sections all rendered this tea gown supremely artistic, partially explaining its inclusion in an article entitled "Art in the Home." For such writers, the tea gown was more than a mere fashion category, or article of clothing; it was the requisite example of artful embodiment in the domestic spaces of the home.

However, while selected examples from the rhetorical world of journalism positioned the tea gown as a powerful cipher for female individuality, in other places a consideration of the category of the tea gown reveals the effects of hegemony, and an increased pressure for a normalized Victorian femininity across mainstream fashion culture. In truth, the majority of illustrated tea gowns do not look all that different from outdoor, day, or visiting dresses. Stylistic differences are subtle, limited to detailing or decorative effects. One example taken from the *Queen* in 1881 (figure 5.3) depicts a typical fashionable tea gown, worn by the figure on the right. Beside it, the front and back view of a morning robe is presented by the figure on the left. Except for the decorative mantle and the length of the gowns, they do not look all that different in terms of cut or construction. Both follow the close-fitting silhouette of the fashionable princess line, use copious amounts of lace down the front of the gown, and both have narrow, close-fitting shoulders (although it is difficult to discern the exact construction of the sleeves for the morning robe, as it is covered by a short waist-length cape trimmed with lace). The tea gown is open in the front, and has a continuous line of lace down the front and is also slightly fuller in the back of the skirt, with a train suitable for indoor use. More importantly, aside from this one feature, the design of the tea gown, and indeed, of both gowns, differs little from dresses designed to be worn outdoors.

Despite these subtleties of stylistic difference, many mainstream fashion journals

FIGURE 5.3 Morning robe and tea gown illustrated in *Queen* 69
(March 12, 1881): 258. National Art Library, Victoria and Albert Museum.

used the terminology of the Aesthetic movement in order to highlight particular features or creative aspects of otherwise fairly straightforward fashionable tea gowns. For several decades, fashionable and artistic tea gowns existed side by side and, in some cases, as discussed in the previous chapter, converged to form a third, hybrid class of gowns, which were typically fashionable in construction but which also referred to the details, fabrics, and finishings of artistic or reform gowns. Thus, although they incorporated many details of mainstream dress such as the corset and bustle, they also might have featured the use of Liberty's printed and silk fabrics, small puffs and gatherings in the sleeves, smocking, or the addition of a Watteau panel (for a typical example, see figure 5.4). On a continuum between conservatively fashionable and rigorously Aesthetic, there appeared a large number of tea gowns that utilized standardized methods of construction supplemented with surface details of an artistic nature. This strategy of deploying Aesthetic terminology in mainstream fashion circles indicates that not only was

No. 15A. THE WATTEAU TEA GOWN.

FIGURE 5.4 Tea gown illustrated in
Queen 68 (1880): 129. National Art Library,
Victoria and Albert Museum.

Aesthetic culture subject to commodification, but that the terms of its definition were fought over and contested.

THE CORPOREAL PRACTICES OF AESTHETIC DRESS

Aesthetic models for tea gowns were ultimately valued for their comfort as well as their ability to communicate an advanced and individual artistic sensibility. It cannot be denied that the pictorial imagery from the Aesthetic movement suggests that women were mostly intended to adorn the spaces they occupied. Below this surface assessment, however, a much more complicated picture emerges. Women were engaged in a broad range of artistic activities and pastimes throughout the closing years of the nineteenth century and were clearly interested in the shifting boundaries of artistic culture. Aesthetic dressing was one route through which this interest in Aestheticism was enabled and even encouraged. Its defining feature was that it was a facet of Aesthetic culture that was sartorial as well as corporeal, able to link one's body directly with an artistic environment. In the 1870s, Eliza Haweis asserted that women's clothes should be designed and worn as art pieces, similar to other beautiful objects in the realm of the fine arts. More importantly, Haweis privileged an artistic sensibility of harmony, line, proportion, and color in clothing as well as in domestic interiors. Thus, the artistically inspired tea gown can be viewed as the requisite dress of refined taste, since it was intended to be worn in the context of Aestheticized domestic space. Its function was related to its suitability as an appropriate container for the Aesthetic body; its comfort and mobility meant that it had a sensory impact beyond its visual appearance. The wearer herself was at the center of Aesthetic dress, experiencing the unrestricted, graceful, and unencumbered folds of drapery as well as the natural-waisted comfort of her attire.

Mainstream fashion, in opposition to Aesthetic dress, was positioned by dress reformers and aesthetes as a negative foil for distinctive and erudite dressing. The tea gown, as much as it was an unstable and evolving genre, was nevertheless used in journalism to connote the creative and fashionable potential of clothing to answer the individual needs and desires of women. While modes of outerwear such as the divided skirt and the bloomer costume might combine fashion and dress reform, they were too politically charged, their design ideals and usefulness lost for the majority of middle-class consumers amid a storm of political debate and controversy. The tea gown, though hotly debated in the fashion literature, allowed for a certain flexibility and attention to artistic detail that was enabled rather than compromised by its inclusion as a viable category in mainstream fashion. Thus,

while many fashionable tea gowns still utilized the corset, other models allowed for more experimentation, and ultimately, it was this sartorial free play and dialogue that made the tea gown appealing to women interested in both mainstream fashion and Aestheticism. Moreover, the interest in Aesthetic culture displayed by mainstream fashion critics and writers indicates an opening up of categorical boundaries in fashion culture, and a growing acceptance of creative and exploratory modes of sartorial expression.

Not surprisingly, this growing experimentation, along with the encroachment of the tea gown on other, more stable categories of fashionable dress for dinner, visiting, or elsewhere, was met with censure and cultural anxiety. Objections to the tea gown centered not on those models that were laced too tightly, but rather, those that were seemingly not laced up at all. In an 1881 issue of the *Queen*, a reviewer for fashions worn to a theater opening condemned Aesthetic dresses that were too loose, particularly those based on classical dress and made with soft material that hung in "clinging folds" revealing "too clearly all the curves of the limbs and figure."[20] The use of the tea gown outside appropriate times and spaces was criticized for the same reason. In 1888 a writer for *Woman's World* heralded the rising popularity of the tea gown worn at teatime for its comfort and ease, but warned against its adoption for dinner wear: "In London they are the fashion for home dinner wear, and probably this is why they are made at all events to appear to fit more closely than they originally did. It is not considered that they are in good style if in any way they suggest a dressing-gown or wrapper."[21] Elsewhere, another moralist commented on the use of the tea gown for dinner wear: "Lazy, illogical women have come to attire themselves in the same manner for the dinner-table and the theatre, thus making this pretty garment a decided solecism."[22]

Discussions surrounding the proper use of the tea gown in the journal literature ultimately centered on the duality of the corseted and uncontrolled female body. Notions of good taste and appropriateness of dress were highly debated, with competing discourses on health and morality coming into play. Mainstream fashion journalists linked the abandonment of form-fitting clothing with degenerate thinking and questionable morals. Aesthetic details in tea gowns or evening wear were often contrasted with more proper and appropriate modes of attire for fashionable women. In 1881 a commentator for the *Tailor and Cutter* described the difference in tailoring of inner and outer wear with some perplexity:

> At the present time Ladies will not tolerate anything cut loose or slovenly in the way of tailor made garments of the Jacket class. Though at the same time puffs and frills and other flummeries, such as the "Watteau" training business . . . is de rigueur for

evening wear. But as we have stated with regard to outdoor or walking costume, it is different. Ladies will be fitted well in every respect. . . . We are assured by some of the highest class firms, that costume sleeves in particular, must be made as tight as a glove, in short, a skin fit without a crease or a wrinkle anywhere.[23]

This journal, along with others charting the rise of tailored clothing for women, indicates a concern with good fit, and a growing tension in the market between structured and unstructured models of feminine attire. For such fashion writers, the comfort and ease of certain tea gowns indicate a high level of bodily looseness and laxity — the effort to contain sartorial modes within definable and accepted behavioral boundaries proves that the issue went beyond any one category of clothing. The tea gown was merely one categorical site, a convenient focal point on which to graft social anxieties regarding the physical status of women in Victorian culture. In 1898 a critic reminded readers that "decency in dress means fitness for its purpose as well as its secondary and restricted meaning of modesty." Further, while the commentator allowed for a measure of creativity, it was seemingly allowable only when not contravening moral codes, which were presented as self-evident and fully justified: "Fashion of course modifies all styles hygienic, athletic and ornamental, yet without changing the fundamental principles as to the fit and fair in any of them, and any infringement of these principles leads only too surely in the direction of vulgarity."[24] Elsewhere, adding pathology to the list of suspected failings of nonnormative dressing, in 1890, E. Aria declared, "To dress well is to dress becomingly, consistently, and appropriately in regard to time and place, age and social condition. . . . The dress of a woman reflects her discernment and love of the beautiful, and harmonious and appropriate costume is invariably the index to a well-ordered mind."[25]

Advocates of tight-lacing and dress reformers interested in Aesthetic dress both shared a disregard for the accepted practice of corsetry in its moderate, fashionable, and widely practiced form. Mainstream Victorian culture tended to naturalize dominant and current social values, and thus any form of deviation from these norms would have been viewed as unnatural. The treatment of tight-lacing was the most obvious example of the discourses on health and beauty working to position the too-fashionable woman as socially deviant. In many respects, the same process progressively affected wearers of Aesthetic dress, despite the fact that Aesthetic dress reformers and mainstream fashion culture both used the discourses of health to support their principles of tasteful dressing, and shared much rhetoric in the vilification of tight-lacing. The tea gown, as the garment that crossed over both fashionable and design-reform circles, became the garment that

most clearly articulated these tensions and contradictions. Further, it provides the best case study through which to critically engage with and identify the competing discourses and shifting social categories in Victorian culture aimed at fixing the boundaries of "proper dress."

NATURALISM AND THE DENIGRATION
OF THE AESTHETIC BODY

Based on the widespread rejection of tight-lacing, which was held as morally corrupt and physically damaging, one would think that Aesthetic dress might have been viewed as the ideal antidote. Examining the theoretical writings of Aestheticism reveals a love of naturalism and a valorization of spiritual values that were also evident in much of mainstream culture as expressed through the fashion literature of the period. From its origins, Aesthetic dress linked the notions of the nobility, naturalism, and grace of the female form with the principles of good health. As discussed earlier, Henry Holiday defined the aim of the Healthy and Artistic Dress Union as "the promotion of what is beautiful, healthy, and useful in our dress." Further, he asserted that beauty implied healthfulness and utility, stating that "beauty cannot exist along with disease or unfitness. Harmony is the essence of beauty; disease implies a failure in the harmonious working of the system, and anything which tends to destroy this harmony strikes at the root of beauty."[26] Never was the question of beauty in dress considered without invoking the justification of health and utility, and this was an argument repeated often throughout the dress reform literature of the period. Logically, this should have endeared the wearers, makers, and promoters of Aesthetic dress to a larger Victorian audience, but this did not happen, owing to the growing perception of Aestheticism as an unhealthy attachment to the "beautiful" at the expense of social and cultural utility. Thus, the view of Aestheticism as a movement toward art for art's sake at any cost was largely the result of the ways in which Aestheticism was perceived by a wider Victorian public, rather than based on the actual writings and practices of those involved with Aestheticism.

As much as naturalism was held up as an Aesthetic and spiritual value by many dress reformers, its definition as a function of physical health or moral standards was in continuous flux, especially outside Aesthetic circles. Joanne Entwistle has argued that a romantic understanding of the "natural self" informed the attitudes of many Aesthetic dressers, particularly those interested in Pre-Raphaelite art, where a rather simple understanding of the connection between nature and the body presented the self as a unified whole. Thus, I would argue that the awareness of

the body as culturally defined was partially disavowed by the majority of Aesthetic dressers, who sought to return to an organic mode of physical being that might "truly" express their individual personalities. However, this naturalized body used in the discourses of health and art was a cultural contrivance, a device used in arguments for and against artistic reform. Naturalism was a conflicted philosophical arena; discourses of art, health, and morality interacted and occasionally collided, with objects often functioning as the focal point of such debates. Consequently, "natural" forms of dressing must also be seen as constructed and, therefore, an expression of cultural attempts to modify or represent the body in specific ways.[27]

It was this ambivalent framing of the natural body that ultimately led to the denigration and spurning of the Aestheticized body and, by extension, Aesthetic dress. In 1887, a writer for the *Artist and Journal of Home Culture* commented, "Around the altar of Naturalism crowds an ever-increasing throng of earnest adorers.... To sacrifice truth for the sake of pictorial effect is held to be inexcusable."[28] Thus, one contested aspect of naturalism involved notions of conventional and appropriate uses of nature in pictorial endeavors; the debate centered on what aspects of nature were chosen and their suitability for artistic contemplation and representation. Consequently, a moralistic brand of naturalism was often employed where selective aspects of the natural world were despised and rejected based on assertions of what was right, good, and appropriate subject matter for art. What was acceptable on a moral level was considered the rightful outcome of a "healthy" kind of naturalism, and conversely, what was considered undesirable or questionable on a moral level was attacked as symptomatic of an unhealthy naturalism verging on morbid sensuality.

Many critics saw an important distinction between the naturalism of the Pre-Raphaelite Brotherhood of the 1850s and the conception of naturalism implicit in expressions of the movement in subsequent decades. The critic Harry Quilter claimed that the early practitioners' idea of "painting occurrences as they happened, emotions as they actually appear, and nature as it actually looks, had practically disappeared." The later Pre-Raphaelites' approach to naturalism, he went on, has been "rightly accused" of having an "unworthy" project that "inculcated a philosophy of life and morality out of which it was impossible that healthiness of thought or feeling should come."[29] Thus, the accepted Victorian view of naturalism was one that was largely mediated by prevailing social values overly concerned with questions of morality.

Throughout the 1880s, Aestheticism, often linked with later developments in Pre-Raphaelite art, was increasingly understood as an epicurean approach to life, and for many this signaled an emphasis on Aesthetic dress as a form of idle

pleasure, a pleasant pastime of visual display and perusal, ultimately leading to nothing. As early as the late 1870s, the critical literature surrounding the art shown at the Grosvenor Gallery was positioning second-wave Pre-Raphaelite art as occasionally symptomatic of lax morals and an unhealthy focus on the sensuous and corporeal aspects of beauty. The Grosvenor Gallery, as a locus of both Aesthetic painting and dressing, was presented in the literature as a space of visual spectacle and display, where Aesthetic individuals were on exhibition as much as the art itself, circulating in the public realm and communicating a studied commitment to an artistic lifestyle. Quilter extended his critical views of Aesthetic art production to those who consumed and produced Aesthetic culture, characterizing them as a "Gospel of Intensity" and claiming that "the evil is spreading from pictures and poems into private life; it has attacked with considerable success the decoration of our houses, and the dresses of our women."[30]

A trend in art criticism toward viewing the painting of Grosvenor favorites such as Edward Burne-Jones as melancholic, self-indulgent, sensual, and corrupt indicates a growing intolerance toward Aestheticism in the literature of the period, and an insistence that such art was morally bankrupt or incapable of lofty ideals. The perceived perversion of naturalism was the chief objection to such work, in which the female body was viewed as both naturalistic (from the standpoint of verisimilitude) and corporeal (and therefore sensual). The focused attention on forms of beauty that were unhealthy or tainted coincides with the social construction of an Aesthetic body that is at once sensuous and malevolent in some way, while at the same time passive, limp and depressive. Quilter, in discussing *Laus Veneris* by Burne-Jones (figure 3.1), wrote that although the work was very beautiful, it also had an "enervating and depressing" effect on the viewer. Further, he asserted that the type of beauty offered in the work was of a "sad, weary, hopeless" kind.[31] Frederick Wedmore, another prominent art critic of the period, identified the figures in the work as intensely sensual, summarizing their fleeting type of beauty as the result of "yearnings not to be gratified because they are insatiable." For Wedmore, this type of beauty was indicative of disease and immorality, the signs of which were visible on the surface of the body itself. Analyzing the figure of Venus, he characterized her body as "unpleasant and uncomely, and the soul behind it, or through it . . . ghastly." Linking the inner dimensions of the figure with its exterior appearance, he concluded that the soul had known "strange tortures" and that the body therefore "writhed with every impulse of sickness instead of health."[32]

The overwhelming emphasis of dress and textiles in this painting points to the importance of Aesthetic dress in the symbolic framing of the body in this work. The looseness of the gowns, high natural waists, and presence of a Watteau panel

in one of the figures establish this connection. Yet critical reviews of the work at the time it was exhibited focused on the bodies and made little mention of the dress, despite the fact that by this time, such clothing was easily recognizable as a picturesque interpretation of actual forms of Aesthetic dress worn on real bodies, particularly in the form of artistically inspired tea gowns. Thus, although originally intended to be a form of attire as healthy as it was beautiful, Aesthetic dress eventually became linked in the minds of the public with notions of ill health and lax moral standards. This reversal of the original meaning and function of Aesthetic dress was the result of shifting discourses on the Aesthetic body, and is clear evidence of the cultural anxiety surrounding notions of the uncontrolled female body in late Victorian culture.

The fact that themes of illness and disease were linked with Aestheticism and, by extension, Aesthetic dress, is ironic, since Aesthetic dress was, in point of fact, closer in construction to rational, moderate, and hygienic forms of dress than to fashionable models. Perhaps not surprisingly, shortly after the popularization of Aesthetic dress in the early 1880s, many proponents of rational and hygienic dress reform actively disassociated themselves from artistic forms of sartorial redress, further tilting the cultural discourses on health with regard to dress away from Aestheticism. While early political forms of dress reform and early models of Aesthetic dress shared many motivations and qualifications for what constituted healthy and beautiful dress, by the 1890s there was a distinct break between these groups, with many dress reformers rejecting Aestheticism on the basis of its highly contested status with regard to health and morality. Instead, tailor-made costumes suitable for walking or cycling became the focus.[33] While dress reform utilized rationalism and the authority of the medical professions to establish the acceptability of looser forms of clothing intended for activity and mobility, ultimately the theories behind Aesthetic dress were more fragile and open to attack. This was primarily because Aesthetic dress, though it shared an emphasis on the free motion of the body, was based on the precepts of beauty, sensuality, freedom (both intellectual and artistic), and pleasure. Within Aesthetic circles, health was understood as a natural byproduct or in some cases a precursor of these qualities. This point was progressively lost amid the normative Victorian rhetoric of naturalism and femininity, which ultimately prevailed over competing and alternative ideologies. Ultimately, Aesthetic dress fell out of favor, not merely because of the changing tastes of artistic and fashionable dressers, but because of a wider denigration of the Aesthetic body in the visual and material culture of the period, which ultimately implicated Aestheticism in the growing Victorian preoccupation with illness and moral corruption.

CONCLUSION

The Value of
Aesthetic Dress

As I have shown, the image of the Aesthetic dresser in British visual culture varied widely and was at times contradictory. Representations of this figure, both visual and textual, ranged from idealized depictions of an advanced and authentic individual with rarefied artistic tastes to less positive views of the female aesthete as mannish, deviant, or intensely artificial. A key aspect of Aesthetic dress was the flexibility and changeability of its meaning over the course of its development. This is no doubt partially due to the fact that dress is perishable and easily replaceable and thus responds quickly to changing social requirements and standards. Stella Mary Newton has argued that the dress of the upper classes in particular "has always responded more quickly than any of the other applied arts not only to changes in the social pattern but even to the first idealistic theories that have preceded them."[1] This was certainly the case with Aesthetic dress. More than any other form of the decorative arts in Aesthetic culture, dress responded quickly to the changing sensibilities of Aesthetic practitioners. Further, the ceaseless change and restless quality of fashion practices more generally were also felt in response to Aestheticism. Such changeability allowed clothing to reflect shifts in social consciousness with a rapidity absent from other venues of the decorative arts. Self-reflexive and malleable, Aesthetic dress was an important mode of critique that exemplified "the intensity of the mid-nineteenth century's fervour for social reform" and in so doing resulted in the creation of new fashions.[2]

Yet the same currents that allowed dress to be acutely sensitive to shifts in artistic culture also meant that such fashions were transient and inherently individual and eclectic. This is especially true within Aestheticism, which emphasized subjective responses to art rather than judgments of art based on social consensus or academic tradition. Aesthetic dress was the site of the wearer's negotiation of broader standards of taste within Aestheticism and an individual's reception and

exploration of taste as an embodied practice. The complex relationship between standards of taste based on class groupings, and Aesthetic standards of taste, which partially obscured the nuances and distinctions of class-based fashion choices, indicates the symbolic potential of Aesthetic dress for subverting social norms and practices. As fashion was often gendered "female" and seen by many as an acceptable mode of expression and social power for women in the nineteenth century, its alteration along ideological lines would have been symbolically potent. My interest in Aesthetic dress is not based on whether it was actually socially subversive with regard to class boundaries — rather I am interested in the perception that this was possible within Aestheticism, that the imposition of a new caste system might be based on artistic values rather than purely economic ones. Thus, the visual potential of Aesthetic dress to connote the possibility of class mobility is significant primarily for what it reveals about the principles of Aesthetic dress as an avant-garde challenge to social norms and institutional practices.

Fashion was a mode of cultural consecration in the nineteenth century: modernity and the competing needs of different groups and social classes produced rapid transformations in dress that resulted in the use of clothing as a means of social empowerment.[3] Aestheticism affirmed the relative independence of a particular segment of the Victorian art world by providing an alternative route to artistic freedom and innovation, diverging from the entrenched discourses of the Royal Academy and more traditional academic art institutions and practices. Aspiring to a romantic ideal of authentic experience and seclusion from the unenlightened masses, Aestheticism enjoyed the prestige connected to the art market while denying the presence of commerce in its realm by cutting itself off both physically and symbolically. Retreating to erudite settings such as the Grosvenor Gallery or the privacy of the artistic households of friends, Aesthetic elites created their own spaces of leisure, often in contrast to public or academic settings. For Bourdieu, the "capital of consecration" invests objects with symbolic meaning and value in support of a cultural economy that is at the same time largely disavowed.[4] Aesthetic dress was an example of this disavowal in practice, since it sought to address an erudite audience and referred to artistic matters seemingly above market values, commercial concerns, and the demands of patrons. Though the "art for art's sake" stance of some forms of Aesthetic dress might be questioned, its emphasis on the importance of a purified Aesthetic realm over all other considerations was subversive of normative class structures in Victorian culture, at least in principle. Yet, at the same time, it often called for the creation of a new aristocracy of taste, which in some ways created alternative hierarchies of social standing and position. What can be said is that while certainly still excluding the poorest classes who

had little access to Aesthetic modes of art and living, Aesthetic dress did allow a measure of flexibility and social opportunity for those who wore it.

Perhaps more significantly, the reframing of artistic values within Aestheticism reveals the important role of taste in the formation of visual preferences. Taste was a determining factor in the portrayal of Aesthetic dress as well as its reception. The contested nature of Aesthetic dress as either a tasteful or tasteless form of dressing, depending on the perspective taken, reveals the arbitrary nature of taste itself, as well as its function in the mechanisms of social distinction. Hermetic standards of taste were used by various artists and intellectuals to establish the advanced status of their work and to garner artistic and social prestige. Although this is an important facet of how Aesthetic dress came to be defined in its original Pre-Raphaelite and Aesthetic contexts, I believe that notions of taste had more significant ramifications in terms of the dissemination and alteration of artistic values as Aesthetic dress became more widely known. The construction of taste in Aesthetic culture was fleeting, contradictory, and at times unstable, providing Aesthetic dressers with important cultural flexibility. If a central feature of social empowerment involves choice and agency, then the fluid nature of taste with regard to Aesthetic dress allowed for an impressive range of approaches and practices in its reception and actualization. It also helps explain the rapid absorption and deformation of certain aspects of Aesthetic dress in mainstream fashion culture as well as its growing appeal among diverse audiences.

However, the spreading interest in Aesthetic dress among a wider public had the unintended effect of challenging some of the very mechanisms of social and cultural critique that it originally sought to exemplify. As noted, Aesthetic dress played a significant role in the self-definition of Aesthetic elites. It was designed and worn by members of the Aesthetic movement, where it functioned as a form of artistic inscription. Its representation in paintings, illustrations, and design reform manuals signaled its importance as a visual barometer of Aesthetic taste and sensibility. Aesthetic dress came to signify certain esoteric or erudite artistic ideals through an expressive and symbolic language of sartorial gestures, historical referents, and effects of drapery, form, and color. In this way, Aesthetic dress was prevalent in reconstructed imaginings of the past and in contemporary notions of feminine beauty as well. It functioned as a point of negotiation between academic depictions of the female body based on fantasy, historicism, or classicism and new and emerging forms of artistic practice that utilized modern depictions of the female body in contemporary artistic dress. Its increasing presence in the print material of a wider fashion audience indicates its impact on individuals outside this erudite setting, and the authority of artistic discourses in this process. This explains

why the rhetoric of artistic dress and Aestheticism remained symbolically potent long after its guiding principles in terms of construction and application had been lost, adulterated, or otherwise inflected by the conventions of mainstream fashion.

I have outlined the commercialization and popularization of Aesthetic forms of dress in the visual and print culture of the period. Because of the fluid and transformative nature of commodity culture and its cultivation of female consumers, the importation of Aesthetic dress into mainstream culture allowed, however briefly, for a flowering of female creativity in the marketplace of art-related goods. The picture is not as simple as this, of course. Erika Rappaport has summarized consumer culture studies as falling mainly into two broad categories: those that favor the notion of the commercial world as wholly emancipatory for women (a view that tends toward idealizing the entrepreneurial successes of capitalism) and those that devalue and feminize consumerism as a passive response to an active male marketplace (one that is productive of social meanings, and therefore manipulative and wholly prescriptive).[5] Thus, it is necessary to qualify a purely laudatory position on the role of Aestheticism in consumer culture and its ultimate impact on women. Despite the influence of Aesthetic dress on mainstream fashion, its mediation and ultimate absorption by mainstream culture altered and sometimes obscured its basic premises. This shift resulted in a growing hybridization of style and purpose in artistic dressing, as well as debates over what constituted authority and taste in popular iterations of Aesthetic culture. However, in the final analysis, the growing influence of Aestheticism on consumption enhanced women's experiences of, and participation in, the mechanisms of modernity in late nineteenth-century popular culture.

Similarly, Aesthetic dress as an embodied practice deeply influenced by and connected with visual culture would have raised awareness among women with regard to their own bodies as important sites for symbolic interaction and display. Because of the long historical association between female experience and discourses on the body, female subjects have a heightened awareness of themselves as bodies in space.[6] I would argue that women in Aesthetic circles had a doubly heightened awareness of their bodies since they were surrounded by imagery and representations of the Aestheticized female body in the works of art around them and experienced a sense of themselves as artistic objects of contemplation and display. While this is certainly true of any artistic setting in the history of European art where female imagery helped define artistic space, it is worth noting the specific dimensions of this relationship in Aestheticism. Given the central signifying function of the feminine in Aestheticism and the repetitive association of the female body with a range of literary, mythic, and idyllic themes, representations of women

in Aestheticism must have had special significance for women who identified with this imagery. However, the understanding of oneself as a potential Aesthetic object could not have completely obscured women's experience of themselves as embodied subjects within Aesthetic culture. Nor would it negate the agency they possessed with regard to the importance of the feminine and the domestic in Aesthetic settings. It can be argued that this seemingly contradictory position is partially resolved with the creation of Aesthetic dress where the wearer both enacted herself as a creative work and presented herself as an image of Aesthetic idealism — in essence synthesizing the subject/object split that had characterized the position of female viewers in relation to academic art throughout the nineteenth century. This assertion is possible only if one considers the act of Aesthetic dressing as a form of artistic production. If Aesthetic dressing is indeed considered as such, a theoretical space is enabled wherein Aesthetic dress can be seen as much more than simply a representation of the Aestheticized female body through dress, or the mimicking of historical models of dress by avid artistic audiences.

The Aesthetic body enshrined in Aesthetic dress was a highly charged site for corporeal negotiation, resistance, and reform. Yet the refusal of many Aesthetic dressers to conform to Victorian standards of conventional clothing practices enhanced the popular perception of eccentric forms of dress as marginal and morally suspect. In an age where modest forms of corsetry were the norm, those who tight-laced and those who went without the corset were viewed with equal suspicion. The issue of the corseted body, from the extreme manipulation of tight-lacing to the gentle support provided by "hygienic" or "rational" forms of corsetry, involves many of the cultural discourses that also influenced Aesthetic dress. There was a constant tension in the fashion literature between the uncontrolled and morally lax body, sometimes linked with Aesthetic dress, and the licentious and vulgar body, usually constricted through tight-lacing. Forming a strange alliance, radical Artistic dress reformers and conservative right-wing cultural pundits often shared the view that tight-lacing had unnatural and horrific effects on the female body. They both advocated the banishment of tight-lacing, though for very different reasons and with very different proposed alternative forms of dress in mind. Thus, Victorian women had to work within a narrow and highly codified range of options to fall within the dictates of appropriate sartorial and corporeal convention.

What is important to remember is that while the tailor-made outfit of the 1880s and '90s would come to form the template of respectable dress for the emerging professional woman, the New Woman, and the suffragette, it would still be worn with a corset and would conform to accepted Victorian values of morality and decency. This was likely strategic within political circles and was well-suited to

the fight for legitimacy among organized feminist circles focused on economic and professional equality for women. What is also true, however, is that Aesthetic dress in its most extreme form was equally valuable in creating the conditions for social change and for providing an alternative route for the enhancement of female pleasure, power, and agency through more creative and exploratory avenues. Despite its adulteration and hybridization by mainstream fashion culture, in its original formations and in the early writings of design reformers, it signaled a call for artistic change and invited creative women to explore notions of embodiment and sartorial play. Such excursions would open the door for the artistic experiments in dress in the avant-garde circles of the early twentieth century. Art nouveau, Secessionism, Orphism, Dada, and later surrealism, are just a few examples of artistic movements that benefited from the spirit of creative dress reform first proposed in Aesthetic circles.

Perhaps the preeminent value of Aesthetic dress lay in its emphasis on diversity and individual choice for women. In the late 1870s, Eliza Haweis remarked on the influence of Pre-Raphaelite dress on contemporary standards of beauty:

> Those dear and much abused "pre-Raphaelite" painters, whom it is still in some circles the fashion to decry, are the plain girls' best friends. They have taken all the neglected ones by the hand. All the ugly flowers, all the ugly buildings, all the ugly faces, they have shown us have a certain crooked beauty of their own, entirely apart from the oddness which supplies the place of actual beauty sometimes, and is almost as attractive.[7]

This acknowledgment of the transformative powers of clothing, particularly modes informed by an aesthetic sensibility and a commitment to individual taste, establishes the historical importance of Aesthetic dress. Beyond standard notions of beauty, artistic values privilege other visual signifiers of worth and expand the boundaries of the beautiful itself to become more eclectic, more inclusive, and ultimately more open to revision and reform.

Looking back, I believe there are still lessons to be learned from nineteenth-century artistic circles and their related clothing practices. I would argue that this potential for art and dress reform to challenge conventional value systems is still relevant today. The popular framing of beauty remains deeply inflected by notions of class, gender, and race, but seems to be most clearly defined by discourses of health and the body. Individuality in dress is something we still prize, and yet ironically, though on the surface postmodern fashion suggests a plethora of forms and is suggestive of diversity and individual choice, in practice, high fashion remains prescriptive and dictatorial with regard to the looks of a particular season or the designers and colors that are considered "in fashion." More alarming still is

the physical internalization of a narrow set of beauty ideals that have caused the fashioned body of the twenty-first century to be impossibly thin and tall. Only a small minority of genetically fated individuals ever attains this ideal, and even then, Western culture's obsession with youth delimits and constrains pictorial depictions of beauty even further. One glance at any fashion magazine of today reveals the absurdity of sixteen-year-old girls donning fashions intended to be bought and worn by much older women. That we live with the specter of lost youth constantly nipping at our heels is one of the great tragedies of our age. It reveals the disturbing possibility that we have not really progressed from the nineteenth century in our efforts to democratize fashion, expand the boundaries of choices for women, or answer the needs and requirements of women's comfort and mobility. While the clothes of today may be convenient, malleable, and able to move with the body, it is the notion of the fashionable body itself that remains in need of reform.

NOTES

INTRODUCTION

1. For an important discussion of the connections between Aesthetic culture, social reform, and Victorian philanthropy, see Diana Maltz, *British Aestheticism and the Urban Working Classes, 1870–1900: Beauty for the People* (Houndmills, Basingstoke, UK: Palgrave Macmillan, 2006).

2. Elizabeth Siddall's name was changed to "Siddal" following her introduction into the Pre-Raphaelite circles surrounding Rossetti. In a landmark essay by Griselda Pollock based on research compiled by her and Deborah Cherry, the significance of such textual and visual revisions into the lives of many of the women associated with Pre-Raphaelitism is examined. Pollock argues that in the creation of the name Siddal, the historical person born with the name Siddall ceased to be as important in the writings and theories of the Pre-Raphaelites as the iconic image she presented, and the representation of her life and art as symbolic of Pre-Raphaelite ideals of femininity and beauty. See Griselda Pollock, "Woman as Sign in Pre-Raphaelite Literature: The Representation of Elizabeth Siddall," in *Vision and Difference, Femininity, Feminism and the Histories of Art* (London: Routledge, 1988), 91–114.

3. Although the term "Aesthetic dress" was most frequently used in the late 1870s and '80s, the terms "Pre-Raphaelite dress" and "Artistic dress" were also utilized, sometimes interchangeably.

4. This exemplar of Aesthetic dress in art was first highlighted in the work of Stella Mary Newton, who published a seminal text on dress reform in the nineteenth century. See Stella Mary Newton's *Health, Art and Reason: Dress Reformers of the 19th Century* (London: John Murray, 1974), 50–51.

5. Alexandra Palmer has pointed out the necessity of balancing theory with the careful study of material culture. See Alexandra Palmer, "New Directions: Fashion History Studies and Research in North America and England," *Fashion Theory* 1, no. 3 (1997): 297–312.

6. For a useful analysis of social groupings in the art world and the processes by which standards of taste and the authority of art are formed, see Pierre Bourdieu, *Distinction: A Social Critique of the Judgment of Taste* (Cambridge, MA: Harvard University Press, 1984), and *The Field of Cultural Production: Essays on Art and Literature* (New York: Columbia University Press, 1993).

7. The notion of "art for art's sake" has a long history in Aestheticism, from the early writings of Théophile Gautier to those of Matthew Arnold, Walter Pater, and Oscar Wilde, all of whom were significant for the development of a purist approach to Aestheticism. Significantly, they had varying perspectives on the role and meaning of art in culture. Pater, in his 1873 text *Studies*

in the History of the Renaissance, spoke of the "love of art for art's sake" and the need to "burn with a hard, gem like flame." The immense following this book inspired among those involved with the Aesthetic movement points to the importance of this central image of the aesthete whose passion for art subsumes all material concerns. In general, however, an art-for-art's-sake stance promoted the notion that art should exist in and for itself, above social, religious, or moral prescription.

8. Joanne Entwistle, *The Fashioned Body: Fashion, Dress and Modern Social Theory* (Cambridge: Polity Press, 2000), 108–9.

9. Bourdieu, *Field of Cultural Production*, 82–83.

10. For a critical overview of Bourdieu's theory of habitus in relation to the body and fashion, see Entwistle, *Fashioned Body*, 35–37.

11. Dianne Sachko Macleod, *Art and the Victorian Middle Class: Money and the Making of Cultural Identity* (Cambridge: Cambridge University Press, 1996), 289.

12. Charlotte Gere, *Artistic Circles: Design and Decoration in the Aesthetic Movement* (London: V&A Publishing, 2010), 131.

13. Macleod, *Art and the Victorian Middle Class*, 280.

14. T. J. Jackson Lears, *No Place of Grace: Antimodernism and the Transformation of American Culture, 1880–1920* (New York: Pantheon Books, 1981), xiii.

15. Ibid., xiv.

16. For broader arguments dealing with the role of modernity in fashion, see Christopher Breward, *The Culture of Fashion* (Manchester: Manchester University Press, 1994).

17. Ilya Parkins and Elizabeth M. Sheehan, introduction to *Cultures of Femininity in the Modern Period* (Lebanon, NH: University of New Hampshire Press, 2011), 1.

18. Regenia Gagnier, "Productive Bodies, Pleasured Bodies: On Victorian Aesthetics," in *Women and British Aestheticism*, ed. Talia Schaffer and Kathy Alexis Psomiades (Charlottesville: University Press of Virginia, 1999), 280.

19. Kathy Alexis Psomiades, "Beauty's Body: Gender Ideology and British Aestheticism," *Victorian Studies* 36 (Fall 1992): 32–33, 37, 48.

20. Diana Crane, *Fashion and Its Social Agendas: Class, Gender, and Identity in Clothing* (Chicago: University of Chicago Press, 2000), 1.

21. Entwistle, *Fashioned Body*, 21.

22. Ibid., 24–28, 40, 76.

23. Elizabeth Wilson, *Adorned in Dreams: Fashion and Modernity* (Berkeley: University of California Press, 1987), 9.

24. Numerous scholarly studies explore discourses of the body with regard to female subjectivity as well as analyzing the historical split between mind and body in Western culture and its social ramifications for women. Of relevance to my study are Catherine Gallagher and Thomas Laqueur, eds., *The Making of the Modern Body: Sexuality and Society in the Nineteenth Century* (Berkeley: University of California Press, 1987); Ludmilla Jordanova, "Natural Facts: A Historical Perspective on Science and Sexuality," in *Nature, Culture and Gender*, ed. Carol MacCormack and Marilyn Strathern (Cambridge: Cambridge University Press, 1980); and Elizabeth V. Spelman, "Woman as Body: Ancient and Contemporary Views," *Feminist Studies* 8, no. 1 (Spring 1982).

CHAPTER I. DRESS REFORM AND THE AUTHORITY
OF ART IN VICTORIAN AESTHETIC CULTURE

1. What was considered "modern" in the nineteenth century usually connoted what was up-to-date and novel. Many forms of artistic culture that would now be considered antimodern, or even historicist, were considered modern in the nineteenth century. Thus Pre-Raphaelite art, in its original phase, was considered to be on the cutting edge and quite avant-garde by some critics, and regressive by others, depending on the perspective and set of artistic principles applied. In dress reform and fashion culture, the category of the "modern" is even more problematic, as "modern" modes were usually tied to the marketplace and to the commercial fashion world; but the term was also used to describe new or highly inventive styles, many of which came out of a dress reform context (the bloomer costume, the dual or bifurcated skirt model, and in some cases, Aesthetic dress itself).

2. Edwina Ehrman, "Women's Dress," in *The Cult of Beauty: The Aesthetic Movement: 1860–1900*, ed. Stephen Calloway and Lynn Federle Orr (London: V&A Publishing, 2011), 206. See also Sophia Wilson, "Away with the Corsets, on with the Shifts," in *Simply Stunning: The Pre-Raphaelite Art of Dressing* (reprint, Cheltenham: Cheltenham Art Gallery & Museums, 1996), 20.

3. Elizabeth Wilson, *Adorned in Dreams: Fashion and Modernity* (Berkeley: University of California Press, 1985), 209.

4. Stella Mary Newton has argued that the prototype for this type of gown, represented in a pen-and-ink study by Dante Gabriel Rossetti in 1846, probably belonged to Christina Rossetti. See Stella Mary Newton, *Health, Art and Reason: Dress Reformers of the 19th Century* (London: John Murray, 1974), 31.

5. When examining a range of photographs from this series, it becomes clear that Morris is in fact wearing two different dresses: one more unstructured and fuller in the back, the sleeves tight at the wrists; and the other belted at the waist with pleats at the shoulder seam, and ornamental cuffs folded back at the wrists. See Diane Waggoner, "From Life: Portraiture in the 1860s," in *The Pre-Raphaelite Lens: British Photography and Painting, 1848–1875* (Washington, DC: National Gallery of Art, 2010), 102.

6. Charlotte Gere, "The Art of Dress, Victorian Artists and the Aesthetic Style," in *Simply Stunning: The Pre-Raphaelite Art of Dressing*, ed. Sophia Wilson and Jonathan Benington (reprint, Cheltenham: Cheltenham Art Gallery & Museums, 1996), 17.

7. Jonathan Benington, in catalog for *Simply Stunning: The Pre-Raphaelite Art of Dressing* (Cheltenham: Cheltenham Art Gallery & Museums, 1996), catalog no. 24, p. 59. Benington states that the collaboration between Jane Morris and Rossetti in the design of the dress is made clear in some of his earliest surviving letters to her.

8. Eliza Haweis, "The Art of Dress," in *The Art of Beauty and the Art of Dress* (New York: Harper & Brothers, 1878, 1879; reprint, in a single volume, New York & London: Garland, 1978), 98. Haweis herself uses the term "Pre-Raphaelite" and also addresses its misapplication to a wide range of artistic products. In describing this process she asserts that the term became "one of the nicknames that invariably attach to every reaction in its early days."

9. Walter Crane, "On the Progress of Taste in Dress, in Relation to Art Education," *Aglaia* 3 (Autumn 1894): 7–8.

10. *Artist* 1, no. 4 (April 15, 1880): 111. The Pre-Raphaelite Brotherhood, formed initially in 1848, included Dante Gabriel Rossetti, William Holman Hunt, and John Everett Millais — later it extended its reach to include others, but these were the original founding members. William Michael Rossetti once stated that "the movement was partly one of protest and partly one of performance; protest against the general intellectual flimsiness and vapid execution of British Art in those days, and performance in the way of serious personal thought in invention and design, and serious personal minute study of Nature as the solid substratum of all genuine execution." Quoted in Henry Treffry Dunn, *Recollections of Dante Gabriel Rossetti and His Circle*, edited and annotated by Gale Pedrick (London: Elkin Mathews, 1904), 83–84.

11. Early on, Rossetti's work was associated with symbolism, primarily for its erotic allusions. Henry Treffry Dunn, in charting the diverging careers of original Pre-Raphaelite members, wrote that "Rossetti, on the other hand, pursued beauty as his main object, combined with ideal or symbolic suggestiveness." Dunn, *Recollections*, 84.

12. Lucy Crane, *Art and the Formation of Taste: Six Lectures by Lucy Crane* (London: Macmillan and Co., 1882), 5–6.

13. G. F. Watts, "On Taste in Dress," *Nineteenth Century* 13 (January–June 1883): 45.

14. Ibid., 46.

15. Ibid., 49.

16. Lucy Crane, *Art and the Formation of Taste*, 127–28.

17. *Artist and Journal of Home Culture* 6 (June 1885): 183. In this quote, the term "fashion" is presented in a positive light — an interesting deviation from the vilification of fashion by almost all other proponents of dress reform. It is important to note that in the context of many fashion and home decorating journals, the use of the term "fashion" is inclusive; that is, it includes various forms of aesthetic and artistically inspired modes and styles. The opposition between *fashionable* and *artistic* forms of dress is a distinction that is generally made in the art and design reform literature that is more overtly political in its efforts to alter or change the terrain of all aspects of the decorative arts that are prone, as they see it, to commercial exploitation.

18. Oscar Wilde, quoted in *Artist and Journal of Home Culture* 9 (May 1888): 139.

19. E. M. King, quoted in *Artist and Journal of Home Culture* 4 (June 1883): 184.

20. There is an important distinction to be made between the moderate use of corsetry and the term "tight-lacing," a rhetorical phrase used to condemn the overly restrictive use of the corset to unnaturally reduce the size of the waist. See Valerie Steele, *The Corset: A Cultural History* (New Haven, CT: Yale University Press, 2001), 87–90.

21. Lucy Crane, *Art and the Formation of Taste*, 132–33.

22. "Fitness and Fashion," *Magazine of Art* 5 (1882): 339.

23. Margaret Oliphant, *Dress* (London: Macmillan and Co., 1878), 4.

24. Ibid., 5.

25. Ibid., 64–65.

26. Ibid., 65–66.

27. Haweis, "Art of Beauty," 12–13.

28. Ibid., 23–24.

29. "Proposed Reform in Female Dress," *Artist and Journal of Home Culture* 2 (July 1, 1881): 214.

30. Rational Dress Association, *Catalogue of Exhibits and List of Exhibitors* (London, 1883), 2.

31. *Rational Dress Society's Gazette* 1 (April 1888): 1.

32. "On Fashion," *Rational Dress Society's Gazette* 3 (October 1888): 2.

33. *Aglaia: The Journal of the Healthy and Artistic Dress Union* (London: Hope-Hoskins, July 1893 to Autumn 1894).

34. Henry Holiday, *Reminiscences of My Life* (London: William Heinemann, 1914), 402–3.

35. *Aglaia* 1 (July 1893): 3.

36. Ibid., 4.

37. Ibid., 5.

38. *Aglaia* 2 (Spring 1894): 44.

39. *Artist and Journal of Home Culture* 4 (April 1883): 121.

40. E. W. Godwin, *Dress and Its Relation to Health and Climate* (London: William Clowes & Sons, 1884), 2.

41. "On Fashion," *Rational Dress Society's Gazette* 3 (October 1888): 4.

42. Ludmilla Jordanova, *Sexual Visions: Images of Gender in Science and Medicine between the Eighteenth and Twentieth Centuries* (Hertfordshire: Harvester Wheatsheaf, 1989), 41.

43. Godwin, *Dress*, 1.

44. Newton, *Health, Art and Reason*, 36–39.

45. Of course the use of a corset in fashionable gowns was still a major point of difference between Aesthetic dress and fashionable dress during these two periods.

46. "Colour in Dress," *Magazine of Art* 5 (1882): 158.

47. G. F. Watts, preface to *Transactions of the Guild & School of Handicraft*, vol. 1, ed. C. R. Ashbee (London: Guild and School of Handicraft, 1890), 11.

48. Lucy Crane, *Art and the Formation of Taste*, 106–7.

49. Ibid., 109–10.

50. Susan Casteras, "Pre-Raphaelite Challenges to Victorian Canons of Beauty," in *The Pre-Raphaelites in Context* (San Marino, CA: Henry E. Huntington Library and Art Gallery, 1992), 19.

51. Roger Smith, "Bonnard's *Costume Historique* — a Pre-Raphaelite Source Book in Costume," *Journal of the Costume Society* 7 (1973): 28.

52. Wilson, *Adorned*, 209.

53. Henry Treffry Dunn, in his personal memoir of Rossetti, described Rossetti's working space and procedures, which included a number of costumes in a "large wardrobe at the back of the studio," as well as an old cabinet that contained a "rare store of necklaces, featherwork, Japanese crystals, and knick-knacks of all kinds, sufficient to stock a small window." See Henry Treffry Dunn, *Recollections of Dante Gabriel Rossetti and His Circle*, edited and annotated by Gale Pedrick (London: Elkin Mathews, 1904), 27.

54. Haweis, "Art of Dress," 98.

55. Newton, *Health, Art and Reason*, 34.

56. Godwin, *Dress*, 7.

57. Ibid., 77.

58. A. N. W. Pugin, *The True Principles of Pointed or Christian Architecture* (London, 1841),

quoted in Alf Boe, *From Gothic Revival to Functional Form: A Study in Victorian Theories of Design* (New York: Da Capo Press, 1979), 25.

59. Haweis, "Art of Beauty," 29–30.

60. "Colour in Dress," *Magazine of Art* 5 (1882): 158.

61. Alice Comyns Carr, "The Artistic Aspect of Modern Dress," *Magazine of Art* 5 (1882): 244.

62. Ibid., 243.

63. Ibid., 246.

64. Oliphant, *Dress*, 69.

65. "Fitness and Fashion," *Magazine of Art* 5 (1882): 339.

66. The use of smocking in Aesthetic dress most likely drew on original designs for a loose-fitting shift-like garment known as a smock. Generally associated with a rural and timeless ideal of peasant life and the perceived simple pleasures of the laboring classes, such gowns were gathered at the wrists, yoke, and neck, and were considered functional as well as decorative.

67. Godwin, *Dress*, 77–78.

68. Oliphant, *Dress*, 68.

69. Between the fifteenth and seventeenth centuries, various laws were passed to ensure that the sartorial image of the nobility would be protected; consequently, strict decrees were passed to regulate the clothing that could be worn by various classes. Many of the types of clothes and materials favored by the nobility at that time were, therefore, prohibited for wear by commoners. For an in-depth analysis of these laws, see Daniel Roche, *The Culture of Clothing, Dress and Fashion in the* Ancien Régime, trans. Jean Birrell (New York: Cambridge University Press 1994).

70. Valerie Steele, *Fashion and Eroticism: Ideals of Feminine Beauty from the Victorian Era to the Jazz Age* (New York: Oxford University Press, 1985), 152.

71. The use of stays to, in a sense, "inhabit" the acceptable "fashionable" body was a question of degree rather than a hard-and-fast principle. It is too simplistic to state that corset wearers were moralistic and conventional and that dress reformers were all revolutionaries on the fringes of society — open-minded and liberal in their sexual views. In reality the picture is far more complex; dress reformers sometimes still suggested the use of light stays for support, while conservatives and moralists objected to tight-lacing as a form of physical extremism and vanity that was both debasing and, ultimately, indicative of sexual perversion. This debate will be covered in greater depth in chapter 5.

72. Henry Holiday, "The Artistic Aspect of Dress," *Aglaia* 1 (July 1893): 13.

73. Walter Crane, "On the Progress of Taste," 8–13.

74. Ibid., 13.

75. T. J. Jackson Lears, *No Place of Grace: Antimodernism and the Transformation of American Culture, 1880–1920* (New York: Pantheon Books, 1981), xiii.

76. Henry Holiday, "The Artistic Aspects of Edward Bellamy's 'Looking Backward,'" *Transactions of the Guild & School of Handicraft*, vol. 1, ed. C. R. Ashbee (London: Guild and School of Handicraft, 1890), 62.

77. Holiday, "'Looking Backward,'" 64.

78. Lucy Crane, *Art and the Formation of Taste*, 128–29.

79. Joanne Entwistle, *The Fashioned Body: Fashion, Dress and Modern Social Theory* (Cambridge: Polity Press, 2000), 108.

80. Elizabeth Cumming and Wendy Kaplan, *The Arts and Crafts Movement* (London: Thames & Hudson, 1991), 7.

81. Peter Stansky, *Redesigning the World: William Morris, the 1880s, and the Arts and Crafts* (Princeton, NJ: Princeton University Press, 1985), 32–34.

82. Cumming and Kaplan, *Arts and Crafts Movement*, 28.

83. Anthea Callen, "Sexual Division of Labour in the Arts and Crafts Movement," in *A View from the Interior: Feminism, Women and Design*, ed. Judy Attfield and Pat Kirkham (London: Women's Press, 1988), 162.

84. Lynn Walker, "The Arts and Crafts Alternative," in Attfield and Kirkham, *View from the Interior*, 172. Walker notes that "the number of women designers taking part in the exhibitions of 1888, 1896, and 1910 showed a continuous increase, and in fact there were five times as many women designers in 1910 as in 1888."

CHAPTER 2. AESTHETIC DRESS IN
THE WORK OF JAMES MCNEILL WHISTLER

1. Linda Merrill, *The Peacock Room: A Cultural Biography* (Washington, DC, and New Haven, CT: Freer Gallery of Art and Yale University Press, 1998), 153.

2. Ibid., 131.

3. Details of Cicely Alexander's dress are noted in a letter from Whistler to Mrs. William Alexander held by the Print and Drawing Department of the British Museum (Alexander Family Album, 21).

4. Susan Grace Galassi, "The Artist as Model: Rosa Corder," in *Whistler, Women, and Fashion*, ed. Margaret F. MacDonald et al. (New Haven, CT: Frick Collection in association with Yale University Press, 2003), 124.

5. Valparaiso Notebook, Glasgow University Library (MS Whistler NB9), 26–29. Margaret MacDonald has argued that, based on the notes surrounding these sketches, the notebook was in use right up until the early 1870s. In addition to this, she notes that, in cut and design, the drawings of these gowns, carried out on the last few pages of the notebook, share features with the gowns pictured in the paintings of the *White Girl* series, portraits of Frances Leyland, and in the case of the riding crop, to the portrait of May Alexander. Margaret F. MacDonald, *James McNeill Whistler: Drawings, Pastels, and Watercolours: A Catalogue Raisonné* (New Haven, CT: Paul Mellon Centre for Studies in British Art by Yale University Press, 1995), 112–13.

6. Deanna Bendix, "Whistler as Interior Designer: Yellow Walls at 13 Tite Street," *Apollo* 143, no. 407 (January 1996): 34.

7. Haweis, "Art of Beauty," 9.

8. Bendix, "Whistler as Interior Designer," 34. Bendix has noted that some of the best descriptions we have of Whistler's interiors come from the cartoons and satirical commentary provided by George du Maurier in the pages of *Punch*. Given du Maurier's involvement with

the very social circles he parodied in the press, we can give some credence to his awareness of the flavor and atmosphere that these spaces evoked, as well as to certain details of their construction. See also Deanna Bendix, *Diabolical Designs: Paintings, Interiors, and Exhibitions of James McNeill Whistler* (Washington, DC: Smithsonian Press, 1995), 17.

9. Bendix, *Diabolical Designs*, 29.

10. Louisine Elder, quoted in Bendix, "Whistler as Interior Designer," 33. Elder, who was married to Henry Osborne Havemeyer, amassed an extensive art collection later in life. See L. W. Havemeyer, *Sixteen to Sixty: Memoirs of a Collector* (New York: privately printed, 1961), 205.

11. Bendix, "Whistler as Interior Designer," 33.

12. Margaret F. MacDonald, "East and West: Sources and Influences," in MacDonald et al., *Whistler, Women, and Fashion*, 67.

13. Mrs. E. Pritchard, *The Cult of Chiffon* (London, 1902), quoted in Aileen Ribeiro, "Fashion and Whistler," in MacDonald et al., *Whistler, Women, and Fashion*, 32.

14. Branka Nakanishi, "A Symphony Reexamined: An Unpublished Study for Whistler's Portrait of Mrs. Frances Leyland," *Museum Studies* 18, no. 2 (1992): 160.

15. For a full discussion of this little-known study, see ibid., 156–67.

16. James McNeill Whistler, *Ten O'Clock Lecture*. The *Ten O'Clock Lecture* was first presented as a public lecture, Prince's Hall, Piccadilly, February 20, 1885. The text was privately printed in 1885; minor revisions were made in 1886, and the lecture was finally published by Chatto and Windus in 1888. Original manuscript held by Glasgow University Library (Whistler W780). Transcription is available at http://www.whistler.arts.gla.ac.uk/miscellany/tenoclock/.

17. Oscar Wilde, "The Relation of Dress to Art," *Pall Mall Gazette*, February 28, 1885, quoted in Margaret MacDonald, "Whistler: Painting the Man," in MacDonald et al., *Whistler, Women, and Fashion*, 10.

18. Merrill, *Peacock Room*, 64. Merrill has argued that in contrast to Pre-Raphaelite works such as William Holman Hunt's *The Awakening Conscience* (1853), which refers to moral and spiritual redemption through the depiction of a garden reflected in a mirror, *Symphony in White No. 2* offers only a reflection of art, and thus presents an "ideal of art, twice removed from life."

19. Susan Grace Galassi, "Whistler and Aesthetic Dress: Mrs. Frances Leyland," in MacDonald et al., *Whistler, Women, and Fashion*, 95–96.

20. Bendix, *Diabolical Designs*, 92.

21. Nakanishi, "Symphony Reexamined," 163.

22. Ibid.

23. Ibid., 162.

24. Whistler, *Ten O'Clock Lecture*.

25. J. M. Whistler in a letter to Anna Matilda, dated March/May 1880, Glasgow University Library (Whistler LB4/19–22), reprinted in *The Correspondence of James McNeill Whistler*, http://www.whistler.arts.gla.ac.uk.

26. Charles Baudelaire, "The Painter of Modern Life," in *The Painter of Modern Life and Other Essays*, trans. Jonathan Mayne (London: Phaidon, 1964), 32–33. This essay was originally published in installments in *Le Figaro* on November 26 and 28 and December 3, 1863.

27. Whistler, *Ten O'Clock Lecture*.

28. Merrill, *Peacock Room*, 64–65.

29. Baudelaire, "Painter of Modern Life," 12.

30. Bendix, *Diabolical Designs*, 3.

31. William Eden Nesfield in a letter to Whistler, dated September 19, 1870, Glasgow University Library (Whistler N20). Nesfield was an architect and designer and a friend of both Whistler and Moore. The works that Whistler felt were too similar were his own *Symphony in Blue and Pink* and Moore's *Shells*.

32. The majority of these notebooks are held by the University of Glasgow Library, Special Collections.

33. H. Heathcote Statham, "The Grosvenor Gallery," *Macmillan's Magazine* 36 (June 1877): 114–15.

34. *Artist and Journal of Home Culture* 5 (June 1, 1884): 164.

35. Ibid., 200.

36. Ibid., 199.

37. Whistler, *Ten O'Clock Lecture*.

38. *Artist and Journal of Home Culture* 7 (April 1, 1886): 113.

39. Entwistle, *Fashioned Body*, 74–75.

40. Baudelaire, "Painter of Modern Life," 30.

41. Patricia de Montfort, "White Muslin: Joanna Hiffernan and the 1860s," in MacDonald et al., *Whistler, Women, and Fashion*, 86.

42. Ibid.; Merrill, *Peacock Room*, 47.

43. Merrill, *Peacock Room*, 48. Whistler frequently taxed his sitters' patience to the point of breaking. He often had them pose for long hours and usually needed to be reminded that they required breaks.

44. De Montfort, "White Muslin," 87–88.

45. George du Maurier in a letter to Thomas Armstrong, February 1862, quoted in Merrill, *Peacock Room*, 62.

46. De Montfort, "White Muslin," 89.

47. Ibid., 88. De Montfort has pointed out that Fanny Cornforth, Rossetti's model for many of his paintings at this time, was sent to purchase unusual fabrics and also acted as assistant seamstress for some of the dresses and draperies that appeared in Rossetti's work. De Montfort argues that it is possible that Hiffernan may have performed a similar role in Whistler's work. Some of the notes in a notebook attached to Whistler's passport from 1862/64, containing details on the intended construction of the sleeves of the gown in muslin, are in Hiffernan's handwriting.

48. Ellen Terry, *The Story of My Life* (London: Hutchinson & Co., 1908), 124.

49. Louise Jopling, *Twenty Years of My Life, 1867–1887* (London: John Lane the Bodley Head Ltd., 1925), 228.

50. Bendix, "Whistler as Interior Designer," 32.

51. Nakanishi, "Symphony Reexamined," 160.

52. J. M. Whistler in a letter to Frances Leyland, 1868–71, Library of Congress (Manuscript Division, Pennell-Whistler Collection, PWC2/16/03), reprinted in *The Correspondence of James McNeill Whistler, 1855–1903*, ed. Margaret F. MacDonald, Patricia de Montfort, and Nigel

Thorp, online Centenary edition (Centre for Whistler Studies, University of Glasgow, 2003), at http://www.whistler.arts.gla.ac.uk/Correspondence.

53. Nakanishi, "Symphony Reexamined," 159–60.

54. Ibid., 163.

55. Joseph and Elizabeth Pennell quoted in Nakanishi, "Symphony Reexamined," 166.

56. Galassi, "Whistler and Aesthetic Dress," 95.

57. Reina Lewis, *Gendering Orientalism: Race, Femininity and Representation* (London: Routledge, 1996), 4.

58. Aileen Ribeiro, "Fashion and Whistler," in MacDonald et al., *Whistler, Women, and Fashion*, 32.

59. *Queen*, January 7, 1888 (Whistler PC9, Special Collections — University of Glasgow Library, 46).

60. Andrew Stephenson, "Refashioning Modern Masculinity: Whistler, Aestheticism and National Identity," in *English Art, 1860–1914: Modern Artists and Identity*, ed. David Peters Corbett and Lara Perry (Manchester: Manchester University Press, 2000), 146.

CHAPTER 3. THE GROSVENOR GALLERY

1. Pierre Bourdieu, *The Field of Cultural Production: Essays on Art and Literature* (New York: Columbia University Press, 1993), 76–78.

2. Entwistle, *Fashioned Body*, 105–8. For broader arguments dealing with the role of modernity in fashion, see also Christopher Breward, *The Culture of Fashion* (Manchester: Manchester University Press, 1994).

3. Diana Crane, *Fashion and Its Social Agendas: Class, Gender, and Identity in Clothing* (Chicago: University of Chicago Press, 2000), 1.

4. Although she focuses on the productive output of Aesthetic writers rather than artists, Talia Schaffer thoughtfully articulates the inherent dualities of female aesthetes who, "living like New Women while admiring Pre-Raphaelite maidens," tried to reconcile oppositional formations of identity. See Talia Schaffer, *The Forgotten Female Aesthetes: Literary Culture in Late-Victorian England* (Charlottesville: University Press of Virginia, 2000), 5.

5. H. Heathcote Statham, "The Grosvenor Gallery," *Macmillan's Magazine* 36 (June 1877): 118, quoted in Colleen Denney, *At the Temple of Art: The Grosvenor Gallery, 1877–1890* (Cranbury, NJ: Associated University Presses, 2000), 15.

6. Geoffrey Squire, "The Union of Persons of Cultivated Taste," in Wilson and Benington, *Simply Stunning*, 8. Squire points out that many of the artists, poets, and critics who came to be associated with the movement were actually part of smaller groups with common goals and aims, or were following their "own personal interests and inclinations," and that some of them actually detested aspects of the movement despite the indispensable nature of their own contributions.

7. Walter Hamilton quoted in Squire, "Union of Persons of Cultivated Taste," 9.

8. Ibid., 9. Squire argues that the Aesthetic movement might be more correctly described as a "League of Friends" or an "Affiliation of Enthusiasts." He asserts that a unifying description, or any effort to find a shared thread among the practices and goals of those associated with Aes-

theticism, ultimately "imposes certain limits on what was really a complex climate of thought, shared to some extent by many, of whom more than a few would never imagine that they might be eligible to join such an apparently exclusive group."

9. Entwistle, *Fashioned Body*, 113–14.

10. See Christopher Newall, *The Grosvenor Gallery Exhibitions: Change and Continuity in the Victorian Art World* (Cambridge: Cambridge University Press, 1995); Susan P. Casteras and Colleen Denney, eds., *The Grosvenor Gallery: A Palace of Art in Victorian England* (New Haven, CT: Yale Center for British Art, 1996).

11. *Artist and Journal of Home Culture* 8 (June 1887): 185.

12. Newall, *Grosvenor Gallery Exhibitions*, 12.

13. *Aesthetic Review, Devoted to Literature, Art, and General Intelligence* 9 (June–July 1877): 132.

14. In this context, I use the term "amateur" to indicate those exhibitors who were not paid for their work and who, as a general rule, did not sell their paintings.

15. Denney, *At the Temple of Art*, 128. See also Paula Gillett, "Art Audiences at the Grosvenor Gallery," in Casteras and Denney, *Grosvenor Gallery*, 39–58. For more on women artists at the Grosvenor, see Charlotte Yeldham, *Women Artists in Nineteenth-Century France and England: Their Art Education, Exhibiting Opportunities and Membership of Exhibiting Societies and Academies, with an Assessment of the Subject Matter of Their Work and Summary Biographies*, 2 vols. (New York: Garland, 1984), vol. 1, tables 1 and 5.

16. Denney, introduction to Casteras and Denny, *Grosvenor Gallery*, 2.

17. Ibid., 3. For a fuller description of the Aesthetic circles who patronized the Grosvenor, see Charlotte Gere, *Artistic Circles: Design and Decoration in the Aesthetic Movement* (London: V&A Publishing, 2010), 46–55.

18. Jopling, *Twenty Years of My Life*, 114.

19. "Artist's Homes," *Magazine of Art* 5 (1882): 184.

20. Eliza Haweis, *Beautiful Houses: Being a Description of Certain Well-Known Artistic Houses* (London: Sampson Low, Marston, Searle, & Rivington, 1882), iii–iv. Other "Aesthetic" houses featured in this text included those of Sir Frederick Leighton, William Burges, Alma-Tadema, G. H. Boughton, Alfred Morrison, Mr. Haseltine, and Mr. Stevenson.

21. "Artist's Homes," *Magazine of Art* 5 (1882): 186.

22. Haweis, *Beautiful Houses*, i. It is important to note that sections of this text were first published as articles in 1880–81, in one of the most eminent fashion journals of the day, *Queen*.

23. Haweis, *Beautiful Houses*, ii–iii.

24. Ibid., 31.

25. "Artist's Homes," *Magazine of Art* 5 (1882): 185.

26. *Artist and Journal of Home Culture* 6 (January 1885): 20.

27. Holiday, "Artistic Aspect of Dress," 17.

28. *Artist and Journal of Home Culture* 6 (October 1885): 319.

29. Steele, *Fashion and Eroticism*, 151.

30. E. W. Godwin, "Modern Dress," *Architect* 15 (June 10, 1876): 368.

31. *Artist and Journal of Home Culture* 8 (June 1887): 191.

32. "Dress at the Private Views of the Grosvenor Gallery and the Royal Academy," *Queen* 69 (January 8, 1881): 33.

33. "The Grosvenor Gallery," *Aesthetic Review, Devoted to Literature, Art, and General Intelligence* 9 (June–July 1877): 132.

34. *Athenaeum*, no. 2539 (June 24, 1876): 866.

35. Ibid., 867.

36. Walter Crane, "On the Progress of Taste," 7.

37. Holiday, "Artistic Aspect of Dress," 28.

38. See Elizabeth Cowie, "Woman as Sign," *m/f*, no. 1 (1978): 49–63; Deborah Cherry and Griselda Pollock, "Woman as Sign in Pre-Raphaelite Literature: A Study of the Representation of Elizabeth Siddall," *Art History* 7, no. 2 (1984): 206–24.

39. Kathy Alexis Psomiades, *Beauty's Body: Femininity and Representation in British Aestheticism* (Stanford, CA: Stanford University Press, 1997), 135.

40. Ibid., 152.

41. Alison Gernsheim, *Victorian and Edwardian Fashion: A Photographic Survey* (New York: Dover, 1963), 62.

42. Jopling, *Twenty Years of My Life*, 139.

43. Denney, *At the Temple of Art*, 130.

44. Deborah Cherry, *Painting Women: Victorian Women Artists* (London: Routledge, 1993), 89–90.

45. Denney, *At the Temple of Art*, 130.

46. *Queen* 69 (January 8, 1881): 33.

47. George William Erskine Russell, *Half-Lengths* (New York: Duffield and Co., 1913), 101.

48. Charlotte de Rothschild, quoted in Gere, *Artistic Circles*, 99.

49. Cherry, *Painting Women*, 89.

50. Gillett, "Art Audiences," 41.

51. Cherry, *Painting Women*, 83.

52. For a nuanced discussion of the significance of dress in the life and work of Marie Spartali Stillman, see Cherry, *Painting Women*, 89–90, and Casteras and Denney, *Grosvenor Gallery*, 160.

53. Alice Comyns Carr, in her published memoirs of her time among the bohemian elite in London's art scene, took great pains to note the dress and Aesthetic fashions of individuals such as Marie Spartali Stillman. In discussing the at-home parties given by the Burne-Jones family, she wrote: "The same people came Sunday after Sunday, and the party generally consisted of John Ruskin, George Howard (afterward Earl of Carlisle), the beautiful Mrs. Stillman, who, though a painter of some note herself, often posed as Burne-Jones's model." Alice Comyns Carr, *Mrs. J. Comyns Carr's Reminiscences*, ed. Eve Adam (London: Hutchinson & Co., 1926), 64.

54. Cherry, *Painting Women*, 88–89; Denney, *At the Temple of Art*, 160.

55. *Artist* 1, no. 2 (February 14, 1880): 50–51. After January 1881, the *Artist* changed its name to the *Artist and Journal of Home Culture*.

56. Letter by E. Burne-Jones to C. E. Hallé, October 3, 1887, the Grange, West Kensington (referred and forwarded to Sir Coutts Lindsay), National Art Library, Victoria and Albert Museum.

57. Jopling, *Twenty Years of My Life*, 114–15.

58. *Artist and Journal of Home Culture* 3 (February 1882): 55.

59. Lucy Crane, *Art and the Formation of Taste*, 92–93.

CHAPTER 4. POPULAR CULTURE
AND THE FASHIONING OF AESTHETICISM

1. *Queen* 69 (March 5, 1881): 225. The author is careful to mention the proper fabrics to be used with these styles, writing that they might be "made up in the following materials: No. 1. Short skirt of old-gold silk, bouillonné to the waist on one side; over-dress of soft cream coloured silk, edged with pearls, pearl ornament at the side; slashes of old-gold on sleeves and round top of dress. No 2. Long skirt of plush; dress of cashmere or thick soft silk, edged with embroidery in gold and colours; puffs at the elbows, and the filling in of the neck of Madras muslin; embroidered belt and satchel."

2. "Dress and Fashion, London Fashions," *Queen* 68 (July 3, 1880): 7. "In the Row" likely refers to "Rotten Row," the fashionable thoroughfare in Hyde Park, where people came to see and be seen during the London season.

3. *Queen* 69 (May 7, 1881): 470. The advertisement on this page refers to the services of Mme Bengough, 13 Norland Terrace, Notting Hill. The use of such clothing "types" illustrates the attempt on the part of dressmakers and clothing retailers to address different female audiences, drawing on visual symbolism and the power of stereotyping in order to illustrate the ability of clothing to express the personality of the wearer. In this way the Kate Greenaway example might evoke innocent simplicity, as much as the Girton blouse could intimate studious intellect or female industriousness.

4. Advertisement for "My Queen Vel-Vel," *Lady's Pictorial* 16 (July 21, 1888): 80 (insert).

5. Advertisement for "My Queen Vel-Vel," *Lady's Pictorial* 16 (December 1, 1888): 628 (insert).

6. *Lady's Pictorial* 16 (December 15, 1888): 704, illustrations on p. 701. There is an inherent problem in assessing the Aesthetic status of such advertising and the accompanying fashion illustration. Despite the rhetoric of the advertisers and writers, Pilotell's drawings show a female figure with a fashionable silhouette, one that is tightly corseted and features a pronounced bustle. It is hard to discern whether this depiction is simply a convention of mainstream fashion illustration or whether this was intentional in order to render the textile more appealing to a wider fashionable audience, while still drawing on the cachet associated with Aesthetic dress.

7. *Queen* 69 (April 2, 1881): 334.

8. *Cassell's Family Magazine*, 1880, 119.

9. Mme. *Schild's Monthly Journal of Parisian Dress Patterns and Needlework* 13 (April 1880): 2.

10. *Queen* 67 (March 27, 1880): 275.

11. *Artist and Journal of Home Culture* 3 (May 1882): 152. On Pfeiffer see Barbara Onslow, *Women of the Press in Nineteenth-Century Britain* (London: Macmillan, 2000), 148, 234.

12. *Queen* 69 (April 23, 1881): 411.

13. *Queen* 67 (January 10, 1880): 31.

14. Terry, *Story of My Life*, 349–50.

15. Diane Waggoner, "From Life: Portraiture in the 1860s," in *The Pre-Raphaelite Lens: British Photography and Painting, 1848–1875* (Washington, DC: National Gallery of Art, 2010), 99–100.

16. Valerie Cumming, "Ellen Terry: An Aesthetic Actress and Her Costumes," *Costume* 21 (1987): 67–74.

17. *Queen* 68 (July 24, 1880): 77.

18. "The Magazine for Every Cultivated Home," *Magazine of Art* 5 (1882): title page.

19. *Artist* 1 (March 15, 1880): 65. After January 1881, the *Artist* changed name to the *Artist and Journal of Home Culture*. In addition, the column "Art in the House" was later changed to "Art in the Home," and the semi-regular special columns on "Dress and Fashion" were amalgamated into a larger "Domestic Art" section and then apparently forgotten altogether. By 1884 it is hard to find a direct mention of fashion or dress in the index. This suggests that the interest in Aesthetic dress and artistic aspects of dress reform, at least for this journal, was largely focused in the late 1870s and early 1880s.

20. *Queen* 70 (October 1, 1881): 344.

21. *Queen* 70 (October 22, 1881): 413.

22. *Queen* 69 (May 7, 1881): 466.

23. *Queen* 70 (August 6, 1881): 143.

24. The popularization of Aesthetic dress as an unintended side-effect of parody has been noted by several scholars of the Aesthetic movement. For an interesting discussion of the destabilizing effects of the satirical commentary on Aesthetic dress in cartoons and the theater, see Rebecca N. Mitchell, "Acute Chinamania: Pathologizing Aesthetic Dress," *Fashion Theory* 14, no. 1 (2010): 45–64.

25. Jopling, *Twenty Years of My Life*, 90. Other figures who also appeared in the cartoon for *Punch* included Frederic Leighton and James McNeill Whistler.

26. Carr, *Mrs. J. Comyns Carr's Reminiscences*, 84–85.

27. "Colour in Dress," *Magazine of Art* 5 (1882): 158.

28. *Lady's Pictorial* 16 (November 3, 1888): 490.

29. "Art Notes," *Magazine of Art* 5 (1882): xii.

30. *Artist and Journal of Home Culture* 5 (January 1884): 22.

31. Newton, *Health, Art and Reason*, 119. Oscar Wilde's impact went beyond the Victorian public, extending outward to dress reform circles outside the United Kingdom. For a full discussion of Wilde's influence in the arena of Aesthetic dress, particularly in a literary context, see Mary Warner Blanchard, "Bohemian Boundaries, the Female Body, and Aesthetic Dress," in *Oscar Wilde's America: Counterculture in the Gilded Age* (New Haven, CT: Yale University Press, 1998), 137–77.

32. *Lady's Pictorial* 16 (December 1, 1888): 613.

33. *Lady's Pictorial* 15 (April 28, 1888): 470 (insert).

34. During a visit to the textile department of the Victoria and Albert Museum, I had the opportunity to examine this gown myself in order to observe the features and techniques used in its construction. For further details on this dress, see *Four Hundred Years of Fashion*, ed. Natalie Rothstein (London: V&A Publications, 1984), 43, 139.

35. Many of the key features that define this dress as Aesthetic, including the use of the sprig pattern satin to reference the eighteenth century, were pointed out to me in 2003 by Jenny

Lister, who was then assistant curator of textiles at the Museum of London. This gown was recently featured in the exhibition *The Cult of Beauty: The Aesthetic Movement 1860–1900*, held at the Victoria and Albert Museum from April 2 to July 17, 2011.

36. Newton, *Health, Art and Reason*, 70–71.

37. Steele, *Fashion and Eroticism*, 153.

38. *Artist and Journal of Home Culture* 2 (March 1, 1881): 84.

39. W. P. Frith, *My Autobiography and Reminiscences*, vol. 2 (London: Richard Bentley and Son, 1887), 256.

40. Ibid., 257.

41. Newton, *Health, Art and Reason*, 88.

42. For an in-depth view of the tangled social structures and artistic patronage at work in this setting, see Caroline Dakers, *The Holland Park Circle: Artists and Victorian Society* (New Haven, CT: Yale University Press: 1999). For more on Aesthetic portraits, see Barbara Bryant, "The Grosvenor Gallery, Patronage and the Aesthetic Portrait," in Calloway and Orr, *Cult of Beauty*, 158–82.

43. Pierre Bourdieu, "Structures, Habitus and Practices," in *The Polity Reader in Social Theory* (Cambridge: Polity Press, 1994), 95.

44. Walter Crane, "On the Progress of Taste," 8.

45. Lucy Crane, *Art and the Formation of Taste*, 32–33.

46. *Queen* 70 (October 1, 1881): 344.

47. Anne Anderson, "Life into Art and Art into Life: Visualising the Aesthetic Woman or 'High Art Maiden' of the Victorian 'Renaissance,'" *Women's History Review* 10, no. 3 (2001): 441.

48. For several useful sources on this topic, see *Victorian Women's Magazines: An Anthology*, ed. Margaret Beetham and Kay Boardman (Manchester: Manchester University Press, 2001); Margaret Beetham, *A Magazine of Her Own? Domesticity and Desire in the Woman's Magazine, 1800–1914* (London: Routledge, 1996); Alison Adburgham, *Women in Print: Writing Women and Women's Magazines from the Restoration to the Accession of Victoria* (London: Allen & Unwin, 1972).

49. "Fitness and Fashion," *Magazine of Art* 5 (1882): 337–38.

50. *Cassell's Family Magazine*, 1880, 442.

51. Henry Holiday, Letter to Miss Osborne, dated February 13, 1896, Special Collections, National Art Library, Victoria and Albert Museum.

52. Other scenes included "Ancient Greece," "18th Century England," "A Street Scene of the Present," and "A Street Scene of the Future." See *Henry Holiday, 1839–1927: An Exhibition at the William Morris Gallery* (London: London Borough of Waltham Forest Libraries & Arts Department, 1989), 19. For a full description of the event, see Holiday, *Reminiscences of My Life*, 408.

53. Elizabeth Wilson, "The Invisible Flâneur," in *Postmodern Cities and Spaces*, ed. Sophie Watson and Katherine Gibson (Oxford: Blackwell, 1995), 65. Diverging from the arguments put forth by Griselda Pollock and Janet Wolff regarding the importance of separate spheres in understanding the art production of women, Wilson argues that the experiences of men and women in both the private and public realm need to be reassessed — this is particularly true in any consideration of the role of female producers and consumers in popular culture.

54. *Woman's World*, 1888, 365.

55. Wilson, *Adorned*, 144. Wilson points out that advances in architecture, such as the elegant colonnade along Regent Street designed by John Nash, facilitated the development of shopping in the pursuit of leisure and even social recognition. Nash's colonnade "became the mecca of the fashionable shopper, the thoroughfare was a promenade, and society's élite went there at least as much to see and be seen as to shop."

56. Ibid., 150. By the 1870s, London guidebooks began to list commercial spaces where women could safely and appropriately have lunch or stop for refreshment, even when unattended by a gentleman. *Women's Gazette*, 1876, quoted in Wilson, "Invisible Flâneur," 67.

57. Erika Diane Rappaport, *Shopping for Pleasure: Women in the Making of London's West End* (Princeton, NJ: Princeton University Press, 2000), 6–12.

58. Wilson, *Adorned*, 144.

59. Wilson, "Invisible Flâneur," 68.

60. Lewis F. Day, "Fashion and Manufacture," *Transactions of the National Association for the Advancement of Art and Its Application to Industry, 1888–1891*. Vol. 1 (of 3), reprinted in *The Aesthetic Movement and the Arts and Crafts Movement: Periodicals — A Garland Series*, ed. Peter Stansky and Rodney Shewan (New York: Garland, 1979), 218–22.

61. Dorothy Lane, "The Art of Dress," in *The Lady at Home and Abroad Her Guide and Friend* (London: Abbott, Jones & Co., 1898), 181.

62. Day, "Fashion and Manufacture," 224–25.

63. E. Ward & Co., *The Dress Reform Problem: A Chapter for Women* (London: John Dale & Co., 1886), 2.

64. E. M. King, Hon. Sec., *Rational Dress Association, Exhibition Catalogue* (1883), 3.

65. "Beauty and Fitness," *Rational Dress Society's Gazette* 3 (October 1888): 6.

66. "Fitness and Fashion," *Magazine of Art* 5 (1882): 339.

67. Day, "Fashion and Manufacture," 220–21.

68. Ibid., 225.

69. *Queen* 69 (February 26, 1881): 196.

70. Haweis, "Art of Beauty," 15.

71. Ibid., 224.

72. "Colour in Dress," *Magazine of Art* 5 (1882): 160.

73. *Home Art Work* 7, no. 32 (April 1890): 8.

74. Steele, *Fashion and Eroticism*, 80–85.

75. A. E. F. Eliot-James, "Shopping in London," *Woman's World*, 1889, 6.

76. "Library, Healthy and Artistic Dress Union," *Aglaia* 2 (Spring 1894): 44.

77. *Artist and Journal of Home Culture* 2 (June 1, 1881): 192.

78. "Colour in Dress," *Magazine of Art* 5 (1882): 159.

79. *Rational Dress Association, Exhibition Catalogue*, 1883, 5.

80. *Queen* 69 (March 19, 1881): 273.

81. For a critical assessment of the relationship between orientalism, gender, and consumption in the context of Liberty's see Sarah Cheang, "Selling China: Class, Gender and Orientalism at the Department Store," *Journal of Design History* 20, no. 1 (2007): 1–16.

82. *Lady's Pictorial* 16 (October 6, 1888): 343 (illustration on 351).

83. Steele, *Fashion and Eroticism*, 157–58.

1. Mrs. Johnstone, "The Latest Fashions," *Woman's World*, 1890, 75–76.

2. Ada S. Ballin, *Health and Beauty in Dress from Infancy to Old Age* (London: John Flack, 1893), 3. This text is a revised version of the first edition, published by Sampson, Low, Marston, Searle & Rivington in 1885.

3. *Girl's Own Paper* 4, no. 196 (September 29, 1883): 826.

4. Entwistle, *Fashioned Body*, 33–36.

5. Wilson, *Adorned*, 13. See also Steele, *Corset*, 90.

6. Luke Limner, *Madre Natura versus the Moloch of Fashion* (London: Bradbury, Evans, & Co., 1870), 26–27.

7. Mary W. Blanchard, "Boundaries and the Victorian Body: Aesthetic Fashion in Gilded Age America," *American Historical Review* 100, no. 1 (1995): 25–26.

8. *Cassell's Family Magazine*, 1880, 441–42.

9. *Woman's World*, 1890, 25.

10. Steele, *Fashion and Eroticism*, 157–58.

11. "Fitness and Fashion," *Magazine of Art* 5 (1882): 338.

12. Holiday, "Artistic Aspect of Dress," 15.

13. *Mme. Schild's Monthly Journal of Parisian Dress Patterns and Needlework* 16 (July 1880): 1.

14. *Woman's World*, 1888, 378.

15. *Woman's World*, 1890, 185.

16. Ibid., 83.

17. Lane, "Art of Dress," 186.

18. It is important to note that the earlier *Ladies' Pictorial* was interested in issues of dress reform and current events. The later *Lady's Pictorial* was the more mainstream and fashionable of the two magazines.

19. *Artist and Journal of Home Culture* 11 (January 1890): 29.

20. *Queen* 69 (April 23, 1881): 411.

21. *Woman's World*, 1888, 186.

22. E. Aria, "Dressing as a Duty and an Art," *Woman's World*, 1890, 477.

23. *Tailor and Cutter* 16 (1881): 151

24. Lane, "Art of Dress," 181.

25. Aria, "Dressing as a Duty," 476.

26. Holiday, "Artistic Aspect of Dress," 13.

27. Entwistle, *Fashioned Body*, 109–10.

28. *Artist and Journal of Home Culture* 8 (August 1, 1887): 258.

29. Harry Quilter, "The New Renaissance; or, the Gospel of Intensity," *Macmillan's Magazine* 42 (September 1880): 398.

30. Quilter, "New Renaissance," 392–93.

31. Ibid., 396.

32. Frederick Wedmore, "Some Tendencies in Recent Painting," *Temple Bar, A London Magazine for Town and Country Readers* 53 (July 1878): 339.

33. *Rational Dress Gazette, Organ of the Rational Dress League* 1 (June 1898): 2. There can be no doubt that the author is referring to artistic forms of dress when she writes, "Some of the costumes worn might be most suitable for the stage, or the country, or for gymnastic suits, but look utterly out of place in London streets. We advise, we entreat, all Leaguers to get only a tailor-made costume. The most expensive stuff, the daintiest idea is spoiled and useless if home-made or even dressmaker-made. The suitable dress for London is a neat, plain and, above all, *well-cut*, tailor-made coat and knickers."

CONCLUSION

1. Newton, *Health, Art and Reason*, 2.
2. Entwistle, *Fashioned Body*, 2.
3. Ibid., 105–8.
4. Pierre Bourdieu, *Field of Cultural Production*, 75.
5. Rappaport, *Shopping for Pleasure*, 13.
6. Entwistle, *Fashioned Body*, 20–26.
7. Haweis, *Art of Beauty and the Art of Dress*, 273–74.

BIBLIOGRAPHY

"A Fairyland of Fabrics." *Home Art Work* 7, no. 32 (April 1890): 8–9.

"A Little Waist Paper." *Ladies' Pictorial* 1, no. 1 (1880): 8.

Adburgham, Alison. *Shopping in Style: London from the Restoration to Edwardian Elegance.* London: Thames & Hudson, 1979.

———. *Women in Print: Writing Women and Women's Magazines from the Restoration to the Accession of Victoria.* London: Allen & Unwin, 1972.

"Aesthetic Dress." *Queen* 70 (1881): 344.

"Aesthetics and Watteau Figures for Outline Embroidery." *Queen* 70 (1881): 128.

Anderson, Anne. "Life into Art and Art into Life: Visualising the Aesthetic Woman or 'High Art Maiden' of the Victorian 'Renaissance.'" *Women's History Review* 10, no. 3 (2001): 441–62.

Aria, E. "Dressing as a Duty and an Art." *Woman's World*, 1890, 476–78.

Arnold, Janet. *A Handbook of Costume.* London: Macmillan, 1973.

"Art Dress at Liberty's." *Lady's Pictorial* 16 (November 3, 1888): 486.

"Artistic Home Dress." *Lady's Pictorial* 16 (December 15, 1888): 704.

"Artist's Homes." *Magazine of Art* 5 (1882): 184–86.

Ashelford, Jane. *The Art of Dress: Clothes and Society, 1500–1914.* London: National Trust, 1996.

Attwood, P. "Maria Zambaco: Femme Fatale of the Pre-Raphaelites." *Apollo* 293 (July 1986): 31–37.

Ballin, Ada S. *Health and Beauty in Dress from Infancy to Old Age.* London: John Flack, 1893.

Bateman, Charles T. G. F. *Watts.* London: George Bell & Sons, 1901.

Baudelaire, Charles. "The Painter of Modern Life" (1863). In *The Painter of Modern Life and Other Essays.* Translated by Jonathan Mayne. London: Phaidon, 1964.

"Beauty and Fitness." *Rational Dress Society's Gazette*, no. 3 (October 1888): 5–6.

"Beauty at the Grosvenor Private View." *Artist and Journal of Home Culture* 8, no. 6 (1887): 191.

Beerbohm, Max. *A Note on "Patience."* London: Miles & Co., 1918.

Beetham, Margaret. *A Magazine of Her Own? Domesticity and Desire in the Woman's Magazine, 1800–1914.* London: Routledge, 1996.

Beetham, Margaret, and Kay Boardman, eds. *Victorian Women's Magazines: An Anthology.* Manchester: Manchester University Press, 2001.

Bendix, Deanna. *Diabolical Designs: Paintings, Interiors, and Exhibitions of James McNeill Whistler.* Washington, DC: Smithsonian Press, 1995.

———. "Whistler as Interior Designer: Yellow Walls at 13 Tite Street." *Apollo* 143, no. 407 (January 1996): 31–38.

Bennett, Mary. *Artists of the Pre-Raphaelite Circle: The First Generation.* Catalogue of works in the Walker Art Gallery, Lady Lever Art Gallery, and Sudley Art Gallery. London: Published for the National Museums and Galleries on Merseyside, Lund Humphries, 1988.

Blackburn, Henry. *Artists and Arabs or Sketching in Sunshine*. London: Sampson Low, Son, and Marston, 1868.

Blanchard, Mary W. "Boundaries and the Victorian Body: Aesthetic Fashion in Gilded Age America." *American Historical Review* 100, no. 1 (February 1995): 21–50.

———. *Oscar Wilde's America: Counterculture in the Gilded Age*. New Haven, CT: Yale University Press, 1998.

Boe, Alf. *From Gothic Revival to Functional Form: A Study in Victorian Theories of Design*. New York: Da Capo Press, 1979.

Bourdieu, Pierre. *Distinction: A Social Critique of the Judgment of Taste*. Cambridge, MA: Harvard University Press, 1984.

———. *The Field of Cultural Production: Essays on Art and Literature*. New York: Columbia University Press, 1993.

———. "Structures, Habitus and Practices." In *The Polity Reader in Social Theory*, 95–110. Cambridge: Polity Press, 1994.

Brake, Laurel. *Subjugated Knowledges: Journalism, Gender, and Literature in the Nineteenth Century*. New York: NYU Press, 1994.

Breward, Christopher. *The Culture of Fashion*. Manchester: Manchester University Press, 1994.

———. "Femininity and Consumption: The Problem of the Late Nineteenth-Century Fashion Journal." *Journal of Design History* 7, no. 2 (1994): 71–89.

Bryant, Barbara "The Grosvenor Gallery, Patronage and the Aesthetic Portrait." In *The Cult of Beauty: The Aesthetic Movement, 1860–1900*, edited by Stephen Calloway and Lynn Federle Orr, 158–82. London: V&A Publishing, 2011.

Buckley, Cheryl. "Made in Patriarchy." In *Design Discourse: History, Theory, Criticism*, edited by Victor Margolin, 251–62. Chicago: University of Chicago Press, 1989.

Bullen, J. B. *The Pre-Raphaelite Body: Fear and Desire in Painting, Poetry and Criticism*. Oxford: Clarendon Press, 1998.

Callen, Anthea. "Sexual Division of Labour in the Arts and Crafts Movement." In *A View from the Interior: Feminism, Women and Design*, edited by Judy Attfield and Pat Kirkham, 151–64. Women's Press, 1988.

———. *Women Artists of the Arts and Crafts Movement, 1870–1914*. New York: Pantheon, 1979.

Calloway, Stephen, and Lynn Federle Orr, eds. *The Cult of Beauty: The Aesthetic Movement, 1860–1900*. London: V&A Publishing, 2011.

Caplin, Madame Roxey A. *Health and Beauty, or, Woman and her Clothing Considered in Relation to the Physiological Laws of the Human Body*. London: Kent and Co., 1864.

Carr, Alice Comyns. "The Artistic Aspect of Modern Dress." *Magazine of Art* 5 (1882): 242–46.

———. *J. Comyns Carr: Stray Memories*. London: Macmillan and Co., 1920.

———. *Mrs. J. Comyns Carr's Reminiscences*. Edited by Eve Adam. London: Hutchinson & Co., 1926.

Casteras, Susan. "Pre-Raphaelite Challenges to Victorian Canons of Beauty." In *The Pre-Raphaelites in Context*, 13–35. San Marino, CA: Henry E. Huntington Library and Art Gallery, 1992.

Casteras, Susan P., and Colleen Denney, eds. *The Grosvenor Gallery: A Palace of Art in Victorian England*. New Haven, CT: Yale Center for British Art, 1996.

Cheang, Sarah. "Selling China: Class, Gender and Orientalism at the Department Store." *Journal of Design History* 20, no. 1 (2007): 1–16.

Cherry, Deborah. *Painting Women: Victorian Women Artists.* London: Routledge, 1993.

Cherry, Deborah, and Griselda Pollock. "Woman as Sign in Pre-Raphaelite Literature: A Study of the Representation of Elizabeth Siddall." *Art History* 7, no. 2 (1984): 206–24.

"Colour in Dress." *Magazine of Art* 5 (1882): 158–60.

Cooper, H. J. *The Art of Furnishing on Rational and Aesthetic Principles.* London: C. Kegan Paul & Co., 1880.

Cowie, Elizabeth. "Woman as Sign." *m/f*, no. 1 (1978): 49–63.

Crane, Diana. "Clothing Behavior as Non-Verbal Resistance: Marginal Women and Alternative Dress in the Nineteenth Century." *Fashion Theory* 3, no. 2 (1999): 241–68.

———. *Fashion and Its Social Agendas: Class, Gender, and Identity in Clothing.* Chicago: University of Chicago Press, 2000.

Crane, Lucy. *Art and the Formation of Taste: Six Lectures by Lucy Crane.* London: Macmillan and Co., 1882.

Crane, Walter. "On the Progress of Taste in Dress, in Relation to Art Education." *Aglaia* 3 (Autumn 1894): 7–14.

Cumming, Elizabeth, and Wendy Kaplan. *The Arts and Crafts Movement.* London: Thames & Hudson, 1991.

Cumming, Valerie. "Ellen Terry: An Aesthetic Actress and Her Costumes." *Costume* 21 (1987): 67–74.

Cunningham, Patricia A. *Reforming Women's Fashions, 1850–1920: Politics, Health, and Art.* Kent, OH: Kent State University Press, 2003.

Dakers, Caroline. *The Holland Park Circle: Artists and Victorian Society.* New Haven, CT: Yale University Press: 1999.

Day, Lewis F. "Fashion and Manufacture." In *Transactions of the National Association for the Advancement of Art and Its Application to Industry, 1888–1891.* 3 vols. Reprint in *The Aesthetic Movement and the Arts and Crafts Movement: Periodicals — A Garland Series,* edited by Peter Stansky and Rodney Shewan. New York: Garland, 1979.

de Grazia, Victoria, and Ellen Furlough, eds. *The Sex of Things: Gender and Consumption in Historical Perspective.* Berkeley: University of California Press, 1996.

de Marly, Diana. *The History of Haute Couture, 1850–1950.* London: Anchor Press, 1980.

de Montfort, Patricia. "White Muslin: Joanna Hiffernan and the 1860s." In *Whistler, Women, and Fashion,* edited by Margaret F. MacDonald, Susan Grace Galassi, and Aileen Ribeiro, with Patricia de Montfort, 76–91. New Haven, CT: Frick Collection in association with Yale University Press, 2003.

Denney, Colleen. *At the Temple of Art: The Grosvenor Gallery, 1877–1890.* Cranbury, NJ: Associated University Presses, 2000.

Dollman, J. C. Review of "An Artist on Modern Dress." Paper given at Trinity College, January, 20, 1880. *Artist* 1, no. 2 (1880): 50–51.

"Dress at the Private View of the Grosvenor Gallery." *Queen* 69 (1881): 466.

"Dress at the Private Views of the Grosvenor Gallery and the Royal Academy." *Queen* 69 (1881): 33.

"Dr. Woodhouse on the Physical Effects of Female Dress and Costumes." *Queen* 69 (1881): 626.

Dunn, Henry Treffry, *Recollections of Dante Gabriel Rossetti and His Circle*. London: Elkin Mathews, 1904.

Ehrman, Edwina. "Women's Dress." In *The Cult of Beauty: The Aesthetic Movement, 1860–1900*, edited by Stephen Calloway and Lynn Federle Orr, 206–7. London: V&A Publishing, 2011.

E. J. H. "Girlhood." In *The Girl's Own Indoor Book: Containing Help to Girls on All Matters Relating to Their Material Comfort and Moral Well-Being*, edited by Charles Peters, 19–22. London: Religious Tract Society, 1888.

Eliot-James, A. E. F. "Shopping in London." *Woman's World*, 1889, 5–8.

Entwistle, Joanne. "Fashion and the Fleshy Body: Dress as Embodied Practice." *Fashion Theory* 4, no. 3 (2000): 323–48.

———. *The Fashioned Body: Fashion, Dress and Modern Social Theory*. Cambridge: Polity Press, 2000.

Evans, Lawrence, ed. *Letters of Walter Pater*. Oxford: Clarendon Press, 1970.

Evett, Elisa. "The Late Nineteenth-Century European Critical Response to Japanese Art: Primitivist Leanings." *Art History* 6, no. 1 (March 1983): 82–106.

"Fitness and Fashion." *Magazine of Art* 5 (1882): 336–39.

Flower, William Henry. *Fashion in Deformity: As Illustrated in the Customs of Barbarous and Civilised Races*. London: Macmillan and Co., 1881.

Foucault, Michel. *The Archaeology of Knowledge*. Translated by A. M. Sheridan Smith. London: Pantheon, 1972.

———. *The Order of Things: An Archaeology of the Human Sciences*. London: Tavistock, 1970.

Fowler, O. S. *Intemperance and Tight Lacing, Considered in Relation to the Laws of Life*. London: J. Watson, 1849.

Gagnier, Regenia. "Productive Bodies, Pleasured Bodies: On Victorian Aesthetics." In *Women and British Aestheticism*, edited by Talia Schaffer and Kathy Alexis Psomiades, 270–89. Charlottesville: University Press of Virginia, 1999.

Galassi, Susan Grace. "The Artist as Model: Rosa Corder." In *Whistler, Women, and Fashion*, edited by Margaret F. MacDonald, Susan Grace Galassi, and Aileen Ribeiro, with Patricia de Montfort, 116–31. New Haven, CT: Frick Collection in association with Yale University Press, 2003.

———. "Whistler and Aesthetic Dress: Mrs. Frances Leyland." In *Whistler, Women, and Fashion*, ed. Margaret F. MacDonald, Susan Grace Galassi, and Aileen Ribeiro, with Patricia de Montfort, 92–115. New Haven, CT: Frick Collection in association with Yale University Press, 2003.

Gallagher, Catherine, and Thomas Laqueur, eds. *The Making of the Modern Body: Sexuality and Society in the Nineteenth Century*. Berkeley: University of California Press, 1987.

Gere, Charlotte. "The Art of Dress, Victorian Artists and the Aesthetic Style." In *Simply Stunning: The Pre-Raphaelite Art of Dressing*, edited by Sophia Wilson and Jonathan Benington, 10–19. Exhibition catalog. Cheltenham: Cheltenham Art Gallery and Museums, 1996 (reprint edition).

———. *Artistic Circles: Design and Decoration in the Aesthetic Movement*. London: V&A Publishing, 2010.

Gilbert, W. S. *Patience or Bunthorne's Bride*. London: G. Bell and Sons, 1911.

Gillett, Paula. "Art Audiences at the Grosvenor Gallery." In *The Grosvenor Gallery: A Palace of Art in Victorian England*, edited by Susan P. Casteras and Colleen Denney, 39–58. New Haven, CT: Yale Center for British Art, 1996.

Ginsburg, Madeleine. *An Introduction to Fashion Illustration*. London: Pitman, 1980.

Girouard, Mark. *Sweetness and Light: The Queen Anne Movement, 1860–1900*. Oxford: Clarendon Press, 1977.

Godwin, E. W. *"Claudian," a Few Notes on the Architecture and Costume: A Letter to Wilson Barrett, Esq*. Westminster, 1883.

———. *Dress and Its Relation to Health and Climate*. Handbook for the International Health Exhibition. London: William Clowes & Sons, 1884.

———. "Modern Dress." *Architect* 15 (June 10, 1876): 368.

"The Grosvenor Gallery." *Aesthetic Review* 9 (June–July 1877): 132.

"The Grosvenor Gallery." *Illustrated London News* 70 (1877): 450.

Harberton, F. W. "A Plea for Dress Reform." *Queen* 68 (1880): 332.

Haweis, Eliza. "The Art of Beauty; the Art of Dress." In *The Art of Beauty and the Art of Dress*. New York: Harper & Bros., 1878, 1879. Reprint, in a single volume, New York & London: Garland, 1978.

———. *Beautiful Houses: Being a Description of Certain Well-Known Artistic Houses*. London: Sampson Low, Marston, Searle, & Rivington, 1882.

Holiday, Henry. "The Artistic Aspect of Dress" *Aglaia* 1 (July 1893): 13–30.

———. "The Artistic Aspects of Edward Bellamy's 'Looking Backward.'" In *Transactions of the Guild & School of Handicraft*, vol. 1, edited by C. R. Ashbee, 53–72. London: Guild and School of Handicraft, 1890.

———. "The Figure in Design." *Transactions of the National Association for the Advancement of Art and Its Application to Industry*, 172–82. London, 1891.

———. *Reminiscences of My Life*. London: William Heinemann, 1914.

Houze, Rebecca. "Fashionable Reform Dress and the Invention of 'Style' in Fin-de-Siècle Vienna." *Fashion Theory* 5, no. 1 (2001): 29–56.

Huyssen, Andreas. "Mass Culture as Woman: Modernism's Other." In *After the Great Divide*. Bloomington: Indiana University Press, 1986.

"Hygienic and Economical Dress." *Queen* 70 (1881): 297.

Ishiyama, Akira, ed. *The Charm of Art Nouveau Fashion Plates of the Late 19th Century*. Tokyo: Graphic-sha Publishing, 1986.

Jaeger, Gustav. *Health Culture*. Translated by Lewis R. S. Tomalin. London: Adams Bros., 1892.

Jopling, Louise. *Twenty Years of My Life, 1867–1887*. London: John Lane the Bodley Head Ltd., 1925.

Jordanova, Ludmilla. "Natural Facts: A Historical Perspective on Science and Sexuality." In *Nature, Culture and Gender*, edited by Carol MacCormack and Marilyn Strathern, 42–69. Cambridge: Cambridge University Press, 1980.

———. *Sexual Visions: Images of Gender in Science and Medicine between the Eighteenth and Twentieth Centuries*. Hertfordshire: Harvester Wheatsheaf, 1989.

King, E. M. *Rational Dress; or, the Dress of Women and Savages*. London: Kegan Paul, Trench & Co., 1882.

Lambourne, Lionel. *The Aesthetic Movement*. London: Phaidon, 1996.

Lamont, L. M. *Thomas Armstrong, a Memoir, 1832–1911*. London: Martin Secker, 1912.

Lane, Dorothy. "The Art of Dress." In *The Lady at Home and Abroad: Her Guide and Friend*. London: Abbott, Jones & Co., 1898.

Lears, T. J. Jackson. *No Place of Grace: Antimodernism and the Transformation of American Culture, 1880–1920*. New York: Pantheon Books, 1981.

Lee, Frederick George. *Immodesty in Art, an Expostulation and Suggestion: A Letter to Sir Frederick Leighton, Bart. President of the Royal Academy*. London: George Redway, 1887.

Levy, Amy. "Women and Club Life." *Woman's World*, 1888, 364–66.

Lewis, Reina. *Gendering Orientalism: Race, Femininity and Representation*. London: Routledge, 1996.

Lillie, Lucy C. *Prudence: A Story of Aesthetic London*. Illustrated by George du Maurier. London: Sampson Low, Marston, Searle, & Rivington, 1882.

Limner, Luke. *Madre Natura versus the Moloch of Fashion*. London: Bradbury, Evans, & Co., 1870.

Linton, Lynn. *Modern Women*. New York: Worthington Co., 1886.

Loftie, W. J. *A Plea for Art in the House, with Special Reference to the Economy of Collecting Works of Art, and the Importance of Taste in Education and Morals*. Art at Home Series. London: Macmillan and Co., 1876.

MacDonald, Margaret F. "East and West: Sources and Influences." In *Whistler, Women, and Fashion*, edited by Margaret F. MacDonald, Susan Grace Galassi, and Aileen Ribeiro, with Patricia de Montfort, 52–75. New Haven, CT: Frick Collection in association with Yale University Press, 2003.

Macleod, Dianne Sachko. *Art and the Victorian Middle Class: Money and the Making of Cultural Identity*. Cambridge: Cambridge University Press, 1996.

———. *James McNeill Whistler: Drawings, Pastels, and Watercolours: A Catalogue Raisonné*. New Haven, CT: Paul Mellon Centre for Studies in British Art by Yale University Press, 1995.

———. "Whistler: Painting the Man." In *Whistler, Women, and Fashion*, edited by Margaret F. MacDonald, Susan Grace Galassi, and Aileen Ribeiro, with Patricia de Montfort, 2–15. New Haven, CT: Frick Collection in association with Yale University Press, 2003.

Maltz, Diana. *British Aestheticism and the Urban Working Classes, 1870–1900: Beauty for the People*. Houndmills, Basingstoke, UK: Palgrave Macmillan, 2006.

Marsh, Jan. *Pre-Raphaelite Women Artists*. London: Thames & Hudson, 1998.

Maynard, Margaret. "'A Dream of Fair Women': Revival Dress and the Formation of Late Victorian Images of Femininity." *Art History* 12 (September 1989): 322–41.

Mayo, Janet. *A Survey of Artistic Dress, 1881–1893*. MA thesis, Courtauld Institute of Art, University of London, 1977.

Merrill, Linda. *The Peacock Room: A Cultural Biography*. Washington, DC, and New Haven, CT: Freer Gallery of Art and Yale University Press, 1998.

"Mr. E. Burne Jones's Pictures." *Athenaeum*, no. 2539 (1876): 866–67.

Myrene. "The Art of Being Graceful." In *The Lady Beauty Book*. London: "The Lady" Offices, 1890.

Nakanishi, Branka. "A Symphony Reexamined: An Unpublished Study for Whistler's Portrait of Mrs. Frances Leyland." *Museum Studies* 18, no. 2 (1992): 157–67.

Newall, Christopher. *The Grosvenor Gallery Exhibitions: Change and Continuity in the Victorian Art World*. Cambridge: Cambridge University Press, 1995.

Newton, Stella Mary. *Health, Art and Reason: Dress Reformers of the 19th Century*. London: John Murray, 1974.

Oliphant, Margaret. *Dress*. London: Macmillan and Co., 1878.

"On Fashion." *Rational Dress Society's Gazette*, no. 3 (October 1888): 2–4.

Onslow, Barbara. *Women of the Press in Nineteenth-Century Britain*. London: Macmillan, 2000.

Ormond, Leonée. "Dress in the Painting of Dante Gabriel Rossetti." *Costume* 8 (1974): 26–29.

———. "Female Costume in the Aesthetic Movement of the 1870s and 1880s." *Costume* 1–2 (1967–68): 47–52.

Palmer, Alexandra. "New Directions: Fashion History Studies and Research in North America and England." *Fashion Theory* 1, no. 3 (1997): 297–312.

Parkins, Ilya, and Elizabeth M. Sheehan, eds. *Cultures of Femininity in the Modern Period*. Lebanon, NH: University of New Hampshire Press, 2011.

Pater, Walter. *Studies in the History of the Renaissance*. London: Macmillan, 1873.

Pollock, Griselda. "Woman as Sign in Pre-Raphaelite Literature: The Representation of Elizabeth Siddall." In *Vision and Difference, Femininity, Feminism and the Histories of Art*, 91–114. London: Routledge, 1988.

Pritchard, Mrs. E. *The Cult of Chiffon*. London: Grant Richards, 1902.

———. "Proposed Reform in Female Dress." *Artist and Journal of Home Culture* 2, no. 7 (1881): 214–15.

Psomiades, Kathy Alexis. "Beauty's Body: Gender Ideology and British Aestheticism." *Victorian Studies* 36 (Fall 1992): 31–52.

Quilter, Harry. "The New Renaissance; or, the Gospel of Intensity." *Macmillan's Magazine* 42 (September 1880): 391–400.

Rappaport, Erika Diane. *Shopping for Pleasure: Women in the Making of London's West End*. Princeton, NJ: Princeton University Press, 2000.

Rational Dress Association. *The Exhibition of the Rational Dress Association, Catalogue of Exhibits and List of Exhibitors*. London: Rational Dress Association, 1883.

Ribeiro, Aileen. "Fashion and Whistler." In *Whistler, Women, and Fashion*, edited by Margaret F. MacDonald, Susan Grace Galassi, and Aileen Ribeiro, with Patricia de Montfort, 16–51. New Haven, CT: Frick Collection in association with Yale University Press, 2003

Roche, Daniel. *The Culture of Clothing, Dress and Fashion in the Ancien Régime*. Translated by Jean Birrell. New York: Cambridge University Press, 1994.

Rothstein, Natalie, ed. *Four Hundred Years of Fashion*. London: Victoria and Albert Museum, 1984.

Russell, George William Erskine. *Half-Lengths*. New York: Duffield and Co., 1913.

Russet, Cynthia. *Sexual Science: The Victorian Construction of Womanhood*. Cambridge, MA: Harvard University Press, 1989.

Sato, Tomoko, and Toshio Watanabe, eds. *Japan and Britain: An Aesthetic Dialogue, 1850–1930*.

London: Lund Humphries in association with Barbican Art Gallery and Setagaya Art Museum, 1991.

Seebee, F. *Journal of "An Aesthetic."* Exmouth: T. Freeman, Journal Office, 1884.

Shepherd, Kristen Adelle. *Marie Spartali Stillman: A Study of the Life and Career of a Pre-Raphaelite Artist.* MA thesis, George Washington University, 1998.

Shonfield, Zuzanna. "Miss Marshall and the Cimabue Browns." *Costume* 13 (1979): 62–72.

Simmons, William. *Knickerbockers for Both, a Lively Letter or Two on Dress Reform.* Reading: F. W. Starkley, 1882.

Simply Stunning: The Pre-Raphaelite Art of Dressing. Edited by Sophia Wilson and Jonathan Benington. Exhibition catalog. Cheltenham: Cheltenham Art Gallery and Museums, 1996 (reprint edition).

Smith, Roger. "Bonnard's *Costume Historique* — a Pre-Raphaelite Source Book in Costume." *Journal of the Costume Society* 7 (1973).

Spelman, Elizabeth V. "Woman as Body: Ancient and Contemporary Views." *Feminist Studies* 8, no. 1 (Spring 1982): 109–31.

Squire, Geoffrey. "The Union of Persons of Cultivated Taste." In *Simply Stunning: The Pre-Raphaelite Art of Dressing*, edited by Sophia Wilson and Jonathan Benington, 5–9. Exhibition catalog. Cheltenham: Cheltenham Art Gallery and Museums, 1996 (reprint edition).

Stansky, Peter. *Redesigning the World: William Morris, the 1880s, and the Arts and Crafts.* Princeton, NJ: Princeton University Press, 1985.

Statham, H. Heathcote. "The Grosvenor Gallery." *Macmillan's Magazine* 36 (June 1877): 112–18.

Steele, Valerie. *The Corset: A Cultural History.* New Haven, CT: Yale University Press, 2001.

———. *Fashion and Eroticism: Ideals of Feminine Beauty from the Victorian Era to the Jazz Age.* New York: Oxford University Press, 1985.

Stephenson, Andrew. "Refashioning Modern Masculinity: Whistler, Aestheticism and National Identity." In *English Art, 1860–1914: Modern Artists and Identity*, edited by David Peters Corbett and Lara Perry, 133–49. Manchester: Manchester University Press, 2000.

Taylor, Lou. *The Study of Dress History.* Manchester: Manchester University Press, 2002.

Terry, Ellen. *The Story of My Life.* London: Hutchinson & Co., 1908.

Trodd, Colin. "The Authority of Art: Cultural Criticism and the Idea of the Royal Academy in Mid-Victorian Britain." *Art History* 20, no. 1 (March 1997): 3–22.

Victoria and Albert Museum. *Liberty's, 1875–1975, Exhibition Guide.* London: Victoria and Albert Museum, 1975.

Waggoner, Diane. "From Life: Portraiture in the 1860s." In *The Pre-Raphaelite Lens: British Photography and Painting, 1848–1875.* Washington, DC: National Gallery of Art, 2010.

Walker, Lynn. "The Arts and Crafts Alternative." In *A View from the Interior: Feminism, Women and Design*, edited by Judy Attfield and Pat Kirkham, 165–73. Women's Press, 1988.

———. "Home and Away: the Feminist Remapping of Public and Private Space in Victorian London." In *New Frontiers of Space, Bodies and Gender*, edited by Rosa Ainley, 65–75. London: Routledge, 1998.

Ward, E., & Co. *The Dress Reform Problem: A Chapter for Women.* London: John Dale & Co., 1886.

Watts, G. F. "On Taste in Dress." *Nineteenth Century* 13 (January–June 1883): 45–50.

———. Preface to *Transactions of the Guild & School of Handicraft*. Vol. 1, edited by C. R. Ashbee. London: Guild and School of Handicraft, 1890.

Wedmore, Frederick. "Some Tendencies in Recent Painting." *Temple Bar, a London Magazine for Town and Country Readers* 53 (July 1878): 334.

Whistler, James McNeill. Letter to Anna Matilda, dated March/May 1880. Glasgow University Library (Whistler LB4/19–22). Reprinted in *The Correspondence of James McNeill Whistler*, http://www.whistler.arts.gla.ac.uk.

———. *Ten O'Clock Lecture*. Prince's Hall, Piccadilly, February 20, 1885. Privately printed in 1885, 1886, Chatto and Windus, 1888. Original manuscript held by University of Glasgow Library (Whistler W780), transcribed for the website of the Centre for Whistler Studies at the University of Glasgow.

———. *Valparaiso Notebook* [1866–75]. University of Glasgow Library, Special Collections (MS Whistler NB9).

Whistler Press Clippings. University of Glasgow Library, Special Collections (microfilm no. 4687 — Press cuttings PC1-PC12).

Wilde, Oscar. "The Relation of Dress to Art." *Pall Mall Gazette*, February 28, 1885.

Williams, Raymond. *Culture and Society: 1780–1950*. New York: Columbia University Press, 1983. First published in 1958.

Wilson, Elizabeth. *Adorned in Dreams: Fashion and Modernity*. Berkeley: University of California Press, 1985.

———. "The Invisible Flâneur." In *Postmodern Cities and Spaces*, edited by Sophie Watson and Katherine Gibson, 59–79. Oxford: Blackwell, 1995.

Wilson, Sophia. "Away with the Corsets, on with the Shifts." In *Simply Stunning: The Pre-Raphaelite Art of Dressing*, edited by Sophia Wilson and Jonathan Benington, 20–27. Exhibition catalog. Cheltenham: Cheltenham Art Gallery and Museums, 1996 (reprint edition).

Yeldham, Charlotte. *Women Artists in Nineteenth-Century France and England: Their Art Education, Exhibiting Opportunities and Membership of Exhibiting Societies and Academies, with an Assessment of the Subject Matter of Their Work and Summary Biographies*. 2 vols. New York: Garland, 1984.

INDEX

Page numbers for illustrations are italicized.

Denney, Colleen, 72, 77, 91

design reform and reformers, 7–15, 25; artistic freedom and social empowerment, 32–33; role of women, 76, 99, 136. See also artistic reform; dress reform and reformers

Dollman, J. C., 99

domestic spaces, 78–79, 147

drapery, xiii, 41–42, 84–85, 88. See also colors; fabrics

Dress and Its Relation to Health and Climate (handbook), 17

dressmaking, 9–11. See also Aesthetic dress; dress reform and reformers; fashion

dress reform and reformers, xi–xii, 7, 9–15, 128–29, 131–33; Aesthetic dress and, xxix, 33–34, 111–12, 160, 186n33; criticism of commercialism, 125–26; historicism and, 22–27, 29; influence on fashion, 121; naturalism/health and, xxix, 16–19; Pre-Raphaelitism and, 1–2, 112; public interest in, 127; tea gowns and, 147; tight-lacing and, 143, 165. See also Haweis, Eliza; Oliphant, Margaret

du Maurier, George, 113

dyes, xiii–xiv. See also aniline dyes

eclecticism: Aesthetic culture/Aestheticism, 21–22, 78–79; Aesthetic dress and, 103; Whistler and, 44–45, 54

Elder, Louisine, 41

embroidery, 8–9, 91, 151. See also crewelwork

Entwistle, Joanne, xxii, xxix–xxxi, 32, 57, 71, 73–74, 144, 157

fabrics, 103–4, 105–6, 112, 136–37, 181n1. See also Aesthetic dress; colors; drapery

fashion: art and, xx, 49–50, 82–86, 110, 133, 136; comfort/health aspects (see health); commercial aspects, 125–26 (see also consumer culture); criticism of, 133, 136; as empowering, xxx–xxxi; gender and, xxix; interior design and, 79–80; mainstream, 107, 115, 125; tea gowns and, 150–54,

152–53. See also Aesthetic dress; clothing and dress; colors; fabrics

fashion journalism/literature, xxi, xxix, 9, 172n17; Aesthetic dress and, 102–9, 111, 121–22, 125–26; art world and, 127; dress reform and, 128. See also names of journals

fashion reform. See dress reform and reformers

fashion scholarship, xx

female body/embodiment, xxx–xxxi, 144–45, 155; Aesthetic culture/Aestheticism and, 164–65; centrality of, 71; naturalism and, 16–18, 154. See also beauty; self-expression/self-fashioning/self-representation

femininity: Aesthetic culture/Aestheticism and, xi, 71; Aesthetic dress and, xxvii–xxxi, 98; consumer culture and, 90; Victorian culture and, 142, 145–47, 151, 160, 165

Forget Me Nots (painting), 88, 89

Foucault, Michel, xx, xxx

Frith, William Powell, 122–24

Gagnier, Regenia, xxvii–xxviii

Galassi, Susan, 63–64

gender, 64, 71; fashion and, xxix, xxx–xxxi; inequality, 33, 76, 98; relations, xx–xxi, xxvii; roles, 129–30

Girl's Own Paper (journal), 27, 144

Godwin, E. W., 17–18, 24, 81

"Gothic Gowns," 115

Gothic revival, 24

gowns, 39; artistic, 135, 136; tea (see tea gowns)

Great Britain, xi, xiii. See also London

"Greek Dress," xvii, xix

Greek revival. See classicism

Greenaway, Kate, 26, 27, 103–4, 104, 106, 135, 136

Grimshaw, John Atkinson, 49

Grosvenor Gallery, xxiv–xxv, 70–101, 159; Aesthetic culture/Aestheticism and, 72–75; Aesthetic dress and, 73, 90, 98; artistic currents, 81–82; artists and, 76; fashion and art, 82–86; interiors, 75,

77–78; negative views of, 99; women and, 71–74, 76–77

Hallé, C. E., 74, 99–100
Haweis, Eliza, xix, 5–6, 12–13, 22, 24–25, 166, 171n8; aesthetic and artistic sensibilities, 41, 134, 154; domestic spaces, 78–79, 154
The Hay Field (painting), xiii, *xiv*
health: beauty and, 17–18, 143; dress/fashion and, 1, 9–11, 16–18, 143, 145 (*see also* Aesthetic dress:illness and)
Healthy and Artistic Dress Union, xvi, 14–16, 28, 128, 157
Hellenism. *See* classicism
Hiffernan, Joanna, 58–60, *59*, 64, 65, 177n47
historicism, 78–79; Aesthetic dress and, 33–34, 107–8; antimodernism and, 30; dress reform and, 21–24. *See also* classicism; medievalism: Aesthetic culture/Aestheticism
Holiday, Henry, 14, 29, 31–32, 80, 86, 128, *149*, 157
Holland Park, 109, 124
Home Art Work (journal), *135*, 136
home decor. *See* interior design

identity formation, xxix, xxxi, 70–74. *See also* self-expression/self-fashioning/self-representation
individualism/individuality, 31–32; Aesthetic culture/Aestheticism, 73; Aesthetic dress and, xxii, xxvi, 166; in fashion, 134. *See also* self (concept of); self-fulfillment
interior design, xxiv, 20, 79–80, 111

Japanese art. *See* Asian art
The Japanese Dress (painting), 42, *43*
japonisme, 36
Jones, Edward Burne. *See* Burne-Jones, Edward
Jopling, Louise, 61–62, 77–78, *91*, *92*, 93, 97, 100, 113

journal literature, 80; Aesthetic dress and, xix, 102–3, 128; consumer culture and, 136; dress reform and, 127–28, 132; tea gowns (debate), 155–56. *See also* fashion journalism/literature; *names of journals*

Kensington, xiii, 109, 127
kimonos, 42
King, E. M., 9, 13, 132

Ladies' Pictorial (journal), 185n18
Lady's Pictorial (journal), 103–7, 114–17, 127, 138–40
Lane, Dorothy, 131, 150
Laus Veneris (painting), 84, *85*, 159–60
Lears, T. J. Jackson, xxv–xxvi, 31
Levy, Amy, 129
Lewis, Reina, 64
Leyland, Frances, 22, 23, 62–63, 66; portrait by Rossetti, 50; portrait by Whistler, 39–40, 42, 44, 49–50, 63
Leyland, Frederick, 62, 64
Liberty's (department store), 41–42, 137–40; artistic and tea gowns, *xviii*, *118*, 138, 184n81; dress department, xxi
Limner, Luke, 145
Lindsay, Caroline Blanche, 74, 77–78, 93–95, *94*
Lindsay, Coutts, 74–75, 77–78
London, xi–xiii
Looking Backward, 31
Love's Messenger (painting), 95–97, *96*

MacDonald, Margaret, 42
Magazine of Art (journal), xvii, xix, 10–11, 19, 25, 27, 111; art and fashion, 136; "Colour in Dress," 114, 136–37, *139*; dress reform and, 133, 147, 149
Mariana (painting), 5, 21
materialism, 30–31. *See also* consumer culture
medicine and dress/fashion. *See* health
medievalism, 21–28, *26*. *See also* classicism
Merleau-Ponty, Maurice, xxx

Walker, Lynn, 33

Watteau panels, plaits, and toilette, 4, 19, 103, 109, *119*, *152–53*

Watts, George Frederic, 8, 20, 94, 110

Wedmore, Frederick, 159

Whistler, James McNeill, 2, 35–69, 175–76n8; on Aesthetic dress, 46–47, 49–52, 54; as artist-dandy, 45, 51, 54, 67–68; Asian art and, 49, 54; Baudelairean approach, 52–53 (*see also* artist-dandy); contemporary view of, 55–57; depictions of/relationships with women, 61–62; fashion and, 49–51, 53, 57–58, 63, 67–69; modernism and, 46–50, 53, 54; on nature, 51–52; orientalism and, 47, 49, 64–66, 68; portraits, 61, 63 (*see also individual titles*); self-fashioning, 53–55, 177n31; sketches, *40*, *42*, 175n5; social elements of his work, 64–65; social life, 41, 61–62

White Girl series, 35, 61. See also *Symphony in White, No. 1: The White Girl* (painting);

Symphony in White, No. 2: The Little White Girl (painting)

Who Is It? (painting), 86, *88*

Wilde, Oscar, 9, 182n31; on Aesthetic dress, 46; influence of, 114–15, 117; on interior design and fashion, 80

Wilson, Elizabeth, xxx, 70–71, 129–30, 144

Woman's World (journal), xviii–xix, 115, 117, 129, 141, 150

women: Aesthetic culture/Aestheticism and, xxviii, 71–73; artistic, 91; clothing and dress, xi–xii (*see also* Aesthetic dress; dress reform and reformers; fashion); consumer culture and, xxii, 127, 129–30; design reform and, 76, 99, 136; dress reform and, 127; empowerment of, 32–33, 36, 66–67, 90; Grosvenor Gallery and, 71–74, 76–77; identity formation and, 73–74, 178n4, 181n3; role of art and, 57, 71, 76, 99. See *also* artists, women; middle class